MASTERPIECES FROM PARIS

Van Gogh, Gauguin, Cézanne & beyond

POST-IMPRESSIONISM FROM THE MUSÉE D'ORSAY

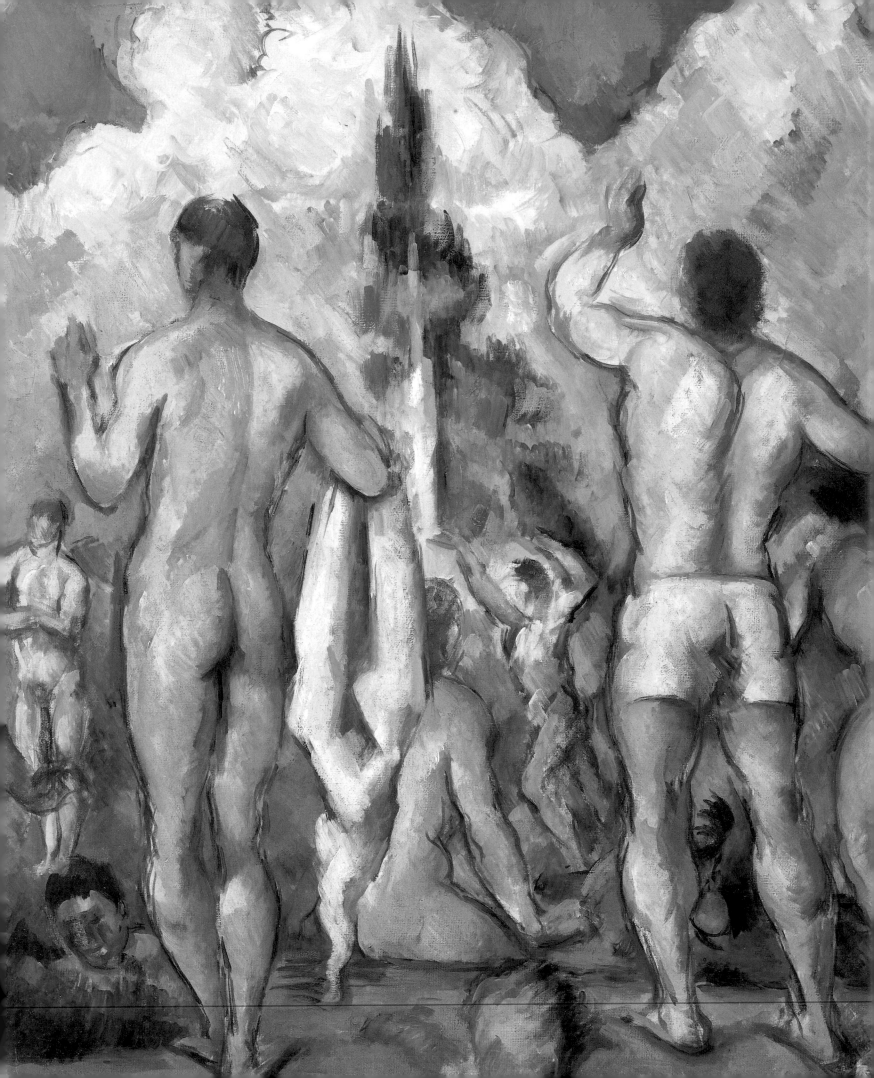

MASTERPIECES FROM PARIS

Van Gogh, Gauguin, Cézanne & beyond

POST-IMPRESSIONISM FROM THE MUSÉE D'ORSAY

Guy Cogeval, Sylvie Patry,
Stéphane Guégan and Christine Dixon

Musée
d'Orsay

national gallery of **australia**

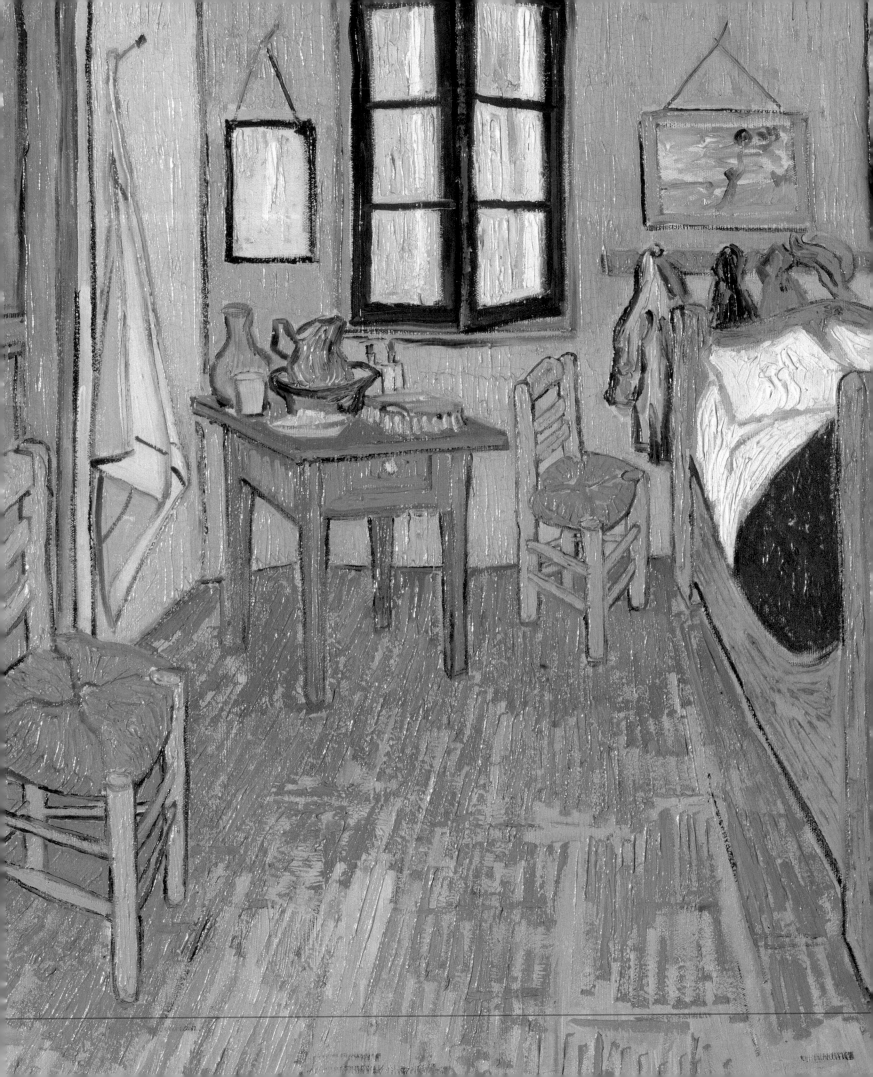

Contents

Exhibition partners

An exhibition of this scale cannot be realised without the generous support of our partners.
The National Gallery of Australia would to thank the following organisations:

Presenting Partners

Principal Partners

Major Sponsors

Supporters

The National Gallery of Australia's 2009 summer exhibition—*Masterpieces from Paris: Van Gogh, Gauguin, Cézanne and beyond* is important for Australia. Hundreds of thousands of people are expected to see the exhibition over the four months it is in Canberra.

Through this significant exhibition, National Australia Bank will build on our existing relationship with the National Gallery of Australia. NAB has a major commitment to education, investing in the now to help build a prosperous future for generations to come. In this context, we are delighted to be strengthening our relationship with the Gallery as Art Education and Access Partner for *Masterpieces from Paris.*

As a Principal Partner we join the Gallery in presenting the many education and public programs associated with the exhibition. People from all walks of life—mums and dads, children, students and teachers—will have the opportunity to discover these great works of art by the Post-Impressionist masters.

Creating opportunities to invest in people and communities is important to NAB. Through partnerships such as with the National Gallery, we aim to build genuine connections so that we can continue to help grow vibrant and sustainable communities, helping all Australians to reach their potential, whether it is in the arts or any other field.

NAB is very proud to be part of bringing such a magnificent and important exhibition as *Masterpieces from Paris: Van Gogh, Gauguin, Cézanne and beyond* to Australia.

Cameron Clyne
Group CEO
National Australia Bank

The ACT Government, through Australian Capital Tourism, is delighted to partner with the National Gallery of Australia to bring this major exhibition to the Australian public.

Masterpieces from Paris: Van Gogh, Gauguin, Cézanne and beyond, is one of the most exceptional art events ever to be held in Australia and a rare opportunity for audiences to see works from the Musée d'Orsay in Paris.

Canberra is proud to host the world première of the exhibition, which features 112 works including masterpieces by Vincent van Gogh, Paul Gauguin, Paul Cézanne, Georges Seurat, Pierre Bonnard, Claude Monet, Maurice Denis and Edouard Vuillard.

Our collaboration with the National Gallery affirms our commitment to partnership initiatives that drive interstate and international visitation to the ACT. Tourism is vital to the ACT's economy, contributing more than $1.2 billion and accounting for almost 13 000 jobs.

I encourage those visiting Canberra for *Masterpieces from Paris* to also discover the story of our nation through all our famed attractions. Nowhere is Australia's journey as a nation better reflected than in our capital.

I would like to congratulate the National Gallery of Australia for delivering such an outstanding event and I hope you enjoy these inspiring works of art.

Andrew Barr, MLA
Minister for Tourism, Sport and Recreation

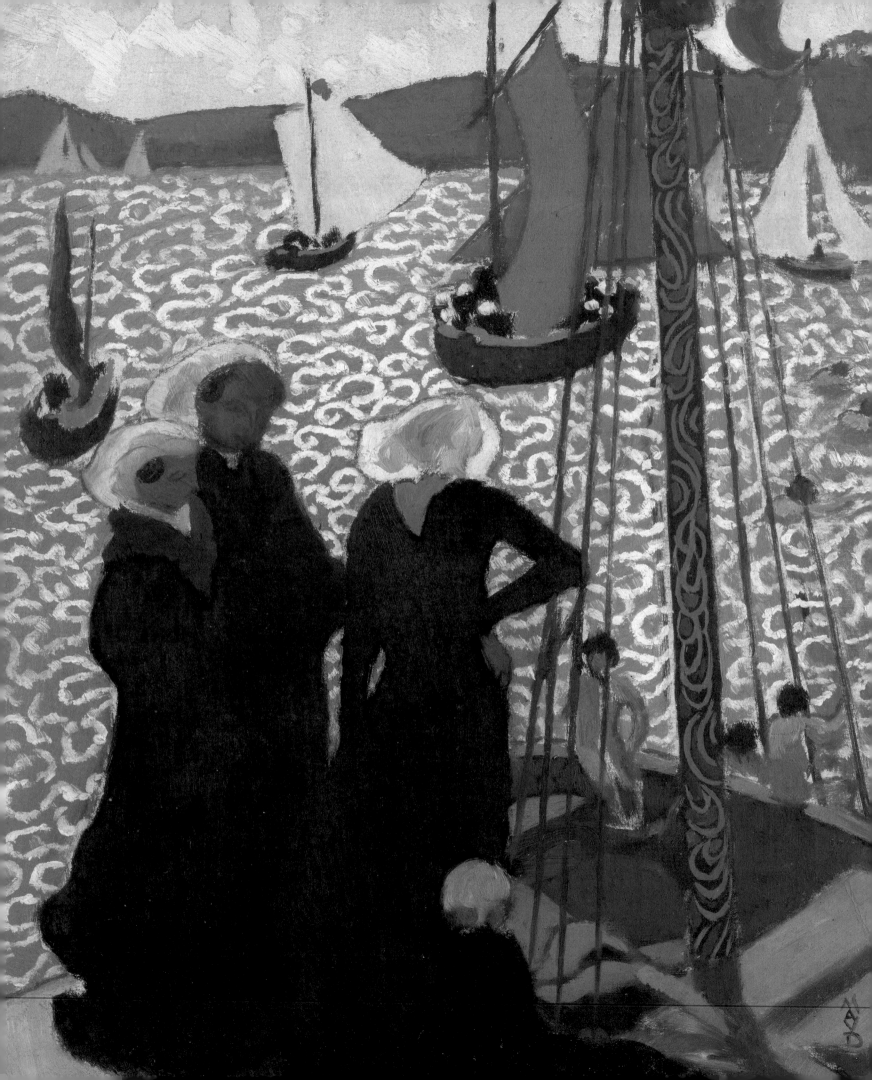

President's foreword

International collaborations that seek to present high-quality exhibitions contribute in an exemplary way to the knowledge and dissemination of works of art, as well as spreading French artistic creativity throughout the world.

The Musée d'Orsay has for many years undertaken ambitious projects with different countries with this purpose. In 2010, on the occasion of a major renovation program being carried out at the Musée d'Orsay, the museum will send part of its collection abroad, exhibiting these works of art in three countries who are long-term partners of France, especially in the cultural domain: Australia, Japan and the United States.

The exhibition proposes to show the stylistic evolution of the great Impressionist painters after 1886, the date of their last group exhibition, and to reveal the decisive turning point that occurred around 1900, with the later generations and the encounter between the avant-garde and the renaissance of mural painting. The great masters such as Monet, Cézanne, van Gogh, Gauguin, Toulouse-Lautrec, Seurat, 'Le Douanier' Rousseau, Bonnard and Vuillard will testify through their work to the exuberance and quality of this revival.

This exceptional event brings together more than one hundred masterpieces which will no doubt never again be lent out for an exhibition as a group once they return to the Musée d'Orsay. I offer my best wishes that it meets with its anticipated success and that it stimulates the interest of the Australian public, thereby further strengthening the connections forged between our two countries.

Nicolas Sarkozy
President of the French Republic

Prime Minister's foreword

Masterpieces from Paris will be counted amongst the most extraordinary international art events to be hosted in Australia. Many of the most heralded works of art are among this group of 112 paintings, which almost never leave the Musée d'Orsay in Paris, France. It is, therefore, a unique opportunity for Australians to view these masterpieces at home in our very own National Gallery of Australia.

Consider the names for a moment—Vincent van Gogh, Paul Gauguin, Paul Cézanne, Georges Seurat, Pierre Bonnard, Claude Monet, Maurice Denis and Edouard Vuillard innovators, influencers and luminaries. Today we might point to the approach these artists took to an example of 'mashup' culture. They combined the Impressionists' concern with colour, the play of light and atmosphere, with deliberate examination of form and shape.

What is marvellous about this exhibition is that visitors will be able to actually see these pivotal and valuable works. Visitors can move beyond the images they have grown up with, rendered in postcards, reproduction posters and art books, and explore for themselves the artists' choice of brushstrokes, the quality of colour, and the meaningful choices of character and form.

The exhibition has been mounted with the collaboration of the Musée d'Orsay, and I thank them for their generous assistance. Congratulations to the National Gallery of Australia for securing and presenting another compelling international exhibition.

The Honourable Kevin Rudd MP
Prime Minister of Australia

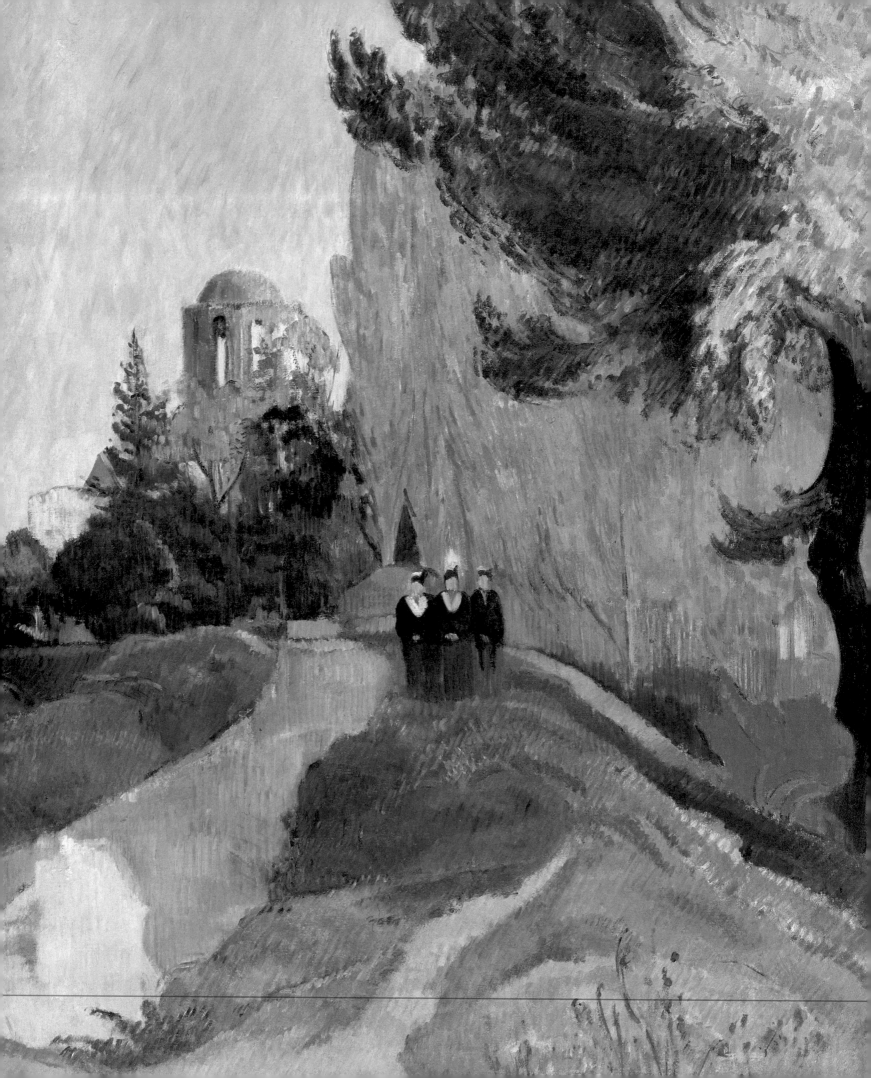

Directors' foreword

The Musée d'Orsay and National Gallery of Australia are delighted to collaborate on this extraordinary exhibition, one of the most spectacular to come to Australia. *Masterpieces from Paris: Van Gogh, Gauguin, Cézanne and beyond, Post-Impressionism from the Musée d'Orsay* explores the dramatic changes in late nineteenth-century European art through some of the best-known and much-reproduced paintings. Indeed many of these paintings are central to the Musée d'Orsay's high reputation, both in France and overseas. There are only a handful of Post-Impressionist works in Australia —including Georges Seurat's *Study for Le Bec du Hoc, Grandcamp* 1885 at the National Gallery of Australia—so the opportunity to create an exhibition from a single collection of such outstanding quality is rare indeed.

Post-Impressionism announces a break from Impressionism, the revolutionary movement which occurred in France in the second half of the nineteenth century. By the mid 1880s, artists were experimenting with even more radical ideas. Van Gogh's intense, richly coloured surfaces communicate emotionally through the artist's expressive manipulation of paint. Gauguin's monumental, decorative and often exotic works stand for a new and at times brutal aesthetic directness. Cézanne's mastery of the genres of still-life, landscape and portraiture fulfils his own prophetic promise to 'astonish with an apple!' These artists encapsulate the challenges to painting and the development of a multi-faceted avant-garde at this time: Pointillism, Neo-Impressionism, Synthetism, Symbolism, School of Pont-Aven, Cloisonnism, the Nabis and Intimism.

Beside some of the most famous painters, the exhibition includes Symbolist masterworks by artists who are now less known to a general public, but who had a profound impact on their own contemporaries. Visitors will find jewel-like domestic scenes and figures, portraits of friends and family members, as well as several large decorative schemes designed for specific interiors. In chronicling the Post-Impressionists' development from Impressionist and Salon painting, *Masterpieces from Paris* reveals cross-influences between artists, and shows the flowering of the modern movements throughout Europe. These fascinating paintings forecast the development of Fauvism, Cubism, Expressionism and led also to Abstraction in the twentieth century.

It is fitting that *Masterpieces from Paris* should come from one national capital to another and we recognise the role of both governments in this exciting project. The exhibition has been made possible here by the Australian Government's indemnification scheme, Art Indemnity Australia, which has supported major exhibitions in this country for thirty years. We also acknowledge the vital support of the ACT Government as a presenting partner through Australian Capital Tourism, and the National Australia Bank as Education and Access partner. We also thank our Principal Partners Channel Nine and JCDecaux; and our Major Sponsors Qantas, The Yulgilbar Foundation and The Canberra Times. Staff of both the Musée d'Orsay and the National Gallery of Australia have worked extraordinarily hard to ensure the success of this exhibition and accompanying publication.

We know great numbers of visitors from all parts of Australia and further afield will visit Canberra this summer and autumn, to enjoy this remarkable exhibition.

Guy Cogeval,
President of the Musée d'Orsay, Paris

Ron Radford AM, Director,
National Gallery of Australia, Canberra

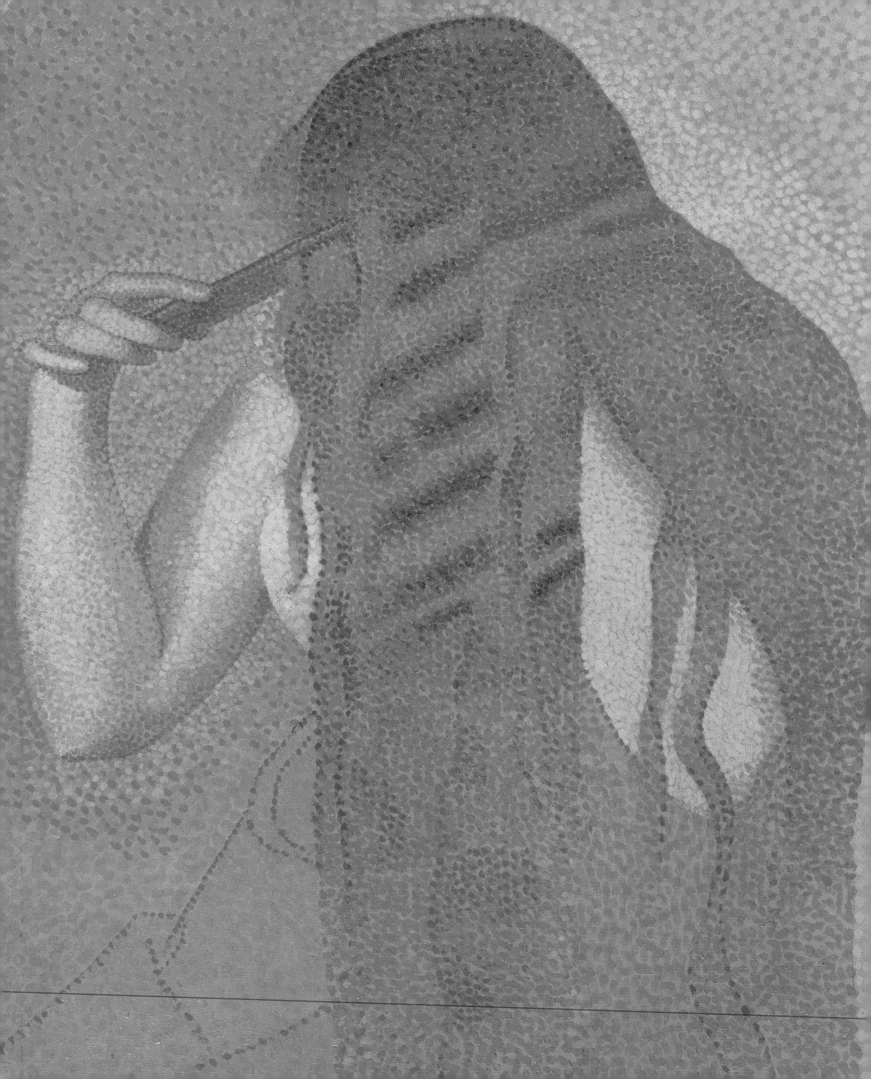

Introduction

Why is it so important for this exhibition of Post-Impressionism to come to the National Gallery of Australia? Along with the brilliant quality and compelling nature of the paintings, it seems of great consequence to look at an art movement which changed the course of modern art—an area of strength in our National Collection. Yet Post-Impressionism itself is so thinly represented in the collections of this country. Individual artists in this exhibition are now famous, and exhibitions concentrating on single artists such as van Gogh and Cézanne have previously been held in Australia. But no such ambitious enterprise—examining what happened to French art after Impressionism—has ever been shown here. Now, thanks especially to Guy Cogeval, President of the Musée d'Orsay, we have the opportunity to view this extraordinary exhibition. He personally chose most of the works for the exhibition, in consultation with the National Gallery. The Musée d'Orsay, of course, holds the world's largest collection of Post-Impressionism and we are grateful that the Museum has generously loaned so many of its greatest treasures.

The essays and entries of this catalogue underline how Post-Impressionism is a strangely amorphous style: in fact, it is not a normal art movement at all, but rather the clamorous reaction by the mid 1880s to Impressionism, which was then the prevailing modern art. As Guy Cogeval recounts in his essay 'Beyond Impressionism', cultural and social uncertainties mount throughout the nineteenth century, and painters increasingly assert diverse solutions, while the role of colour becomes ever more important. In her essay 'Impressionism versus Post-Impressionism?', Sylvie Patry argues that the new painting styles took account of the Impressionist revolution, while some older artists—Monet and Cézanne in particular—engaged in rich, creative exchanges with the younger generation. Two of the heroes of Post-Impressionism, Gauguin and van Gogh, have their fateful and dramatic artistic and personal trajectories examined by Stéphane Guégan in his essay, 'Van Gogh and Gauguin: The resurrection of Delacroix?', where the dominant theme of the role of colour reappears. The final discussion, 'Inventing modern art', by Christine Dixon, investigates the role of Seurat as an exemplar of modernity, and the overarching influences of Gauguin and Cézanne on the Symbolists and the Nabis.

Following the essays, the catalogue includes discussions and analyses of all 112 works in the exhibition, written by the curatorial staff of the National Gallery of Australia—Christine Dixon, Mark Henshaw, Jane Kinsman, Simeran Maxwell, Emilie Owens and Lucina Ward. These include fascinating details about the artists and their paintings, often using the artist's own words or those of contemporary critics.

Post-Impressionism had a vital, if delayed, role in the development of modern art in Australia. Before the end of the First World War, Grace Cossington-Smith, Roland Wakelin and Roy de Maistre were among major local artists who made breakthroughs in Sydney. Later, in Melbourne, artist–teachers such as George Bell and William Frater were among the others.

I sincerely hope that our visitors to *Masterpieces from Paris: Van Gogh, Gauguin, Cézanne and beyond, Post-Impressionism from the Musée d'Orsay* leave the exhibition with a new understanding of this extraordinary period of the beginning of modern art, and filled with vivid memories of these wonderful paintings produced by the greatest artists of Post-Impressionism.

Ron Radford AM
Director, National Gallery of Australia

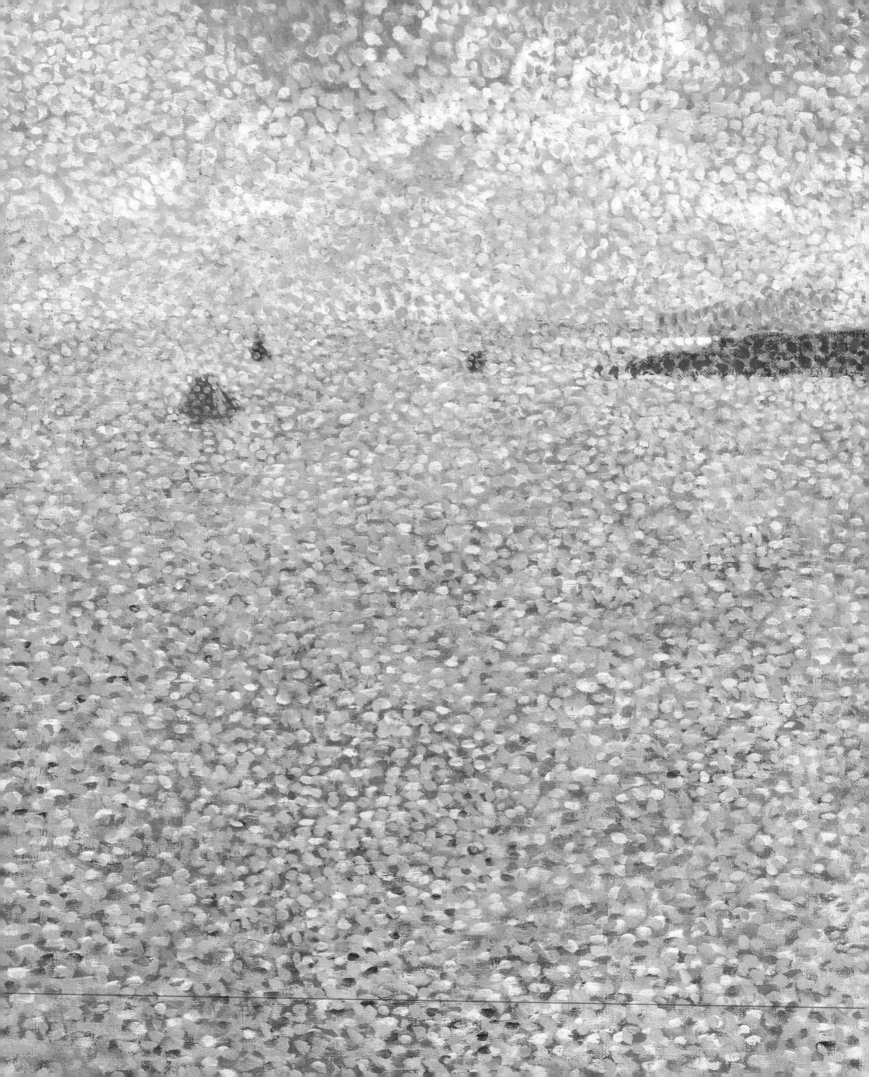

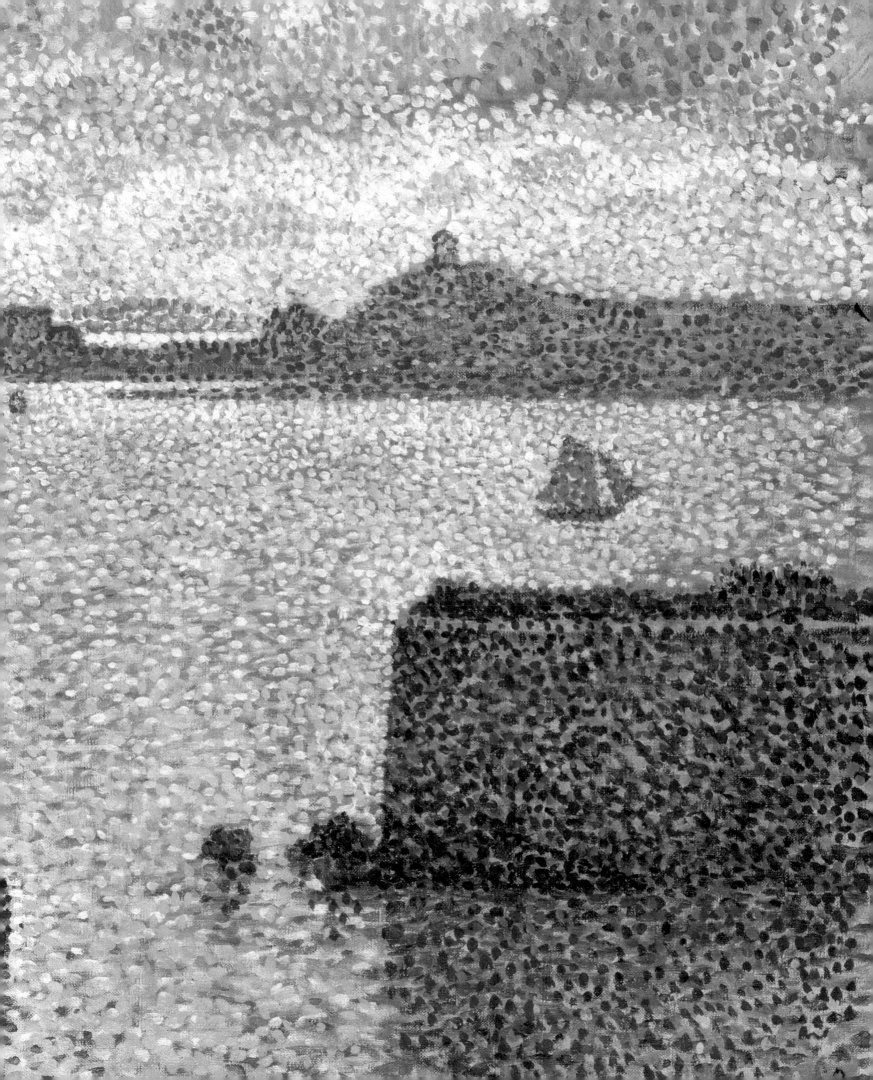

Beyond Impressionism

Guy Cogeval

The idea of Post-Impressionism, as forged by
Roger Fry in 1910, is under question today.
Fry set up a black-and-white opposition between
Impressionism, as a subjectless form of painting
limited to imitation and scrutiny, and the art
that came after it. This meant, in particular, the
contributions of Cézanne, Gauguin and van Gogh
were the bearers for their part of a more inventive
and conceptual form of art.

While stimulating at the time, the ideas of the
English critic need to be seriously re-examined.
The overcoming of Impressionism, for him, was
loaded with significance. But can we just shake
off what was a genuine revolution in our perception
and awareness of modernity? If we examine
Post-Impressionism as a continuation of and
engagement with Impressionism, instead of a
simple rejection of it, the art we encounter
becomes more complex and even more interesting.

To take Edouard Manet as a yardstick, the
disturbance in the rules of painting was too
great between *Luncheon on the grass*[1] and *Olympia*[2]
painted in 1863 and *Georges Clemenceau*[3] and
The bar at the Folies-Bergère[4] painted in 1880.
In less than twenty years, his painting moves from
a sombre density marked by the shadow of

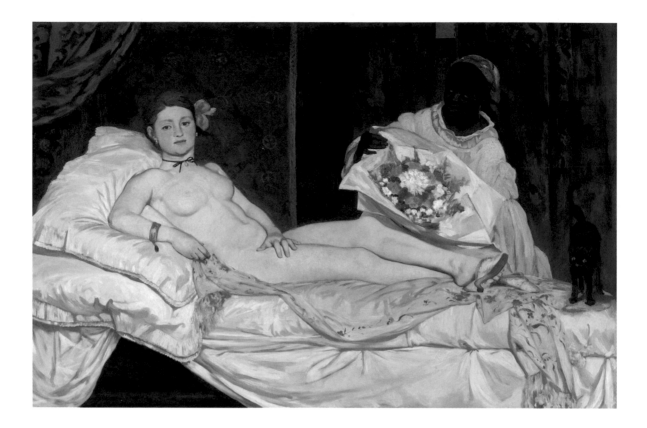

Edouard Manet
Olympia 1863
oil on canvas
130.5 x 190.0 cm

Musée d'Orsay, Paris
given to the state by public
subscription on the initiative of
Claude Monet 1890 RF 664
© RMN (Musée d'Orsay) /
Hervé Lewandowsk

(previous page)
Georges Seurat
*Study for 'A Sunday
afternoon on the island
of La Grande Jatte'* 1884
(detail) cat.13

Diego Velázquez to a style that alternates between laconic minimalism and a shimmering virtuosity incorporating tricks of perspective.

Towards 1880, the Impressionist exhibitions are no longer met with a flood of criticism, and its protagonists feel they have exhausted subjects drawn from Parisian life and its surrounding suburbs —the glamour of Italy and even Northern Africa is beginning to attract Monet and Pierre-Auguste Renoir. The wave of Romanticism broke between 1840 and 1850, and Neo-Classicism had lost the innocence of its first 'Greek shepherds' and other 'Cupid Sellers',[5] due to the twin impact of the rediscovery of Shakespearean theatre and the Nordic saga of the *Nibelungenlied*.

Even further back, Italian Mannerism, around 1530 and 1550, had also been a period marked by doubt, divisions and melancholia, set against the backdrop of religious wars where brutal tensions followed the calm of the new visual order of the Renaissance. Pontormo's tormented bodies and *cangianti*,[6] Bronzino's combinations of acid hues, Parmigianino's electric intensity, and finally the unbridled inventiveness of the Fontainebleau School: all these testified to a desire to push the accepted inheritance of the Quattrocento to extremes, or even to pervert it. Rather than creating a coherent set of rules, Mannerism had proliferated via reference and rupture, by making attacks on the past and nostalgia.

The advent of Post-Impressionism, to tell the truth, is even more complex, and certainly occurred over a much more compressed period of time. It covers at most around fifteen years—approximately 1885 to 1900—during which there is an increasing sense of an uncontrollable acceleration in the evolution

of pictorial language. During that period, music, whether orchestral or lyrical, is slowly assimilating the effects of the Wagnerian revolution, and architecture is still drawing out the implications of its ever-improving mastery of iron and glass. Painting, as it were, explodes. After Impressionism, nothing in French art—and soon internationally—can ever be the same again. *Sensation* has become entrenched as an autonomous and absolute fact, necessitating an objective submission to the direct experience of phenomena. The question is no longer whether this is a case of artistic continuity or rupture: Impressionism shatters into innumerable fragments, it dazzles like a scintillating nebula. We could say that Post-Impressionism is, in a way, the 'brilliance' of this combustion.

The period is thus an especially confused one, and fulfils a long-term tendency that runs through the whole of the nineteenth century. That century was characterised by the progressive and irrepressible ascendancy of colour, even though its Neo-Classical dawn sought to impose the absolute authority of drawing—from Johann Joachim Winckelmann to William Blake, Jacques-Louis David to John Flaxman.[7] In the lead-up to these shortcomings of Fauvism, colour overflows lines—it spurts, dribbles and runs, swarming over the whole canvas. In a certain sense, Post-Impressionism represents the high-point of an irrepressible vital impetus (*élan vital*)[8] but most of its protagonists also claim to be returning to the 'grand' style, with its classical harmonies and ordered compositions, and even (in Gauguin's case, and to a lesser extent in Seurat's) invoke Jean-Auguste-Dominique Ingres in relation to Eugène Delacroix. This contradiction spills over into the ideological domain as well: like their Impressionist predecessors, the Post-Impressionists claim to be living the ethics of modernity at a heightened intensity, but they also lay down its ideology. For them, sincerity still remains the primary measure of the value of a work of art. In this regard, how can we not recall Monet confiding his desire to be reborn blind, so as to be liberated from the conventional schemas of sight? How can we not think of John Ruskin, for whom only the naive outlook—an attitude of the mind combining an intuitive understanding of nature with an objective search for reality—could strip the veil of illusion? In fact, no artist during the *fin de siècle* period could remain unaware of the ethical force of Impressionism, which became one of the voices that niggled at the conscience of the bourgeoisie, slowly undermining the shaky foundations of the academic and Realist idols of the Third Republic. This attitude of provocation is intensified by the Post-Impressionists.

The same period is marked by the rise of idealism and a resurgence of the repressed impulses of Romanticism. Unlike Gustave Courbet, or even

Edouard Manet
Georges Clémenceau 1879–80
oil on canvas
94.5 x 74.0 cm

Musée d'Orsay, Paris
gift of Mrs Louisine
W. Havemeyer 1927 RF 2641
© RMN (Musée d'Orsay) /
Hervé Lewandowski

Manet, Gauguin and Seurat are symptomatic of a generation that is fairly indifferent to political events, but finds the surrounding atmosphere of mediocrity suffocating. Their denunciation of the absurdities of the 'moral order'[9] as well as narrow-mindedness and 'radicalism'[10] of a complacent 'middle' France, pushes the extremes together. On the one hand, a few members of the avant-garde are involved in the extreme-left struggles of the post-Commune period (the painters Pissarro and Luce), or anarchism (Signac, and the critic Félix Fénéon)—and on the other hand, the aristocrats, sophisticates and dandies are condemned to the ivory tower by their contempt for petty bourgeois positivism (the painters Moreau and Khnopff, and the novelist Joris-Karl Huysmans, for example).

Disappointments weigh heavily in the post-1870 period, and not only in France because of its defeat against the Prussian armies[11]: in the recently unified states such as Italy and the German empire, the new ruling classes give artists the impression of having completely betrayed the generous and democratic aspirations of 1848. Developments in the plastic arts at the end of the century are thus more than ever conceived in terms of rupture—better still, in terms of scandal, defiance, or secession, because the gulf dividing them from the average taste of the general public grows ever wider. Echoing the howls of the press at the time of the second Impressionist exhibition held at Paul Durand-Ruel's gallery in 1876 ('a wretched group afflicted with the madness of ambition'[12]), Seurat's first canvases are greeted by howls of laughter about the monkey on a leash and the stiffness of the couple[13], while the Synthetist exhibition at the Cafe Volpini narrowly escapes an almost universal indifference in 1889.

The freedom of the creator appears more than ever a threat to the established order, a reserve of corrosive potential in relation to the arsenal of accepted values. And even an enlightened critic such as Ruskin doesn't hesitate, in 1878, to heckle James Abbott McNeill Whistler for 'flinging paint in the public's face'[14] with a work sold for what he considers to be the exorbitant price of two hundred guineas. In the court case that Whistler brings against Ruskin to obtain some redress, the artist's right to free invention clearly triumphs over tradesman-like compliance with norms and fetishisation of the 'too-perfect': the two hundred guineas demanded for a work of art is in fact, according to the painter's own words, 'for the knowledge I have gained in the work of a lifetime'.[15]

Not all artists however can afford to maintain this attitude of superb defiance in the long term, and for those who don't attempt the path of assimilation, there remains only the retreat into the recesses of the mind (the Symbolists), exile (Gauguin), or voluntary semi-reclusion (van Gogh).

New tensions

This malaise is not simply a calculated reaction or a convenient posture. It is something the Impressionists—who don't simply retire from the scene following their years of splendour—feel cruelly. The third Impressionist exhibition, held at Durand-Ruel's in April 1877, marks a sort of high point for the group, which presents a united front for the last time, and launches the journal *L'Impressioniste* to respond to *Le Figaro's* invective. Georges Rivière suggests in it that the Impressionists judged or praised the treatment of a subject more than the subject itself.[16] Criticism is much more favourable towards them, from Philippe Burty to Ernest Chesneau, from Paul Mantz to Louis Edmond Duranty and Jules-Antoine Castagnary.[17]

In 1878 Théodore Duret devotes a small monograph to them, *Les peintres Impressionnistes*, which is not quite devotional in tone. For that, we

need to wait another ten to twenty years, during which time the group will imperceptibly unravel: Manet dies in 1883, Pissarro drifts towards Neo-Impressionism, and Renoir exhibits at the Salon in 1881, 1882, and 1883—despite Durand-Ruel's admonishments—before a trip to Italy leads him to 'discover' Raphael. Renoir shares with Monet the conviction that a certain redevelopment of studio practice is necessary, a serious blow to the principle of composition outside and in front of the motif (*en plein air*). At the same time, the relations between Monet and Durand-Ruel become more acrimonious, while Gustave Caillebotte complains of the divisive effect of Degas' cynicism on the rest of the group. To top it all, Emile Zola, formerly a luminous defender of Impressionism in its initial battles, shows his total lack of understanding of the movement in his novel *The masterpiece* (*L'Oeuvre*) 1886, where he lends the traits of his old childhood friend Cézanne to the failed and misunderstood painter Claude Lantier.

Each of the Impressionists thus sets off on his own path, with no dominant direction apparent. Once again, as in the earlier history of art, the period appears to be given over to the most contradictory ideologies and aspirations. Certainly, positivism seems more robust than ever[18]—to such an extent that many authors have, willy-nilly, interpreted Impressionism as a sort of second coming of positivism's concern for the real in the domain of aesthetics. Yet rare are the Impressionists who escape the formidable appeal of idealism during the final decade of the century. Monet himself is driven by a quest for the mysterious via stylisation—his 1888 series on Antibes excites Stéphane Mallarmé: 'I have placed your work above all others' for some time, but I believe this is your finest hour.'[19] With his 1920–26 *Waterlilies* series for the Musée d'Orangerie in Paris, he will go even further in his pursuit of a decorative art of suspended forms and eternal appeal.

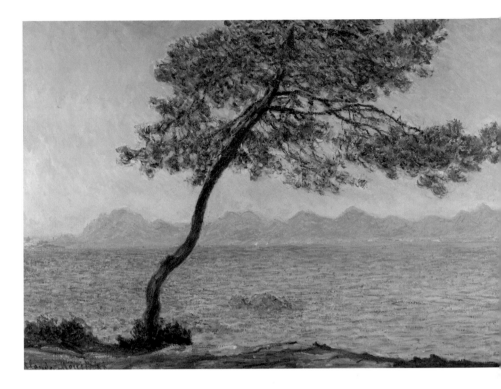

Claude Monet
Antibes 1888
oil on canvas
65.5 cm x 92.4 cm

Courtauld Institute of Art Gallery, London
The Samuel Courtauld Trust, Courtauld Gallery, London bequest of Samuel Courtauld 1948 P.1948.SC.276

In 1882 Renoir is sent to Palermo by the *Revue Wagnérienne* to paint a portrait of Richard Wagner, the living idol of the Symbolists, while Wagner himself is getting ready to finish *Parsifal*. Some of the most influential theorists of Symbolism, Teodor de Wyzewa and Albert Aurier, devoted very favourable articles to Monet and Renoir.

In contrast, the attitude of the aging Impressionists with regard to the new generation of painters bears a certain ill-will: Degas doesn't refrain from mocking Seurat; Renoir can't understand why Gauguin needs to send himself into exile to find new material, and Pissarro holds his indulgent attitude to Symbolism against this so-called Tahitian painter. In return, the old guard are exposed to the criticisms of the newcomers, who consider that the obvious progress of Impressionism in the area of perception was perhaps obtained at the expense of imagination. Redon expresses the idea very simply in the reflections of his old age,

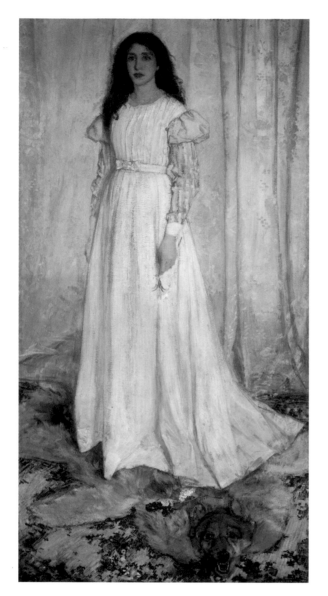

To myself (A soi-même):

> I refused to board the Impressionist ship because I found the ceiling too low ... Real parasites of the object, [the Impressionists] cultivated art solely on the visual field, and in a way closed it off from what goes beyond that and what can give the humblest sketches, even the shadows, the light of spirituality. I mean a kind of emanation that takes hold of our spirit and escapes all analysis.[20]

Whether enthusiastic or more reserved in their attitude, writers begin to draw conclusions from the Impressionist period, which is another way of saying that it is coming to an end. This is the case with Fénéon, as also with the poet Jules Laforgue:

> The Impressionist eye is, in short, the most advanced eye in human evolution, the one which until now has grasped and rendered the most complicated combinations of nuances known.
>
> The Impressionist sees and renders nature as it is—that is, wholly in the vibration of colour.[21]

Similarly, for Aurier, writing in 1891, Impressionism would simply be 'a refined, spiritualised, dilettantish realism, but realism nonetheless'.[22]

If confusion appears to reign, it is because we too often carve up the history of art into convenient slices—Neo-Impressionism, Synthetism, Symbolism, Fauvism and so on—and imprison painters inside each separate compartment. Where materialist evolutionism meets historicising art criticism, the temptation has no doubt been overwhelming to superimpose a host of cultural and sociological phenomena on the Impressionist canvas. These include the triumph of positivism, the emergence of the middle classes—as studied in particular by Karl Kautsky and Eduard Bernstein[23]—the irresistible rise of imperialisms, the monopolistic evolution of relations of production, the atmosphere of Guy de Maupassant's novellas, and—why not?—the Impressionistic tonality that is supposed to characterise French music in the *fin de siècle* period, from Ernest Chausson to Claude Debussy and Paul Dukas. This kind of generalising, but ultimately reductive, interpretation is in part due to the golden age of Impressionism occurring at the same time as the full triumph of Realism.

But is not Impressionism's singularity and its greatness as a movement precisely its creation of an irreducible category of painting—namely, the *visible*, as distinct from Symbolism which, for its part, aspired to a convergence between languages and the synaesthesia of different forms of expression? In reality, Impressionism is as

little able to be assimilated to Realism as it is to Symbolism. Before being a record of weekend leisure activities in the countryside or a chronicle of reflections cast upon water, it proclaims a new way of painting, a new way of translating reality through its objectification using plastic means. Without going so far as to claim that it sounds the death knell for the subject in painting, Impressionism marks the first step towards a certain dematerialisation of the image.

This is what Whistler, who was even better equipped than his French colleagues to face the new conditions of painting, anticipated by suppressing the ritualistic importance of a painting's title. Already in the 1860s a full-length portrait of a young girl was for him a *Symphony in white no. 1* 1862,[24] a tactile panorama of Trouville was *Harmony in blue and silver* 1865,[25] the Battersea Bridge at night was a *Nocturne: blue and gold* 1872[26] and the portrait of his mother was *Arrangement in grey and black no. 1* 1871.[27] There could be no more radical reduction of painting to its brute materiality, by the same token capturing life's visual appearance within allegories that border on the alchemical.

Vision and perspective

The Impressionists moreover taught us to see the world differently. As Ernst Gombrich has observed, Western man, since the Renaissance, has docilely recognised the world through a certain number of codes for organising space, a set of 'stabilising habits'.[28] Caught in the geometrical net of natural perspective, objects appear to find a permanent escape from the flux of appearances. Impressionism detonates these security devices and takes us inside the dizzying swirl. This is no doubt the Impressionists' main legacy. Thirty years before Albert Einstein's discoveries of the relationship between mass and energy, the canvases of Renoir, Monet, Degas and Pissarro already herald an awareness of the

fact that reality swims in a field of waves, and that matter is replenished by *light*, which itself has become the paradigm of movement. The idea that physical reality is not static organises this study of the dissolving effect of light. Captured in the undulating radiation, objects as well as people are both revealed and effaced in this texture. This is also the impression we get from the works of Seurat as well as the works of Vuillard or Bonnard (albeit very differently). The surface is made up of more or less uniform marks which blur the boundaries between the objects and the shadows

James Abbott McNeill Whistler
Nocturne: blue and gold (Old Battersea Bridge)
c. 1872–75
oil on canvas
68.3 x 51.2 cm

Tate Collection, London presented by The Art Fund 1905 N01959

23

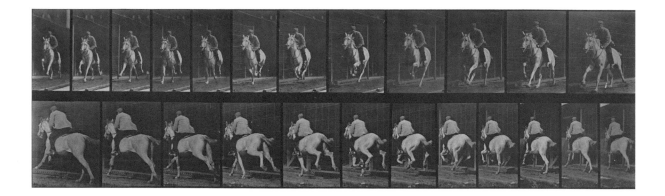

Eadweard J. Muybridge
*'Pandora' galloping,
saddled* c. 1885
plate 630 from *Animal
locomotion*, vol. 9
University of Pennsylvania,
Philadelphia, 1887
collotype photograph
34.8 x 49.4 cm

National Gallery of Australia
Canberra
purchased 1975 1975.649

(opposite)
Nadar
Aerial view of Paris 1858
albumen silver photograph

© Hulton-Deutsch Collection/
CORBIS

Louis Lumière
*Arrival of a train at La
Ciotat* 1895
frame from 35mm print,
black and white, silent,
about 45 seconds.

Museum of Modern Art,
New York, acquired from the artist
Image: Photofest

they project. Reality's profusion, which used to be expressed in hierarchical relations, in predictably sized series lined up underneath the gridded layout of the painting, is henceforth presented as a battlefield of energy and matter.

All the painters strive to highlight the palpability of the surface which the Renaissance had wanted to present as diaphanous. The brushstroke, which the Academic teaching tradition ingeniously disguised beneath glazes, becomes visible, indiscreet, provocative. More than a sign of the artist's personal calligraphy, the brushstroke becomes the fundamental—because irreducible—element of pictorial discourse. The pigments, enlivened by the light that hits them, make the coloured surface breathe, swell and recede. Lured by the combination of this network of effects, the eye *lives* the movement, while at the same time each colour loses its attachment to its traditional signifiers—a dog can be blue, a man red, a field of wheat indigo—and instead takes on a particular psychological and allegorical dimension. In this sense, we can clearly trace the path of an *emotive* theory of colour stretching from Seurat to Wassily Kandinsky.

In this way, feeling can be separated from the subject, and painting thus explores an autonomous system for triggering emotions, expressed in terms of the direction of lines, rhythms, and the associations of shapes.

Painting and photography

It is a paradox that painting, at the very moment it claims its autonomy, becomes strongly reliant on photography. And no longer simply in the sense that artists such as Delacroix or Courbet avoid their models having to hold interminable poses by using snapshots of nudes, but because photography gives rise to a new perspective on people, objects and landscapes. Photography produces a new environment: whether through Nadar's snapshots showing Paris from a hot-air balloon (1858), or else the first news reports—from the Englishman Roger Fenton in the Crimea (1855), and the American Mathew Brady during the Civil War (1861–65), revealing views of destroyed towns unseeable for most people before that time. The multiplication of images, the inventory of a nation's heritage, the instant change of spatial perspective are its disconcerting conquests. The technological developments come in a rush: from the invention of Scott Archer's glass-plate collodion (1851) to the first Kodak portable camera (1888)—which most painters will rush to buy—via the first experiments in three-colour printing by Ducos du Hauron and Charles Cros in 1869. Soon Eadweard Muybridge is in a position to analyse a horse's gallop (1878), highlighting the glaring inadequacies of the human eye, as well as the errors in the traditional representation of animal

locomotion. Another few years and Thomas Edison, then the Lumière brothers in particular, will manage, by creating cinema (1895), to achieve a major nineteenth-century aspiration: recreating life in its real duration and full spatiality. In other words, in a narrative arc that incorporates *time*.

These dazzling developments in the photographic image prompt us more than ever to ask the question of its place in relation to painting. At first glance, and as Delacroix had anticipated, photography achieves such a degree of faithfulness in the imitation of nature that it renders anything non-innovative in the plastic arts banal. If we agree to set aside the unrealistic codification imposed by its reproduction in black and white, the precision of the contours that photography takes directly from reality makes the intrinsic rhetoric of all illusionist painting seem outdated. Yet most of the recognised painters of the period are swallowed up in the imitative impasse. From Jean-Louis-Ernest Meissonier to Jules Bastien-Lepage, from Jean-Léon Gérôme to James Tissot, how many artists succumbed to the temptations of a photographic-style painting whose polished technique and immutably theatrical composition, despite a few superficial references to the new forms of expression, served to reassure the Salon audiences? Paradoxically, photography, which expresses the profusion of life in a captured instant, becomes for these painters a pretext for eternalising repetitive rituals, ideally frozen in the form of *tableaux vivants*. Thus J.B. Edouard Detaille's Napoleonic charges will clearly show galloping horses whose legs are gathered up under their belly, as scientifically shown in Muybridge's shots, rather than splayed in a wide arc as painters had believed was the case up to Théodore Géricault and George Stubbs. But photographic truth, quite unlike a simple slice of life, is above all the truth of a moment, encapsulated within an image which has the succinctness of geometry and poetry. Degas precisely chooses this moment to paint *The fallen*

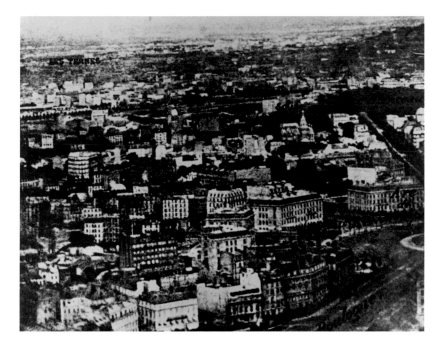

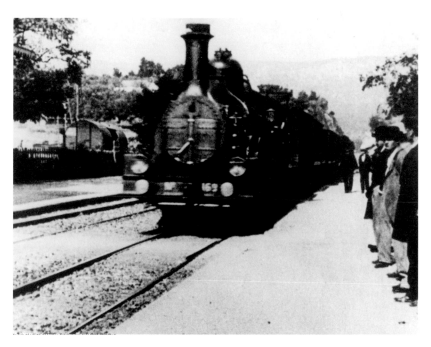

jockey c.1896–98[29], an expressionist work, with its horse's legs deliberately arranged in a jump he now knows is actually impossible.

In fact photography is something that Degas grasped very quickly. Despite his discreet and

25

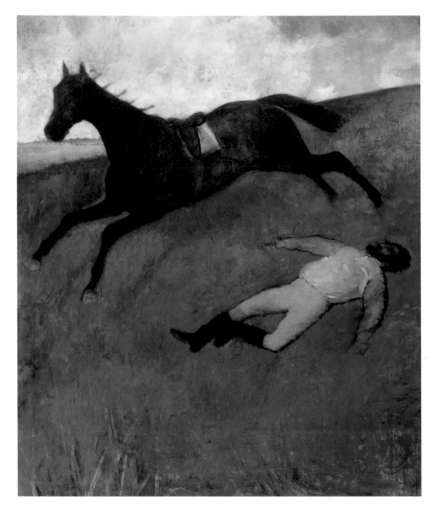

capture sudden movement, *le bougé*[32]—the blur of movement that is still poorly captured by the photographic apparatus of the time, and which haunted Manet—achieves the status of a system for Degas, by becoming the knowing fixation of an imperceptible transition.

In painting, Degas is the gravedigger of Romanticism. After him it is no longer possible to imagine a time that stands still: his fascination with the instantaneous ultimately reveals his secret complicity with a chance that can be subdivided into fractions at will. If no one was better than him at making points of view swirl around in confined spaces, the other Impressionists were no less aware of the attractions of the camera obscura. We see bird's-eye perspectives on Parisian boulevards, sunlight-flooded places and points flattering the Haussmanian gutting of the streetscape; close shots that seem to tip towards the front of the composition, and passers-by who brutally intrude into the frame. The works of Seurat, marked by a rhythmic decomposition of movement, were possibly influenced by Etienne-Jules Marey's chronophotographic (motion-study) analyses. For all of them, photography prompts the idea that it is no use to simply *describe* nature—it is now necessary to show *how* the artist feels or experiences it.

'Through the unknown, we'll find the new'[33]

It is impossible to avoid mentioning at this point that the painting of the avant-garde, refusing to rummage as before and as always through the drawers of literature for ideas to steal, turns decisively towards foreign fields: to the sciences (for the study of the decomposition of white light), to music (Gauguin, like Whistler, refers to 'symphonies', and to 'harmonies of shades' in painting) or to indigenous cultures ranging from Brittany to Oceania. While anthropology is still in its infancy, artists show a passionate interest in these untainted societies, turned in

Edgar Degas
The fallen jockey
(Jockey blessé) c. 1896–98
oil on canvas
181.0 x 151.0 cm

Kunstmuseum, Basel
acquired with the special
assistance of the Basel regional
government 1963 G1963.29
© Kunstmuseum Basel

ambiguous silence on the subject—shared as it happens by all the Impressionists—he undertakes a dialogue of the subtlest kind with it. Marvelling at the fact that houses aren't represented from below, in the manner in which they are actually seen when walking down the street, he gradually dares in his work to adopt the most acrobatic points of view, as in *Miss La La at the Cirque Fernando* 1879,[30] and *The tub* 1886.[31] He multiplies compositions that relegate the protagonists to the edge of the scene, as if to throw the dramatic centrality they traditionally enjoy off its axis, while at the same time shrinking distant objects using a distortion of focus specific to the photographic lens. And the endeavour to

on their primordial and intact belief systems, unaware of the new relationships developing in urbanised and industrialised regions of the world. Whether Celtic or Maori, 'primitivist' art hasn't experienced the contamination of the illusionist imperative: we can thus understand the correlations that are made between Symbolism's nostalgia for origins and an 'untamed' language that expresses sacred significations in a few geometrical interlacings. The primitivist hermeneutic has nothing to do with relationships of dimension, perspectival space, or contouring. From Gauguin to Paul Klee, the avant-garde will become enthusiasts for frontal arrangements of colours on common materials, and already before Marcel Mauss' sociological theories, the idea insinuates itself that only colour can awaken the state of nature that slumbers within each 'civilised' man, inducing a trance-like state within.

More decisive still will be the influence of Japanese art at the end of the nineteenth century, and which can only be compared in terms of impact with the subsequent shock of African art around 1905–07. Circulating in the West from around the 1850s, Japanese woodcuts—the famous *ukiyo-e*—prove that a coherent system of reproducing reality doesn't have to owe anything to the visual funnel or topographical grid of the Italian tradition. For the Japanese artist, the hierarchy of appearances is not organised in relation to the eye as the hypothetical geometric centre of the surrounding world. On the contrary, artists feels themselves to be one element within a universal gravitational force in which they don't claim to set up any definitive and constraining order. Hence the longitudinal *kakemonos* (scroll paintings) where objects or landscapes that are subject to different perspectives can coexist; hence the framings of Hokusai, Kiyonaga or Hiroshige, which brutally carve up reality by accentuating the acceleration of the foreground and the vanishing of the far-away: techniques Degas may have been inspired by, combining them

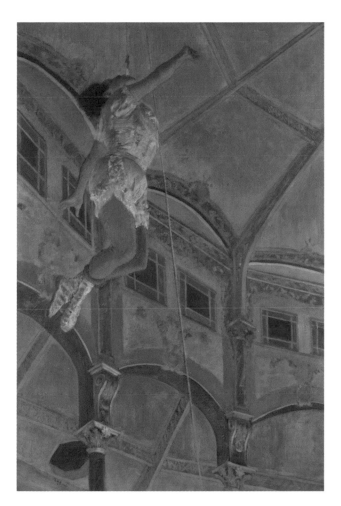

with those of photography. It is also perhaps this double influence that Monet referred to when he undertook his famous painting series of poplars, cathedrals and windmills. These series—fragments in a single sequence observing the succession of atmospheric effects on an immobile object, and foundational moments in a new aesthetic sensibility—may have been partly inspired by Hokusai's *Thirty-six views of Mount Fuji* c.1831.

These convergences have a profound impact on what becomes almost a change in civilisation, because the *fin de siècle* period is also the scene of upheavals that are created by the new conditions of industrial production: the emergence of the applied arts and design, the multiplication and

Edgar Degas
Miss La La at the Cirque Fernando (Mlle La La au Cirque Fernando) 1879
oil on canvas
117.2 x 77.5 cm

The National Gallery, London
bought, 1925 NG4121
© The National Gallery, London

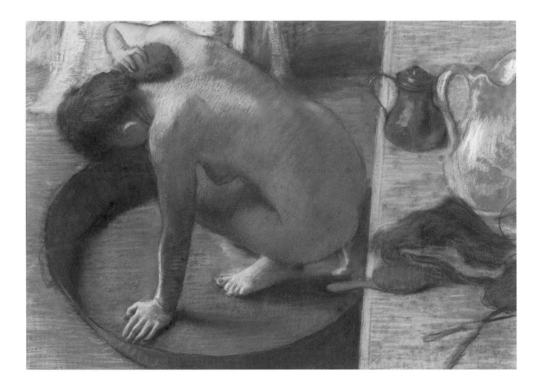

distribution of the image through new printing processes such as chromolithography, and the affirmation of middle-class tastes. The weight of the Impressionist interlude continues to be felt in the evolution of the plastic arts, but its ramifications end up being barely recognisable.

The new century seems to begin under the auspices of a sort of rediscovered unity in the arts, formed around the magnetic centre that became Art Nouveau. As the Arts and Crafts Movement in England, Jugendstil in Germany and Austria, and Liberty in Italy, this is the first style that is European in scope, thus prefiguring the decline of Paris as the unique and undisputed centre of nineteenth-century artistic creation. In Brussels, the Les XX (The Twenty) group embraces both the Neo-Impressionists and Gauguin, van Gogh and Toulouse-Lautrec. And the destiny of the twentieth century will now take shape as much in Vienna—around artists Gustav Klimt and Egon Schiele, composers Gustav Mahler, Arnold Schönberg and A.M.J. Berg, the sociologist M.C.E. Weber, the writer Robert Musil, and Sigmund Freud—as in Munich, 'the Athens of Mitteleuropa', where the painters Kandinsky (in Franz von Stuck's studio), Giorgio de Chirico and Alfred Kubin, and the composer Richard Strauss, spend their formative years.

Heralded first by the decorative arts, the 'modern' style quickly contaminates the others—it finds a favourable soil in painting, with the two-dimensional tendencies shown by Gauguin and the Nabis. Art Nouveau perpetuates the lessons of Symbolism by insisting on the fusion of architecture, mural painting, and decoration understood in a broad sense, in order to produce a holistic effect. The general oscillation of the universe thus comes to be expressed by the rhythmic interplay of forces specific to each form of art. Significantly, Monet's *Waterlilies* tried to open the same path at the same time.

Notes

1 Musée d'Orsay, Paris.

2 Musée d'Orsay, Paris.

3 Musée d'Orsay, Paris.

4 Courtauld Institute of Art, London.

5 Charles Baudelaire mocked the clichéd Neo-Classical paintings at the 1859 Salon as the 'hordes of Cupid Sellers'. See Charles Baudelaire and Jonathan Mayne (ed. and trans.), *Art in Paris 1845–1862: Salons and other exhibitions*, London: Phaidon 1965, pp. 144–216.

6 *Cangianti* is the painting practice, developed in Italy in the fourteenth century, of using multiple tones or combinations of colours to express volume and create the effect of light and shadow. See Janis Callen Bell, 'Cangianti', in Jane Tuner (ed.), *The Dictionary of Art*, London: Macmillan 1996, vol. 5, p. 614.

7 Winckelmann (1717–1768) was a German art historian, archaeologist and pioneering Hellenist; Blake (1757–1827) was a English poet, painter and printmaker; David (1748–1825) was a Neo Classical French painter; and Flaxman (1755–1826) was a English sculptor and draughtsman.

8 The original French term derives from the philosophy of Henri Bergson.

9 The government program of 'ordre moral', instituted in 1873.

10 The Radical party, or movement, was a mainstream Republican movement by the end of the nineteenth century.

11 The Franco-Prussian War, 19 July 1870 – 10 May 1871.

12 'Five or six lunatics, including a woman, a wretched group afflicted with the madness of ambition, have decided to come together here to exhibit their work … And it's a pile of obscenities that the public is being exposed to, without any thought given to its potentially fatal consequences. Yesterday a young man leaving the exhibition was arrested in Rue Le Peletier for biting passers-by …' Albert Wolff, 'Le Calendrier parisien', *Le Figaro*, 3 April 1876, quoted in Ruth Berson (ed.), *The new painting: Impressionism, 1874–1886, documentation*, San Francisco: Fine Arts Museum of San Francisco 1996, vol. 1, pp. 110–11.

13 'The monkey! The misplaced shadows! The stiffness of the couple!'. Félix Fénéon, 'Les impressionnistes', *La Vogue*, 13–20 June 1886, quoted in Berson, pp. 443–44.

14 John Ruskin, *Fors clavigera*, 2 July 1877. Quoted in Richard Dorment, Margaret F. MacDonald, *James McNeill Whistler*, London: Tate Gallery Publications 1994, p. 136.

15 Whistler's words in court in the 1878 libel case brought against John Ruskin. Quoted in Richard Dorment, Margaret F. MacDonald, p. 138. Whistler won the case, but was only awarded damages of a farthing (less than a penny) and faced huge costs.

16 'What distinguishes the impressionists from other painters is that they treat a subject for its tonal values and not for the subject-matter itself.' Georges Rivière, *L'impressioniste, journal d'art*, no. 1, 6 April 1877. Translation in Charles Harrison and Paul Wood with Jason Gaiger (eds) *Art in theory, 1815–1900: an anthology of changing ideas*, Oxford: Blackwell 1998, pp. 593–98, quotation p. 594.

17 See *The new painting: Impressionism 1874–1886*, by Charles S. Moffett. San Francisco: Fine Arts Museums of San Francisco 1986. Burty was an art critic for *Gazette des beaux-arts* and wrote for the newspaper *Le Rappel*, the avant-garde journal *La Renaissance littéraire et artistique*, and *La République française*; Chesneau wrote for *L'Opinion nationale, Le Constitutionnel, L'Artiste* and *Revue des deux mondes*; Mantz wrote for *Gazette des beaux-arts*; Duranty wrote for *Paris-Journal, Gazette des beaux-arts, Les Beaux-arts illustrés* and *Chronique des arts*; and Castagnary wrote for *Le Présent, Monde illustré, Siècle* and *Nain jaune*.

18 A school of thought holding that the only authentic knowledge is that based on actual sense experience, avoiding Metaphysical speculation.

19 18 June 1888, letter 663, in Stéphane Mallarmé, Henri Mondor and Lloyd James Austin (eds), *Correspondance*, Paris: Gallimard 1969, vol. 3 1886–1889, p. 212.

20 Odilon Redon, Mira Jacob and Jeanne L. Wasserman (trans.), *To myself: notes on life, art and artists*, New York: George Braziller 1986, p. 110.

21 Jules Laforgue, 'L'impressionnisme', *Mélanges posthumes: oeuvres complètes*, 4th edn, vol. 3, Paris: 1902–03, quoted in Harrison, Wood and Gaiger, pp. 937–38.

22 Albert Aurier, 'Le symbolisme en peinture; Paul Gauguin', *Mercure de France*, March 1891, in Pierre-Louis Mathieu (ed.), *Le symbolisme en peinture: van Gogh, Gauguin et quelques autres*, Caen: L'Echoppe 1991, p. 18.

23 Karl Kautsky (1854–1938) was a Marxist theoretician and Eduard Bernstein (1850–1932) was a social democrat theoretician and politician.

24 National Gallery of Art, Washington, D.C.

25 Isabella Stewart Gardner Museum, Boston.

26 Tate Britain, London.

27 Musée d'Orsay, Paris.

28 See Ernst Hans Gombrich, *L'Art et l'Illusion*, London: Phaidon, 6th edn, 2002.

29 Offentliche Kunstsammlung Basel, Kunstmuseum, Basel.

30 National Gallery, London.

31 Musée d'Orsay, Paris.

32 Literally 'the moved', *le bougé* is a term which refers to the blur when the camera or subject (accidentally) moves at the moment a shot is taken; i.e. something that was still, and then moved.

33 This is the last line of Baudelaire's poem 'The voyage'. See Robert Lowell (ed. and trans.) and Sidney Nolan (ill.), *The voyage and other versions of poems by Baudelaire*, London: Faber and Faber 1961, p. 37.

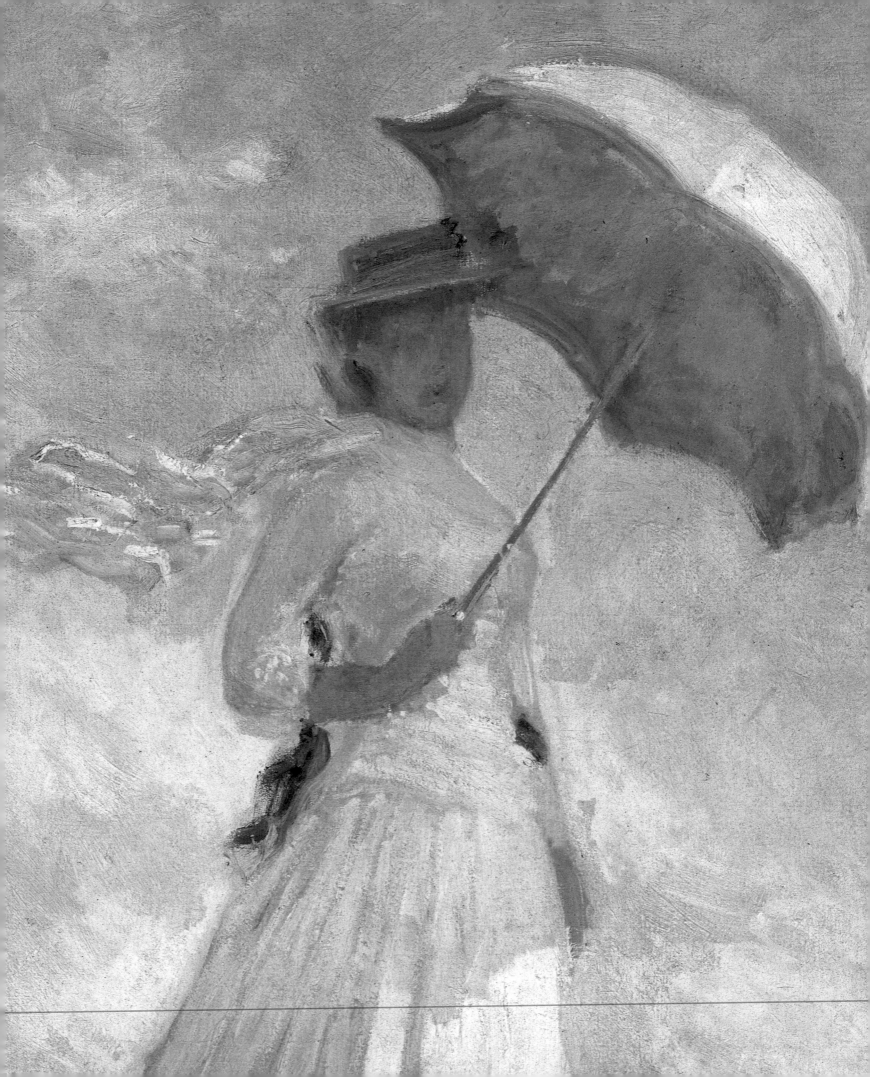

Impressionism versus Post-Impressionism?

Sylvie Patry

*Let's just call them post-impressionists; at
any rate, they came after the impressionists*
Roger Fry[1]

In 1886, the last Impressionist exhibition was
held in Paris. The event brought to a close an
adventure begun in 1874 by a group of artists
trying to break free of Salon exhibitions and the
jury system which decided the fate of artistic
careers. Among the first exhibitors in 1874 had
been Cézanne, Degas, Monet, Berthe Morisot,
Pissarro, Pierre-Auguste Renoir and Sisley. In
1886, in the last of the eight exhibitions, all of
which had been subjected to intense polemic
and mocking attacks, only Pissarro, Morisot and
Degas appear in the catalogue.

It was a time of dispersal, disagreements and self-
questioning. Even the agenda that had initially
brought the artists together—a luminous style of
painting (*peinture claire*) executed outdoors and
drawing its subjects from modern life—seemed
to have failed. In keeping with a more general
feeling of failure, the same year saw publication
of Emile Zola's *The masterpiece* (*L'Oeuvre*), a novel
dedicated to the Paris art world which the author

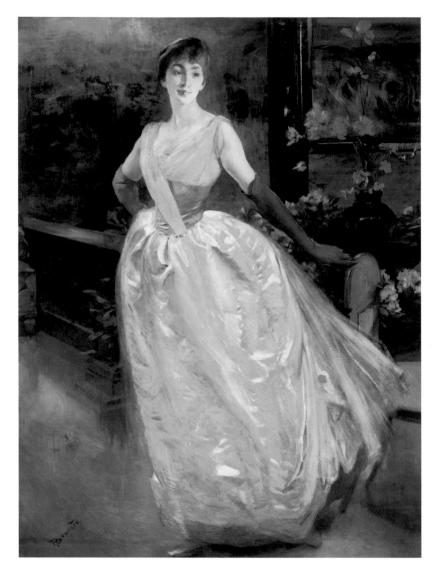

Monet's phrase 'just as we reach our goal' expresses things correctly, because in 1886 the Impressionists' situation was improving, even if unevenly. The first successes had occurred for Monet, Renoir and Degas; though there were continuing difficulties for Pissarro and Sisley, and violent incomprehension and hostility continued towards Cézanne. Paul Durand-Ruel, the group's faithful dealer since 1872, organised an exhibition in New York in 1886, opening up the possibility of a new promising market and audience. At the same time, the 'pictorial grammar' of the Impressionists was being taken up and adapted by the 'official' painters offering it up in a more acceptable version. Besnard (a former Grand Prix de Rome laureate and future member of the Académie des Beaux-Arts) began painting with a freer touch, far removed from the traditional highly polished style of an Alexandre Cabanel or a William-Adolphe Bouguereau. Using a new luminous palette, this 'modern' style made Besnard a stand-out at the 1886 Salon, where his portrait of *Madame Roger Jourdain* (cat. 2) was a hit. Besnard appropriated the Impressionists' light and movement, and also painted his times, to the point that Degas was prompted to utter the barbed words: 'he is a man who tries to dance with leaden soles'.[4] Though, as Denis would recall in 1905, 'the perfectly understandable attitude of Degas wasn't appropriate for young people who, at a particular moment, owed [Besnard] the revelation of completely new insights into their art'.[5]

In the middle of the 1880s, such popularisers as Besnard were blurring the edges of Impressionism and the new energy it had brought to painting. The new generation, precisely the Post-Impressionists who emerge in the middle of the 1880s, were seeking to define themselves in relation to Impressionism. These modern 'artistic circles' (to use the poet Emile Verhaeren's expression, collecting together the profuse movements—Symbolism, Neo-Impressionism, Cloisonnism, the Nabis and others which

Albert Besnard
Madame Roger Jourdain or Portrait of Mrs R. J…
(Portrait de Mme R. J…) 1886
oil on canvas

Musée d'Orsay, Paris
© RMN (Musée d'Orsay) / Hervé Lewandowski

Cat. 2

(previous page)
Claude Monet
Study of a figure outdoors: woman with a sunshade turned to the right 1886
(detail) cat.1

knew so well.[2] Zola's fictional painter Claude Lantier (for whom Zola borrowed many traits from Cézanne and Monet) commits suicide in the face of his inability to achieve his masterpiece. In consequence of the book's publication, Cézanne fell out with Zola, his friend since childhood. Monet was similarly disturbed: he feared the press would seize on the novel to present the Impressionists as 'failures'. As he lamented to Zola: 'My battle has been a long one, and my worry is that, just as we reach our goal, this book will be used by our enemies to deal us a final blow.'[3]

appeared in Paris at that time) have often been seen as calling into question, and wanting to go beyond, an Impressionism which they discredited as being both outdated and well on the path to achieving commercial success and institutional recognition. Does not the term 'Post-Impressionism' itself refer—for the man who invented it, the English critic Roger Fry—not only to what comes 'after' Impressionism, but also to what goes 'against' it?[6]

Understood as a historical marker, the neutrality of the term 'Post-Impressionism' reflects the difficulty of situating Impressionism within this new context. Post-Impressionism has not always rejected Impressionism. In fact, Post-Impressionism fed off an Impressionism that was ceaselessly being redefined by its great founders—Monet, Renoir, Cézanne, Pissarro—men who themselves took into account the innovations offered up by Post-Impressionism. Additional to the model of chronological succession, or of the staunch hostility the two movements showed towards one another, we need to recognise the creative exchanges that occurred between Impressionist and Post-Impressionist circles. The cases of Monet and Cézanne, who manifest in Zola's protagonist as the great 'failure' of the New Painting of the 1870s, offer significant examples of these relationships—sometimes ones of rivalry and competition—leading to the renewal and redefinition of Impressionism in the 1880s and 1890s.

1886: Impressionism in crisis

A sign of the discords and difficulties of the times, the eighth and final Impressionist exhibition took place in 1886, after four years of silence following the previous exhibition, which had been marked by the dazzling contributions of Pissarro, Renoir and Monet. The richness and exceptional consistency of the 1882 exhibition, however, had had more to do with circumstances than the intention of the artists: Durand-Ruel, the holder of significant stocks of Impressionist paintings, himself put together Monet's and Renoir's consignments against their wishes (leading Renoir to comment, 'I won't be the one who will exhibit'[7]). Paradoxically, what in hindsight appears to be one of the greatest Impressionist exhibitions was in fact dominated by commercial considerations, and owed nothing to a jointly promoted aesthetic agenda.

Putting the 1886 exhibition together required all of the energy and financial resources of Morisot, Mary Cassatt and Henri Rouart, a friend of Degas'. The exhibition almost didn't happen because of the difficulties they ran into during its preparation in autumn 1885. From among the founding members of the group, only Morisot, Degas and Pissarro agreed to take part. Without any aesthetic common denominator, and against a backdrop of dissension among the artists, the exhibition was simply called, in all plainness, the Eighth Painting Exhibition. But, as the paradox of the 1882 exhibition demonstrated, the 'crisis' that showed its full face in 1886 was simply the outcome of earlier history.[8] By the end of the 1870s, the movement was being called into question even by its own members.

The disputes were essentially strategic, aesthetic and political in nature, without factoring in the inevitable personal enmities and privileged relationships between certain individuals. At the end of the 1870s, against a backdrop of more general economic difficulties, the question was raised of the relevance of exhibiting in the margins of the official circles. The Impressionist exhibitions—partly because of the publicity produced by the opposing forces of often-savage criticism and a group of convinced admirers—were not complete financial flops. The artists generally covered their costs, though they didn't sell very much or fetch high prices. As Sisley wrote to the critic Théodore Duret, a fervent defender of the Impressionist cause:

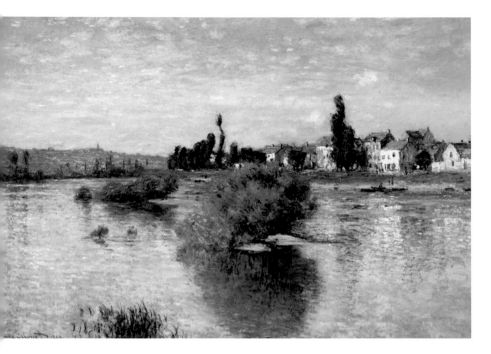

Claude Monet
Lavacourt 1880
oil on canvas
98.4 x 149.2 cm

Dallas Museum of Art, Dallas
Munger Fund inv. 1938.4.M

It is true that our exhibitions have served to make us known and in this have been very useful to me, but I believe we must not isolate ourselves too long. We are still far from the moment when we shall be able to do without the prestige attached to official exhibitions.[9]

In 1879, Sisley, Cézanne and Renoir, who had already opened up a breach which excluded them from the Impressionist group, sent works to the Salon. Of the three, only Renoir was selected by the Jury: his *Portrait of Madame Charpentier and her children* 1878[10] was a success, and garnered him a new clientele. By now only Pissarro and Degas remained faithful to the initial Impressionist rationale of independence. The following year, even Monet succumbed, when his *Lavacourt* 1880[11] was accepted by the Salon.[12] The work is a landscape quite specifically painted for the occasion[13]: the technique has a more 'finished' aspect, and the composition is tempered by the use of traditional devices which include the *repoussoir* technique (a strongly defined foreground element), elements of vegetation allowing the viewer to orient themselves spatially and graduating the perspective. Subsequently, even Cézanne also ended up being accepted by the Salon, for the first and only time in his career—in 1882.

While both Cézanne and Monet abandoned the Impressionist exhibitions altogether from the early 1880s, they each took separate paths. Cézanne endured ongoing isolation (not entirely by choice), being forever rejected and eternally absent. He only exhibited four times—twice with the Impressionists, in 1874 and 1877; in 1882; and then at the 1889 International Exhibition in Paris—before he finally received his first solo exhibition in 1895, at the gallery of the dealer Ambroise Vollard. Cézanne's independent tendency became more pronounced from 1886, when his father's death guaranteed him financial independence, freeing him definitively from the need to sell work to survive. Monet, partly because he was hardly in such a financial situation and needed to support his large family,[14] sought to multiply opportunities to show his work. Already, in 1880, he had been granted a solo exhibition, thanks to the intervention of Renoir, and this was the beginning of his rising commercial success. Monet's paintings would fetch more and more, while Cézanne's prices, alongside Pissarro's, would remain the lowest among the Impressionists.[15] In 1886 Monet abandoned Durand-Ruel for Georges Petit because of the latter's aggressive sales technique. Petit hung later converts to Impressionism—like Gervex (cat. 4) or Besnard (cat. 2)—side-by-side on his gallery walls with those Impressionists, such as Monet (in 1885 and 1886)[16] and Renoir. Monet also developed the habit of pitting dealers against each other for his work, playing Durand-Ruel off against Bernheim-Jeune for example, while Cézanne's interests were essentially represented by his son Paul, especially when Vollard entered the picture. Before that, the younger generations could only admire Cézanne's paintings in the modest shop of Père Tanguy, a Paris hardware dealer.

Counter to Cézanne's and Monet's approaches, Pissarro retained a preference for the independent, innovative group exhibition. These different career choices also corresponded to the men's political differences. In Renoir's eyes, the communitarian ethic inspired by Pissarro's socialist and anarchist ideals was merely one form of the group's intransigence against the official art world, whose position included elements of anti-Semitism (Pissarro was Jewish). But beyond this, there were also real aesthetic differences at the root of the Impressionist crisis of the 1880s, dating back to the first exhibition in 1874. Certainly there were shared preoccupations and ambitions that had brought the future Impressionists together from the 1860s—focused around around *peinture claire*, working outdoors, and a taste for effects of instantaneity and for subjects drawn from modern life. But it was not to promote these aesthetic principles that the group had formed itself into a Société Anonyme d'Artistes Peintres, Sculpteurs, Graveurs at the end of 1873. Rather, it was to exhibit and sell their work without the required imprimatur of the Salon Jury.[17] There was not, in fact, any artistic unity to the first Impressionist exhibition. The Impressionists did not compose any manifesto; nor did they choose a name for themselves (this being assigned to them, mockingly, in 1874).[18] Already in 1874, two tendencies had emerged. On the one hand, there were the figure painters such as Renoir or Degas; the critics did not consider the latter to be an Impressionist, on the grounds of his precise drawing skills. And on the other hand, there were the pure landscape artists, with their fresh and vibrant colours— Pissarro, Sisley and Monet. Even then, Cézanne appeared to be unclassifiable.

After the unbridled Impressionist innovations of the 1870s, a sense of non-fulfilment started to set in. Renoir felt he had reached an impasse, later reflecting: 'a sort of break … came in my work about 1883. I had wrung Impressionism dry and I finally came to the conclusion that I knew neither

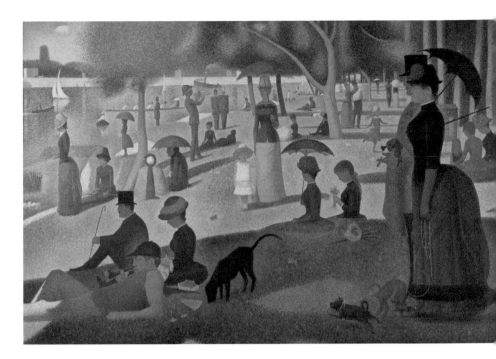

how to paint nor how to draw.'[19] More generally, it seemed that as the 1870s became the 1880s, Impressionism had still not yet produced its great masterpiece. At the Salon of 1880, Zola lamented:

> the real misfortune is that no artist of this group has achieved powerfully and definitively the new formula which, scattered through their works, they all offer … we seek in vain the masterpiece that is to lay down the formula and make heads turn. This is why the struggle of the impressionists has not succeeded.[20]

Monet and Cézanne drew differing conclusions on the Impressionists' situation, without losing the esteem and admiration the two artists held for each other. For Monet, the solution was to go deeper into Impressionism and its apparent immediacy. He declared in 1880: 'I am still and always will be an Impressionist.'[21] Cézanne however wanted to transcend this aesthetic of spontaneity, with a quest for a 'logic of organised sensations'.[22] It is precisely around this question that a new response was offered at the 1886 exhibition, in the painting sensation of the young Seurat with his *A Sunday afternoon on the island of La Grande Jatte* 1884–86.

Georges Seurat
A Sunday afternoon on the island of La Grande Jatte (Un dimanche après-midi à l'île de la Grand Jatte) 1884–86

oil on canvas
207.5 x 308.1 cm

The Art Institute of Chicago, Chicago
Helen Birch Bartlett Memorial Collection 1926.224
Photograph © The Art Institute of Chicago

35

Impressionism and Neo-Impressionism

The advent of the young guard gathering around Seurat from about 1884 to 1885 highlights the crisis of Impressionism. In the autumn of 1885 Pissarro, Renoir, Sisley, Cassatt, Morisot, Degas, Monet and Gustave Caillebotte all seemed to have agreed to hold another independent exhibition—one that was also free of the established dealers, since Durand-Ruel was kept away from the exhibition's organisation. It was precisely over the issue of integrating the new generation of painters, and more particularly the Seurat group, that strong differences of opinion emerged. The suggestion to integrate came from Pissarro. He may also have been thinking of Gauguin's participation, but at the time, above all, he was pushing Seurat, Signac and their friends—for whom the *Bathers at Asnières* 1884[23] (shown at the Société des Artistes Indépendants exhibition of 1884), represented the first manifesto. For Pissarro, Seurat's Neo-Impressionism—to which he had been converted before Signac in the winter of 1885–86—was a 'new phase in the logical march of impressionism'.[24] It was opposed to the 'old impressionism'; it was 'scientific' impressionism, as opposed to 'romantic impressionism'.[25]

In the theoretical texts of the critic Félix Fénéon, which accompany and follow the emergence of the new movement around 1886–87, we find a dialectic of rupture and continuity between Impressionism and Neo-Impressionism. For Signac, the very term 'Neo-Impressionist' was a gesture 'to pay tribute to the work of … [its] precursors and to reveal the common goal underlying the divergence of method, namely *light* and *colour*'.[26] This explains why Gauguin referred to Seurat and his friends at that time as 'new Impressionists',[27] and why one of the first overviews of Impressionism, widely read in France and the United States at the turn of the century, Camille Mauclair's *L'Impressionism, son histoire, son esthétique, ses maîtres* 1904,[28] still includes

the Neo-Impressionists as part of the history of Impressionism. Fénéon presents the Neo-Impressionists as a continuation of Impressionism, with the notion of 'progress' being essential to the movement. Seurat, Signac, Albert Dubois-Pillet and the others pursued the 'new vision'[29] of the 'old Impressionists': in their faithfulness to particular subjects[30]; to sites (the Grande Jatte had previously been painted by Monet); to the way the brushstrokes were distributed, and more generally to the use of bright colour and light. The reform concerned all these aspects of painting and pictorial technique, including: the brushstroke—mastering the point, or cross-shaped mark, rather than the 'comma-shaped' stroke; colour—systemisation of the use of complementary colours; use of the in-vogue scientific theories of Michel Eugène Chevreul, Ogden Rood and Charles Henry—and composition.

The Neo-Impressionists thus claimed to take Impressionism as their starting point, and to improve it thanks to science—which is systematic and methodical. On these points, the break was clear, and the new guard's attack on the 'improvisational effect' of Impressionist painting was violent. This 'improvisational effect' was criticised as being 'cursory, blunt and imprecise'.[31] From this point of view Cézanne—in the regularity of his brushstrokes and the rigour of his vision—appears as a 'connecting link'[32] between Impressionist instinct and Neo-Impressionist method. Cézanne increasingly focuses on a restricted number of themes in Aix-en-Provence, opening a chapter in his work at the beginning of the 1880s that is generally considered to be classic. His paintings of male and female bathers (cat. 36) represent releases from the here-and-now, in favour of a classic timelessness. While Cézanne stayed faithful to topographical fact, to the point where we can precisely identify each of the sites he painted, he smoothed over its edges with modern elements, or transformed it to the point where a railway track resembled an artefact from

antiquity (as in his *Mount Sainte-Victoire and the viaduct of the Arc River Valley* 1882–85[33]). More importantly, in the eyes of the Neo-Impressionists, Cézanne, who had already felt the need to break the rules and surpass Impressionism by the end of the 1870s, built up his motif using a controlled and deliberate brushstroke that was a function of the necessities of observation and the role it played in the different parts of the composition.

Monet, on the other hand, was a particular target of the Neo-Impressionists, even though he had been an essential figure for the young Signac, who wrote to him in 1883: 'For the last two years I have been painting, having only ever had your works as models and following the great path that you have opened up for us'.[34] Ultimately Signac and his friends saw themselves as the authentic upholders of Impressionism, to the exclusion of the 'old' guard which they saw as incapable of exploiting all the possibilities of light and colour (declaring with Fénéon that 'the glory days of impressionism are past'[35]). Against this new generation, Monet advanced the validity of Impressionism as he practised it. The paintings he produced around 1886–88 can thus be considered responses to the Neo-Impressionists, against the backdrop of the struggle for the leadership of Impressionism. In this case, the term 'Impressionism'[36] is understood as it was in the 1880s, in the broad sense of 'modern painting', or the anti-Academic avant-garde which also belonged to this category in the 1880s and 1890s.[37]

In 1886 Monet returned to figure painting, which he had practically abandoned since the 1860s in favour of landscape: *Study of a figure outdoors: woman with a sunshade turned to the right* 1886 (cat.1) is a response to the immobile figures in Seurat's work. The emphasis on movement is a critique of the hieratic quality of Seurat's compositions: for Monet, on the contrary, the Neo-Impressionists' light and colour are instead the result of depicting movements and fleeting,

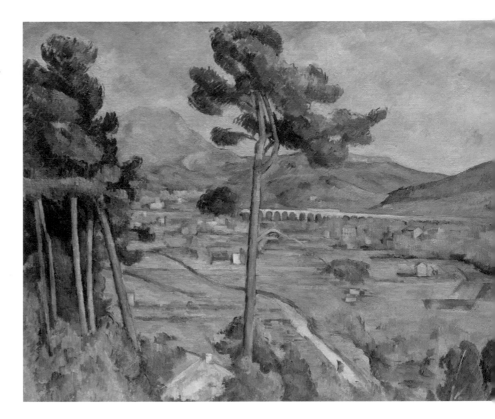

transitory effects. He reinterprets figure and decorative painting in strictly Impressionist terms—the two versions of *Study of a figure outdoors: woman with a sunshade*[38] are conceived by Monet as decorative works—thus taking the battle onto the Neo-Impressionists' own terrain, and refusing to let Impressionism be relegated to easel paintings and landscapes. There is an equally vivid opposition between Seurat's *Le Bec du Hoc, Grandcamp* 1885[39] painted in the summer of 1885 and shown in the eighth Impressionist exhibition, and Monet's views of Belle Ile produced in 1886. Serenity, calmness, immobility and gravity characterise Seurat's vision, while the tumult of waves, turbulence and movement characterise Monet's. For Monet, unlike Seurat, nature is not a set of elements that must be taken apart and analysed for reconstituting on the canvas from a dominant point of view (i.e., with the artist as master of the natural spectacle observed).

Paul Cézanne
Mount Sainte-Victoire and the viaduct of the Arc River Valley 1882–85
oil on canvas
65.4 x 81.6 cm

The Metropolitan Museum of Art, New York
H.O. Havemeyer Collection, bequest of Mrs. H.O. Havemeyer 1929 inv. 29.100.64
© The Metropolitan Museum of Art / Art Resource, NY
Photograph: Malcolm Varon

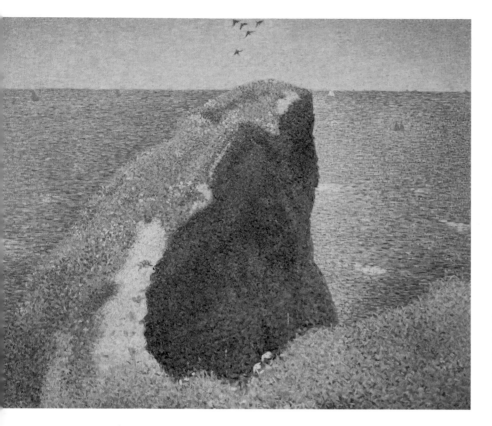

Georges Seurat
Le Bec du Hoc, Grandcamp
1885
oil on canvas
64.8 x 81.6 cm

Tate Collection, London
purchased 1952 N06067

The imperative, rather, is to seek a state of osmosis between nature and the painter. The artist has to tune in to nature's wavelength in order to grasp its particularities and its protean nature, rather than its immutable laws.

Impressionism and Symbolism

This quest for the immediate and transient was also called into question by another Post-Impressionist circle—the Symbolists. In the months following the final 1886 Impressionist exhibition, the poet Jean Moréas published the manifesto of literary Symbolism, which defined the work of art as the expression of the Idea—'the enemy … of objective description'.[40] In 1891, the young critic Albert Aurier spelt out its implications for painting, which had to become *idéiste* (literally, 'idea-ist') by devoting itself to 'that most elevated thing in the world

… the Idea'. This was in opposition to 'realist art, whose sole aim is the representation of material appearances'.[41] In Aurier's view, Impressionism could 'only be a variety of realism, a refined, spiritualised, dilletantish realism, but realism nevertheless'.[42] This interpretation of Impressionism was shared by the various Symbolist circles, whether the 'painters of the soul' or the Rosicrucian painters (who only portrayed landscapes which included figures or representations of modern life)[43], or members of the Cloisonnist movement (such as the Nabis). Denis, the Nabis theoretician, made no reference to Impressionist painters in his manifesto, *Of Neo-Traditionalism (Du Néo-Traditionnisme)*. But he did denounce their 'concern to be natural'.[44] Though Denis' criticism is also more subtle: he believed that Impressionism was simply a 'premonition' that couldn't come to fruition, because it was based on the false idea of an art that would be the 'product of all optical experience'.[45] And he believed there was no such thing as pure sensation: 'Art is no longer simply a visual sensation that we receive, a photograph, however refined, of nature. No, it is the creation of our spirit, for which nature is simply the pretext.'[46]

Neither Aurier nor Denis denied the subjective element in Impressionism, but they did deny that it had any ability to reach the level of the Idea. They believed that Impressionist paintings were not 'signs' that referred to a 'beyond' of sensation. Reading Aurier's text, Pissarro became indignant on this point:

> This gentleman must think we are idiots! All art is like that! The object of sensation is just a sign that develops the idea! Any artist that's really an artist agrees you need signs, which have to be truly artistic to develop the idea. That's the whole thing.[47]

For Pissarro, all art, from the time of the ancient Egyptians and the Chinese, was *idéiste*. Pissarro highlighted the contradiction in Aurier's argument: if the idea was the foundation of the work, then it was sufficient in itself and, taking

this to its logical extreme, there was no more need for painting and drawing. Like the novelist Octave Mirbeau, who took up the defence of the Impressionists against the Symbolists, Pissarro claimed that in art, sensation is the *source* of ideas. In the end, Pissarro admitted that of course painting was not a simple recording of sensations. He was joined on this point by Monet and Cézanne. In an ironic twist, at the beginning of the 1890s the Impressionists were declared by Mirbeau (and other critics like Georges Lecomte or Gustave Geffroy) to be the only true poets able to go *beyond* sensations and create an authentic painting of the ideal, the dream and the suggestion; while Mirbeau accused the Symbolists of being 'horrendous materialists who see only the subject and have none of the sensations that emanate from works of art'.[48]

There is even a shift in Monet's art practice at the beginning of the 1890s: the Impressionist aesthetics of spontaneity, emphasised around 1886–89 when confronted with the Neo-Impressionists, was replaced by his distancing himself from the motif in his paintings. With the idea of the series (for example, of painting a sequence of haystacks, or the face of Rouen cathedral, under changing conditions of light), the motif is more than ever subordinated to sensation and the observation that captures the transformations. Paintings begun in the field are resumed and completed in the studio in order to create harmonious sets of canvases. Finally, the construction of the motif is less and less faithful to topographical fact, in order to take on a decorative rhythm. In a counter-offensive to the Symbolist attacks, Mirbeau celebrated the genius of Monet—his ability to extract from a place:

> at a glance, the essence of form and colour and, I would also say, of intellectual life, of thought … from this supreme moment of concentrated harmony, where dream becomes reality … Claude Monet's landscapes are the supra-sensible forms of our thoughts.[49]

As example, Mirbeau gave Monet's *In a boat on the Epte* 1888[50] (see also cat. 5). Mirbeau also wondered why the Symbolists wanted to 'claim van Gogh as one of their own … why van Gogh, rather than Monet or Cézanne?'[51]

From the viewpoint of Symbolists such as Denis and the Nabis, for whom 'every work of art is the equivalent of a sensation',[52] Cézanne achieved the 'right balance' between two qualities which the nineteenth century mistakenly thought opposed: 'nature and style'; the necessary distortion and reinterpretation of the world.[53] Denis' *Homage to Cézanne* (cat. 39) testifies to Cézanne's rich lesson, coupled with that of Odilon Redon (depicted on the painting's left). It confirms Cézanne's significance for a reinvigorated Impressionism amidst the rich profusion of Post-Impressionist avant-gardes.

Claude Monet
*The rocks at Belle-Ile
(Rochers à Belle-Ile)* 1886
oil on canvas
59.5 x 73.0 cm

Ny Carlsberg Glyptotek,
Copenhagen
given by the Ny Carlsbergfondet
1961 inv. I.N. 2820

Notes

1 Roger Fry, quoted by Desmond MacCarthy, quoted in Alan Bowness, 'Introduction', in John House and MaryAnn Stevens (eds), *Post-Impressionism: cross-currents in European painting*, London: Royal Academy of Arts 1979, p. 9.

2 Zola was a childhood friend of Cézanne's in Provence. He was a defender of Manet and the future Impressionists from the 1860s.

3 Letter from Monet to Zola, 5 April 1886, quoted in Richard Kendall (ed.), *Manet by himself*, London: Macdonald Orbis 1989, pp. 116–17.

4 Quoted by George Moore, *Impressions and opinions*, London: T. Werner Laurie 1913, p. 226.

5 Maurice Denis, 'La Peinture', *L'Ermitage*, 15 November 1905, in Maurice Denis and Jean-Paul Bouillon (ed.), *Le Ciel et l'Arcadie*, Paris: Hermann 1993, p. 88.

6 The term came into being on the occasion of a major survey exhibition of French art organised at Grafton Galleries in London (Manet and the Post-Impressionists, 8 November 1910 – 15 January 1911).

7 Letter from Renoir to Durand-Ruel, 26 Feb 1882, Lionello Venturi, *Les Archives de l'impressionisme: lettres de Renoir, Monet, Pissarro, Sisley et autres*, New York: Burt Franklin, 1968, vol. 1, letter 10, pp. 120–21. Translated in John House, *Renoir, master impressionist*, Sydney: Art Exhibitions Australia, 1994, p. 36.

8 See John Rewald's irreplaceable *The history of Impressionism*, New York: Museum of Modern Art 1946; and also Joel Isaacson, *The crisis of Impressionism 1878–1882*, Ann Arbor: The University of Michigan Museum of Art 1980.

9 Quoted in Rewald, p. 421.

10 The Metropolitan Museum of Art, New York.

11 Dallas Museum of Art, Dallas.

12 Monet had prepared three works in the same format: the Dallas Museum of Art work was accepted; *The ice floes* 1880, Shelburne Museum, Vermont, was rejected, while *Sun setting over the Seine at Lavacourt* (*Sunset on the Seine, winter effect*) 1880, Petit Palais, Musée des Beaux-Arts de la Ville de Paris, Paris, was judged too innovative and was put aside by the artist himself.

13 'Something safer and wiser, more bourgeois,' as Monet writes to Théodore Duret in March 1880. Quoted in Daniel Wildenstein, *Monet: the triumph of Impressionism*, vol. 1, Köln: Taschen; Paris: Wildenstein Institute 1996, pp. 157–58.

14 Alice Hoschedé had six children from her marriage to her first husband, Ernest Hoschedé. Monet also had two children from his first wife, Camille, who died in 1879.

15 In the 1870s, the Impressionist paintings were selling for around 150 to 300 francs (see for example the auction organised by the Impressionists in 1875); in the 1880s, around 1000 to 1500 francs. In 1892, Monet's *Haystacks* sold for between 4000 and 6000 francs per painting, 'wildly successful' according to Pissarro; in 1895 he sells three *Cathedrals* to Isaac de Camondo for 15 000 francs each. In 1894, at the sale of Duret, Monet's *The turkeys* 1876 (Musée d'Orsay, Paris) is listed at 12 000 francs whereas the record for Cézanne is 800 francs. When Vollard decides to represent Cézanne the following year, the dealer decides not to let go of any paintings for less than 800 francs.

16 Monet accepts at that point the condition laid down by Petit: not to participate in any kind of Impressionist exhibition.

17 Impressionism has long been analysed on the model of the avant-gardes of the twentieth century: but it was never organised in the way that these were, with a theoretical manifesto or strong theoretical position. We should rather, according to Jean-Paul Bouillon, understand them in the context of the *sociétés d'artistes* (artist companies) that proliferated in the second half of the nineteenth century. See Jean-Paul Bouillon, 'Société d'artistes et institutions officielles dans la second moitié du XIX siècle', in *Romantisme*, vol. 54, 1986, pp. 89–113.

18 By the journalist Louis Leroy, in the title of an article mocking the exhibition in *Le Charivari*, 25 April 1874. He has a Neo-Classical landscape painter standing in front of Monet's *Impression, sunrise* 1872 (Musée Claude-Monet Marmottan, Paris), and saying: 'What does this painting represent? Look in the catalogue—*Impression, sunrise*, well I already knew it was an impression. I said as much to myself, since I am impressed.' The artists only used this term to refer to themselves on one occasion, for the exhibition of 1877. The rest of the time, quarrels divided them over the use of the terms 'independents', 'intransigents' etc, which compete with the term 'Impressionist' amongst the artists and critics.

19 Ambroise Vollard, *An intimate record*, New York: Knopf, 1925, in Nicholas Wadley (ed.), *Renoir: a retrospective*, New York: Hugh Lauter Levin Associates 1987, p. 163.

20 Rewald, p. 447.

21 Recounted by Emile Taboureux in 1880, quoted in Charles Stuckey (ed.), *Monet: a retrospective*, Sydney: Bay Books 1985, p. 92.

22 Cézanne's term, reprised as the title of Lawrence Gowing's book, Dominique Fourcade and Geneviève Petit (trans.), *Cézanne: la logique des sensations organisées*, Paris: Macula 1992.

23 National Gallery, London.

24 Janine Bailly-Herzberg, *Correspondance de Camille Pissarro*, Paris: Presses universitaires de France; Pontoise: Editions du Valhermeil, 1980–1991. vol. 2, p. 56. Translated in Joachim Pissarro, *Camille Pissarro*, New York: Abrams, 1993, p. 212.

25 Janine Bailly-Herzberg, *Correspondance de Camille Pissarro*, Paris: Presses Universitaires de France; Pontoise: Valbermeil 1980, vol. 2, p. 35.

26 Paul Signac and Willa Silverman (trans.), 'From Eugéne Delacroix to Neo-Impressionism', in Floyd Ratliff, *Paul Signac and color in Neo-Impressionism*, New York: Rockefeller University Press 1992, p. 248.

27 Letter to his wife Mette, Paris, 29 December 1885, in Paul Gauguin and Maurice Malingue (ed.), *Letters to his wife and friends*, London: Saturn Press 1946, p. 56.

28 Camille Mauclair, *L'Impressionism, son histoire, son esthétique, ses maîtres*, Paris: Librairie de l'art ancien et moderne 1904.

29 Félix Fénéon, 'L'impressionism', *L'Emancipation sociale*, Narbonne, 3 April 1887, quoted in Félix Fénéon and Joan U. Halperin (ed.), *Oeuvres plus que complètes*, Genève: Droz 1970, vol. 1, p. 65.

30 The other great manifesto of the movement, Signac's *The milliners* 1885–86, Foundation E.G. Bührle Collection, Zurich, is a Degas-style theme.

31 Félix Fénéon, 'Le néo-impressionnisme', *L'Art moderne de Bruxelles*, 1 May 1887, quoted in Fénéon and Halperin, p. 72.

32 Signac, in Ratliff, p. 260.

33 Metropolitan Museum of Art, New York.

34 Undated letter, no doubt written after Signac saw the Monet exhibition at Durand-Ruel in 1883; quoted in Gustave Geffroy and Claudie Judrin (ed.), *Monet, sa vie, son oeuvre*, Paris: Macula 1980, p. 175. *La Route de Gennevilliers* 1883 (Musée d'Orsay, Paris) is a good example, with its broad and sketchy strokes and the site chosen, of the hold of Impressionism over the young Signac.

35 Fénéon, 1887, quoted in Fénéon and Halperin, p. 68.

36 See Paul Hayes Tucker, *Monet in the 90s: the series paintings*, Boston: Museum of Fine Arts; New Haven: Yale University Press 1989, pp. 15–36.

37 To the point where in 1891, Albert Aurier, theoretician of Symbolism and champion of Gauguin, begged that: 'people above all abandon that inept generic term "impressionists", and that this name be strictly reserved for painters for whom art is only a translation of sensations'; see Albert Aurier, 'Le Symbolisme en peinture: Paul Gauguin', *Le Mercure de France*, March 1891, quoted in *Le Symbolisme en peinture*, Caen: L'Echoppe 1991, p. 30. In his letters, Gauguin describes himself indifferently as an impressionist, even after 1886.

38 The second version is *Study of a figure outdoors: woman with a sunshade turned to the left* 1886, Musée d'Orsay, Paris.

39 Tate Gallery, London.

40 Jean Moréas, 'Le Symbolisme', in the *Supplement littéraire du Figaro*, 18 Sept 1886. Translation in Charles Harrison and Paul Wood with Jason Gaiger (eds), *Art in theory, 1815–1900: an anthology of changing ideas*, Oxford: Blackwell 1998, pp. 1014–16, quotation p. 1015.

41 Aurier, pp. 21–22.

42 Aurier, p. 29.

43 Six Rosicrucian Salons took place between 1892 and 1897. The painter Jean Delville created the Salon d'Art Idéiste in 1896 in Brussels, 'against the confusion of the so-called realist, impressionist schools'. Jean Delville quotation in: Introduction, *Premier Salon d'art idéaliste à Bruxelles*, Brussels: [n.p.], 1896, unpaginated.

44 Maurice Denis, 'Définition du néo-traditionnisme', in *Art et critique*, 23 and 30 August 1890. Translation in Charles Harrison and Paul Wood with Jason Gaiger (eds), *Art in theory, 1815–1900: an anthology of changing ideas*, Oxford: Blackwell, 1998. pp. 863–69, quotation p. 866.

45 Maurice Denis, in Charles Harrison and Paul Wood with Jason Gaiger (eds), quotation p. 863.

46 Maurice Denis, 'De Gauguin et de van Gogh au classicisme', *L'Occident*, 15, May 1909, reprinted in *Théories, 1890–1910, du symbolisme et de Gauguin vers un nouvel ordre classique*, 4th edn, Paris: L. Rouart et J. Watelin 1920, pp. 262–78, quotation p. 268.

47 Quoted in Belinda Thomson, 'Camille Pissarro and Symbolism: some thoughts prompted by the recent discovery of an annotated article', *Burlington Magazine*, vol. 124, January 1982, p. 18.

48 Camille Pissarro to Octave Mirbeau, 12 January 1892, reprinted in Janine Bailly-Herzberg, *Correspondance de Camille Pissarro*, Paris: Presses universitaires de France; Pontoise: Editions du Valhermeil 1980–1991, letter 743, vol. 3, p. 186.

49 Octave Mirbeau, 'Claude Monet', *L'Art dans les deux mondes*, 7 March 1891, quoted in Octave Mirbeau, Pierre Michel and Jean-François Nivet (eds), *Combats esthétiques*, Paris: Séguier 1993, vol. 1, pp. 430–31.

50 Museo de Arte, Sao Paulo.

51 Octave Mibeau, 'Van Gogh', *Le Journal*, 17 March 1901, quoted in Mirbeau, Michel and Nivet, vol. 2, p. 297.

52 Maurice Denis, *Théories, 1890–1910, du symbolisme et de Gauguin vers un nouvel ordre classique*, 4th edn, Paris: L. Rouart et J. Watelin 1920, p. 167.

53 Maurice Denis, *Théories, 1890–1910…*, p. 236.

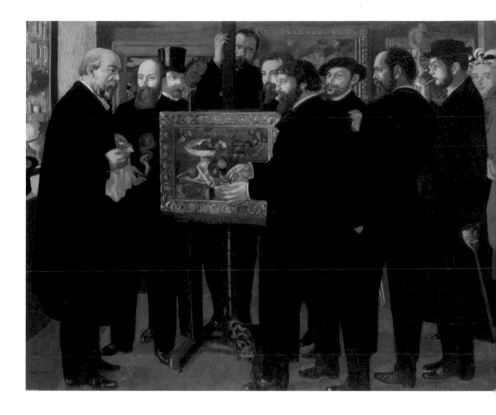

Maurice Denis

Homage to Cézanne
(*Hommage à Cézanne*)
1900

oil on canvas

Musée d'Orsay, Paris
© RMN (Musée d'Orsay) /
Hervé Lewandowski
© Maurice Denis. ADAGP/
Licensed by Viscopy, 2009

Cat. 39

For Françoise Cachin

Van Gogh and Gauguin: The resurrection of Delacroix?

Stéphane Guégan

When Vincent van Gogh travelled to Paris to join his brother at the very end of February 1886, his knowledge of the Impressionists was almost zero. He admitted as much in a letter to H.M. Livens, an English painter he knew in Belgium. He imparted, with a sense of optimism, the reasons for his departure for France. While the cost of living was higher there, and painters were more vulnerable to material hardships, these drawbacks would be offset by Paris' broader commercial potential. The same letter went on to paint a quick picture of the Parisian fine arts scene:

> There is much to be seen here—for instance Delacroix, to name only one master. In Antwerp I did not even know what the impressionists were, now I have seen them and though *not* being one of the club yet I have much admired certain impressionists' pictures—Degas nude figure—Claude Monet landscape.[1]

It's worth noting that van Gogh compared Impressionism with the work of Eugène Delacroix, who had died in 1863 but was still seen as the most innovative painter of recent time. For the Dutch newcomer, he personalised a modern use of colours and an attempt to make painting operate in the same way as music or poetry. At the time Delacroix was a force in anti-Academic artistic circles. Consequently we

can understand why van Gogh was attracted by him and in a position to regard the Impressionists as followers of the master. On the other hand, the legacy of Delacroix, as Signac would put it in 1899, might be exploited in a more daring way than the Impressionists.[2]

As soon as he arrived in Paris, van Gogh was ready to profit from the painters he discovered, from Monet to Seurat. This ought to dissuade art historians from proposing, as they still do, the notion of Post-Impressionism as a concerted reaction against Impressionism. The art historian John Rewald, out of his taste for perfect symmetries, undervalued the very active presence of the early Gauguin in the Impressionist exhibitions between 1879 and 1886.[3] The cases of van Gogh and Gauguin, whom Arles would bring together two years later, is enough to remind us of the complexity of the art world in Paris at the time when the Third Republic was facing the signs of political crisis.[4] Unless you reduce them to some simplistic definition, van Gogh and Gauguin are testaments to the fluidity of this aesthetic field. Post-Impressionism cannot merely be summed up as the overcoming of Impressionism.

It is no accident that questions persist today as to van Gogh's and Gauguin's exact place in this artistic context. How should they be situated in relation to Monet, Seurat, and Cézanne, and also in relation to Symbolism, which produced its own manifesto in 1886? And what of the other traditions which these two artists tapped? Today we know that it would be as neglectful to ignore van Gogh's connections with the painters of the Salon as it would be to ignore the Romantic legacy that Gauguin turned to his advantage. Nothing appalled the two artists more than the sectarianism that was to take hold of critical discourse in the years 1880–90. When the November 1887 exhibition of the Impressionnistes du Petit Boulevard brought together Bernard, Louis Anquetin, Toulouse-Lautrec and himself, van Gogh made clear through the group's name that he and his friends intended to revitalise Impressionism by 'a certain back-street dynamic'.[5] Modernity for the Dutchman-in-exile demanded flexibility among its proponents, rather than the imposition of formalist definitions.

Van Gogh's road to Arles

If van Gogh idealised the friendship and warmth of the Impressionist group, it was because, when young, he had experienced the distress of true solitude, as well as the benevolence of his family who were tolerant of this difficult and less than precocious individual. Born in North Brabant in 1853, van Gogh grew up in a family of pastors and art dealers. His father had followed the first path, while his uncle, another Vincent, embraced the second. It was in The Hague with his uncle that the artist took his first steps in his career as a dealer, after a mediocre performance at school, which was no doubt little suited to this very unstable adolescent. A competent but fickle dealer during the years of his apprenticeship, van Gogh came into close contact with the works of the Barbizon school of landscape painters and their Dutch disciples. He pinned prints by Rembrandt, Salomon van Ruysdael, Jean-François Millet or Charles-François Daubigny to the walls of his room, and also discovered the museums, travelling to Paris as well as London.

He gave up the career of art dealer in 1876, and undertook studies in theology, before discovering the mining-town hell of the Hainaut region of Belgium. There, an army of poverty-stricken proletarians of all ages were being ground down by the pace of runaway industrialisation and the worst imaginable working conditions. However, this would-be Christ of the poor ended up realising that he was hardly in a position to bring them the Light. Two years later, during the summer of 1880, he made the decision to take

up painting, in which he sensed another way of spreading the Word of Christ. His brother Theo, four years his junior and an employee of the Paris gallery Boussod et Valadon, sent him equipment and training manuals. A dedicated autodidact, van Gogh quite quickly mastered the first principles of drawing, which would be reinforced by a few months' study at the Brussels Academy of Fine Arts and the advice lavished on him by his cousin Anton Mauve, a prominent landscape artist of The Hague school. He made rapid progress.

In search of a supposedly more authentic rural world, van Gogh decided to go to Drenthe, an out of the way and desolate region of the Netherlands, to live in tune with this poverty and draw from it a truth that could be translated into his painting. Craggy-faced peasants and small tradespeople were painted in the colours of the soil, by an artist who would, however, soon find the harshness and deadly remoteness of this world unbearable. Abandoning his search, in 1885 he set himself up in Antwerp, where he attended the painting academy and made a few artistic contacts. In front of his mirror, he produced his first self-portraits, as gloomy as the romantic disappointments he experienced in his personal life and the venereal diseases he contracted. His father, his main source of support, died in March 1885. The help and understanding of his brother Theo had by now become indispensable. Emboldened moreover by his first paintings worth exhibiting—at least he thought so—van Gogh now felt the need to brave Paris, the world's premier artistic arena. He would stay in Paris for almost two years—a time spent appropriating the different elements of French modernity.[6]

Self-portraits

We can understand why van Gogh painted about twenty-eight self-portraits in Paris between March 1886 and late February 1888. They form a kind of personal diary, in which he confronted

his lurking malaise and the disappointments of his new life, as well as stretching himself against the master painters of the genre. It was not therefore from a fear of losing his sense of self that he set up a watchful mirror by his easel. The painter's pathology—his schizophrenic and melancholic tendencies, medically speaking—were far from being the sole determinant of his personality and his creative ambition.[7] It is true that van Gogh belonged to an era, explored in the fiction of Emile Zola and Guy de Maupassant, in which the ravages of family heredity were well known.

John Russell
Portrait of Vincent van Gogh 1886
oil on canvas
60.0 x 45.0 cm

Van Gogh Museum, Amsterdam s 0273 V/1962

(previous spread)
Vincent van Gogh
Portrait of the artist 1887
(detail) cat.47

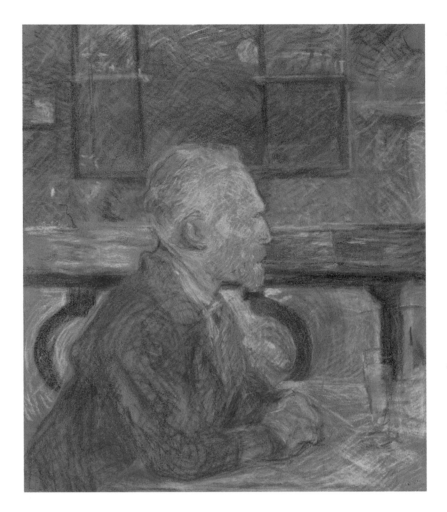

Henri de Toulouse-Lautrec
*Portrait of Vincent van Gogh
(Portrait de Vincent van
Gogh)* 1887
pastel on paper
57.0 x 46.0 cm

Van Gogh Museum, Amsterdam
d 0693 V/1962

As to the technique of the self-portraits of 1887 (cat. 47)—with their extreme Pointillism and strident palette—they summarise the painter's first months spent in France, during which the lessons of the Louvre were multiplied tenfold by the profound impact of Seurat, the bedazzling discovery of Japanese woodcut prints and the cosmopolitan circle of the Atelier Cormon[8] on the Boulevard de Clichy. Two of van Gogh's co-disciples, the Australian artist John Russell, and Toulouse-Lautrec, painted a portrait of the 'newcomer'—the first artist depicting him as a Dutch gentleman,[9] the second as a predator ready to pounce.[10] Bernard also associated with the Dutchman. He would describe him as 'red-haired … with an eagle eye and a cutting mouth, so to speak … stocky … sharp movements, a jerky walk, vehement in his views'.[11] Van Gogh admired the Japonism (*japonaiserie*) of 'le petit Bernard' and Louis Anquetin, and even exhibited alongside them in the winter of 1887. He didn't adopt their Cloisonnist style however, which separated form and betrayed the shimmering colour of Seurat, denying Delacroix's legacy. Apart from his self-portraits and a few bouquets of fritillaries—where the influence of Monet leaps to the eye—van Gogh's Parisian work remained, in style and substance, within the limits of a fairly sober Neo-Impressionism. Only the iconography, which started to incorporate the motif of the shady locales cultivated by the Impressionnistes du Petit Boulevard, created a real distance from his friend Signac. Van Gogh also met Gauguin at this time, although the latter firmly dissociated himself from the group around Seurat.

Several generations of van Goghs had been stricken by the most serious mental illnesses.

For this painter burdened with a heavy genetic legacy, the self-portrait would record every jolt in a risky career path—constantly torn between pugnacious artistic choices and self-doubts about his talent, between self-affirmation and psychological troubles of increasing severity. But rather than being only a response to very real personal crises, the self-portrait provided van Gogh with a means of integrating himself into the Paris community of innovative artists. He often portrayed himself, moreover, with an air of respectability: a dark felt hat, groomed beard, and a calm and determined gaze.

At the Salon des Indépendants, another space where artistic divergences were heightened, van Gogh exhibited three paintings in January 1888, and then headed for the south of France—to Provence, the sunny world of the Naturalist writer Alphonse Daudet and the painter Adolphe Monticelli.[12] He dreamt of gathering Bernard, Charles Laval and Gauguin around

him in Arles. The 'Studio of the South' (*atelier du midi*), with its supposedly healthier climate than Finistère in Brittany, was conceived as the southern equivalent of Brittany's Pont-Aven group, with whom van Gogh had been corresponding throughout 1887. The exchange of self-portraits reinforced the ties between the four painters, without however bringing them together physically. Only Gauguin would join van Gogh at Arles—for a short time from November 1888. Until then, with Theo's support, van Gogh set himself up there and drew and painted many things—not only his symbolic bunches of sunflowers, which distilled for him a private world.

The bawdy subjects of the cafes and brothels dear to the Petit Boulevard group were combined now with some southern nocturnal themes showing an atmosphere of rare intensity. It would be hasty and excessive to attribute the painter's marked inclination toward the night theme simply to his 'madness'. For this student of Rembrandt and Millet, the Provençal stars are more like bearers of a soothing music. He called this harmony of the starry sky his grand 'silence', since in it 'the voice of God' made itself heard.[13] Moreover, in relation to his previous experiments and formats, the Musée d'Orsay's version of *Starry night* 1888 (cat. 49) presented new ambitions. Its status as a popular masterpiece coincides with the arrival in Arles of Gauguin. In *Starry night*, painted in the summer of 1888, van Gogh confirmed his calling to modern painting with a fully realised work. The painter kept his brother Theo informed of *Starry night's* progress—a demonstration of the value he attached to it, and his concern to explain its 'expressionism', so as to avert suspicions of his mental disturbance. (Eugène Boch, whose portrait van Gogh painted against another starry background (cat. 48), received a sketch of this *Starry night*.)[14]

Starry night's movement, emphasising height (ascent) rather than depth, drawing the eye

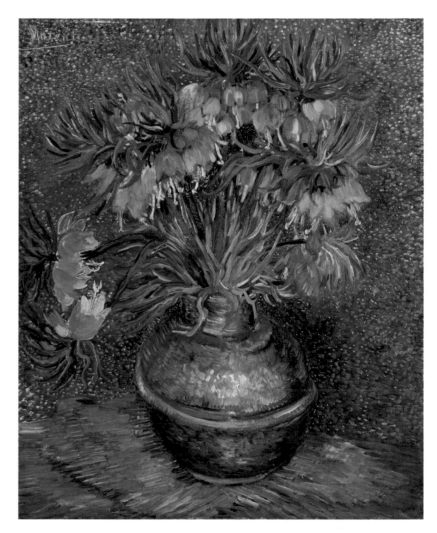

upward rather than into the painting, is made up of three gently curving bands. The composition creates a subtle connection between the two lovers in the foreground (representing the transcendence of the heart) and the radiant constellation of stars at the top (the transcendence of the sky). Through a palette of muted blues and greens, the painter makes his precious yellow dance all the more vividly. Each stroke is emphatic, repeated in a rhythm, so that the canvas fills and vibrates with the murmuring of Provençal nights. His letter to Theo stressed the deliberate interplay between the lights of the town and the lights of the sky, charged with

Vincent van Gogh
Imperial Crown fritillaries in a copper vase (Fritillaires couronne impériale dans un vase de cuivre) 1887
oil on canvas

Musée d'Orsay
© RMN (Musée d'Orsay) /
Hervé Lewandowski

Cat. 46

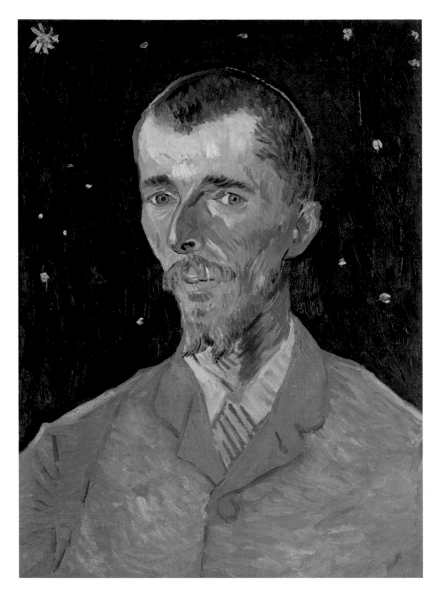

their heavenly message. The infinite no longer suggests human angst, solitude and vulnerability. Van Gogh's sky speaks positively: behind its magnificence is the implied presence of the divine. It is a sky of summer and true hope.

Soon after, Gauguin would respond to van Gogh's pressing invitations, and join him at Arles—though less out of any taste for communal utopias than because he needed the graces of the painter's art dealer brother, Theo.

Gauguin's road to Arles

For a long time it was thought that Gauguin the artist didn't come into himself until he entered his forties, around 1888, after an experimental phase whose only virtue was to prepare him for his true beginning—the paintings of Martinique, and above all those from his first stay in Pont-Aven in Brittany.

Did not this man reputed to be hostile to the values of the West, this rebel fleeing Paris and its compromises, require such a double rupture in order to create himself? In 1946 Rewald almost dismissed the artist from his *History of Impressionism*, a book that was to determine how Gauguin was interpreted for thirty years.[15] More space was devoted there to Cézanne and Edouard Manet than Gauguin, even though Gauguin had exhibited five times with the Impressionist group—as many times as Monet, and more than Pierre-Auguste Renoir and Sisley. A stockbroker turned 'primitive' painter, Gauguin retold the story of his artistic journey many times, and elaborated on his Peruvian background—giving credence to the broad outlines of a myth forged during his lifetime.[16] How could we doubt the internal necessity, the existential quest and deep aesthetic wellsprings of a man who had suffered so much to bring his art to fruition?

Gauguin's self-portraits, like van Gogh's, have made no small contribution to the sanctification of his persona and thus to the simplification of his real biography. It has often been said in print that the man who made his fortune in banking also intended to successfully make his career in painting. His social habits no doubt changed after the break with his family and the embracing of a cosmopolitan and vaguely self-destructive bohemia. Gauguin created a destiny for himself as a stateless saint. His romanticism was solid as a rock. Was he not born on 7 June 1848, between two revolutions in France?[17]

After the premature death of his father Clovis, a republican journalist, and an early childhood in Peru with his mother's family, Gauguin returned to France and Catholic boarding schools around the age of eight. After years of schooling unmarked by brilliance, but equipping him with a solid foundation of high culture, the young man signed up to the merchant navy, serving as navigator for three years on the *Jérôme Napoléon*. Discharged in April 1871, he returned to France and its capital, which was then in the throes of turmoil and bloodshed following the most recent battles of the Paris Commune. At the beginning of 1872 he rented an apartment with his sister Marie, near Place Bréda and Gustave Arosa's apartment—a family friend and one of the most enlightened modern art connoisseurs in the capital. With his support, Gauguin was taken on by a broker, a position that ensured him a comfortable income. It was during this time that he met Emile Schuffenecker, who was then on the verge of devoting himself to painting. In the group around Arosa, Gauguin also made the acquaintance of the Danish woman Mette Gad (1850–1920), whom he married in November 1873. Gauguin's debut in painting dates from this year.

The Gauguins set up house in 1875 in Rue de Chaillot, in the middle of Paris' 16th arrondissement, not far from the banks of the Seine where Gauguin would sometimes set up his easel. The landscapes the young painter produced display a sort of rural bonhomie, already coupled with a great proficiency beneath their initial spontaneity; these stuttering works herald the future alliance of Gauguin and Pissarro. In 1877 Gauguin and his wife moved to more rural Vaugirard, where housing was less expensive. In April 1879 Gauguin was invited at the last minute to take part in the fourth Impressionist exhibition—an invitation which seems to have come from Pissarro, Gauguin taking the opportunity to strengthen his recently made connection with him. The Gauguin family

by then included three children, Emile, Aline and Clovis. The years 1873–79 saw Gauguin lose some of his social ranking but gain artistic status in the eyes of the painters whose work he had been collecting for some time—Pissarro and his group, in the first instance. At this time three important elements coalesce: Gauguin's entrepreneurial personality, Arosa, and Arosa's collection of modern masters—Jean-Baptiste-Camille Corot, Delacroix, Honoré Daumier and Gustave Courbet. There is no doubt, however, that it was Pissarro who made the deepest impression upon him, at least up until 1886.

These choices reveal Gauguin's aesthetic orientation within the Impressionist scene. In style and substance, technique and emotional register, his work owes less to the example of Monet and Renoir than to the emanating influence of Manet, Cézanne, Degas and Pissarro. It is also marked by the combined practice of painting and sculpture. Thus Gauguin's period of professionalisation began, which he pursued with determination amidst increasing material difficulties. Alongside the Pissarro-style landscapes, figure paintings become more numerous—assisted by the success of Gustave Caillebotte and Degas. While nudes still remained the exception, there were interior scenes that defamiliarised the everyday. Some very curious still-lifes also anticipated Gauguin's future tendency to the baroque in Tahiti, in their asymmetry and shimmering hues. A primitivist tendency similarly appeared first during this period, in the bas- and high-reliefs that Gauguin sculpted with admirable vigour.

When financial crisis forced him to leave Paris, Gauguin lived in Rouen for a time, before moving to Denmark. His painting gained in density, to the point of claustrophobia, and also in its intensity, the vibrations of its colours in the style of Delacroix and Cézanne. We are struck by the heightened surface effects and the more energetic structuring of space. By the same token,

quality of an environment not yet entirely discovered by the rest of the world. The Pension Gloanec in Pont-Aven, where he took a room, sheltered a cosmopolitan range of folk under its roof. The contrast with Paris was great enough to suggest for them a preserved human and cultural authenticity. The painter quickly realised, however, that he was idealising these 'domestic primitives'. His painting, on the other hand, substituted a newly archaic style for the Celtic primitivism he couldn't find.

In his letters, Gauguin described himself as being surrounded by friends and listeners. He crossed paths with Bernard. Laval, another Cormon disciple, accompanied him to the French Caribbean colony of Martinique, where the two men's painting blossomed as it underwent a process of orientalisation. But the trip, lasting from April to mid November 1887, was disastrous for their health and financial situation. By the end of January 1888, having sold three paintings to Theo van Gogh and seen Vincent move from Paris to the south of France, Gauguin returned to Brittany and the Pension Gloanec. Penniless, or almost so, pursued by fevers contracted in Martinique, and having encountered little receptiveness or comprehension for his work from the time he had started to modify his Impressionism with a more Symbolist language, Gauguin still had his 'rage to paint'[18.] In 1891 the critic Albert Aurier would describe this Japonist-style painting—which gathered colours into dense, firmly delimited zones and used uncommon framing devices to divide up the canvas—as being highly subjective, giving excessive emphasis to its Platonist or idealist character.[19] But it is clear that the transformation in Gauguin's work would have been less dramatic without the stimulating presence of Bernard and Laval. As Gauguin wrote to Schuffenecker in August 1888: 'The group is getting larger. "Le petit Bernard" is here and he has brought back some interesting things from Saint-Briac [Brittany]. There's a man who has no fear.'[20]

execution becomes more disciplined, as outlined at this time in Gauguin's *Notes synthétiques*, which he wrote following the inspiration of Charles Blanc and Charles Baudelaire. There was a formal and theoretical reorientation, accompanied by a heightened freedom in the non-mimetic use of colour. Then came the time for his definitive emancipation from the Impressionist group—which broke up with the eighth and final Impressionist exhibition in 1886.

In the summer of that year, Gauguin returned to Brittany, following many others who had been moved by the unrefined and mysterious

This is a veiled way of Gauguin acknowledging his artistic debts—which are clear in the paintings, and the competition engendered by these tense artistic exchanges. Looking at the paintings that Bernard signed and dated in 1887—still-lifes and bathers (cat. 55)—confirms the radical clarity of the young artist's choices. A year later he would exchange ideas on an equal footing with Gauguin: they were both using flat, vivid patches of colour and Synthetist designs. But the beautiful portrait of his sister that Bernard produced at this time, styled like a recumbent medieval tomb sculpture, takes on the softened colours of a lover's daydream, embodying the emergent iconography of Symbolism (cat. 60). The painter, moreover, would soon throw in his lot with the religiously inspired Rosicrucian group and align himself with the Nabis in 1891. Sérusier, whose artistic journey is not without its parallels to Gauguin's, painted his famous *The talisman* in 1888 (cat. 72). This painting summed up his encounter with the Pont-Aven group. In retrospect, this almost abstract landscape could be seen to form the Nabis' New Commandments. Like Bernard, Sérusier was to give increasing prominence to religious subjects and archaic devotional forms—whose mythology Gauguin had already developed for himself before departing for Tahiti and transposing it to the tropics.

From Arles to Tahiti

At the end of 1888 Gauguin, by now connected to van Gogh, and especially to his art dealer brother Theo, joined Vincent in Arles. Here he was to experience, over a two-month period, an intense collaboration which has been misleadingly reduced to the episode of van Gogh's cut-off ear and the two men's violent break with each other. Temperaments and aesthetics may well have been at cross-purposes in Arles, but the men's discord would prove artistically productive. It would be better to speak of healthy competition between the two artists rather than a dialogue

of the deaf, for it was through the clash of their irreconcilable positions that the two artists each affirmed their own orientations—more expressionist in van Gogh's case, more contemplative in Gauguin's. It's impossible, in any case, to deny their common desire to push colour and image to extremity. Throughout this time, the man from Pont-Aven remained in contact with his 'Breton' friends—Bernard in the first instance. In a famous letter reflecting this triangular relationship, Gauguin summed up in two words what he was looking for in his painting, this tension between the life-force of reality and the harmony of Synthetist art: 'It's funny, Vincent

Paul Gauguin
Les Alyscamps 1888
oil on canvas

Musée d'Orsay, Paris
© RMN (Musée d'Orsay) /
Hervé Lewandowski

Cat. 56

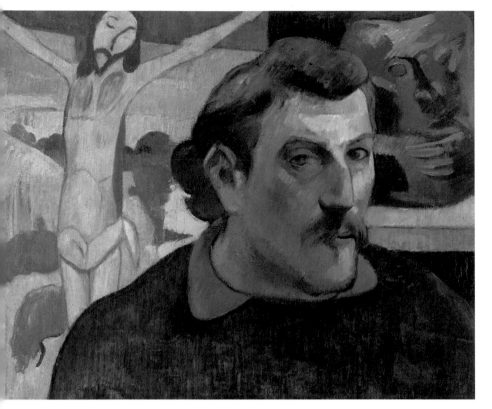

the promotional efforts of the Impressionist and Synthetist group. Gauguin exhibited in Brussels, and in Paris in May on the occasion of the Exposition Universelle. He was surrounded by all the young artists—Bernard, Anquetin, Laval and even Schuffenecker.

The Symbolist reviewers gave a mixed reception to the new label. The most enthusiastic critic was the already mentioned Aurier, who had just published two articles by Gauguin in the *Moderniste illustré*, of which he was editor-in-chief. In these the painter lauded the inventiveness of the Eiffel Tower, and the revival of the decorative arts in the name of a similar alliance between modern materials and non-mechanistic concepts. It is understandable that in his hatred of the manufactured goods of the old Europe—a decrepit world in his view—Gauguin expressed in August a desire for the 'unknown'. After being electrified by the oriental pavilions at the 1889 Paris Exposition, he announced to Bernard his intention to get a position in the French colony of Tonkin (Vietnam) to recharge himself there and, after a planned two years' living in the colonies, return to France more 'robust'.

Although he returned to Brittany that summer, his thoughts were already taking him far away. Pont-Aven now seemed too civilised to him, overloaded with daubers arriving from all directions. A few kilometres away, and more isolated, the small fishing village of Le Pouldu better represented the basic way of life which he considered necessary for his painting. In reality, however, he staggered back and forth between Pont-Aven and his new place of retreat.

In the letters he sent to van Gogh, whom he never forgot, Gauguin confessed his desire to paint, through his models, 'the savageness … that is also in me'.[22] His painting emphasised this internal, hallucinatory otherness, using an apparently clumsy visual language. In his *Portrait*

sees Daumier to be done in this environment, I on the other hand see some colourful Puvis [de Chavannes] mixed with Japan.'[21] It's a definition that, going on the evidence, applies to Gauguin's most noted works from his Arlesian adventure—*Les Alyscamps* in particular, shorn of any allusion to the old cemetery that made such an impression on van Gogh (cat. 56).

By mutilating himself after a banal dispute with Gauguin on 23 December 1888, van Gogh put an end to this strange artistic cohabitation and indicated his need for formal medical treatment. He soon chose to be hospitalised, before returning to the north and playing out his final passion for painting in Auvers. Gauguin would live henceforth with the guilt of their messy falling out and van Gogh's subsequent death. Even more so given that, during 1889, while van Gogh was still alive, the Pont-Aven painter redoubled

of the artist with 'The yellow Christ' 1890–91 (cat. 65), a manifesto of archaism in its numerous and enthusiastic references to non-Western cultures, we can nevertheless make out the confidently trained artist. The painting is presented like an unusual collage, with Gauguin's fine, intense face firmly inscribed between the rustic Christ of a Breton church and a would-be Peruvian vessel from which a third face emerges. Like the Romantics before him, Gauguin's choice to identify himself with Christ sanctifies his independence as an artist and idealises his refusal to compromise his solitude as a man wounded by the society in which he has only a few disciples.[23] But the reference to non-Western cultures also indicates their presence at this time as the source of a regenerated painting style in terms of form and symbolism.

This monumental work, however modest its actual physical dimensions, has a softness, a harmony, an order and a gravity that suggest a whole other side to Gauguin's artistic personality. This primitive, moreover, has a certain genius for publicity. While objecting to the project to exhibit van Gogh (as planned by Bernard after van Gogh's suicide in July 1890), Gauguin extended his connections in the Symbolist writing scene. He had been back in Paris since February, and was busy on all fronts, especially with regard to his planned move to the tropics. He now dreamt of another home base, in French Polynesia: 'Even Madagascar,' he wrote to Redon in September,

> is too near the civilised world; I shall go to Tahiti … I judge that my art, which you like, is only a seedling thus far, and out there I hope to cultivate it for my own pleasure in its primitive and savage state.[24]

Gauguin was determined to make this reimmersing of himself (moving 'towards the distant horizons and towards himself', in the Symbolist poet Stéphane Mallarmé's expression[25]) seem feasible and productive. The poet and his circle contributed to the project's realisation by supporting the auction that Gauguin organised before his departure. The sale, on 23 February 1891, brought in less than 10 000 francs (around 35 000 euros or 60 000 Australian dollars), a modest result—but the publication, one after the other, of long articles by Octave Mirbeau and Aurier, strengthened the artist's position. While Aurier again invoked Plato and Greek idealism to explain Gauguin, Mirbeau put the finishing touches on the myth of the stateless individual nurtured from childhood on the example of the utopian socialist Charles Fourier, and determined to flee civilisation: 'the better to listen to the inner voices that are suffocated by the clamour of our passions and disputes'.[26]

Gauguin's Tahitian exile took place in stages. The primitives he initially discovered, in Papeete, were not those his heart desired. In this French colony, the indigenous population had abandoned most of their customs, and only a few tattoos preserved the 'primitive means of art, the only means that are good and true',[27] from the same cultural amnesia. We know that Gauguin continued to attempt to reconstitute this lost (or at the very least hybridised) culture, using different iconographic sources, of whose artificiality he was not always the best judge—as in the case of photographs which he believed captured a pre-colonial state, whereas they were actually its product.[28]

Arriving in Tahiti in June 1891, by September Gauguin was already on the lookout for a less tainted geographic and cultural space. He was enchanted by Mataiea; he would spend almost two years there and complete several major paintings. In the midst of a landscape that had taken on a Baudelairean aspect—with its pink lagoons, its mauve or red soils, its luxuriance saturated with flowers, fruits and mysterious women—the painter continued to create a dialectic between religions and cultures in a

Paul Gauguin

Arearea (Jokes) (Arearea (Joyeusetés)) 1892

oil on canvas

73.0 x 94.0 cm

Musée d'Orsay, Paris RF 1961 6
© RMN (Musée d'Orsay) /
Hervé Lewandowski

Gauguin gave Eugène Tardieu, who was intrigued by this style of painting which had no clear instruction manual, a few keys to the 'musical' operation of his works:

> I arrange lines and colours so as to obtain symphonies, harmonies that do not represent a thing that is real, in the vulgar sense of the word, and do not directly express any idea, but are supposed to make you think the way music is supposed to make you think, unaided by ideas or images, simply through the mysterious affinities that exist between our brains and such arrangements of colours and lines.[32]

Meeting with little sympathy for, or comprehension of, his art, feeling bitter and tired of his living conditions, the artist returned to Tahiti, though without giving up hope on his Parisian career. Under contract with the dealer Ambroise Vollard from 1900, he chose another island group in French Polynesia, the Marquesas, for the final phase of his *atelier des tropiques*. The syphilitic and alcoholic man continued to manage the reception of his works from a distance, while the faux-primitive continued his dialogue with the masters— Lucas Cranach, the Greeks of the Parthenon and, very often, Delacroix. Following his death in May 1903, the twentieth century would go on to make Gauguin one of its cultural shamans. Two years before, Bernheim-Jeune had organised the first memorial retrospective of van Gogh in Paris. Maurice de Vlaminck and André Derain, among others, were impressed by this exhibition. In combining Gauguin's and van Gogh's innovations, the future Fauve painters would continue to emulate the so-called savageness of Delacroix.[33]

syncretism that would be striking on his return to Europe. If *Tahitian women* 1891 (cat. 66) is reminiscent of Delacroix's *Women of Algiers in their apartment* 1849[29] then *Arearea* 1892[30] draws on the tradition of Egyptian art.

These were two of the forty-four paintings Gauguin exhibited at Paul Durand-Ruel's gallery in Paris in November 1893. Only eleven of these works sold; Degas was one of the few buyers. In the sale catalogue's preface, itself decorated with woodcuts, Charles Morice repeated the Gauguinesque idealisation of 'a Tahiti prior to [arrival of] our terrible sailors and the perfumed pap of Mr Pierre Loti'.[31] The Paris press was a little disconcerted by the apparently barbaric subjectivity of this painter who was able 'to put so much mystery into so much brightness'. The faithful Mirbeau also referred to Gauguin's 'imaginative abundance' and 'depth of thought'.

Notes

1 Letter 459a, Paris, August–October 1886, viewed 16 September 2009, www.vggallery.com/letters/553_V-T_459a.pdf.

2 Paul Signac and Willa Silverman (trans.), *From Eugène Delacroix to Neo-Impressionism*, in Floyd Ratcliff, *Paul Signac and color in Neo-Impressionism*, New York: Rockefeller University Press 1992, pp. 193–285.

3 See John Rewald, *The history of Impressionism*, New York: Museum of Modern Art 1946.

4 See Richard Thomson, 'The cultural geography of the Petit Boulevard', in Cornelia Homburg, *Vincent Van Gogh and the painters of the Petit Boulevard*, Saint Louis: Saint Louis Art Museum in association with Rizzoli 2001, pp. 64–107. This was the Boulangist Crisis. The Boulangists were a conservative political grouping gathered under the popular leadership of General George Boulanger. They challenged the government of the Third Republic, culminating in the possibility of a coup d'état in January 1889, though this did not in fact eventuate.

5 See Thomson, 'The cultural geography of the Petit Boulevard', p. 66.

6 See Françoise Cachin and Bogomila Welsh-Ovcharov (eds), *Van Gogh à Paris*, Paris: Ministère de la culture et de la communication, and Editions de la Réunion des musées nationaux 1988.

7 See François-Bernard Michel, *La face humaine de Vincent Van Gogh*, Paris: Grasset 1999.

8 Fernand Cormon was an influential academic-historical painter.

9 *Vincent van Gogh* 1886, Van Gogh Museum, Amsterdam.

10 *Portrait of Vincent van Gogh* 1887, Van Gogh Museum, Amsterdam.

11 Emile Bernard, 'Souvenirs sur van Gogh', *L'Amour de l'art*, vol. 4, December 1924, pp. 393–400.

12 On the importance of Monticelli in relation to van Gogh's 'solar' style and his decision to spend time in Arles, see Marie-Paule Vial (ed.), *Van Gogh, Monticelli*, Paris: Réunion des musées nationaux 2008.

13 See Sjraar van Heugten, Joachim Pissarro and Chris Stolwijk, *Vincent van Gogh and the colors of the night*, New York: The Museum of Modern Art; Amsterdam: Van Gogh Museum 2008.

14 See van Gogh's letter to Boch, Arles, 2 October 1888, letter 553b, viewed on 27 August 2009, www.vggallery.com/letters/670_V-E_553b.pdf.

15 Richard R. Brettell and Anne-Birgitte Fonsmark, *Gauguin and Impressionism*, New Haven: Yale University Press 2005, p. 368.

16 For a good overview, free from the myths which have long distorted our reading of the painter, see Belinda Thomson, *Gauguin*, London: Thames and Hudson 1987.

17 The February 1848 revolution brought down the French monarchy, there was an unsuccessful rebellion in June, and a new Republican government was formed in December 1848.

18 Gauguin to Vincent, from Pont-Aven, late February 1888. Translated by Robert Harrison, edited by Robert Harrison, number GAC 28. WebExhibits online museum website, http://webexhibits.org/vangogh/letter/18/etc-Gauguin-GAC28.htm.

19 Albert Aurier, 'Le symbolisme en peinture. Paul Gauguin', *Le Mercure de France*, March 1891, pp. 155–65.

20 Quoted in Victor Merlhès (ed.), *Correspondance de Paul Gauguin. Documents, témoignages*, Paris: Fondation Singer Polignac 1984, p. 210.

21 November 1888, quoted in Merlhès, p. 284.

22 October 1889, quoted in Belinda Thomson (ed.), *Gauguin by himself*, Boston: Little Brown 1993, p. 106.

23 On the Romantic sources of the painter, see Stéphane Guégan, *Gauguin, le sauvage imaginaire*, Paris: Editions du Chêne 2003.

24 September 1890, quoted in Daniel Guérin (ed.) and Eleanor Levieux (trans.), *Paul Gauguin: the writings of a savage*, New York: DaCapo 1996, p. 42.

25 See Jean-Michel Nectoux, *Mallarmé: un clair regard dans les tenebres peinture, musique, poesie*, Paris: Adam Biro 1998, p. 98.

26 Octave Mirbeau, 'Paul Gauguin', *L'Echo de Paris*, 16 February 1891, translated in Marta Prather and Charles F. Stuckey, *Gauguin: a retrospective*, New York: Hugh Lauter Levin Associates, 1987, pp. 136–47, citation at p. 136. Also reproduced in *Octave Mirbeau, Combats esthétiques*, edition compiled, introduced and annotated by Pierre Michel and Jean-François Nivet, Paris: Séguier, 1993, vol. 1, pp. 418–22, quotation, p. 418: 'so as to be better able to listen to the inner voices that are smothered by the noise of our passions and quarrels'.

27 See Jules Huret, 'Paul Gauguin discussing his paintings', *L'Echo de Paris*, 23 February 1891, in Guérin and Levieux, p. 48.

28 See Elizabeth C. Childs, 'The Colonial lens: Gauguin, Primitivism, and photography in the Fin de siècle', in Lynda Jessup (ed.), *Antimodernism and artistic experience*, Toronto: University of Toronto Press 2001, pp. 50–70.

29 Musée Fabre, Montpellier. An earlier 1834 version is held in the Musée du Louvre, Paris.

30 Musée d'Orsay, Paris.

31 Pierre Loti was a popular French novelist and naval officer who published somewhat sentimental books based on his many travels.

32 Eugène Tardieu, 'Interview with Paul Gauguin', *L'Echo de Paris*, 13 May 1895, quoted in Guérin and Levieux, p. 109.

33 Around 1900 the young Derain made many copies after Delacroix in the Louvre.

Eugène Delacroix
Women of Algiers in their apartment (Femmes d'Alger dans leur intérieur)
1849
oil on canvas
85.0 x 112.0 cm

Musée Fabre, Montpellier
gift of Alfred Bruyas 1868
Inv. 868.1.38

Inventing modern art

Christine Dixon

For a new era, new techniques. It's simply a matter of common sense
Joris-Karl Huysmans, *L'art moderne* 1883[1]

The brief lives of two men—Georges Seurat died at the age of thirty-one in 1891, Vincent van Gogh at thirty-seven in 1890—help to illuminate the upheaval of art after Impressionism matured and increasingly was accepted as the modern style. Neither artist was very successful commercially, although both received acclaim from his peers. Each practised his craft for little more than a decade. The careers of other brilliant artists were short-lived also: Henri de Toulouse-Lautrec died at thirty-seven, Paul Gauguin at fifty-four. The old master Paul Cézanne, on the other hand, was born the year before Claude Monet, his Impressionist forerunner. He outlived the others, to die in 1906 at the age of sixty-seven.

The artistic inventions and experiments of these five artists and their followers, as well as those of the quirky group who called themselves the Nabis, are now clustered together and their art defined as Post-Impressionist. This term Post-Impressionism, however, did not define a movement in art. It was

One great achievement of modern art, after the novel idea of Impressionism was grudgingly accepted, was that painters might stop trying to imitate or exactly reproduce static reality. Rather, artists could transform into paint their views of a changing world. Only a dozen years marked the journey between the outraged rejection of Monet's *Impression: sunrise* 1873[2] shown at the first Impressionist exhibition of 1874, and the eighth and final Impressionist exhibition of 1886, where Seurat showed his monumental canvas, *A Sunday afternoon on the island of La Grande Jatte* 1884–86[3] (p. 35). After the explosive impact of Impressionism—revolution through the eye—something new happened to art. Fresh aesthetic beliefs and personal experiences replaced the recording of momentary sensations.

When he somewhat impatiently advocated 'new techniques for a new era', the poet and critic Joris-Karl Huysmans was discussing Impressionist painting. His advice, however, applied just as crucially to the next generation of artists. Few new subjects appeared after Impressionism, as artists continued to produce portraits as well as still-lifes, landscapes and figure paintings. Symbolist art allowed new flights of fancy, equivalent to the religious and mythological themes central to the art of the past. Modern Symbolism could include a personal narrative, as in Emile Bernard's self-portrait as a betrayed lover (cat. 94). His emotional storm had artistic consequences, as can be seen in the hot colours and hallucinations of his fevered imagination. But Nabis artists and those working in Brittany and the south of France, in the countryside or in the streets and parks of Paris (cat. 108) and its suburbs, often trained their vision onto the private realm of a new middle class, and the realities of modern life. It seems odd that living artists were vilified by their peers for considering as valid subjects the circumstances and times which surrounded them. Conservative thinkers, who included Salon artists and academic writers, were

not named by its adherents, nor by its opponents, as Impressionism was; there was no manifesto, and no group exhibitions were held. It wasn't even labelled until after the phenomenon had ended, already overtaken by later 'isms' such as Fauvism and Cubism. The main protagonists were all dead by 1906. Not until four years later, in 1910, was the term invented by Roger Fry. He was an English curator, art critic, painter and designer, and sought a word to describe the phenomenon of French modern art to a sceptical, even hostile, English audience.

frightened by the present and the future. They fundamentally believed that painting should strive for *mimesis*—the exact imitation of nature—or resemble a literary art form which invoked the past. That is, artists would illustrate imaginary narratives such as historical or classical stories, myths or legends, in order to reinforce the intellectual and political status quo.

In the central decades of the century, from about 1840 to the 1880s, avant-garde literature and music, as well as visual art, attempted to render truthfully the nature of contemporary life and consciousness in Paris and the provinces. Realist and Romantic ideas inspired modern writers, composers and artists, including the novelists Honoré de Balzac, Gustave Flaubert and Émile Zola, the musicians Georges Bizet and Charles Gounod, and such painters as Gustave Courbet, Edouard Manet and Monet. By the end of the century it was the anti-naturalist modern writer Marcel Proust who would capture the moral and aesthetic quandaries of the Third Republic, its uncertainties and emotions; he appealed for creativity to establish meaning in life.[4]

By 1870 the moral certainties of the Second Empire were under attack, and divisions between the ruling monarchists and opposing republicans were reinforced. The Catholic church's dominance, especially in the army and the state, was challenged by free-thinkers and radicals, including cultural ones. After the disastrous military defeat of the Franco–Prussian war of 1870–71, and before the government's bloody suppression of the Paris Commune which immediately followed, a grand political compromise was instituted by the formation of the Third Republic—a republic run by monarchists. Prosperity increased in France in the 1870s, despite the hated war reparations due to Germany, until a series of bank failures in the 1880s. The consequent financial disruptions and credit squeeze lasted until the mid 1890s, and

Jean-Louis-Ernest Meissonier
The siege of Paris (1870–1871) (Le siège de Paris (1870–1871)) c. 1884
oil on canvas
53.5 x 70.5 cm

Musée d'Orsay, Paris
gift from Luxembourg 1898
RF 1249
© RMN (Musée d'Orsay) / Hervé Lewandowski

meant significant reorganisation in the ways art was bought and sold. Dealers and commercial galleries withdrew from supporting avant-garde artists, retreating into safer fields, such as works by Barbizon realists, Salon painters, or Old Masters. It was harder for living artists to sell their pictures or gain commissions, and more difficult for dealers to offer allowances to young painters or buy their work for stock.

The political and economic instability of the 1880s and 1890s was matched by an undermining of official institutions such as the Academy of Fine Arts, which ran the Salon exhibitions and the training school, the Ecole des Beaux-Arts. The French state assumed it would control visual culture through its system of patronage and rewards, including purchases, commissions, medals and awards. As well as the Impressionists' unofficial shows between 1874 and 1886, the Groupe

such as Fernand Khnopff. His debt to Whistler can be seen in the modulated tonal and chromatic range, and in the sitter's pose, in his portrait, *Marie Monnom* 1886 (cat. 88). More diverse groups appeared in the 1890s, such as the Société des Beaux-Arts, founded in 1891, whose members produced work in the field of decorative arts such as screens and lamps in the new vogue of the Arts and Crafts movement in Britain. The mystic Salon de la Rose + Croix, avowedly Catholic and occult in its aims, held Rosicrucian exhibitions each year from 1892 to 1897; surprisingly, these were staged at the gallery of Durand-Ruel, Monet's dealer.

Did any women artists feature in the Post-Impressionist experiments? Female Impressionist painters were not uncommon, and include Eva Gonzalez, Berthe Morisot, and Mary Cassatt, all active in the 1870s—so what happened in the next generation? If proficient and conservative enough, women could show at the Salon, the official exhibiting body and source of state commissions and purchases. But female students were not permitted to enrol at the official art school, the Ecole des Beaux-Arts, until 1897. Many frequented private art schools, especially the Académie Julian. There, separated from male students after 1878, they paid higher fees, but were allowed to take life classes featuring nude models, unlike many other art schools.

Two major visual phenomena influenced French art in the second half of the nineteenth century: photography and Japanese prints. Although the primary function of naturalist and realist painting was to attempt to replicate the world, photographs could now replace that role, albeit in monochrome, but with a much more centralised view. The technical consequences of photography included cropping the scene, off-centre compositions, and the widest scope of vision that could be imagined from a fixed viewpoint. Several of these, coincidentally, also characterised those thousands of Japanese woodblock prints

des Indépendants was formed in 1883, and the Société des Peintres-Graveurs mounted its first exhibition in 1889. Juried entry was rejected: no old fossils should be allowed to deny art because it was new or different! The situation sometimes allowed compromises, as when Maximilien Luce exhibited his experiments in a new painterly language at the Indépendants, but applied them to conventional subjects in order to attract buyers.

Artists tried new and unusual venues to show their works, including cafes, shop windows (most famously that of the colour merchant Père Tanguy near Montmartre), cabarets, studios, barracks and disused exposition pavilions. In Brussels, the avant-garde association of artists Les XX (The Twenty) emerged in 1883. Modern artists, from Whistler to Seurat, appeared in their exhibitions, with stylistic consequences for Belgian painters

which infiltrated visual culture in France from the central decades of the nineteenth century.

Japanese woodblock prints, *ukiyo-e*, were produced from the eighteenth century in the tens of thousands. The imported prints first struck the Impressionists with their originality in the 1860s. Their visual novelty included employing flat areas of colour, bold outlines, cropped elements, oblique or unusual angles of approach to composition, and sharply different conventions of perspective. Subject matter was 'the floating world' of everyday life in town and country: various kinds of people and activities, public and private, are realised visually with contrasting patterns of textiles and surfaces. Another wave of appreciation came in the 1880s and 1890s, with new generations looking at Japanese and Chinese art, especially prints and painting. The dealer Georges Petit organised an exhibition of more than three thousand Japanese works of art in 1883,[5] while another thousand *ukiyo-e* prints were shown at the Ecole des Beaux-Arts in May 1890.

In the 1880s Georges Seurat conceived the modern world in a new light: instead of the Impressionists' fleeting instantaneity, he offered a monumental rendering of the ongoing situations of everyday life. Each of his great presentations of bourgeois and artistic life or entertainment— *Bathers at Asnières,*[6] *A Sunday afternoon on the island of La Grande Jatte, Models,*[7] and *The circus*[8] (see studies, cats 12, 13, 14, 17–20, and 27)—seems to freeze any movement so that we, like the artist, bear witness to modern life and its sensory experiences. In successive studies for the standing model (cats 17 and 18), he changes her stance and makes a still figure more dynamic simply by varying the angle of her leg. Seurat aimed high: he wanted modern art to have dignity, even a gravitas equivalent to enduring classical art—specifically Greek art's highest achievement, the marble friezes of the Parthenon. Pissarro was among his earliest supporters, positing that:

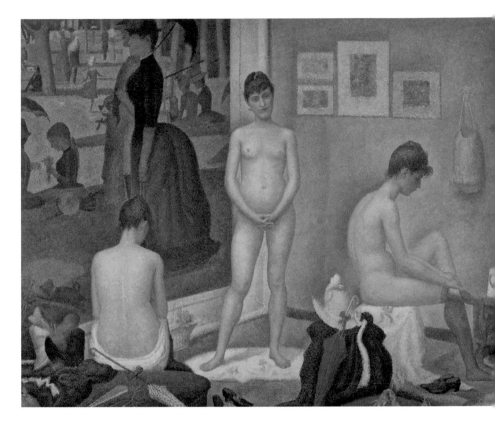

Seurat has something new to contribute, which these gentlemen [Manet, Armand Guillaumin, Auguste Renoir], despite their talent, are unable to appreciate … I am personally convinced of the progressive character of his art, and certain that in time it will yield extraordinary results.[9]

The art of Seurat contains an explosive potential of visual and physical motion. His paintings explore the sensory range of sight, sound, and touch. Their radical nature is obscured by the often convoluted theorising on colour and the technique of Divisionism offered by his followers. Seurat, who spoke but did not write about his idea of Chromatic or Chromo-Luminarism,[10] drastically changed his ideas about how to portray movement in the last years of his short career. In contrast to the stately, slow-moving vertical cylinders of his people in the park on La Grande Jatte, with calm horizontal lines dominating, in later paintings such as *The circus* (study, cat. 27),

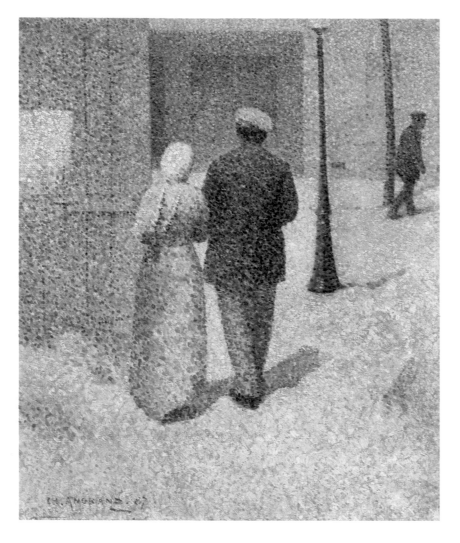

designation accentuated the scientific approach popular with anarchist and socialist thinkers of the time: a fractured and unequal society could only be healed through modern, rational methods. Scientific methods included the optical investigation of colour and perception, influenced by such writers as M.E. Chevreul, Charles Blanc, Ogden Rood and Charles Henry,[11] as well as the chemistry of pigments and paint.

The apparently rational and controlled technique of small coloured dots or patches or strokes of paint was 'objective', according to Seurat, demonstrating a scientific attempt to analyse the nature of light and colour and how these frame the physical world. Such rigour attracted many converts: certainty is very attractive in a situation of change. Paul Signac spent the rest of his life practising Neo-Impressionism, championing its theories and the importance of its dead master, Seurat. But by 1918 the classical style incorporated rococo flourishes such as fantastic colours and circular rhythms (cat. 32). Charles Angrand, Henri-Edmond Cross, Georges Lemmen, Maximilien Luce, Pissarro and Théo van Rysselberghe, among others, executed works using Divisionist techniques for the next decade.

Flatness, evenness and lack of impasto characterise the style, minimising three-dimensionality in a two-dimensional medium. Artists used light grounds to brighten the effects of colours, often employing similar-sized marks, sometimes the same shape, to reduce the emotional impact of paint. In the hands of a genius such as Seurat, these techniques were simply the means to an end, and could be manipulated to produce masterpieces of infinite variety. Several of his followers made extraordinary works, but often then painted themselves into an artistic corner, to become prisoners of an aesthetic formula. Some, like Pissarro, soon rejected the concept, while others retreated into conventional, even reactionary styles. Another possible path was to

arabesques, diagonals and sweeping curves animate the canvases.

Various terms have been used for the style adopted by Neo-Impressionist artists in the 1880s and 1890s: the 'New' Impressionism, which refreshed the earlier movement; Divisionism, for the separation of colours laid down beside each other rather than blending; and Pointillism, for the little spots or points of colour which stipple the surfaces of the paintings. Seurat's own awkward term, Chromatic Luminarism, implied using the colours of light as a method of simulating the brilliance of daylight. This

absorb elements of Symbolism, and then produce engaging but slightly eccentric combinations of neutral technique married to emotive themes.

Many Neo-Impressionist painters allied themselves politically with anarchism, although they argued for the transformation of capitalism by peaceful methods rather than random acts of terrorist violence which activist revolutionaries enacted in France, Italy and Russia in the 1880s and 1890s.[12] Their aim of decorative harmony implied social and political, as well as aesthetic means. Angrand's *Couple in the street* 1887 (cat. 30) is a rare urban scene, which depicts a gently affectionate and personal connection between its working-class subjects. Symbolists also appreciated the underlying idealism of the Neo-Impressionist project, although they advocated irrational or emotional means of achieving social cohesion through music and art.

Van Gogh, on the other hand, envisaged a temporary and always conditional vision of the world: we are fallible and human, never perfect. His painted views depend on feelings, as well as aesthetic theories and mediated positions on the meaning of art. A latecomer to professional painting, he arrived at the atelier of Fernand Cormon in Paris in 1886, at the age of thirty-two; his fellow students included Toulouse-Lautrec (cats 52–54) and the Australian John Russell (who both painted his portrait, see pp. 45 and 46). He conceded in theory that life drawing and conventional study were important to the development of an artist, but perhaps was too individualist in his vision to accept such training. Van Gogh took elements of Divisionist colour theory and techniques such as colour oppositions, dashes and dots, and added them to his hatched drawing style to form a characteristic technique of parallel and swirling paint strokes.

But van Gogh's great poetic invention—emotion communicated visually through intense colour

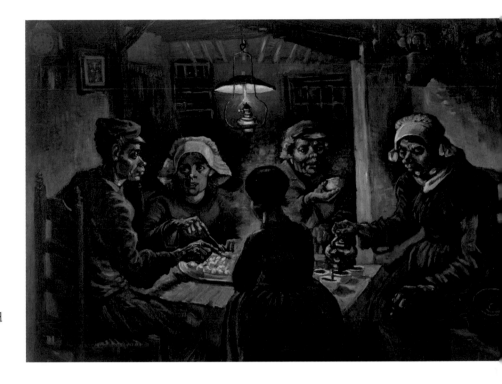

and the expressive manipulation of paint—in part came out of his rejection of the constraining rules of Neo-Impressionism, although he adopted some of its lessons of chromatic harmony and dissonance. He wrote to his brother Theo that he thought Divisionism was a real discovery:[13] 'But,' he continued, 'we must already see to it that this technique does not become a universal dogma any more than any other.'[14]

In the final years of his mature work, from 1888 to 1890, van Gogh produced more than four hundred paintings, in which colours become purer and increasingly subjective, and textures richer and more painterly. He always admired the example of Rembrandt's impasto, and had struggled with the dark palette of naturalism in his first important painting, *The potato eaters* 1885.[15] Monet was one of Theo van Gogh's artist clients in Paris; his staccato brushwork, each stroke loaded with paint, influenced Vincent's understanding of how an artist's technique could

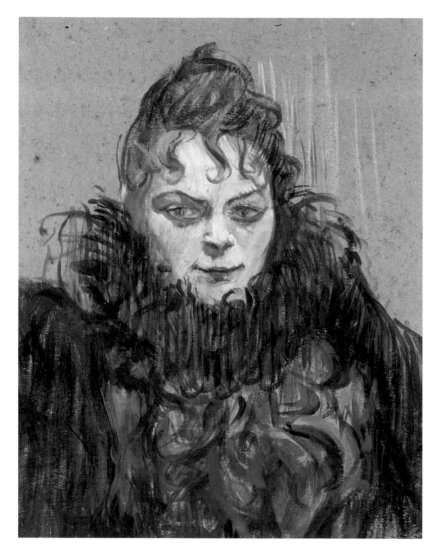

of colour employed in juxtaposition by the Neo-Impressionists. Gauguin's brushstrokes are generally dry and abrupt, only becoming more fluent as his vision matured in Oceania. But they are never luscious like van Gogh's, a painter who seems to ooze oils onto canvas as though the mixture should retain its liquid nature, only guided into their destined channels by the artist's hand. We are aware of the canvas as a ground when looking at Gauguin's work, as this is an artificial arena where his ideas play out in the physical sphere of a painting. Van Gogh looks on the landscape as an uninterrupted realm of art, which exists in a duality between the best of God's creation and the halting ability of humans to comprehend it. So it is absorbed into the artist's consciousness, and the observed part is captured on canvas and covered in paintstrokes, perhaps in order to heal it—or himself (see cat. 49).

Henri de Toulouse-Lautrec, in contrast, seems to be an artistic loner, less influenced by the past or his peers than most artists at the time. He observes human behaviour and body language closely, like Honoré Daumier, that great caricaturist and graphic artist of mid-nineteenth-century France, and Edgar Degas, another brilliant loner of French art. As a painter, Toulouse-Lautrec is often a portraitist, more radical and modern in his poster designs than is evident in most of his oil studies on card. His debilitating genetic physical condition, as well as bouts of illness and alcoholism, curtailed his achievement as a painter, especially of large works on canvas. Like van Gogh, he did not attract any close admirers, as Seurat and Gauguin did; unlike van Gogh, he appeared to follow no-one.[16]

The graphic, even calligraphic, nature of Toulouse-Lautrec's paintings imparts a sketch-like, unfinished quality even to completed compositions. Animated by whip-like lines, strong diagonals, and subjects cropped and placed

evoke sensations. For the Impressionists these were physical and optical effects, but for van Gogh, as well as Gauguin and the Symbolists, the nature of modern art implied emotional and social revelation, not just sensory phenomena.

The bright, clear and deep colours—oranges, reds, yellows, blues, purples and greens—adopted by Gauguin and van Gogh stand for a new aesthetic directness, even brutality. Often presented in large patches of unmediated hues, or outlined in black or blue, they are different in kind from the small pure touches

off-centre, such studies suggest their creator does not seem to aspire to high art. Toulouse-Lautrec painted on card or canvas, which might be left bare or may show through his thinned medium of oil paint mixed with turpentine (cat. 53). His decision not to 'finish' works, in both senses of the word, has a parallel in Cézanne's increasing tendency from the 1890s to refuse completion. For Cézanne, this culminated in a series of watercolours which seem to tremble on the edge of disappearing into transparency on white paper. The two artists' aesthetic motivations, however, could hardly be more disparate: one evokes the short-lived moment of pleasure and sensory experience, the other eternal truths which seem to underpin both nature and art.

Despite their differences, both Toulouse-Lautrec and Cézanne were admired by the Nabis. The Nabis group of artists was formed as a secret society in 1888–89 by young men rebelling against the conservatism of their teachers. Some studied at the Académie Julian (Paul Sérusier, Maurice Denis, Pierre Bonnard, Paul Ranson) and others at the Ecole des Beaux-Arts (Edouard Vuillard and Ker-Xavier Roussel). In a large painting by Denis (cat. 39), Sérusier is depicted explaining a still-life by Cézanne (a painting once owned by Gauguin) to another inspirational figure, Odilon Redon. Consciously casting themselves as the future of art—the name *Nabi* is based on the Hebrew and Arabic words for 'prophet'—they emulated earlier examples from their century, and attracted more adherents. Brotherhoods such as the Nazarenes in Germany and the Pre-Raphaelites in Britain had similarly banded together against an unsympathetic art world, aiming to produce art like none ever witnessed. The Nabis wished to expand their creations beyond easel painting. They favoured large murals, screens, panels and the applied arts, as well as more characteristic tiny renditions of interiors, often featuring family and friends as decorative human elements.

The Nabis looked mainly to two models, Pierre Puvis de Chavannes and Gauguin. They even made Gauguin an honorary Nabi. Puvis, a stylistically independent progenitor of Symbolism, produced large stylised wall decorations and canvases in muted tones featuring large, simplified planes (cat. 85). He stated that: the 'true role of painting is to animate walls. Apart from that, one should never create paintings larger than one's hand.'[17] Gauguin, younger than Puvis and even more experimental, contributed to the Nabis' interest in flatness and patterning. Sérusier famously had a painting lesson from Gauguin when the two met in Brittany in 1888, resulting in Sérusier's *The talisman* (cat. 72), the most radical and earliest abstract depiction of a subject in art history. The Nabis then saw, and were subsequently inspired by, Gauguin's paintings exhibited at the Cafe Volpini during the 1889 Exposition Universelle.

Nabis artists enacted some of the rites required by a secret society: each member had a special name, they invented a secret language, met ritually in a restaurant, then monthly at Paul Ranson's Paris studio. They may even have dressed in fancy costumes, although this was later disputed. Religion and the occult were among their intellectual and aesthetic concerns, most directly expressed in Denis' choices of subject. Pierre Bonnard and Edouard Vuillard mainly depicted intimate domestic scenes of little or no drama, while Félix Vallotton painted private and public scenes more detached in mood. It was the Nabis' avid viewing of Japanese prints that underpinned their almost obsessive depiction of contrasting designs in clothes, walls and floors. In 1899 their only group exhibition under the name Nabis was held, at Durand-Ruel's gallery. By then the artists had begun to go their separate ways—some physically, to Pont-Aven in Brittany or to the south of France, or intellectually to Symbolism, or by choosing the applied arts over painting.

Paul Cézanne's appetite for mythological or symbolic content in his art was occasional and erratic, as his *The apotheosis of Delacroix* 1890–94 attests (cat. 33). After his agonising experience as an exhibitor at the first and third of the eight Impressionist exhibitions in 1874 and 1877, he withdrew from Parisian artistic circles. The excoriating criticism of his paintings—Cézanne was singled out for more vitriol than the others—reinforced his view of himself as being more advanced aesthetically than other artists, and therefore more likely to be misunderstood. His exploration of form, built up through square brushmarks, and his rendering of vertical overlapping layers of perspective, were truly revolutionary because of the ways they questioned the physical world. In his work, Cézanne investigates reality, picks it apart, then restacks its components into an equivalent, parallel view. It is fiction, like all art, but a fiction based on the wonder of material things rather than the imaginary narratives of conventional artists, or the evanescent scenes presented by the Impressionists.

Experiment became necessary in the last decades of the nineteenth century, because conventional painters could not help idealising their subjects. Perhaps Modernists may have gone too far in the other direction, making their subjects neutral or banal, or even too pretty. Cézanne was initially influenced by Pissarro, whom he knew by 1863. As early as the 1860s he presented paint on canvas in 'undisguised brushstrokes'.[18] But he increasingly came to see the Impressionist style as attempting only an optical rendering of reality, not engaging enough of an artist's intellect and emotion. Always dissatisfied with his own artistic explorations, Cézanne provoked extreme reactions in others by his radical offers to solve the problems of painting. Conservative critics and the public laughed at what they (and indeed Madame Cézanne) saw as his lack of facility, while some artists admired but did not imitate him.[19] His first solo exhibition, comprised of more than 150 works, was held as late in his career as November 1895, in Ambroise Vollard's Paris gallery.

Those neat oppositions which can be advanced to define the differences between the Impressionists and the rebels of Post-Impressionism—harmony versus dissonance, belief or scepticism, smooth rather than rough—were almost identical categories to those cited against Impressionism by Realist and Salon painters and their supporters in the 1860s and 1870s. Such generalisations can be applied only partially, if at all. Some artists, such as Puvis de Chavannes and Redon, were hardly to be contained within any school, while others reacted variously to the advances and discoveries of their mentors and colleagues. Gauguin's search for the exotic—in Brittany, the West Indies and the Pacific—has a strange parallel in Henri Rousseau's imaginary jungles found in his trips to the zoological gardens of Paris. But then definitions are problematic: Rousseau proposed to Picasso in 1908 that the pair were 'the two greatest painters of the era, you in the Egyptian genre, I in the modern genre'.[20]

The process of inventing modern art was a long one, beginning with the battles of Romanticism and Realism, and continuing with Impressionism and its heirs. After the turn of the next century, the paintings we now call Post-Impressionist inspired novel stylistic movements. A complex process of cross-fertilisation, discovery and rejection took place, which went far beyond the common simple genealogies of Fauvism, Cubism and Expressionism. Like the vexed artistic inheritance of the Post-Impressionists, new times would bring forth new creative strategies.

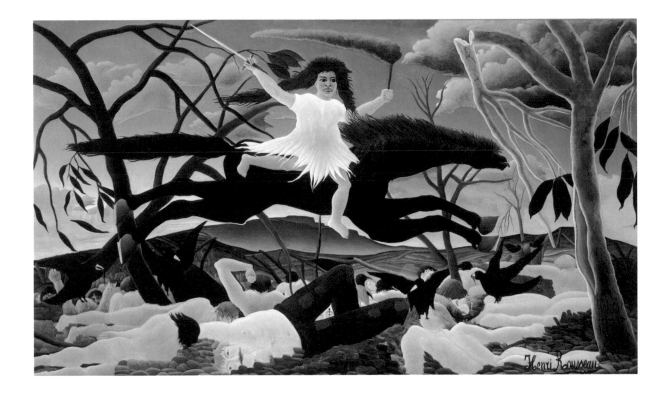

Notes

1 'A temps nouveaux, procédé neufs. C'est affaire simple de bon sens', quoted in Paul Smith, *Seurat and the avant-garde*, New Haven: Yale University Press 1997, p. 69.

2 Musée Marmottan Monet, Paris.

3 The Art Institute of Chicago, Chicago.

4 His great novel in seven parts, *In search of lost time*, or *Remembrance of things past* (*A la recherche du temps perdu*), was finally published between 1913 and 1927.

5 Bernard Denvir, *Post-Impressionism*, London: Thames and Hudson 1992, p. 78.

6 National Gallery, London.

7 The Barnes Foundation, Merion.

8 Musée d'Orsay, Paris.

9 Letter from Camille Pissarro to his son Lucien, March 1886, quoted in John Rewald (ed.), *Camille Pissarro, letters to his son Lucien*, London: Kegan Paul, Trench, Trubner and Co. 1943, p. 73.

10 See Floyd Ratliff, *Paul Signac and color in Neo-Impressionism*, New York: The Rockerfeller University Press 1992, p. 9.

11 Seurat owned or had read treatises such as M.E. Chevreul's *De la loi de contraste simultané des couleurs et ses applications*, 1839; Charles Blanc's *Grammaire des arts du dessin*, 1867; Ogden Rood, *Modern chromatics*, 1879, published in French in 1881 as *Théorie scientifique des couleurs*; and Charles Henry's *Cercle chromatique et rapporteur esthétique*, 1888.

12 Fénéon and others were arrested after fatal bombings in Paris in summer 1884; see Robyn Roslak, *Neo-Impressionism and anarchism in fin-de-siècle France: painting, politics and landscape*, Aldershot: Ashgate Publishing 2007, p. 102.

13 He called the artists Pointillists, a term Seurat abhorred, as it implied that nothing but coloured dots made up the style.

14 Letter 528, Arles, c.27 August 1888, viewed 27 August 2009, www.vggallery.com/letters/648_V-T_528.pdf

15 Van Gogh Museum, Amsterdam.

16 Toulouse-Lautrec scrutinised Japanese art and adopted some of its conventions for his graphic art, particularly lithographic posters and prints. These strongly influenced Nabis artists, particularly Bonnard and Vuillard.

17 Quoted in Marius Vachon, *Puvis de Chavannes: un maître de ce temps*, Paris: Société d'Edition Artistique 1900, p. 75.

18 Belinda Thomson, *Impressionism: origins, practice, reception*, London: Thames and Hudson 2000, p. 202.

19 Gauguin owned six works by Cézanne. Denvir, p. 26.

20 Quoted in Adriani Götz, *Henri Rousseau*, New Haven: Yale University Press 2001, p. 38.

Henri Rousseau
War (*La guerre*) c.1894
oil on canvas

Musée d'Orsay, Paris
© RMN (Musée d'Orsay) /
All rights reserved

Cat. 112

After Impressionism

Albert Besnard
Edgar Degas
Henri Gervex
Claude Monet
Camille Pissarro
John Singer Sargent
Alfred Sisley

1 Claude Monet

France 1840–1926

Study of a figure outdoors: woman with a sunshade turned to the right
(*Essai de figure en plein-air: femme à l'ombrelle tournée vers la droite*) 1886
oil on canvas, 131.0 x 88.0 cm

Musée d'Orsay, Paris, gift of Michel Monet,
the artist's son 1927, RF 2620
© RMN (Musée d'Orsay) / Hervé Lewandowski

Monet experienced financial success in 1886 when he sold thirteen canvases shown at the Georges Petit gallery in Paris. This allowed him to acquire a small island, Ile aux Orties, near Giverny at the mouth of the Epte, some 80 kilometres west of the capital. The location became a favoured sanctuary for his mistress Alice Hoschedé and their children.[1] The island, like his garden and pond at Giverny, also became a subject for his art.

One day in the summer of 1886 Monet looked up from his boat to see the silhouetted figure of Alice's daughter Suzanne Hoschedé standing on the grassy embankment. He was inspired to paint this vision, as it reminded him of the composition he had painted of his late wife Camille and their little son Jean eleven years earlier in 1875.[2]

This work is one of two versions. Monet has not attempted a recognisable portrait of Suzanne, but rather has painted an ethereal figure, draped in a flowing white dress, wearing a boater with a long scarf fluttering behind her. The features of the woman's face are barely perceptible and perhaps hauntingly recall the face in Monet's vision of his dying wife in 1879.[3]

In *Study of a figure outdoors*, much of Suzanne's torso is shaded by a green umbrella, and the shadows in pale blue and green fall across her body rather than shape it. While the other version of this subject shows the young woman being buffeted in the summer breeze[4], this canvas depicts her in less dramatic conditions; the sky is a dappled blue, and the long grass pink in the sun—echoed in the evanescent clouds behind her.

During the 1880s Monet appears to have concentrated on landscapes devoid of figures, thus this figure depicted in the outdoors is rare. When both paintings of Suzanne Hoschedé went on display, along with a series of haystacks in 1891, Monet commented:

> It's the same young woman, but painted in two different atmospheric effects; I could have done fifteen portraits of her just like the stack of wheat. For me it's only the surroundings which give the real value to subjects.[5]

Jane Kinsman

1 After the death of his first wife Camille, Alice Hoschedé became the artist's mistress. In 1892 the couple married after the death of Alice's husband Ernest Hoschedé the year before.

2 'But it's like Camille at Argenteuil!' Virginia Spate, *The colour of time: Claude Monet*, London: Thames and Hudson 1992, p. 175.

3 Daniel Wildenstein, *Monet: the triumph of Impressionism*, Koln: Taschen; Paris: Wildenstein Insitute 1996, vol. 2, cat. 543, p. 212. The painting referred to is *Camille Monet on her deathbed*, collection of the Musée d'Orsay, Paris.

4 Wildenstein, vol. 3, cat. 1077, p. 408.

5 Spate, p. 175 and note.

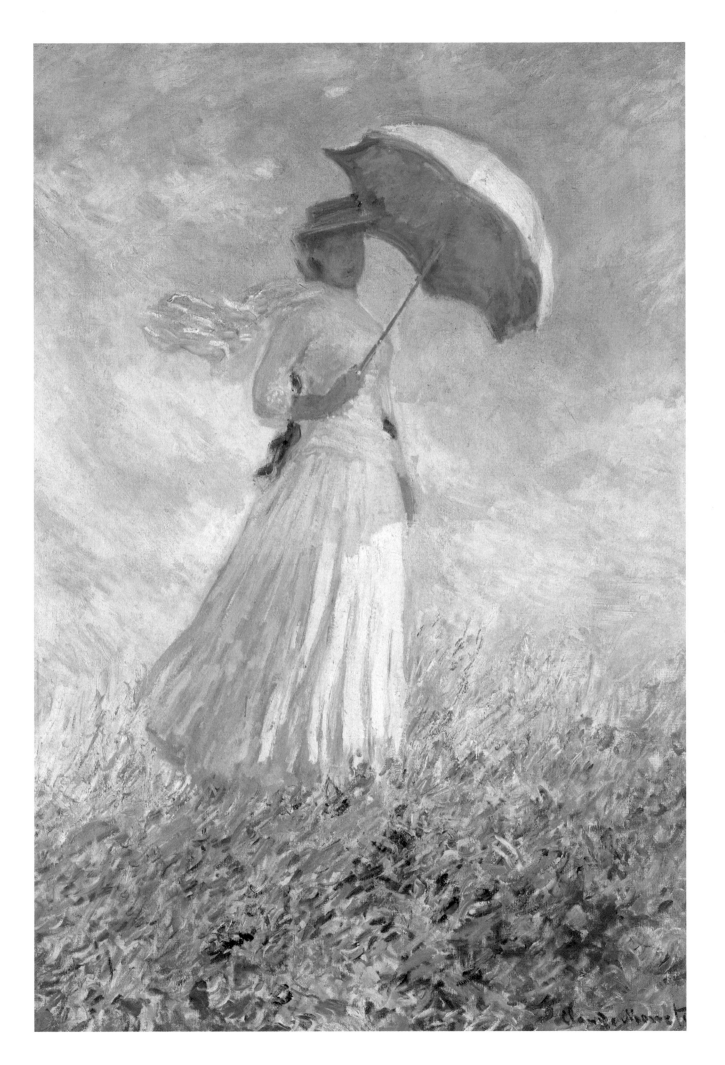

2 Albert Besnard

France 1849–1934

Madame Roger Jourdain or *Portrait of Mrs R. J... (Portrait de Mme R. J...)* 1886
oil on canvas, 200.0 x 153.0 cm

Musée d'Orsay, Paris, gift of Mrs Roger Jourdain,
the sitter 1921, RF 2302
© RMN (Musée d'Orsay) / Hervé Lewandowski

Besnard began his career at the conservative Ecole des Beaux-Arts in Paris. He was taught by the notoriously purist academic painter Alexandre Cabanel, whose infamous refusal to allow Edouard Manet to exhibit at the 1863 Salon led to the establishment of the Salon des Refusés.[1] By 1868 Besnard was exhibiting at the Paris Salon. A sojourn in London from 1879 until 1881, where he studied the British portrait tradition and J.M.W. Turner, proved very influential on his work. On his return to Paris he received a number of portrait commissions from prominent members of France's Third Republic.

Madame Roger Jourdain was the stand-out work of the 1886 Salon. Here Besnard combined orthodox academic traditions with the looser painterly elements of Impressionism, creating what he called an 'environmental' portrait. Rejecting idealisation and concentrated naturalism, Besnard focused instead on the sitters' surroundings, which he believed to reflect their personalities and 'express their relationship with the world in which they live'.[2] Besnard captures the elegantly gowned society hostess Henriette Roger Jourdain (d.1928) in a minx-like yet graceful pose using two sources of light to create a theatrical atmosphere—the figure appears backlit by hazy blue moonlight, while her face and gown are illuminated by a yellowish-white glow from an artificial source.

Despite Besnard's looser brushwork and treatment of colour and light, the Impressionists denied any affiliation with him, claiming he had simply stolen superficial elements from their style. Degas ridiculed Besnard's attempts, saying: 'yes, yes, he *flies* with our own wings [but] … he is a man who tries to dance with leaden soles'.[3] The Symbolists, however, embraced Besnard's fusion of styles—particularly his use of colour to denote mood—with Teodor de Wyzewa commending *Madame Roger Jourdain* as a 'symphony of blues and whites'.[4]

Henriette and her artist husband Joseph lived on Paris' Boulevard Berthier, surrounded by artists, writers and composers, including Besnard. She became a muse for many.

The annual Salon was the nineteenth-century equivalent of today's tabloids. The public scrambled to see portraits of the famous faces of the day, and Henriette was one such figure. Throughout her life, scandalous allegations dogged her—many lovers, a morphine addiction, and finally her death from a sleeping pill overdose.

Simeran Maxwell

1 Wayne Andersen, 'Manet and the Judgement of Paris', *ARTnews*, vol. 72, no. 2, February 1973, p. 67.

2 Besnard, quoted in John House and Maryanne Stevens, 'France', in *Post-Impressionism: crosscurrents in European and American painting 1880–1906*, Washington D.C.: National Gallery of Art 1980, p. 57.

3 Quoted by George Moore, *Impressions and opinions*, London: T. Werner Laurie 1913, p. 226.

4 Teodor de Wyzewa, 'Notes sur la peinture wagnérienne et le salon de 1886', *Revue wagnérienne*, 8 May 1886, quoted in House and Stevens, p. 45.

3 John Singer Sargent

Italy 1856 – Great Britain 1925

La Carmencita c.1890
oil on canvas, 232.0 x 142.0 cm
Musée d'Orsay, Paris, purchased from the artist 1892, RF 746
© RMN (Musée d'Orsay) / Gérard Blot

Sargent was born in Europe, of expatriate American parents. He was profoundly influenced by the Spanish masters Velazquez, El Greco and Goya, and by Manet's reworking of them. In the 1870s he studied at the atelier of Carolus-Duran, and placed second in the entrance examination for the Ecole des Beaux-Arts, on his second attempt. After early success at the Salon, Sargent lived in Britain and travelled occasionally to the United States for portrait-painting binges.[1]

The Spanish dancer known as La Carmencita first came to fame at the Exposition Universelle in Paris in 1889, where Sargent probably saw her performing in a tent. She presented herself as a classically trained ballet dancer named Carmen Dausset, neither a Gypsy nor flamenco performer.[2] The name was famous from Bizet's opera *Carmen* of 1875. By February 1890 she was dancing in a music hall in New York City,[3] when Sargent encountered her at a private performance at a friend's party and asked her to pose for him.

In the portrait, the painter is the performer as much as the dancer. Theatricality is the means through which Sargent presents the moving figure in an imaginary space. A dark background is overcome by flaring footlights, which light the dazzling yellow satin and lace costume, and the dancer's paler arms and face. Her dramatic Spanish colouring restates the light tones, her red lips the bright colour, and her dark hair the importance Sargent placed on the manipulation of tones to represent reality, rather than line. In its manipulation of compressed space and repeated dynamic angles, Edouard Manet's painting of another Spanish dancer, *Lola of Valencia* 1862[4] seems to be the model for Sargent's composition. He had the chance to view Manet's retrospective in Paris in 1884, and again at the Exposition Universelle in 1889.

After the painting's triumphant debut at the annual spring exhibition of the Society of American Artists in May 1890, it was shown at the Royal Academy in London the following year. It was praised for its liveliness and drama ('the picture of the year … intensely modern, intensely realistic in treatment'), although the same writer saw it as a little decadent ('something of that halo of decay which gives a lurid fascination to the creations of Baudelaire').[5] On its exhibition in Paris at the Salon in 1892, *La Carmencita* was bought by the French state. Perhaps this went some way towards restituting the hostile reaction Sargent's *Portrait of Madame X* 1884[6] had met at the 1884 Salon, where it was criticised as scandalous, blatantly erotic and artistically eccentric.

Christine Dixon

1 Sargent painted twenty-four portraits on his American trip between September 1887 and May 1888; see Richard Ormond and Elaine Kilmurray, *John Singer Sargent: the early portraits*, New Haven: Yale University Press 1998, cats 192–215, pp. 197–217.

2 M. Elizabeth Boone, *Vistas de España: American views of art and life in Spain, 1860–1914*, New Haven: Yale University Press 2007, p. 139.

3 Carmencita was the first woman to appear in front of an Edison motion picture camera in 1894. See the Library of Congress, American memory site, viewed 25 August 2009, http://memory.loc. gov/cgi-bin/query/r?ammem/papr:@filreq(@field(NUMBER+@ band(edmp+4019))+@field(COLLID+edison)).

4 Musée d'Orsay, Paris.

5 Claude Phillips, *Art Journal*, 1891, p. 198, quoted in Richard Ormond and Elaine Kilmurray, *John Singer Sargent: portraits of the 1890s*, New Haven: Yale University Press 2002, p. 22.

6 Metropolitan Museum of Art, New York.

4 Henri Gervex

France 1852–1929

Madame Valtesse de La Bigne 1879
subsequently dated by the artist 1889
oil on canvas, 200.0 x 122.0 cm
Musée d'Orsay, Paris, gift of Valtesse de La Bigne 1906, INV 20059
© RMN (Musée d'Orsay) / Hervé Lewandowski

Gervex met Edouard Manet in 1876, and began to fraternise with the Impressionists and frequent their haunts. He did not, however, fully embrace the ideas of this 'new painting'. Instead, from early on in his career Gervex sought prestige, wealth and recognition by exhibiting at the Salon des Artistes and later the Salon de la Société Nationale des Beaux-Arts. It was here that Gervex exhibited works of titillating mythological and modern day literary themes, as well as being a society portraitist of some note.

The subject of this portrait is Mme Valtesse de La Bigne. She was born in Paris in 1848, under the less salubrious name of Lucia Emilia Delabigne. With her father an alcoholic and her mother a prostitute, she launched her career as an actress. Her first stage appearance was as Hebe in *Orpheus of the Underworld* by Jacques Offenbach. She also became a noted courtesan in French society. In this portrait Gervex portrays her at the height of her beauty.

As well as taking aristocratic lovers who included Prince Lubomirski, Valtesse enjoyed contact with artistic circles of the day, becoming Gervex's mistress for several years. Other liaisons were with Edouard Manet, Gustave Courbet, Eugène Boudin, Edward Detaille and Alphonse de Neuville—leading one wit to nickname her *L'union des peintres*. She also met Emile Zola and proved an inspiration for his novel *Nana*, first published in serial form in *Le Voltaire* in October 1879.

In this portrait Gervex shunned the idealising of form, fine brushwork and sombre colouring that was popular with the Salon. Instead, he borrowed the brighter palette and looser brushwork of the Impressionists. Madame Valtesse is depicted in a garden full of flowers and foliage, which is touched by dappled light and carefully cropped to surround this most fashionable of figures. The costume suggests a date for the subject's dress between 1878 and 1880.[1]

The painting has been dated '1889', but Madame Valtesse would have been in her early 40s in 1889, and the depiction here is of a fresh-faced younger woman. The artist may have originally shown the work ten years earlier, at the Salon of 1879 under the title of 'Mlle V'.[2] He may have dated the work later as 1889, when the painting went on display at the International Exhibition of that year.[3] The earlier dating would accord with the style of the costume, and no doubt Madame Valtesse would have wanted to be seen and portrayed in the most up-to-date styles.

Jane Kinsman

1 Robert Bell, Senior Curator of Decorative Arts and Design, National Gallery of Australia, advised in correspondence with the author, 3 August 2009: 'The afternoon dress worn by the subject has a closely fitted round bodice reaching the hips beneath which a sheath skirt is decorated with tied back ruched draperies and frills, wrapping the legs. This style, fashionable from about 1875, restricted leg movement and was known in French as *la femme ligotée* … Ruching and pleating of the skirt, as in this example, was more pronounced from 1876 to 1880. By 1876 bodice necklines were cut high and straight plain sleeves with large decorated cuffs were worn. Sleeves began to shorten by 1878 … The depiction of these costume details in the painting suggests a date for the subject's dress between 1878 and 1880.'

2 Salon listing for *Peinture*, 12 May 1879, no. 1355, *Henri Gervex 1852–1929*, Paris: Paris-Musées 1992, p. 30.

3 No. 643, listed in *Henri Gervex 1852–1929*, p. 47.

5 Claude Monet
France 1840–1926

In the Norwegian (*En norvégienne*) c.1887
oil on canvas, 98.0 x 131.0 cm
Musée d'Orsay, Paris, bequest of Princess Edmond de Polignac, née Winaretta Singer 1947, RF 1944-20
© RMN (Musée d'Orsay) / Hervé Lewandowski

Monet often used the figures of his stepdaughters in his paintings of a mediated world of nature and leisure. Here Germaine, Suzanne and Blanche Hoschedé are boating in the 'Norwegian', a type of wooden rowing-boat popular in France at the time. The youngest girl is standing up fishing, while her older sisters sit and relax, Blanche also trailing a rod in the river. The obvious artistic suspects can be seen here: Monet had looked at Japanese woodblock prints for their off-centre compositions, unusual viewpoints, and radical cropping. Photography contributed similar aesthetic strategies, especially wide angles of focus, use of reflections and cut-off vistas.

All external references to the world beyond the river are cut off by the composition, as Monet omits the sky and the earth. We look out over the water at the boat filled with girls, but the view of the far bank is limited by bosky undergrowth. Light is contained within the spear of the boat's interior, intensified in Germaine's white dress and hat, echoed in the blue-and-white costumes of the other young women, with warm touches added by yellow from their straw hats and pink flesh. Vertical mooring stakes connect to the pale reflections of three figures in the water, with sunlight filtering through the foliage and playing on the foreground of the river.

One inspiration for the composition of *In the Norwegian* may have been a woodblock print by Utagawa Toyokuni, *Three women in a boat fishing by moonlight* before 1825[1], which was later recorded as part of Monet's collection of Japanese woodblock prints and, according to Virginia Spate, may have been owned by the artist at this time.[2] The relationship between the works is schematic rather than detailed, with three female figures separated along the gentle arc of the simple vessel. More powerful than its unusual composition—most of the vision action is in the top right quadrant—is the choice of palette, and intensity of colouring. Dark greens and purple-blues dominate the canvas and seem to infiltrate the paler tones of the girls' dresses, which light the interior of the boat.

Monet painted the senses, mainly sight, but evoking others such as hearing, scent and touch. Here the murmuring of wind and water is almost tangible. Time, it seems, has slowed down, almost coming to a standstill, as the girls are content to maintain their position while the summer day persists. Human activity projects into the dreaming world of dark water, foliage and shadows, barely interrupting the eternal flow of the river.

Christine Dixon

1 Illustrated in Virginia Spate, *The colour of time: Claude Monet*, London: Thames and Hudson 1992, p. 185.

2 Spate, p. 186.

6 Edgar Degas

France 1834–1917

Dancers climbing the stairs
(*Danseuses montant un escalier*) 1886–90
oil on canvas, 39.0 x 89.5 cm
Musée d'Orsay, Paris, bequest of Count Isaac de Camondo 1911, RF 1979
© RMN (Musée d'Orsay) / Hervé Lewandowski

Almost half of Degas' paintings were devoted to the ballet. However, like many of his canvases, this one does not actually depict a performance on stage. It was the behind-the-scenes subject matter, in this instance a dance class, which truly delighted Degas.

Degas created *Dancers climbing the stairs* in the horizontal format which he adopted for his frieze-like compositions of dancers, horseracing and hunting scenes. The artist began adopting this shape in painting and in drawing from the late 1870s and continued to use it for over twenty years, exploring its multiple variations and permutations.[1]

Here Degas has composed a narrow, shallow corridor which leads the viewer's eye from the left to the right of the composition and up into the open classroom beyond. A central dancer, dressed in a white tutu, steps up the stairs towards a classroom full of dancers practising their technique. A characteristic ploy used by the artist is the cropping of figures to add a sense of movement and vivacity to his dancers. In this work Degas has applied this strategy in a thoroughly radical manner. One young dancer is shown with her back to the viewer and, wearing a pink sash around her waist, is barely half a torso. She turns as if to speak to another dancer who is but a head and a raised hand. This suggests a sense of immediacy, as if the viewer has just walked in on the scene—one which is really of Degas' imagination rather than drawn from life.

The dancers in the far background are silhouetted against the windows of the rehearsal room—a technique called *contre jour*, another favourite device employed by Degas. Within the confines of the background space, Degas has carefully arranged a cluster of ballerinas in a sequence of favourite poses. The space is a vast expanse of empty walls and empty floors, while the strong diagonal line of the larger figures in the foreground emphasises movement. Despite all of these various elements, Degas has achieved a beautifully balanced composition. Unlike some of his early ballet pictures, which are full of the bustle of a busy rehearsal room, the figures in *Dancers climbing the stairs* possess a certain other-worldliness.

This work was sold on 20 August 1888 to the art dealer Durand-Ruel, providing us with the date by which the work was completed.[2] Stylistically, however, it could have been painted a year or two earlier.

Jane Kinsman

1 For example, *The dance lesson* c.1879 and *Before the ballet* 1890–92, National Gallery of Art, Washington D.C.

2 Journal and stock book from Durand-Ruel archives, in Gary Tinterow, 'Chronology III', in Jean Sutherland Boggs, Douglas W. Druick, Henri Loyrette et al., *Degas*, New York: Metropolitan Museum of Art; Ottawa: National Gallery of Canada 1988, p. 389.

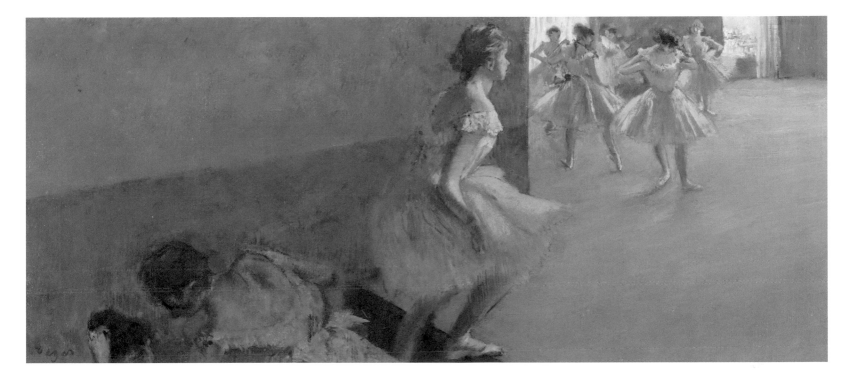

7 Claude Monet

France 1840–1926

Villas at Bordighera
(*Les villas à Bordighera*) 1884
oil on canvas, 115.0 x 130.0 cm

Musée d'Orsay, Paris, purchased with the assistance of the
Fonds du Patrimoine, the Fondation Meyer and funds from
an anonymous Canadian gift 2000, RF 2000-94
© RMN (Musée d'Orsay) / Hervé Lewandowski

The Italian village of Bordighera, a resort filled with gardens and palm trees, became popular in the 1880s as a destination for upper-class English and German travellers. Situated on the Mediterranean coast of Liguria, about twenty kilometres east of the French town of Menton, it attracted Monet and Pierre-Auguste Renoir in 1883 in their search for new, paintable landscapes. Monet returned alone the following year, and painted more than forty views of the area, the town and its gardens. His energy was ferocious; at first he worked on four canvases each day, and between 24 January and 2 February 1884 he completed fourteen.[1]

Monet wanted to paint Mr Moreno's garden in particular, and waited for letters of introduction. He visited on 5 February 1884, and began painting the famous palm trees, interrupted by various excursions around the town and to Monte Carlo. As always, the artist was frustrated by aesthetic and practical difficulties (the blues were difficult, the light changed, it rained). The shimmering golden pinks and blues seemed almost incredible, as Monet wrote to his companion Alice in Giverny:

> Obviously people will exclaim at their untruthfulness, at madness, but too bad—they [also] say that when I paint our own climate. All that I do has the shimmering colours of a brandy flame or of a pigeon's breast, yet even now I do it only timidly. I begin to get it.[2]

Villas at Bordighera is a variant version of another painting. It was made by Monet for his fellow Impressionist artist Berthe Morisot, it seems at the time, as a copy of an identical view, although at twice the size of the first painting.[3] The off-centre composition and radically cropped elements such as trees and buildings point to the ineradicable example of Japanese woodblock prints,

of which Monet was a keen collector. It is interesting how naturally such influences have been absorbed and are no longer an end in themselves. Instead, Monet searches for the southern light, the harsh whites and bright light blues which unify the tamed elements of garden and town with the unconquerable suffused colours of sky and mountains.

The subject of the 'tourist view' was not new in art, as Spate has pointed out—but Monet's approach differs from the Salon's more conventional renditions in 'their resolutely anti-associational character. They do not evoke the past … and do not refer to the inhabitants of the landscape, or its uses. They are, indeed, mute records of places visited, icons of exotic sites … [and are] commodities.'[4] Monet may therefore be the first painter of the avant-garde to bring his famous 'eye' to the business of promoting the safe exoticism of the Mediterranean for the sensory pleasures of modernity.

Christine Dixon

1 Daniel Wildenstein, *Claude Monet: the triumph of Impressionism*, vol. 1, Köln: Taschen; Paris: Wildenstein Institute 1996, p. 195.

2 Quoted in Virginia Spate, *The colour of time: Claude Monet*, London: Thames and Hudson 1992, p. 167.

3 Wildenstein, vol. 2, cat. 856, p. 320.

4 Spate, pp. 166–67.

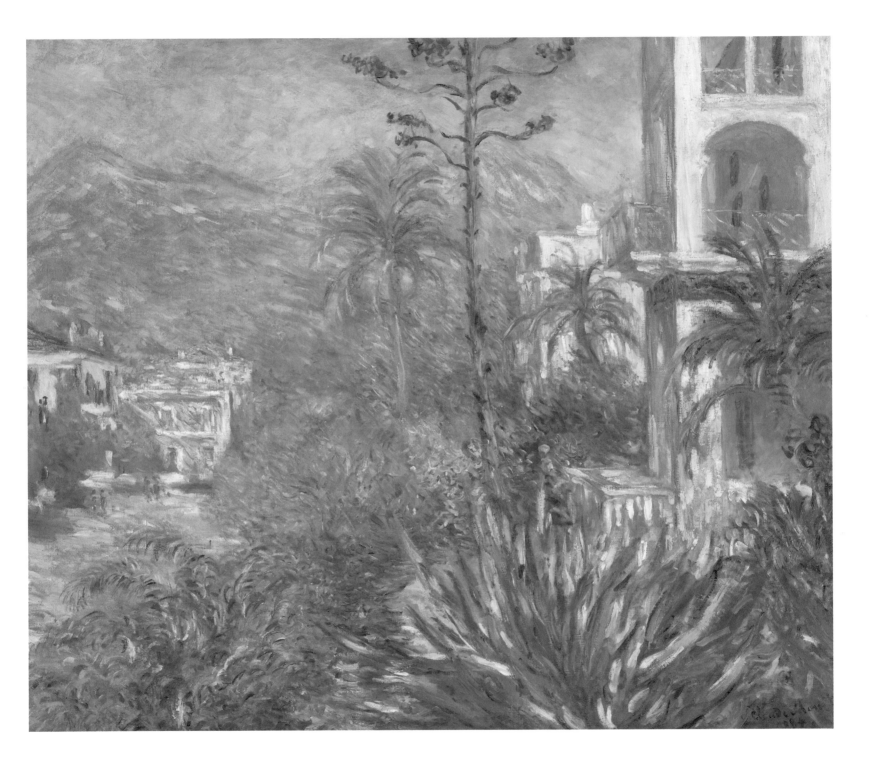

8 Claude Monet

France 1840–1926

Waterlily pond, green harmony
(*Le bassin aux nymphéas, harmonie verte*) 1899
oil on canvas, 89.0 x 93.5 cm
Musée d'Orsay, Paris, bequest of Count Isaac de Camondo 1911,
RF 2004
© RMN (Musée d'Orsay) / Hervé Lewandowski

Aside from painting and gardening, I'm good for nothing.—Claude Monet [1]

Not only did Monet create this painting, he also made everything depicted in it. Monet had settled in Giverny in 1883, with Alice Hoschedé and their large, melded family. By 1890 he had enough funds to buy their home of seven years, and in 1893 he acquired further land, adjacent to the house. Diverting a small stream, Monet began work on the famous pond and magnificent gardens which consumed his attention, providing the main subject for his work, until his death in 1926.

In 1899 Monet painted twelve canvases, mostly square-format, of the pond in different light conditions but from the same vantage point; a further six paintings, in which he shifted his position to include the left side of the bridge, followed in 1900. In these works he celebrates his garden of massed flowering plants, with the water visible through the leaves and flowers, showing reflections of the sky, and of the willows, reeds and other foliage around the pond. This painting is one of those exhibited at Durand-Ruel in November–December 1900. In his review, Gustave Geffroy described

> a minuscule pool where some mysterious corollas blossom … calm immobile, rigid, and deep like a mirror, upon which white water lilies blossom forth, a pool surrounded by soft and hanging greenery which reflects itself in it.[2]

In *Waterlily pond, green harmony*, from his first extended group of paintings of his water garden, Monet compresses the space. He uses the Japanese bridge to anchor his composition but the bridge is truncated so that it no longer links the banks, appearing instead to levitate above the pond.[3] Its arch bisects the canvas, the upper half rendered in an array of greens, grey-blue and pale yellows, while in the lower half he uses a tapestry of pale blues, greens and pinks to convey the waterlilies. The surface of the pond—the horizontal marks and small dabs of the waterlilies and pads interrupted by vertical strokes of greens, yellows and white of the reflections of the vegetation above—seems almost thick enough to walk over. There is only the slightest suggestion of sky, as Monet deftly closes off the background, and all sides of the scene. Along the bottom edge of the canvas, patches of scumbled maroon and violet paint—and a fringe of green grass down the right side—suggest the bank of the pond. In later series Monet foregoes the bridge, banks, and indeed any material context for the pond, in order to concentrate on the surface of the water and the reflections within.

Lucina Ward

1 Maurice Kahn, 'Claude Monet's garden', *Le Temps*, 7 June 1904, quoted in Charles F. Stuckey, *Monet: a retrospective*, Sydney: Bay Books 1985, p. 245.

2 Gustave Geffroy, *Le Journal*, 26 November 1900, quoted in Steven Z. Levine, *Monet, Narcissus and self-reflection: the modernist myth of self*, Chicago: Art Institute of Chicago 1994, p. 194.

3 Paul Hayes Tucker, *Claude Monet: life and art*, New Haven: Yale University Press 1995, p. 181.

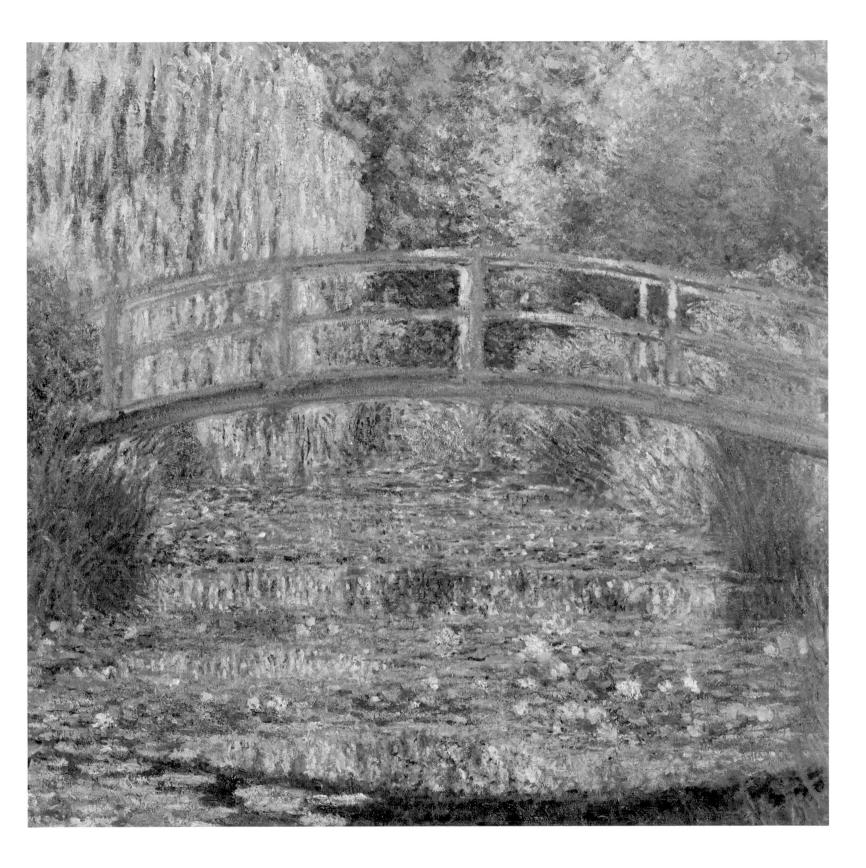

9 Alfred Sisley

France 1839–1899

Moret Bridge (*Le pont de Moret*) 1893
oil on canvas, 73.5 x 92.5 cm

Musée d'Orsay, Paris, bequest of Enriqueta Alsop
in the name of Eduardo Mollard 1972, RF 1972-35
© RMN (Musée d'Orsay) / Hervé Lewandowski

In Sisley's time the towns of the Seine-et-Marne region were busy with local commerce: barges on the canal, a flour and tanning mill at Moret, boat-yards around Saint-Mammès, orchards, gardens and farms at Les Sablons. Sisley visited the area late in 1879, looking for an inexpensive place to live, and came to know it intimately. Veneux-Nadon, seventy-five kilometres from Paris, was his home from 1880; then he lived at Moret, and Les Sablons for six years, before returning to Moret in 1889. Tobias Smollett described Moret-sur-Loing as a 'very paltry' place but nineteenth-century guidebooks enthuse over its 'commanding position on the Loing, its ramparts and gateway, its huge ruined donjon and the beauties of its Gothic church'. [1]

Bridges were a favoured subject and compositional device for Sisley and the Pont de Moret provided the impetus for many works. He produced his first views of it in autumn 1887 and spring 1888, while based at Les Sablons, and several dramatic compositions show the bridge and mill under snow in 1890. [2] He varied his views of Moret, often centring his compositions on the mill with the church of Notre-Dame behind it, and showing the other span of the bridge leading into the town through the Porte de Bourgogne. In 1891 he painted further down the Loing River, from either bank, showing the townscape framed by, or through, a row of poplars. The following year he varied his motif through a sequence depicting the same locations in the morning light and at sunset. Sisley seemed unable to resist scenes in which there was water to offer reflections, and riverbanks for constantly changing activities. [3]

By the time Sisley painted this canvas, he had clearly absorbed the elements of the surrounding landscape, exploited through a highly coloured, densely structured composition of sky and clouds, bricks and mortar, water and reflections. He has positioned himself closer to the bridge, providing a dramatic lead-in to the work as it sweeps from lower-left of the canvas to the mill at centre. The picture plane is neatly bisected, the upper section of sky punctuated by the partially obscured church tower, mill and poplars. Sisley's landscapes are rarely peopled, at least not in the overt way of his contemporaries. Rather than portraying promenading couples or boating parties, the people in Sisley's paintings are presented as part of their surrounds, incidental in both purpose and scale. The figures in *Moret Bridge* merge into the scene as naturally as the clouds in the sky, or the reflections in the water below.

Lucina Ward

1 Richard Shone, *Sisley*, London: Phaidon Press 1999, p. 159.

2 François Daulte, *Alfred Sisley: catalogue raisonné de l'oeuvre peint*, Lausanne: Durand-Ruel 1959.

3 Shone, pp. 51 and 144.

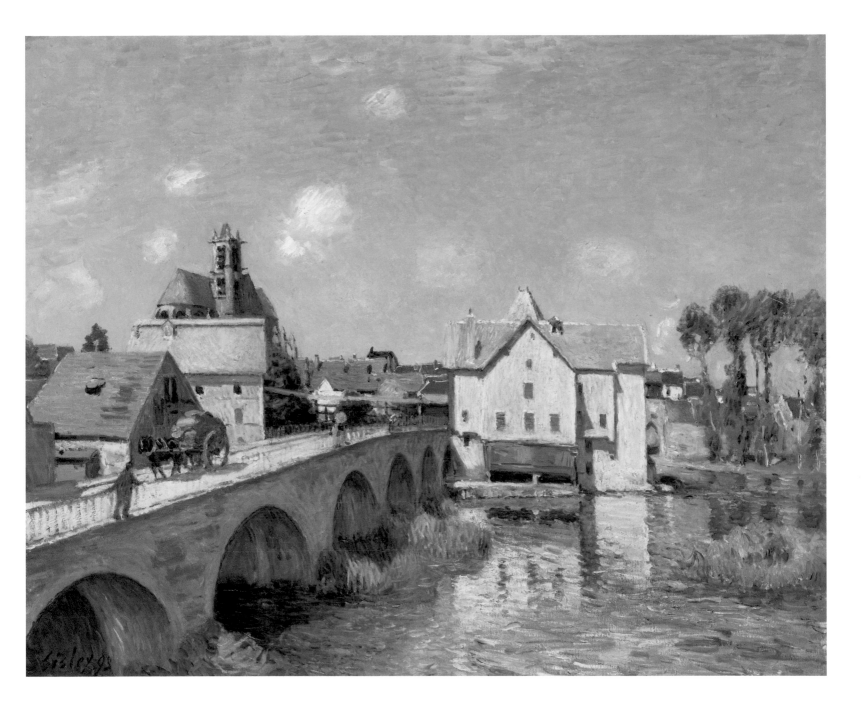

10 Camille Pissarro

St Thomas, West Indies 1830 – France 1903

Pont Boïeldieu, Rouen, sunset, misty weather
(*Le pont Boïeldieu à Rouen, soleil couchant,*
temps brumeux) 1896
oil on canvas, 54.0 x 65.0 cm

Musée des Beaux-Arts, Rouen, on long-term loan from the
Musée d'Orsay, Paris, accepted in lieu of tax 1983, RF 1983-7
© RMN (Musée d'Orsay) / Hervé Lewandowski

Pissarro stayed at the Hôtel de Paris in Rouen from
20 January to 29 March 1896. From his studio on
the third floor he painted different views of the Pont
Boïeldieu over the Seine: at sunset, on an overcast day,
in the fog. The bridge joined the old Gothic city in
the north with the new southern industrial areas of
Sainte-Sever. On the far bank we see boats docking
and unloading cargo, with the urban landscape in the
distance. Pissarro captures the transitive effects of the
mist and smoke, a sense of fugitive movement in the
city's activity. He was attracted to Rouen, describing
it as having terrific character and being just as beautiful
as Venice.[1] Indeed, this juxtaposition between old and
new is part of what makes Pissarro's urban paintings
so intriguing.

A great admirer of Monet's Rouen Cathedral series,
Pissarro painted several views of the quays in Rouen in
1883.[2] From October to November, he worked *en plein
air*, in the streets and around the harbour. However in
1893, following treatment on an eye, his doctor warned
him not to expose himself to dusty conditions. By
working from the window of his hotel room, Pissarro
found a lasting solution to the problem of capturing
the hustle and bustle of the city, its linear and aerial
perspectives, without the impracticalities of installing
oneself in the street. In *Pont Boïeldieu, Rouen, sunset,
misty weather* the tilt of the bridge, as well as its sweeping
angle across the canvas, allow him to make the most of
presenting the busy pedestrian and carriage traffic.

This was one of eleven Rouen paintings exhibited at
Durand-Ruel's gallery in Paris in April–May 1896. The
exhibition was well received: several critics described the
Rouen works as some of his best to date. The works sold,

thus providing the artist with some financial security
at long last. Buoyed by this success, Pissarro returned
to Rouen in September 1896—this time to the Hôtel
d'Angleterre on the other side of the bridge, where his
fifth-floor room offered panoramas of the city's three
bridges. In 1898 he travelled to Rouen for the fourth
time, painting more views of the bridges, as well as
of the Gare d'Orléans and the Quai de la Bourse. His
forty-seven views of Rouen vastly exceed the numbers
of any other series he painted and ensure that cityscapes
dominate his oeuvre.[3]

Lucina Ward

1 Letter to Lucien Pissarro, Rouen, 2 October 1896, letter 1306,
Janine Bailly-Herzberg (ed.), *Correspondance de Camille Pissarro*, vol. 4,
1895–1898, Paris: Presses universitaires de France 1989, p. 266, quoted
in Richard R. Brettell and Joachim Pissarro, *The Impressionist and the
city: Pissarro's series paintings*, New Haven: Yale University Press 192, p. 6.

2 Joachim Pissarro and Claire Durand-Ruel Snollaerts, *Pissarro: critical
catalogue of paintings*, Paris: Wildenstein Institute Publications; Milano:
Skira 2005.

3 The spectacular combination of atmospheric sky, solidity of the stone
bridge, and mirror-like river in Pissarro's Rouen works did not,
however, impress all of his clients. One of the bridges, painted during
the 1896 campaign, was the subject of a letter to the artist from the
then owner, Edmond Decap: 'I have the pleasure to inform you that
I own your two beautiful paintings of Rouen, *Morning effect, Pont
Corneille* and *Evening effect, Pont Boïeldieu*. There is a small error in the
latter, which I allow myself to call to your attention: the bridge's first
pier is not straight. Everyone who has seen the painting has noticed
this defect. Would you rather correct it in Paris or shall I send it to
Eragny.' It is not known whether Pissarro responded; if so, his reply
has not been preserved. In any case, the pier of the bridge remains
'crooked'. (The first work is in a private collection, and the second at
the Birmingham Museum and Gallery, Birmingham; see Pissarro and
Durand-Ruel Snollaerts, vol. 3, cats 1117 and 1125, pp. 706 and 710.)

11 Claude Monet

France 1840–1926

London, Parliament: sun through the fog
(*Londres, le Parlement: trouée de soleil dans le brouillard*) 1904
oil on canvas, 81.0 x 92.0 cm

Musée d'Orsay, Paris, bequest of Count Isaac de Camondo 1911, RF 2007
© Musée d'Orsay, Dist RMN / Patrice Schmidt

The evening mist clothes the riverside world with poetry, as with a veil, and the poor buildings lose themselves in the dim sky, and the tall chimneys become campanili, and the warehouses are palaces in the night, and the whole city hangs in the heavens …—James Abbott McNeill Whistler[1]

Early in 1871 Monet, with his friend Pissarro, went to London, taking in not only the city itself, but its major museums, seeing the works of J.M.W. Turner and John Constable for the first time. In 1872–73, Monet painted his famous *Impression, sunrise*[2] depicting Le Havre, a work which named (if it didn't actually declare) the revolution in art that we now know as Impressionism, featuring in the first 'Impressionist' exhibition of 1874. The work reproduced here—*London, Parliament: sun through the fog*—painted thirty years later, recalls this early, prototypical Impressionist painting, and extends Monet's ongoing meditation on the effect of light on a landscape.

Monet returned to London in the autumn of 1899. By this time he had completed many of his famous series of works: the Rouen Cathedral and haystacks series; and he had begun working on his great waterlily paintings. Seriality represented for him not only a continuing meditation on the effect of light on a particular subject, but a continuing meditation on the materiality of paint itself. His series of paintings, and particularly those devoted to London's Houses of Parliament, many of which represent the acme of his oeuvre, highlight his lifelong obsession with the effect on the human eye of the physical substance we call paint. While this painting and the series of paintings to which it belongs are based on his 1899 stay in London, it was only in 1903 that he recommenced working on them—painting this time not from nature, as was his wont, but, significantly, from memory. In 1904, thirty-seven of these 'Views of London' were shown at Durand-Ruel's now famous May exhibition in Paris. The Symbolist poet and art historian Gustave Kahn observed:

In one of these sunsets, the star is a visible, heavy disk from which emanates the most subtle variations of colour; elsewhere, it spreads like brimstone, like the sulfurated smoke over Gomorrah, in clouds of violet, crimson, purple, and orange, and its reflections lap on a heavy water of rose, blue, green, with mica glints of rose everywhere bloodied with points of red. The sun breaches the fog, illuminating melded flakes of air and water…[3]

London, Parliament: sun through the fog is without doubt one of Monet's greatest hymns to the capacity which paint has to represent our world, and is one of the truly great paintings of the twentieth century.

Mark Henshaw

1 James Abbott McNeill Whistler, 'The ten o'clock lecture', 1885, quoted in Charles F. Stuckey, *Monet: a retrospective*, Sydney: Bay Books 1985, p. 229.

2 Musée Marmottan Monet, Paris.

3 Quoted in Stuckey, p. 227.

Neo-Impressionism

Charles Angrand

Henri-Edmond Cross

Georges Lemmen

Maximillien Luce

Camille Pissarro

Georges Seurat

Paul Signac

Théo van Rysselberghe

12 Georges Seurat

France 1859–1891

Study for 'Bathers at Asnières'
(*Etude pour 'Une baignade à Asnières'*) 1883
oil on wood panel, 15.5 x 25.0 cm

Musée d'Orsay, Paris, gift of Baroness Eva Gebhard-Gourgaud
1965, RF 1965-13
© RMN (Musée d'Orsay) / Hervé Lewandowski

Bathers at Asnières 1884[1] was Seurat's first large canvas. This panel is one of fourteen painted studies and ten drawings which definitely relate to the final canvas; there are several others that have figurative or landscape connections as well.

This study presents a scene of the banks of the Seine at Asnières, a suburb on the edge of Paris, with the factories of Clichy in the background. It is a cropped version of the final composition, with several of the main figures not yet rendered—here the russet-coloured spaniel is reduced to just a head poking in at one corner.

The final version of *Bathers* has five figures sitting on the bank, two in the water and two piles of clothes. Here Seurat has included a simplified version of one of these piles, the seated man in white, and a crouching figure in the water (although his hair becomes an orange hat in the final version). The second naked boy in the water stands in the pictorial space eventually occupied by the final work's largest sitting figure. The general outline of the bridge, buildings and factories appear in the background, similar to the final version, although here they are simply blocked in with broad brushstrokes.

Seurat spent much of his early years painting workers. Initially he planned to do the same in *Bathers*, depicting horses being bathed in the river by stable boys. The landscape was actually a designated 'bathing area' for animals as well as humans—as indicated by the French title, '*Une baignade*'. The large section of yellow clay in the centre of denotes where the horses would have been led to the water.

In this study, the suggestion of labour was replaced by a scene of pure leisure, featuring just human figures. The working- or lower-middle class shown relaxing on the bank have no direct reference to the industry behind them. However, their leisure is not as indulgent as the pastimes presented by the Impressionists.

Completed before Seurat's discovery of Divisionism, here there are three distinct types of brushstrokes.[2] The foreground uses a criss-cross technique to build up the illusion of texture on the grass and bank. For the water, Seurat uses broad horizontal brushstrokes. Irregular daubs of paint make up the sky, characteristic of softer Impressionist textures, with the colours blending into one another. The techniques used in this study mirror those used in the final work; but in the latter they are much tighter and more precisely applied.

Simeran Maxwell

1 National Gallery, London.
2 Seurat retouched the final canvas of *Bathers* in 1887 and added areas of dots, especially the orange hat of one of the bathers in the water.

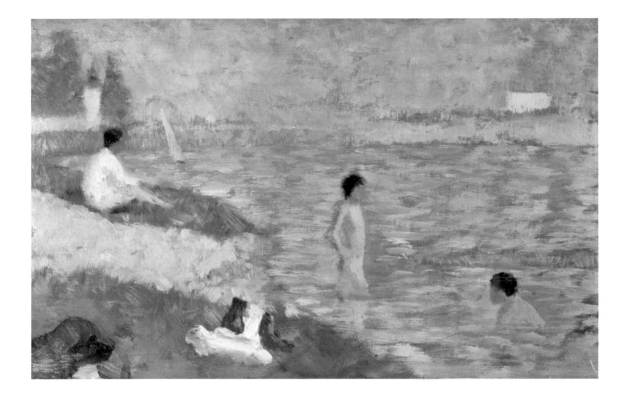

13 Georges Seurat (above)
France 1859–1891

Study for 'A Sunday afternoon on the island of La Grande Jatte' (Etude pour 'Un dimanche après-midi à l'Ile de la Grande Jatte') 1884
oil on wood panel, 15.5 x 25.0 cm

Musée d'Orsay, Paris, gift of Thérèse and Georges-Henri Rivière in memory of their parents 1948, RF 1948-1
© RMN (Musée d'Orsay) / Hervé Lewandowski

14 Georges Seurat (below)
France 1859–1891

Study for 'A Sunday afternoon on the island of La Grande Jatte' (Etude pour 'Un dimanche après-midi à l'Ile de la Grande Jatte') 1884–86
oil on wood panel, 16.0 x 25.0 cm

Musée d'Orsay, Paris, anonymous gift 1930, RF 2828
© RMN (Musée d'Orsay) / Hervé Lewandowski

Before he embarked on creating *A Sunday afternoon on the island of La Grande Jatte* 1886[1], Seurat saw Puvis de Chavannes' *The sacred grove, beloved of the arts and Muses* 1884[2] at the Paris Salon. Set on the banks of an Arcadian stream, the deliberately ordered figures, the intense stillness and the monumental size, all sparked the young artist's interest.[3] Two years later, Seurat's contemporary version was exhibited at the 1886 Impressionist exhibition.

Seurat had made his largest number of preparatory drawings and sketches for this work. His approach was painstaking. He subdivided the composition, classifying it according to its elements. He then started the synthesising process, revising and joining the parts together. With not only immense skill, but an enormous amount of patience, Seurat slowly assembled the composition piece by piece.

The surprising variation we see between these two studies is due in part to Seurat's newfound interest in the effects of different hues, and in divided colour theory. Seurat also experimented with different paint application processes, using a wider brushstroke in these studies than the fine brush points used in the final work. He also tested diagonal brushstrokes, before rejecting them in favour of dots.

In these two studies, differences in the figures' poses, combined with a deep perspective, create considerable vertical movement. Seurat was extremely precise and methodical, ensuring no haphazard placement of figures in the relationship to landscape or to each other. For the most part the landscape remained fixed, and served as a stage for testing figurative combinations. His early panels show tiny figures enveloped by the landscape, whereas these two later studies have larger characters with a sense of their final positioning and authority.

Seurat spent six months sketching on La Grande Jatte, observing it under various light and seasonal conditions, and eventually opting for summer. Nature could never provide Seurat with precisely what he envisioned. Instead, it furnished him with snippets of visual information, which he selected and adapted. Angrand described Seurat's approach: 'He wasn't a slave to nature, certainly not, but he was respectful of it.'[4]

Known as *croquetons*—literally 'sketchettes'—Seurat's studies were all made on small wooden panels. Extraordinarily proud of them, he hung many in his studio. He also exhibited them regularly, demonstrating the significance he felt they had in his oeuvre. Seurat called the panels his 'constant joy'.[5]

Simeran Maxwell

1 The Art Institute of Chicago, Chicago.
2 460 x 1040 cm, Musée des Beaux-arts, Lyons.
3 Richard R. Brettell, *French Salon artists: 1800–1900*, Chicago: Art Institute of Chicago; New York: Harry N. Abrams 1987, p. 113.
4 Quoted in Daniel Catton Rich, *Seurat and the evolution of 'La Grand Jatte'*, New York: Greenwood Press 1969, p. 10.
5 Quoted in Rich, p. 17.

15 Georges Seurat

France 1859–1891

The little peasant in blue (The jockey)
(*Le petit paysan en bleu (Le jockey)*) c. 1882
oil on canvas, 46.0 x 38.0 cm
Musée d'Orsay, Paris, gift of Robert Schmit 1982, RF 1982-54
© RMN (Musée d'Orsay) / Hervé Lewandowski

Towards the end of the summer of 1881, Seurat stayed at the small village of Pontaubert in Burgundy with his friend Edmond Aman-Jean. According to the art critic Félix Fénéon, who owned this painting, the subject of the canvas is a young boy from the region.[1] It was likely that Seurat returned to Paris with the painting and completed it the following year. Seurat and Aman-Jean had met while studying at the atelier Henri Lehmann—a prerequisite to their enrolling at the Ecole des Beaux-Arts. Both had suffered under the 'iron rule' of Lehmann. Emphasis on line and drawing was the hallmark of Lehmann's teaching, while colour was considered an ornament. Because of their rigid and backward-looking studies, Seurat sought inspiration elsewhere.

The work has been known as both *The little peasant in blue* and *The jockey*.[2] The influence of the Barbizon master Jean-François Millet was particularly notable in Seurat's art of the early 1880s. Millet had depicted peasants working in the fields; herding animals, reaping crops, and had also portrayed workers breaking stones. Seurat followed suit. This painting, unlike many of Seurat's scenes of peasants, does not show the young boy actively toiling in the fields. Instead, the small figure simply stares out at the viewer, devoid of character, his features reduced to the essentials. Supporting the alternate suggestion that the subject is a jockey, the youth is dressed in a blue coat with a white high collar, which could be racing silks; and he could be wearing a jockey's cap.

In April 1879, along with his friends Ernest Laurent and Aman-Jean, Seurat visited the fourth Impressionist exhibition at 28 Avenue de l'Opera. The art students experienced an 'unexpected and profound shock' in response to the work they encountered, ultimately

leading to the abandonment of their studies with Lehmann.[3] The exhibition effected Seurat's development in the early 1880s in terms of his brushwork, adoption of colour and subject matter.

While there is an emphasis on the silhouette for his figure, Seurat has adopted a palette of blues, green, flesh-pinks and browns, applied with cross-strokes of the brush. This criss-cross brushwork, which Seurat termed 'broom swept' (*balayé*), suggests the influence which the New Painting methods of Impressionism had on the young Seurat, and which would lead him in new directions for the remainder of his short life.

Jane Kinsman

1 Robert L. Herbert, Françoise Cachin, Anne Distel et al., *Georges Seurat, 1859–1891*, New York: Metropolitan Museum of Art 1991, cat. 80, pp. 115–16.

2 The catalogue raisonné for Seurat' paintings, C.M. de Hauke, *Seurat et son oeuvre*, Paris: Gründ 1961, vol. 1, cat. 16, p. 10, lists the work as follows, *Le petit paysan en bleu*. Hermann Jedding in *Seurat*, Milan: Uffici Press c. 1950, p. 10 gives the title as *Le jockey*.

3 In that exhibition, Degas had works on his modern-day theme of a race course. Léon Rosenthal, 'Ernest Laurent', *Art et décoration*, vol. 29, 1911, p. 66. The Impressionists were described as 'nevrosés' ('loopy'), while the effect on the young art students was 'un choc inattendu et profond'; see also William Innes Homer, *Seurat and the science of painting*, Cambridge, Mass.: The MIT Press 1978, pp. 51–4.

16 Georges Seurat

France 1859–1891

Landscape with 'The poor fisherman' by Puvis de Chavannes
(*Paysage avec 'Le pauvre pêcheur' de Puvis de Chavannes*) c. 1881
oil on wood panel, 17.5 x 26.5 cm

Musée d'Orsay, Paris, purchased with assistance from
Fondation Meyer 2002, RF 2002-29
© RMN (Musée d'Orsay) / Hervé Lewandowski

This early Seurat work was surely never intended to leave the artist's studio. Hastily executed, on two separate dates, it shows an oil sketch of Puvis de Chavannes' *The poor fisherman* (cat. 85) painted over the top of a landscape study. Yet on this small piece of parquet panel we are given a sense of Seurat's early artistic leanings. *The poor fisherman* was shown at the Salon de la Société des Artistes Français in 1881. Seurat, like many young artists, was struck by the painting—so much so that he sacrificed an earlier work to record his impression of it.[1] A rough sketch at best, in the painting underneath we can nevertheless detect the influence of the Impressionists, who prefigured Seurat's development of the Pointillist technique.

The little landscape was painted *en plein air* at St Ouen around 1879. (The other side of the panel, which was detached in 1951, showed a similar landscape.) In this work, using short, sharp brushstrokes, Seurat depicts a distant cottage seen over a body of glistening water. A flowering tree is captured with dabs of pink against a deep green at the centre of the image; in the foreground a suggestion of foliage is rendered in taupe and dark blue-green. The blue of the sky is interrupted by wisps of grey which may represent cloud, smoke, or nothing but a simple experiment with colour mixing by a young artist.

Seurat returned to this sketch in 1881, and painted a copy of *The poor fisherman*, which he had no doubt recently seen at the Salon, over the right hand side. In his rendition of the work Seurat focused on the elongated figure of the fisherman, and especially on the flat colour planes and the gentle curve in the landscape created by the riverbanks. The influence of these undulating compositional lines, the broad expanses of colour and the large-scale format of *The poor fisherman*, can be seen in Seurat's subsequent iconic work, *Bathers at Asnières*[2], completed three years later in 1884.[3]

On the lower right of the panel, Seurat inscribed: 'Hommage à Pierre Puvisse [sic] de Chavannes'. The misspelling of the name has often been read as a joke at Puvis' expense[4], however, given the influence that Puvis' work had on Seurat—he was bitterly disappointed when Puvis toured the 1891 Salon des Indépendants exhibition without so much as a pause in front of his *The circus*, 1891[5]—and the high esteem in which he was held by the young avant-gardes, it was more than likely an honest mistake.

Emilie Owens

1 It is worth noting that Aristide Maillol also made a copy of Puvis de Chavannes' painting. Maillol's was a direct, but slightly smaller, copy and is also in the collection of the Musée d'Orsay, Paris.

2 National Gallery, London.

3 For a more detailed discussion of this influence see Michael F. Zimmerman, *Seurat and the art theory of his time*, Antwerp: Fonds Mercator 1991, p. 149.

4 Robert L. Herbert, Françoise Cachin, Anne Distel et al., *Seurat, 1859–1891*, New York: Metropolitan Museum of Art 1991, p. 109.

5 R.H. Wilenski, *Modern French painters*, London: Faber and Faber 1963, p. 106. *The circus* is in the collection of the Musée d'Orsay, Paris

17 Georges Seurat

France 1859–1891

Model standing, facing the front or *Study for
'Models'* (*Poseuse debout, de face* ou *Etude pour
'Les poseuses'*) 1886
oil on wood panel, 26.0 x 15.7 cm

Musée d'Orsay, Paris, conditional gift of Philippe Meyer 2000,
RF 2000-23
© RMN (Musée d'Orsay) / Michèle Bellot

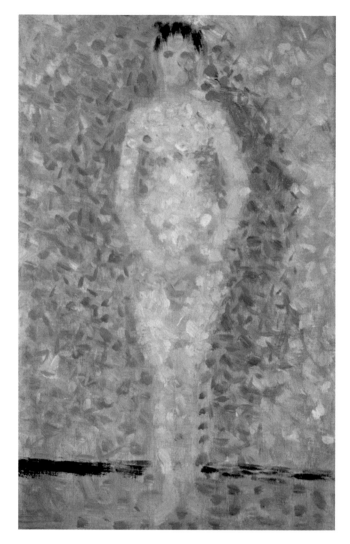

These works are two of four studies for Seurat's
large canvas *Models* 1887–88.[1] Two more studies can
be seen in cats 19 and 20. The studies are painted
on the familiar small panels the artist used to order
his preliminary thoughts on elements of his large
compositions.

In the two versions of a model seen from the front,
the artist debates her very simple pose. In the looser,
presumably earlier study (cat. 17), the woman's knees and
ankles are pressed together. The effect is a static, almost
spinning figure, like a prehistoric figurine. In the next
version (cat. 18), she tilts her head slightly, and places her
weight on the back leg, advancing the other into the
viewer's space. Immediately the pose is more dynamic.

The paint marks in the two studies could not differ more:
the *Model standing, facing the front* is defined by broader,
larger opposing dashes, outlined in pale orange lines,
and given a conventional shadow. *Model from the front*
is more refined and fully realised as a study for the
final canvas; it was even signed. The model stands
in a volumetric space, herself modelled by light and
dark. Unusually, we can see the line drawing outlining
her figure, particularly around the legs. She casts the
suggestion of a shadow, which dematerialises against the
wall. Seurat strongly marked the division between floor
and wall, adding another angle to the composition. He
also painted a stripe at the left and top borders, and then
his characteristic painted internal frame which reprises
his chromatic arguments in contrasting hues.

18 Georges Seurat

France 1859–1891

Model from the front (Poseuse de face) 1887
oil on wood panel, 25.0 x 16.0 cm

Musée d'Orsay, Paris, purchased ex Félix Fénéon collection
1947, RF 1947-13
© RMN (Musée d'Orsay) / Hervé Lewandowski

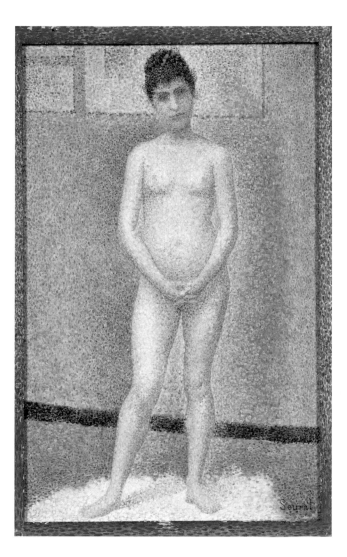

The final version of *Models* (see p. 61) contains three
nude figures, with the same female model portrayed at
left from the back, standing centrally, and on the right in
profile. Set in the artist's studio, the three figures represent
a modern-day Three Graces. They are re-embodied by
a pale, slim Parisian girl, Madeleine Knoblock, who was
Seurat's lover and later the mother of his children. In the
painting, dominating the left side wall of the studio, and
taking up about a third of the canvas, is the right half of
his gigantic masterpiece, *A Sunday afternoon on the island
of La Grande Jatte* 1886[2] (p. 35).

Christine Dixon

1 The Barnes Foundation, Merion, Pennsylvania.
2 The Art Institute of Chicago, Chicago.

19 Georges Seurat

France 1859–1891

Model from the back (*Poseuse de dos*) 1887
oil on wood panel, 24.5 x 15.5 cm

Musée d'Orsay, Paris, purchased ex Félix Fénéon collection 1947,
RF 1947-15
© RMN (Musée d'Orsay) / René-Gabriel Ojéda

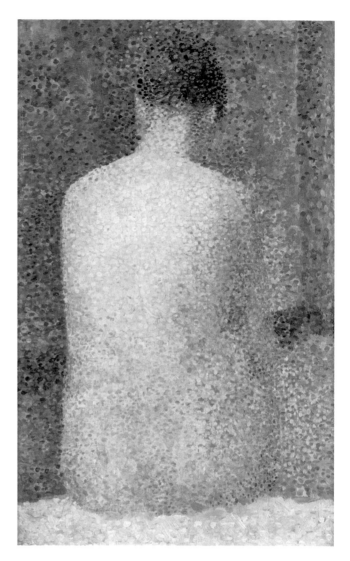

Seurat was a cultivated person, widely read and with an excellent knowledge of the art of the past. His studies in the Musée du Louvre, Paris, included examining the culture of ancient Egypt, and classical Greek and Roman sculpture. *Model in profile*, for example, reworks the well-known Greco-Roman bronze, *The thorn-puller* or *Spinario*. Seurat knew the sixteenth-century copy held in the Louvre. Here the model is preparing for work, or has finished posing, as she doffs or draws on her green stockings. The model seen from the back seems to be resting, while the standing model (cats 17 and 18) poses quietly, at work.

Model from the back is one of the most satisfying of Seurat's realisations of his aesthetic theories. The woman's pale skin is rendered in pink, and modelled with contrasting dots of blues and orange. She sits on a barely executed white sheet, while the darker background is reversed in blue, orange, red, yellow and white. Instead of a doctrinaire display of complementary colour theory, the artist observes in minute detail the slow fall of light on curved living flesh. Seurat acknowledges Jean-Auguste-Dominique Ingres' painting of an odalisque in back view, *Odalisque* or *Large odalisque* 1814.[1] Ingres' nude turns towards us, as though inviting viewers into her secret world, while Seurat's model sits closed and mute.

20 Georges Seurat

France 1859–1891

Model in profile (Poseuse de profil) 1887
oil on wood panel, 25.0 x 16.0 cm

Musée d'Orsay, Paris, purchased ex Félix Fénéon collection 1947,
RF 1947-14
© RMN (Musée d'Orsay) / René-Gabriel Ojéda

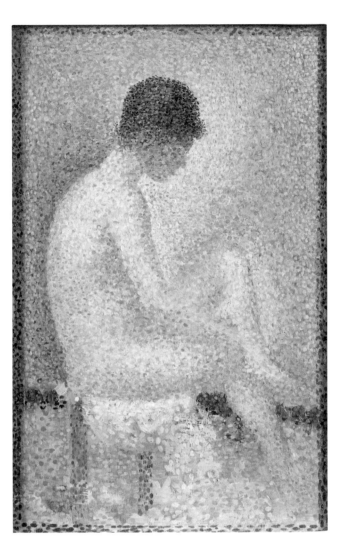

In *Model in profile*, the artist studies another problem, that
of a light figure on a light ground. He intensifies light
tones on the curves of back, arm, right thigh and left leg,
while lightening the silhouette around the head and front
of the body and left knee and shin. The brush marks
differ in size and shape, and impart liveliness by their
changes in direction.

Christine Dixon

1 Musée du Louvre, Paris.

21 Georges Seurat

France 1859–1891

Port-en-Bessin at high tide
(*Port-en-Bessin, avant-port, marée haute*) 1888
oil on canvas, 67.0 x 82.0 cm

Musée d'Orsay, Paris, purchased with funds from a Canadian
anonymous gift 1952, RF 1952-1
© RMN (Musée d'Orsay) / Hervé Lewandowski

Seurat 'washed his eyes' during his regular summer trips
to the Normandy coast. In 1888 he travelled to the
fishing village of Port-en-Bessin. Whereas in previous
years he had trekked long distances to find suitable
motifs to refresh his creative vision, at Port-en-Bessin
he made an 'inventory' of the harbour, plotting it from
different angles.[1] This painting is, in effect, the centre
of Seurat's inventory, looking east, down into the port.
Two other versions look west up to the cliffs, and out
from the coast, while three others feature locations
within the harbour itself.[2] These are some of Seurat's
most marvellously constructed works, in which he
delights in the asymmetrical, enclosed and interlocking
forms of the sails, quays, cliffs and surrounding vegetation.

In *Port-en-Bessin at high tide*, the main part of the canvas
is the sea—fringed by the cliffs and coastal grasses—and
sky. The straight lines of the horizon, the eastern arm
of the breakwater and the quay are interrupted by
masts with their billowing sails, and the flag poles in
the port. The curves of the sails are mimicked by the
untidy stalks of grass along the edge of the cliff. Angular
buildings, rendered in mottled white and greyish
lavender, contrast with the undulating diagonals of the
geological features. A wisp of smoke snakes up from
a chimney at the extreme right; mirrored by the road
which winds up the far cliff, a frequent device in
Seurat's work. The subtle geometry and sparkling late
morning light modulate the abandoned, melancholy
impression of this place seemingly emptied of any
human presence. There are echoes, too, of earlier
compositions: the negative space of the harbour in this
work, if we were to rotate the canvas, is the same shape as

Le Bec du Hoc, Grandcamp 1885 (p. 38), about twenty
kilometres further west along the coast, and the site of
Seurat's first summer campaign.[3]

From a distance, this painting is ostensibly naturalistic
but on closer inspection it is encrusted with thousands
of tiny painted dots organised in complementary pairs.
Seurat creates this effect through a series of layered
'scrims' of paint; the water is a subtle combination of
yellows, greens and blues on a white ground. For the
grassy cliffs, Seurat has overlaid touches of blue, orange
and pink on top of broader strokes of yellow-green to
create the dominant tone. The greater range of hues in
the foreground make us more conscious of the separate
colours.[4] Seurat uses red and blue to build the painted
border of the painting, and then continues the dots onto
the actual picture frame, breaking down the traditional
demarcation between the painting and the wall on which
it is displayed.

Lucina Ward

1 John Russell, *Seurat*, London: Thames and Hudson 1991, p. 222.

2 *Port-en-Bessin, the semaphore and the cliffs* 1888, National Gallery of Art,
 Washington D.C.; *Port-en-Bessin: entrance to the outer harbour* 1888, The
 Museum of Modern Art, New York; *Port-en-Bessin: the outer harbour*
 (*low tide*) 1888, Saint Louis Art Museum, Saint Louis; *Port-en-Bessin,
 the bridge and the quays* 1888, The Minneapolis Institute of Arts,
 Minneapolis; *Sunday, Port-en-Bessin* 1888, Kröller-Müller Museum,
 Otterlo.

3 The National Gallery of Australia, Canberra, holds a study for *Le Bec
 du Hoc* 1885; the final painting is in the Tate Collection, London.

4 Robert L. Herbert, *Seurat: drawings and paintings*, New Haven: Yale
 University Press 2001, p. 129.

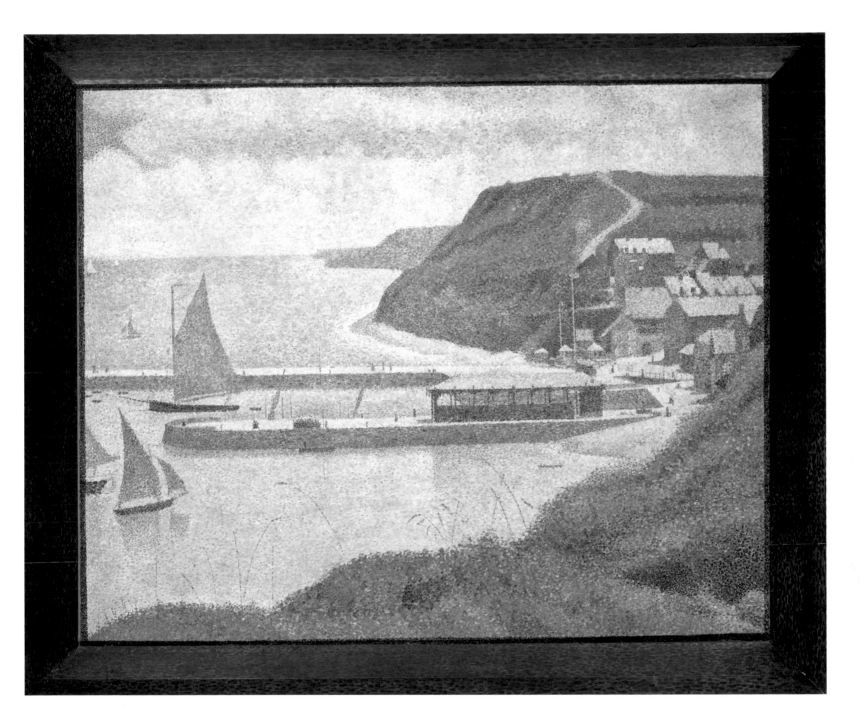

22 Paul Signac

France 1863–1935

Les Andelys (The riverbank)
(*Les Andelys (La berge)*) 1886
oil on canvas, 65.0 x 81.0 cm
Musée d'Orsay, Paris, accepted in lieu of tax 1996, RF 1996-6
© RMN (Musée d'Orsay) / Hervé Lewandowski

Signac entered eighteen works in the eighth and final Impressionist exhibition in May–June 1886, set alongside works by Pissarro and Seurat. Inspired by new ideas in colour theory, these three artists expressed a new interest in the optical mixing of colour, rather than the mixing of colour on the palette. The critic Félix Fénéon was a principal advocate for the art that ventured beyond Impressionism—an art which came to be known as Neo-Impressionism (he actually coined the term '*néo-impressioniste*' in an article published in *L'Art moderne* de *Bruxelles* on 19 September 1886).[1] In his writings, Fénéon criticised the earlier Impressionist artists because their work 'had an appearance of improvisation; their landscapes were views of nature seen at a glance, as if a shutter had been quickly opened and closed; it was hasty and approximate'.[2] It was his view that the Impressionists had 'a propensity for making nature grimace … to prove that the moment was unique and would never be seen again'.[3] In comparison, the art of the 'new' Impressionists possessed a 'distance from the accidental and the transitory'.[4]

From June to September of 1886 Signac lived in the small medieval town of Les Andelys, west of Paris near Giverny, where the Seine flowed through the Normandy countryside to the sea. He delighted in the light, the vibrant colours of the location and its forms—the buildings of the township, the river and its banks, the nearby Château Gaillard and the surrounding farmland. Over the summer months Signac was to paint ten canvases at Les Andelys, using the new method of applying small brushstrokes of unmixed colour. Four of the earliest of these paintings were shown in Paris at the Salon de la Société des Artistes Indépendants in 1887, and Fénéon praised them for their luminosity and their completeness: 'the colours provoke each other to mad chromatic flights—they exult, shout!'[5]

This painting follows the four works referred to by Fénéon, and combines many of the motifs that Signac found attractive in Les Andelys—the shimmering water reflecting trees on an island, and the dappled hazy summer skies. Signac also featured the red roofs of the riverside houses, the verdant greens of the grassy bank, and the chateau high up in the background, redolent with French history as the castle where Richard the Lionheart once lived. In the mid-ground a tiny figure is seated on a small jetty, and in the foreground is the cropped form of a moored boat. A stillness, a sense of history and timelessness, pervades this composition.

Jane Kinsman

1 Quoted in Françoise Cachin, *Signac: catalogue raisonné de l'oeuvre peint*, Paris: Gallimard 2000, p. 352. The term Fénéon had used when reviewing the eighth Impressionist exhibition earlier that year when Signac, Seurat, Camille and Lucien Pissarro had shown their work together, along with Albert Dubois-Pillet, was 'l'avant-garde de l'impressionisme'.

2 Quoted in Joan Ungersma Halperin, *Félix Fénéon: aesthetic anarchist in fin-de-siècle Paris*, New Haven: Yale University Press 1988, p. 99.

3 Fénéon quoted in Halperin, pp. 99–100.

4 Quoted in Halperin, p. 100.

5 Félix Fénéon, 'Correspondance particulière de l'art moderne: L'Impressionisme aux Tuileries', *L'Art moderne, Bruxelles*, 19 September, pp. 300–02, quoted in Marina Gerretti-Bocquillon, Anne Distel, John Leighton et al., *Signac*, 1863–1935, New York: The Metropolitan Museum of Art, Yale University Press 2001, cat. 21, p. 121.

23 Théo van Rysselberghe

Belgium 1862 – France 1926

Sailing boats and estuary
(*Voiliers et estuaire*) c. 1887
oil on canvas, 50.0 x 61.0 cm
Musée d'Orsay, Paris, purchased 1982, RF 1982-16
© RMN (Musée d'Orsay) / Hervé Lewandowski

In this work van Rysselberghe employs the Pointillist technique to luminous effect. The eye is led from the foreground to the mid-ground, and across the expanse of ocean by the jutting landmass, to the horizon where sea and sky mingle. The upper-third of the canvas is dominated by sky—billowing clouds give way to a pale, lemon sunshine that glistens on the water below. In the foreground the ocean reaches right to the very edge of the canvas, emphasised by the deep shadow cast by the jetty. In the distance sailboats become specks on the horizon and a sense of the ocean's enormity is achieved.

Van Rysselberghe worked in many styles throughout his career, and in this work we see the synthesis of several. The inspiration for the composition seems to have come from Seurat, whose seascapes often draw the viewer in with a close-up view of land or a jetty at the side of the canvas, and then give way to an expanse of ocean and sky separated by a thin wedge of land.

Painted in the Pointillist manner which van Rysselberghe adopted after befriending Signac, the delicate, shimmering quality of light in *Sailing boats and estuary* is also reminiscent of James McNeill Whistler. The use of colour is far more naturalistic than in the work of Signac and other Neo-Impressionists, and reveals a tendency towards Realism. Indeed, describing the art of van Rysselberghe, Denis commented: '[his is] an art of probity and reflection, with neither hesitations nor maladroitness, a realistic art, but with all the seductions of reality'.[1]

Sailing boats and estuary illustrates an important moment in modern art: that at which artists found the resolve to depict nothingness. Contrary to the tradition of maritime painting, no boat dominates the scene, no action takes place. We are shown the ocean as flat, calm and unending. Here is stillness.

Emilie Owens

1 Quoted in Robert L. Herbert, 'Théo van Rysselberghe', in Jean Sutter (ed.), *The Neo-Impressionists*, London: Thames and Hudson 1970, p. 184.

24 Maximilien Luce

France 1858–1941

The Seine at Herblay (*La Seine à Herblay*) 1890
oil on canvas, 50.5 x 79.5 cm

This exquisite rendition of graduated pinks and mauves, in delicately stippled brushwork, conveys the light and atmosphere of dusk. We look down onto a property nestled in a bend of the Seine: a white stone wall leads into the dark, densely vegetated section at the centre of the composition, and the roofs jutting up from the hillside. Luce's carefully balanced composition is structured by diagonals—the triangle of grassy bank in the foreground, the interlocking sections formed by the bend in the river. Wedges of high-key colour are complemented by darker sections, and punctuated by the upright trees. Adopting a high viewpoint, Luce, like Seurat in *Port-en-Bessin at high tide* 1888 (cat. 21), exploits the patterns and textures of grasses, bushes, trees and water, set against the distant hills and graded sky.

Luce began experimenting with Divisionist techniques in the mid 1880s. He exhibited seven works at the Salon des Artistes Indépendants in 1887, and in all subsequent exhibitions between 1888 and 1892. He was close to Pissarro (they shared the same radical politics) and through him meet Seurat, Signac and Cross. From 1889, Luce painted central Paris locations between the cathedral of Notre Dame and the Musée du Louvre, particularly the quays and bridges of the Seine, often set at dusk or at night.[1] He continued to paint urban scenes, the animated streets of the Latin Quarter, construction workers, and views over Montmartre throughout his career. He also worked on the Brittany coast and travelled widely in the 1890s—to London, St-Tropez, and Borinage, a Belgium coal-mining district—but unlike his contemporaries, and the Impressionists before him, he did not produce series.

Luce's choices of picturesque scenes along the Seine, as well as his canonical perspectives of Paris, were probably an attempt to attract buyers.[2] From the late 1880s the painter was in dire straits both financially and emotionally; he lived and worked peripatetically, visiting friends for extended periods in an attempt to save money. In 1889 Luce visited Signac at Herblay, now a north-western suburb of Paris—and returned the following year to paint this scene. *The Seine at Herblay* was exhibited in Paris in 1890, and again three years later at the fifth Exposition des Peintres Impressionistes et Symbolistes. Reviewing that exhibition Yves Rambosson complained:

> Once again, the evidence is clear that impressionism is powerless to render night-time effects … there is too much heaviness, and the precision of the brush-strokes cannot communicate the haziness of the enclosing darkness, and the indecisiveness of reflected gleams of light.[3]

These comments seem particularly out of place when contemplating this dusky scene at Herblay however, and if we consider the artist's broader interest in nocturnes. Indeed, *The Seine at Herblay* is surely one the more dramatic and luminous examples of the genre.

Lucina Ward

1 Jean Bouin-Luce and Denise Bazetoux, *Maximilien Luce: catalogue raisonné de l'oeuvre peint*, Paris: Editions J.B.L. 1986.

2 Robyn Roslak, *Neo-Impressionism and anarchism in fin-de-siècle France: painting, politics and landscape*, Aldershot: Ashgate 2007, p. 89.

3 Yves Rambosson, *La Plume*, no. 79, 1 August 1893, p. 352, quoted in Bouin-Luce and Bazetoux, p. 64.

25 Georges Lemmen

Belgium 1865–1916

Beach at Heist (*Plage à Heist*) 1891
oil on wood panel, 37.5 x 45.7 cm
Musée d'Orsay, Paris, purchased 1987, RF 1987-35
© RMN (Musée d'Orsay) / Gérard Blot

The Belgian, Lemmen—like van Rysselberghe (see cats 23 and 26) and other members of Les XX (The Twenty)—was converted to Neo-Impressionism following the exhibition of Seurat's iconic *A Sunday afternoon on the island of La Grande Jatte* 1886[1] (p. 35), at the Salon des XX in 1887. Like many of the Belgian Neo-Impressionists, however, Lemmen did not practise the technique for long. By the turn of the century he had begun to focus on the applied arts, experimenting with a broad range of media including designs for books, posters, carpets, wallpapers and even furniture. He did return to painting later in his career, though, with works which are generally intimate family portraits and scenes of home, painted in a naturalistic style.

During his Neo-Impressionist phase, Lemmen painted portraits as well as land and seascapes, such as *Beach at Heist*. Heist is a popular coastal resort town in the Belgian province of West Flanders, near the country's border with the Netherlands. Many of Lemmen's coastal scenes and landscapes were painted around the area, which was also popular with other Belgian artists (van Rysselberghe summered in the neighbouring town of Knokke in 1887).

While this painting exemplifies Lemmen's Neo-Impressionist work, it also prefigures his move towards an Art Nouveau aesthetic. An abandoned boat rests at the edge of a deserted beach, the sole witness to the brilliance of the sunset over the ocean. A stillness pervades the scene, which is lent a slightly haunting feel by the unnatural shape of the large cloud that dominates the sky, and the lurid colours in which the work is painted. These starkly contrasting colours are applied with the regular, dotted brushstrokes typical of Neo-Impressionism, yet the fanciful shapes they create suggest the whimsical patterns of Art Nouveau: organic, finger-like forms protrude from the cloud in the sky, and the waves form glimmering curls as they wash onto the beach.

Emilie Owens

1 The Art Institute of Chicago, Chicago.

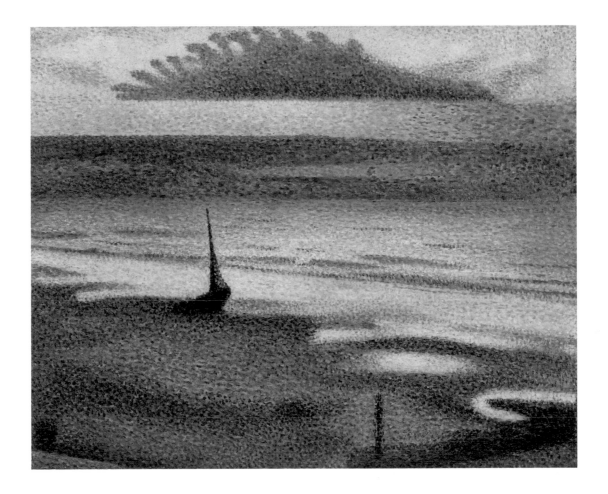

26 Théo van Rysselberghe

Belgium 1862 – France 1926

The man at the tiller (*L'homme à la barre*) 1892
oil on canvas, 60.2 x 80.3 cm
Musée d'Orsay, Paris, gift of Ginette Signac 1976, RF 1976-79
© RMN (Musée d'Orsay) / Hervé Lewandowski

Van Rysselberghe, a member of the Belgian avant-garde exhibiting group Les XX (The Twenty), took part in an aesthetic revolution in his homeland. He was instrumental in inviting Seurat to show his monumental painting *A Sunday afternoon on the island of La Grande Jatte* 1886[1] (see cats 13 and 14) in Brussels, the year after it was first exhibited in Paris. With his friend, the Symbolist poet Emile Verhaeren, van Rysselberghe had visited the Société des Artistes Indépendants, where the painting had a stunning effect. Verhaeren wrote that it 'asked me to forget all colour and spoke to me only of light'.[2]

Influenced by Signac, the theorist and enthusiast of Neo-Impressionism, van Rysselberghe adopted the new technique of Divisionism. He separated hues, and placed them side-by-side on the canvas, where they combine as the viewer perceives them. More startling than his technique is his daring and original composition for *The man at the tiller*. A dark, triangular figure sits in the extreme lower-right corner, counterbalanced by a light triangle of sail and boom at upper left. The blue silhouette of the helmsman forms a wave, reminiscent of Hokusai's *The great wave off Kanagawa* c.1829–32. Curling across the central area are lines of green waves, repeating with variation. A band of white foam links the sailor to the ropes and the sail. The sea's power over the little boat, and the concentration which the man needs to prevail in the elements, contrast with the large distant sailing-ship, secure in a tranquil band of sky and sea forming the top third of the composition.

The chromatic use of opposites is seen best in the blue and orange clothes of the helmsman, opposed by the use of orange and blue for flesh and wood. The sail is not white, but rather picked out in pinks, yellow and blue, intensified in the yellow wood of the boom. Dots and dashes of green and white enliven the moving surface of the waves. As well as tonal divisions, contrasting directions of the paint strokes distinguish each of the picture planes. The canvas is framed in a darker blue, following the theories of Seurat and Signac. Although the sailor has traditionally been identified as van Rysselberghe's friend Signac, the artist's correspondence identifies him as Yves Priol, the Breton crew-man on Signac's yacht *Olympia*.[3] Van Rysselberghe later exchanged this work for one of Signac's paintings, a mark of friendship among artists.

Christine Dixon

1 The Art Institute of Chicago, Chicago.

2 Quoted in Marina Ferretti Bocquillon, 'Signac and Van Rysselberghe: The story of a friendship, 1887–1907', *Apollo*, vol. 147, no. 36, June 1998, pp. 11–18.

3 Marina Ferretti Bocquillon, 'Théo van Rysselberghe et Paul Signac: histoire d'une amité', in *Théo van Rysselberghe*, Brussels: Bozar Books 2006, p. 136

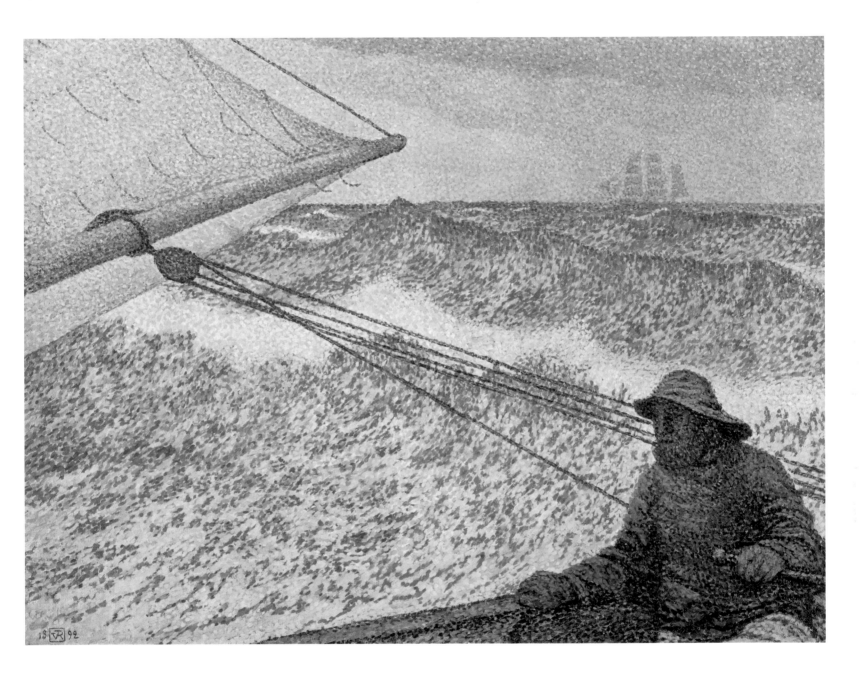

27 Georges Seurat

France 1859–1891

The circus (sketch) (Le cirque (esquisse)) 1891
oil on canvas, 55.0 x 46.0 cm

Musée d'Orsay, Paris, gift of Mrs Jacques Doucet,
according to her husband's wishes 1937, RF 1937-123
© RMN (Musée d'Orsay) / Hervé Lewandowski

By the late 1880s a new venue had become a favoured subject for artists portraying modern life. In his essay, 'Circuses, Theatres, Social Commentary' published in *La Revue indépendante* in December 1887, the critic Félix Fénéon had complained that the Parisian stage was in a serious state of decline:

> For a long time now the stories of adultery recounted on our stages have been utterly dull. Unbearable in everyday life, they've not gained any attraction for having been prolonged by the performances of our best actors ... What's left are our circuses.[1]

Towards the end of the nineteenth century, Paris had four large circuses: the seasonal Cirque d'Eté and Cirque d'Hiver, the chic, more fashionable Nouveau-Cirque, and the Cirque Fernando (subsequently known as Cirque Médrano).[2] The Fernando was the subject of the present work, Seurat's *The circus (sketch)*.

Here we see a young female equestrian performing bareback on a prancing horse, a crop in one hand as an acrobat cavorts behind her. To the left, the ringmaster holds an outstretched whip, orchestrating the performance, while in the foreground a smiling clown stands with his back to the viewer—indicated by his shoulders, while with one hand he pulls back the curtain on the scene. The background shows the bare outlines of a few members of the audience and an orchestra conductor with his baton raised.

This work is the only known oil sketch for Seurat's monumental 1.85 x 1.52 metre painting *The circus* 1891[3]. Both this sketch and the larger canvas, along with several preparatory drawings, were made in the years 1890–91. For *The circus (sketch)* Seurat has chosen the primary colours of red, yellow and blue, applied in feathery brushstrokes on a painted white canvas, and used mixtures of these to make the additional colours of pink and a green.

Seurat had met the French scientist Charles Henry at the eighth and last Impressionist exhibition in 1886, where his work *A Sunday afternoon on the island of La Grande Jatte* 1886[4] was on display. This was Seurat's groundbreaking painting heralding the arrival of his new style. His interest in Henry's theories of linear expression consolidated his own earlier absorption of such ideas, which were expounded by Charles Blanc, whose writings Seurat had begun reading at the age of sixteen.[5] *The circus (sketch)* exemplifies Seurat's interest in linear expression, where a warm palette and upwardly moving lines evoke a sense of joyfulness, evident here in the artist's adoption of dynamic and uplifting lines and his use of reds, pinks and yellows. This painting also reflects the influence on artists by the noted French poster-maker of the day, Jules Chéret, whose brightly coloured, playful imagery entranced all of Paris.

Jane Kinsman

1 'Cirques, Théâtres, Politique.' Quoted in Joan U. Halperin (ed.), *Félix Fénéon: oeuvres plus que completes*, 2 vols, Geneva: Librairie Droz 1970, p. 255.

2 National Gallery, London and The Art Institute of Chicago, Chicago, respectively.

3 Musée d'Orsay, Paris.

4 The Art Institute of Chicago, Chicago.

5 Robert L. Herbert, Françoise Cachin, Anne Distel et al., *Georges Seurat, 1859–1891*, New York: The Metropolitan Museum of Art 1991.

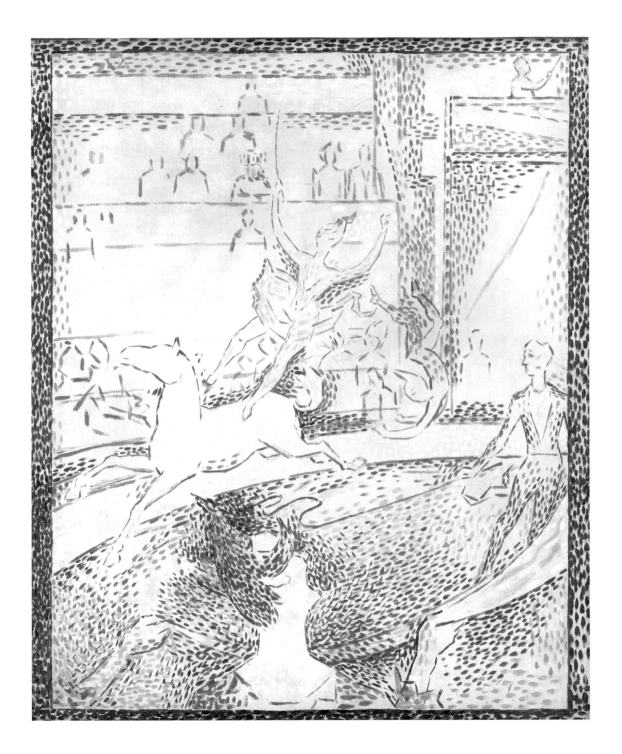

28 Camille Pissarro

St Thomas, West Indies 1830 – France 1903

Hoarfrost, peasant girl making a fire
(*Gelée blanche, jeune paysanne faisant du feu*) 1888
oil on canvas, 92.8 x 92.5 cm

Musée d'Orsay, Paris, transferred from the Direction générale
des douanes et droits indirects 2000, RF 2000-83
© RMN (Musée d'Orsay) / Hervé Lewandowski

This work was painted in Eragny, northwest of Paris, where Pissarro lived from 1884 until his death in 1903. Opposed to the existing social order, Pissarro aspired to a future where power and wealth would be equally shared, and abandoned the city to get closer to an agrarian existence. There are several versions of this particular motif—about six oils, a gouache, a drawing and a watercolour[1]—in the series of rural landscapes that he made after relocating.

As peasants began to feature more prominently in Pissarro's work, he was criticised for copying the ideas of Jean-François Millet. Pissarro strongly refuted this— especially after discovering that Millet was not the radical he had originally thought, having actually opposed the 1871 French Commune. Pissarro's supporters saw his art as authentic representations of peasant life. Degas, for one, aptly described the difference between their approaches: 'Millet? His *Sower* is sowing for mankind. Pissarro's peasants are working to make a living.'[2]

Some admirers tried too hard to authenticate the artist, one describing Pissarro as:

> liv[ing] deep in lower Normandy, on a farm which he cultivates himself and which feeds him from the very soil he works. When the harvest has been good and he is free from his labours in the fields, Pissarro takes up his brushes … and fixes on canvas the rough existence of the creatures and the country life that he leads himself.[3]

True to his socialist ideals, Pissarro vehemently denied these claims, although he firmly believed that his Jewish bourgeois upbringing did not disqualify him from painting peasant themes.

Pissarro believed that painting rural scenes kept him in touch with nature, and reliant on 'sensation'.[4] On the back of the first work in the series which includes *Hoarfrost, peasant girl making a fire* he described the effect he wished to produce on the canvas—that the smoky haze rising around the fire be achieved as 'trembling colour'.[5]

Simeran Maxwell

1 Joachim Pissarro, *Camille Pissarro*, New York: Harry N. Abrams 1993, p. 171; and Richard Brettell and Christopher Lloyd, *A catalogue of drawings by Camille Pissarro in the Ashmolean Museum, Oxford*, Oxford: Clarendon Press 1980, p. 171.

2 Quoted in Belinda Thomson, *The Post-Impressionists*, Oxford: Phaidon 1983, p. 156.

3 Quoted in Richard Thomson, *Camille Pissarro: Impressionism, landscape and the rural labour*, London: The South Bank Centre 1990, p. 51.

4 See Thomson, pp. 46–58.

5 Quoted in Richard R. Brettell, 'Pissarro in Louveciennes: an inscription and three paintings', *Apollo*, vol. 136, no. 369, November 1992, p. 316.

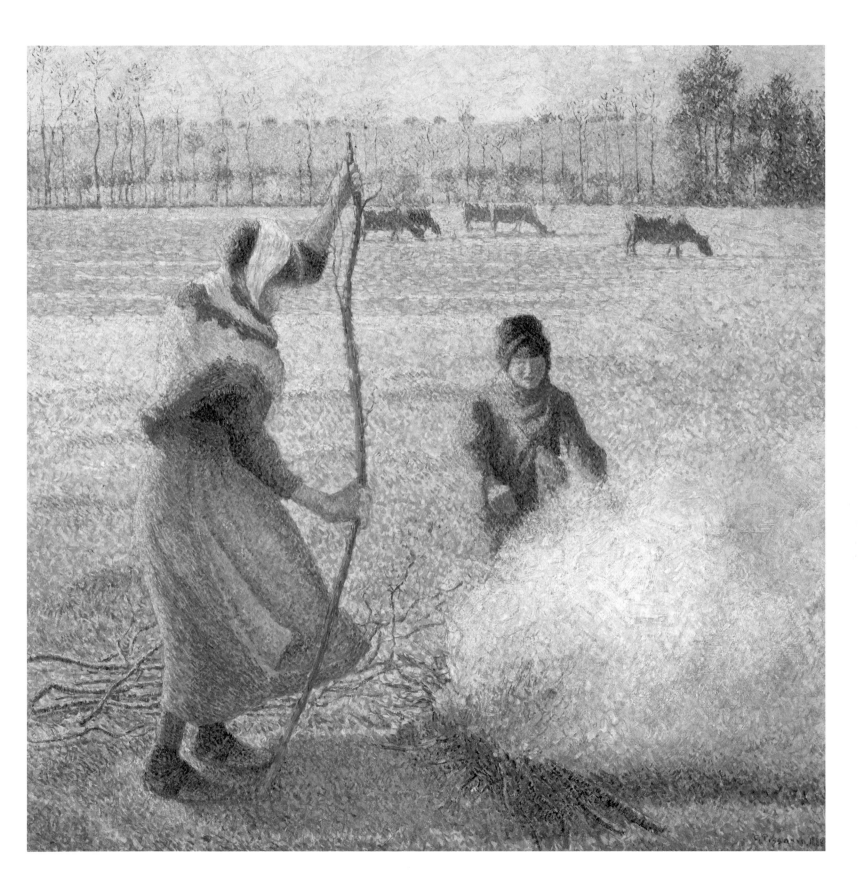

29 Paul Signac

France 1863–1935

Women at the well or *Young women from Provence at the well, decoration for a panel in the shadows* (*Femmes au puits* ou *Jeunes provençales au puits, décoration pour un panneau dans la pénombre*) 1892
oil on canvas, 195.0 x 131.0 cm

Musée d'Orsay, Paris, purchased 1979, RF 1979-5
© RMN (Musée d'Orsay) / Hervé Lewandowski

Angrand and Gauguin—along with many others who viewed the ninth Salon des Indépendants in Paris in 1893—disliked this painting. Angrand opined that Signac should have decided whether it was a landscape or a figure composition. Gauguin derided the collision between the modern and archaic:

> A well by the seashore: some Parisian figures in gaily striped costumes, thirsty with ambition, doubtless seeking in this dry well the water that will slake their thirst. The whole thing confetti.[1]

The contrasts with the muted modernity of one of Angrand's street-scenes (cat. 30), or the solidity of Gauguin's Breton subjects (cats 63 and 67), could not be more dramatic.

In March 1892 Signac sailed from Finistère in Brittany, travelling via the Canal-du-Midi and Marseilles, to the village of St-Tropez on France's southern coast. Signac's subject matter changed rapidly and significantly when he moved south: instead of working-class landscapes in Paris and its suburbs, he now began to paint decorative images of the village and panoramic views of the shoreline. He later built a large studio at La Hune, his villa at St-Tropez—where this painting was long displayed—and until 1913 spent at least six months of most years on the Côte d'Azur.

Women at the well reveals Signac's new interest in large-scale, classically inspired landscape settings, and marks the revival of interest in decorative public art more generally in the 1890s. The brilliant colours of this tapestry-like panel, with its patterns and arabesques, suggest an idealised scene. Its vertical format, blue frame and stylised shadows may be a tribute to Seurat's *The circus*[2],

a work which Signac later owned. The abstract contour of the coast-line divides the canvas via the diagonal, the section of sky balanced by the patterns in the foreground, which are, in turn, picked up by the winding ribbon-like road. The artist's landscapes to date, like Seurat's, had been largely unpopulated. Drawings for *Women at the well* show that Signac may once have conceived it—like his next major work, *In the time of harmony: the golden age is not in the past, it is in the future* 1893–95—as part of a multi-figured composition.[3]

Signac had been drawn south by his friend Cross. Signac left Paris in 1892, disillusioned by the diminished presence of the Neo-Impressionist avant-garde and, in part, because of the surge in anarchist violence and subsequent government crackdown which saw his friends Luce and Félix Fénéon imprisoned in the 'Trial of the Thirty'. *Women at the well*—which captures the temperate climate, aesthetic charm, and decentralised village life of the region—may be seen as his prefiguring of an ideal anarchist future.[4] While Gauguin went to Tahiti searching for paradise, Signac envisioned utopia in coastal Provence.

Lucina Ward

1 *The intimate journals of Paul Gauguin*, London: K.P.I. 1985, n. 1, p. 27.

2 Musée d'Orsay, Paris; the study for *The circus* is cat. 27.

3 Both drawings, and several painted studies, are held in the Musée d'Orsay, Paris. *In the time of harmony: the golden age is not in the past, it is in the future* is in Montreuil.

4 Robyn Roslak, *Neo-Impressionism and anarchism in fin-de-siècle France: painting, politics and landscape*, Aldershot: Ashgate 2007, p. 147.

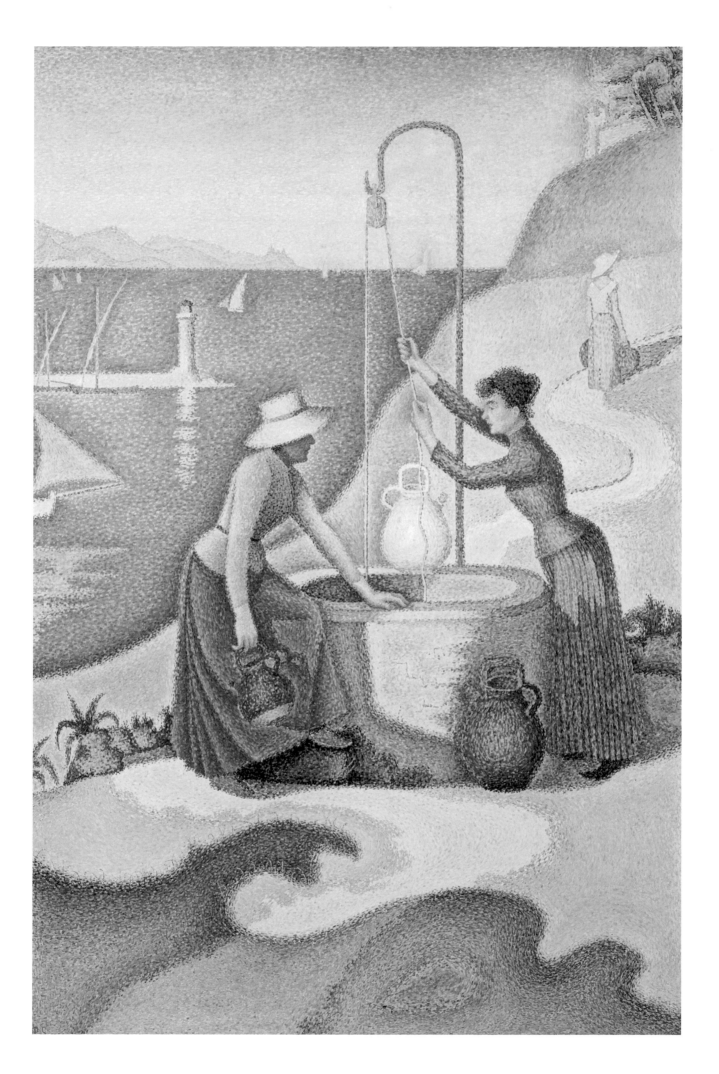

30 Charles Angrand

France 1854–1926

Couple in the street (*Couple dans la rue*) 1887
oil on canvas, 38.5 x 33.0 cm
Musée d'Orsay, Paris, purchased 1950, RF 1977-27
© RMN (Musée d'Orsay) / Hervé Lewandowski

In this small, intimate portrayal of a couple in an unremarkable Parisian street, the mundane subject choice is deliberate. Angrand's commitment to the popular anarcho-socialist ideals of the time meant that for him the life of the ordinary, working-class citizen in the suburbs was as worthy of attention as that of an aristocrat on the Champs-Elysées. Angrand treats these ordinary subjects with compassion: they are dignified in spite of their poverty, and a genuine tenderness has been captured between them. The simple clothing of the couple, and the nondescript street they walk, are an implicit repudiation of the academic art that characterised the official Salon.

After studying to be a teacher, Angrand, who was raised in a small town near Rouen, moved to Paris to pursue a career in painting. He took up a position as a mathematics teacher to support himself and lived in an area close to the cafes favoured by artists and writers of the avant-garde. He was quickly admitted to their circle, and in 1884 was a founding member of the Société des Indépendants.

Couple in the street, while not exhibited in his lifetime, marks an important turning point in Angrand's career. He had previously painted rural subject matter reminiscent of the Realists Jean-François Millet and Gustave Courbet, in a style heavily influenced by the Impressionists. Between 1886 and 1887, he began painting in the Neo-Impressionist style championed by Seurat and Signac. This work, painted in 1887, is a clear indication of this new direction.

Unlike Seurat or Signac's Pointillist paintings, which employ bright, sharply contrasting colours, here Angrand uses a muted palette. On closer inspection it becomes apparent that dots of blue, green, pink and red have been used to deepen shadow and establish tone, but there is no trace of the violent colours that characterise much Neo-Impressionist painting. Yet the whole work glows with warmth. The delicate use of light and shadow is typical of Angrand, whose black and white conté crayon drawings were described by Signac as 'poems of light'.[1]

Despite the success of his paintings in the Neo-Impressionist style, Angrand abandoned the technique and in 1896 moved away from Paris. He spent the rest of his life in almost total isolation, concentrating on the drawings in pastel and conté crayon that Signac so admired.

Emilie Owens

1 Quoted in Pierre Angrand, 'Charles Angrand', in Jean Sutter (ed.), *The Neo-Impressionists*, London: Thames and Hudson 1970, p. 79.

31 Henri-Edmond Cross

France 1856–1910

Madame Hector France or *Portrait of Madame H.F.*
(*Portrait de Madame H.F.*) 1891
oil on canvas, 208.0 x 149.0 cm
Musée d'Orsay, Paris, purchased 1955, RF 1977-127
© RMN (Musée d'Orsay) / Hervé Lewandowski

The subject of this imposing portrait, Irma Clare (1849–1933), was married to Hector France, the French author best-known for the Orientalist tales *Musk, hashish and blood* 1886. The painting was shown in 1891 at the Salon de la Société des Artistes Indépendants in Paris, and announced the first major work of Cross' newly adopted Neo-Impressionist style. Two years later, on 18 May 1893, the painter married his sitter and later in the year they moved to St-Clair, near St-Tropez, in the south of France.

Painted nearly life-size, Irma is shown against an elaborately nuanced backdrop. This is the conventional form for a society portrait, the sitter shown full-length, usually in fashionable dress, portrayed in surroundings which make reference to her interests or family background (see also cats 2, 3 and 4). The monumentality of Irma's figure and the elegant fabrics of her gown are emphasised by the steeply tilted floor, and the impression of depth introduced by the receding tiles. The mottled pink and white rhododendrons at lower left interrupt the picture plane, giving the scene a Japanese inflection, adding a gloriously decorative quality to this harmony of yellows, blues and pinks. Palms, a frieze of fans on the balustrade, and the geometric patterns on the tiled floor add to the exotic mood. Viewed in profile, with a long train, Irma appears to 'float chicly off-centre in an immaterial world approached from below'.[1] Her hair sparkles and evaporates into the night air around her. The lamps, diffused light and overlay of shadows also contribute to the ambience and luxury of the scene. Perhaps Irma has adjourned to an external terrace or balcony, escaping the glittering soiree which is the source of light behind the woven bamboo chair at left. The whole painting is inflected with a grainy, atmospheric glow. Cross' highly regular technique—a 'screen' of small,

regular dots over a densely painted ground—and impeccably aligned marks give the work a certain mechanical facture, reminiscent of early colour printing.

Cross and Irma seem to be an instance of opposites attracting: he serious and secretive; she superficial and pleasure-loving. Maria, the wife of the painter van Rysselberghe (the couples were neighbours at St-Clair) judged Irma petty, base of nature and an idle gourmand.[2] Other artist-friends, such as Angrand, on the other hand, found her fine company, enjoying the warm welcome at St-Clair, and praising her devotion to her husband in his later years.[3] At St-Clair Cross turned to pure landscape, using a vivid palette of saturated colours, but Irma continued to model for him, appearing as one of the figures in *Evening air* 1893–94.[4] In a later *Portrait of Madame Cross* c.1901[5] we see a slightly older Irma, in a large hat and floral gown, seated in the garden, but easily recognisable by her pursed lips and somewhat bulbous nose.

Lucina Ward

1 Robert Rosenblum, *Paintings in the Musée d'Orsay*, New York: Stewart, Tabori and Chang 1989, p. 442.

2 Françoise Baligand, Raphaël Dupouy, and Claire Maingon, *Henri-Edmond Cross: études et l'oeuvres sur papier*, Le Lavandou: Réseau Lalan 2006, p. 81.

3 Isabelle Compin, *H.E. Cross*, Paris: Quatre Chemins-Editart 1964, p. 32.

4 Musée d'Orsay, Paris.

5 Musée d'Orsay, Paris.

32 Paul Signac

France 1863–1935

Entry to the Port of Marseille
(*L'entrée du port de Marseille*) 1911
oil on canvas, 116.5 x 162.5 cm

Musée Cantini, Marseille, on long-term loan from the
Musée d'Orsay, Paris, purchased 1912, RF 1977-324
Photograph: Jean Bernard

The Neo-Impressionist's technique aims … at obtaining a maximum of colour and light. Is this aim not clearly outlined by the beautiful cry of Eugène Delacroix: *The enemy of all painting is grey!*[1]

So stated Signac in his seminal treatise on Neo-Impressionism, *D'Eugène Delacroix à Neo-Impressionisme*.[2] Here we see a typical example of how this notion was realised: individual brushstrokes in vivid pinks and blues are interspersed with flecks of green, purple and orange to capture the play of light on the waters of the harbour, and the passage of clouds across the sky. Signac's friend Cross well described the dazzling effect of the 'play of hues' in Signac's paintings as being 'ravishing as happy combinations of gems'.[3]

While earlier in his career Signac had painted gritty urban landscapes, port scenes and seascapes like this one make up much of his later oeuvre. In his early work he was a devoted follower of Seurat's Pointillism, in which images are constructed using dots of pure colour and identical size. This rendering of Marseille's port is characteristic of Signac's later adaptation of the style: the precise spheres of colour used in his early paintings are replaced with small rectangular slabs, tessellated to give a mosaic effect.

A keen sailor, Signac travelled extensively in his native France and across Europe, painting ports from St-Tropez to Istanbul. It is interesting that, given his anarchist sympathies, many of these paintings recall the work of the Romantic maritime painter J.M.W. Turner and offer idealised versions of the bustling industrial ports. Here yachts and traditional barques are set against a soft city skyline and the whole work is imbued with a rose-golden glow. This is in stark contrast to the reality of Marseille's busy seaport in the years leading up to World War I, when hundreds of ships filled the harbour against the backdrop of a rapidly expanding industrialised city.

The shift to idyllic subject matter exemplified by this work could be read as alluding to the anarchist dream of a future utopian society, but perhaps the painting is better understood as affirming Signac's belief in the revolutionary power of the Neo-Impressionist technique. For him, the technique represented a denial of tradition and a refutation of bourgeois taste that struck 'a solid pick blow to the old social edifice, which, worm-eaten, cracks and crumbles like some abandoned cathedral'.[4]

Emilie Owens

1 Paul Signac, 'D'Eugène Delacroix a Neo-Impressionisme', in Charles Harrison and Paul Wood (eds), *Art in theory 1815–1900: an anthology of changing ideas*, Oxford: Blackwell 1998, p. 979.

2 Paul Signac recorded the theory behind Seurat's system of colour in this text, first published in Paris in 1899.

3 Letter from Cross to van Rysselberghe, 1905, quoted in Marina Gerretti-Bocquillon, Anne Distel, John Leighton et al., *Signac, 1863–1935*, New York: The Metropolitan Museum of Art, Yale University Press, 2001, p. 20.

4 Paul Signac, 'Impressionists and revolutionaries', in Harrison and Wood, p. 797.

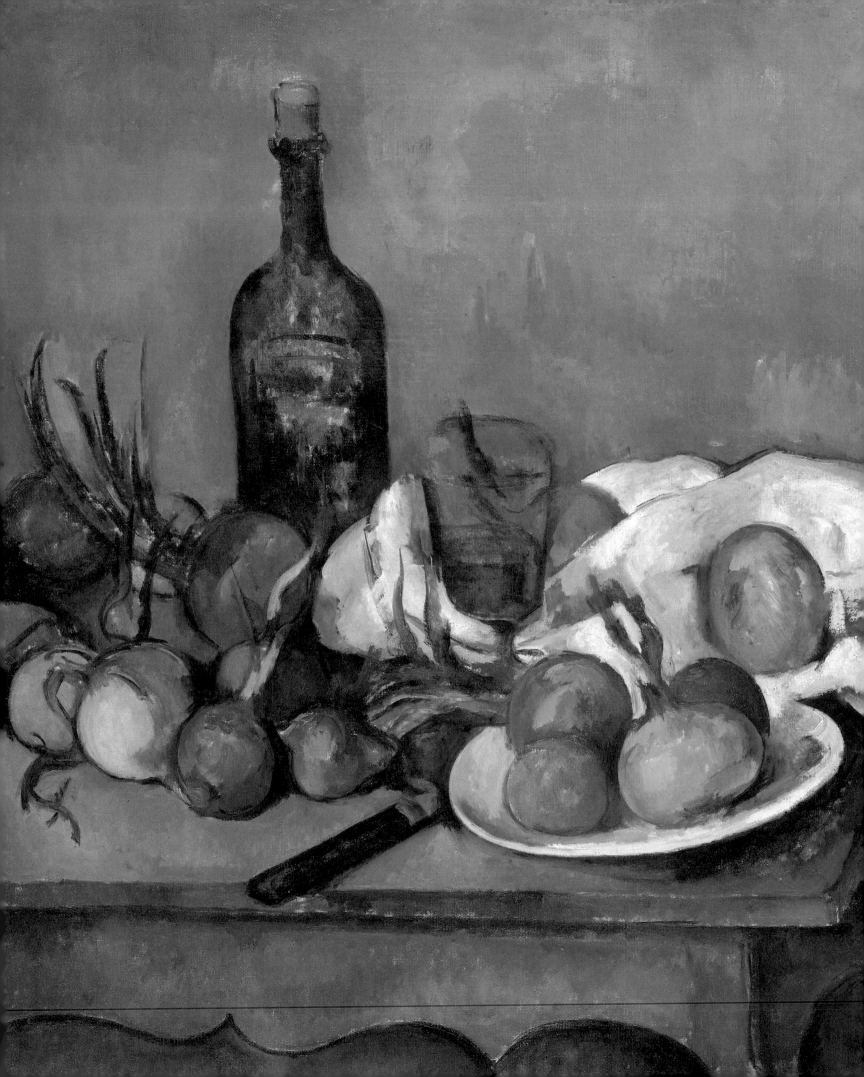

Cézanne and his influence

Paul Cézanne

Maurice Denis

Paul Gauguin

Pablo Picasso

Paul Sérusier

33 Paul Cézanne

France 1839–1906

The apotheosis of Delacroix
(*Apothéose de Delacroix*) 1890–94
oil on canvas, 27.0 x 35.0 cm

Musée Granet, Aix-en-Provence, on long-term loan from the
Musée d'Orsay, Paris, accepted in lieu of tax 1982, RF 1982-38
© RMN (Musée d'Orsay) / Hervé Lewandowski

Cézanne had a lifelong obsession with the great nineteenth-century French artist Eugène Delacroix. From early in his career he made copies after this leading figure of French Romanticism, a dominating figure to later generations of French artists. Towards the end of his life he reflected on the importance of Delacroix as a colourist, and on his work as being a postscript to the Venetian artists: '[H]e's one of the giants. He has no need to blush if that's what we call him, even in the same breath as Tintoretto and Rubens … His palette is still the most beautiful in France.'[1] In comparison, Cézanne had little time for the 'bloodless' Neo-Classical artists. Delacroix, in contrast, painted 'by iridescence'.

The dating of this oil is problematic. As early as the 1860s, Cézanne had drawn sketches whose figures relate to this canvas.[2] Around 1878–80 he created a watercolour which was later to form the basis of *The apotheosis of Delacroix*.[3] This expanded version of the watercolour then formed the basis of this oil version of *The apotheosis*—a painting which has been variously dated.[4] The most likely date for the oil is between 1890 and 1894, on the grounds that it has been executed in a mature style. Furthermore, in 1894 Cézanne was photographed by Eugène Durieu, shown holding a brush in his studio and standing next to the incomplete *The apotheosis*.

In this painting, Cézanne depicts Delacroix borne heavenward by angels, one of whom carries the artist's palette and brush. This, like the previous watercolour, was based on Delacroix's *Lamentation* 1843–44. Cézanne was an avid fan and copyist of the Romantic artist's work and this inclusion is appropriate for such a homage.[5] For his *Apotheosis*, Cézanne has also included a series of the artist's own contemporaries—all Delacroix enthusiasts— who are set in a Provençal landscape of brilliant light

and straggly foliage, with many of the figures wearing Barbizon hats to fend off the sun. At the far right Pissarro is at his easel, and next to him Monet under an umbrella. The artist himself accompanies his pet dog Black in the forefront of the composition. Cézanne gestures skyward towards his hero. Two figures to the left, kneel and pray. One in a frock-coat at the far left is Cézanne's patron and friend Victor Chocquet, another ardent admirer of Delacroix, whose premature death in 1891 may have prompted this painting.[6]

Despite his nearly three-decade long ambition to pay homage to Delacroix, Cézanne failed in his ambition to create his work of devotion to the artist that so inspired him, and died before realising this lifetime's dream.[7]

Jane Kinsman

1 *Joachim Gasquet's Cézanne: a memoir with conversations*, London: Thames and Hudson 1991, p. 197. As noted by both John Rewald, in the preface, and Richard Schiff, in the introduction to this translation by Christopher Pemberton, Gasquet took a fair amount of poetic licence in his reconstructions of his conversations with Cézanne. Richard Schiff, 'Introduction', in Michael Doran (ed.), *Conversations with Cézanne*, Berkeley: University of California Press 2001, pp. xix–xxxiv.

2 Adrien Chappuis, *The drawings of Paul Cézanne: a catalogue raisonné*, vol. 1, London: Thames and Hudson 1973, cats 174 and 175, pp. 85–86.

3 Private collection, London.

4 John Rewald, *Paul Cézanne: the watercolours: a catalogue raisonné*, London: Thames and Hudson 1983, cat. 68, pp. 102–03, which includes the various dates for the watercolour and the oil.

5 St-Denis-du-St-Sacrement, Paris. Sara Lichtenstein, 'Cézanne's copies and variants after Delacroix', *Apollo*, February 1975, pp. 116–27.

6 Rewald, cat. 68, pp. 102–03; Nina Athanassoglou-Kallmyer, 'Cézanne and Delacroix's posthumous reputation', *The Art Bulletin*, March 2005, vol. 87, part 1, pp. 111–29.

7 He lamented this in a letter to the artist Bernard in 12 May 1904. John Rewald (ed.) and Seymour Hacker (trans.), *Paul Cézanne: letters*, New York: Hacker Art Books 1984, pp. 296–97.

34 Paul Cézanne

France 1839–1906

Mount Sainte-Victoire
(*La Montagne Sainte-Victoire*) c. 1890
oil on canvas, 65.0 x 92.0 cm
Musée d'Orsay, Paris, gift of the Pellerin family 1969, RF 1969-30
© RMN (Musée d'Orsay) / Hervé Lewandowski

> The notion of Cézannesque universality rests, geographically at least, on the head of a pin. Is it possible that such a tiny area, with Aix as its centre of gravity, could have produced such powerful effects?—Bruno Ely[1]

Rising to 1011 metres, the massive limestone peak of Mount Sainte-Victoire dominates the countryside around Aix, and the oeuvre of Cézanne. The artist produced at least thirty canvases and many watercolours, unifying the forms and rhythms of the landscape with short diagonal brushstrokes and patches of colour. In his vast panoramas of the early 1880s he contrasts the mountain and foreground vegetation, exploring ways for Mount Sainte-Victoire to become the compositional focus. In later works, the mountain dominates the entire scene, often merging into the sky. By limiting his palette to greens, blues, grey-violet and cream, Cézanne emphasises the grandeur and gravity of the landscape.

Despite the artist's constant moves—he only settled permanently in Aix in 1897—and the difficulty of dating many works, Mount Sainte-Victoire imposes a geological consistency and series-like fidelity on Cézanne's oeuvre.[2] In this painting and others of the first series—*Mount Sainte-Victoire and the viaduct of the Arc Valley* 1882–85 (p.37) and *Mount Sainte-Victoire with large pine* c.1887[3] being two of the most famous—Cézanne shows details of his sister- and brother-in-law's property, the walls, fields and neighbouring farmhouses, the Arc River and railway viaduct. He uses the architectural elements to enhance the landscape, as though to 'contrast the wayward and irregular forms of the natural world with the more orderly geometric shapes of man's own devising'.[4] By changing his position slightly, Cézanne creates subtle variations in the geometric relationship between the landscape and built environment.

In the early paintings, Cézanne employs trees to frame or interrupt his composition; later, as he 'subtracts' these elements, the relationship between mountain and its surrounds is examined in other ways. The wall in the extreme foreground of this painting is a traditional *repoussoir* device, framing the composition and providing an entrée for the viewer; it forms a parallel with the aqueduct in the valley below, and counterpoint to the pyramid-like mountain. The corner of the wall also announces the point at which the foliage sweeps back, like imaginary theatre curtains, to reveal the grandeur of Mount Sainte-Victoire beyond. Rather than applying the same cross-hatching technique to the whole canvas, as he does in the later series, Cézanne adjusts the direction of his brushstrokes to his forms. The canvas is visible between the spare, quickly worked brushwork. As the artist wrote to his first biographer, Joachim Gasquet:

> the blue smell of the pines … must be married to the green smell of the plains which are refreshed every morning, with the smell of stones, the perfume of distant marble from Sainte-Victoire. I have not expressed it. It must be done. And by colours, not literature.[5]

Lucina Ward

1 Bruno Ely, 'Cézanne's youth and the intellectual and artistic milieu in Aix', in Philip Conisbee and Denis Coutagne, *Cézanne in Provence*, Washington D.C.: National Gallery of Art; Aix-en-Provence: Musée Granet; Paris: Reunion de musées nationaux 2006, p. 28.

2 Bruno Ely, 'Gardanne, Montbriand, and Bellevue', in Conisbee and Coutagne, p. 161.

3 Metropolitan Museum of Art, New York and Courtauld Institute Gallery, London.

4 Richard Verdi, *Cézanne*, London: Thames and Hudson 1992, p. 112.

5 Quoted in Nicholas Wadley, *Cézanne and his art*, New York: Galahad Books 1975, p. 77.

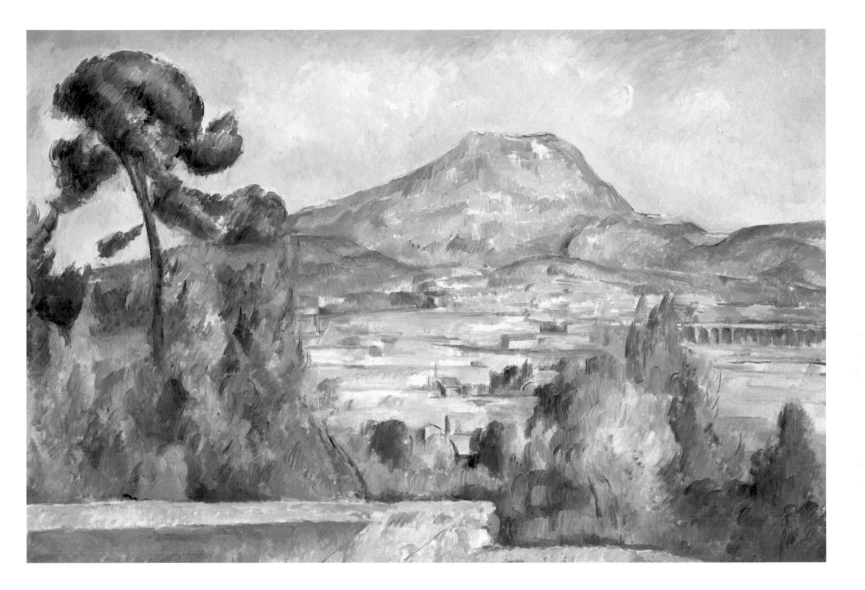

35 Paul Cézanne

France 1839–1906

Rocks near the caves above the Château Noir
(*Rochers près des grottes au-dessus du Château Noir*) c.1904
oil on canvas, 65.0 x 54.0 cm
Musée d'Orsay, Paris, accepted in lieu of tax 1978, RF 1978-32
© RMN (Musée d'Orsay) / Hervé Lewandowski

His method was singular, totally outside conventional means … He began on the shadows, with a single patch, which he then overlapped with a second, and a third, until all of these hues, making a screen, modelled the object by colouring it. I understood immediately that his work was guided by a law of harmony, that the direction of all his modulations was fixed in advance, in his reason.—Emile Bernard[1]

Painted two years before his death, this is one of Cézanne's many paintings celebrating the country around Aix-en-Provence—the majestic vision of Mount Sainte-Victoire, the architectural tectonic forms of the Bibémus quarry, or the gothic melancholy of the Château Noir.

While interested in, and influenced by, Impressionism— he showed works in the exhibitions of 1874 and 1877—Cezanne also reacted strongly against it. 'I wanted to make of Impressionism something solid and enduring, like the art in museums.'[2] The key word here is 'solid'. Cézanne was less interested in capturing the sense of fleeting evanescence than he was obsessed with the capacity of paint, and particularly of colour itself, to realise volumetric form (solidness) and the irrefutable presence of the 'objectness' of the object shown.

As the Bernard quote above indicates, Cézanne was to do so in the most idiosyncratic of ways. In the case of *Rocks*, the finished oil displays the same paradoxical airiness of the watercolour studies which pre-date it, yet the solidity of the boulders is undeniable.

While Cézanne's early work was constantly rejected by the Salon, the fact that Henri Matisse bought *Rocks* shows how much his later work was admired by a number of much younger Impressionist and Post-Impressionist artists.[3] (Matisse and Bernard were thirty years his junior.)

What Cézanne captures in *Rocks* are the ever-present powerful tectonic forces of the earth. There is an undeniable sense of diagonal gravitational pull between the smaller boulder precariously lodged in the extreme upper left of the composition and the larger boulder, seemingly only recently settled in the lower right-hand corner of the painting and staked there compositionally by the trees which seem to emerge from its very surface. There is both movement and stillness here, as though we are caught between moments of impending geological drama. The close focus owes a debt to Gustave Courbet.

This strong diagonal presentation of rock and tree forms also bears a remarkable resemblance to Lorenzo Lotto's *St Jerome in the desert* c.1506[4]. As a devout Catholic, there seems no doubt that for Cézanne, God was always immanent in the landscape. At the end of his life, it was here, in these simpler Provençal landscapes—the Bibémus quarry, the Château Noir, and the rocks of these grottes (grottos), with the quasi-religious devotional overtones of the word itself—that Cézanne found both spiritual solace and artistic inspiration.

Mark Henshaw

1 Bernard, 1 and 15 October 1907, quoted in Françoise Cachin, Isabelle Cahn, Walter Feilchenfeldt et al., *Cézanne*, London: Tate Publishing, 1996, p. 451.

2 Quoted in Genevieve Monnier, In 'Paul Cézanne', Jane Turner (ed.), *The dictionary of art*, vol. 6, London: Macmillan 1996, p. 366.

3 Jacques Guenne, 'Entretien avec Henri Matisse', *L'art vivant*, no. 18, 15 September 1925, pp. 1–6.

4 Musée du Louvre, Paris. Cézanne may have seen Lotto's work on his visits to the Louvre as a young man.

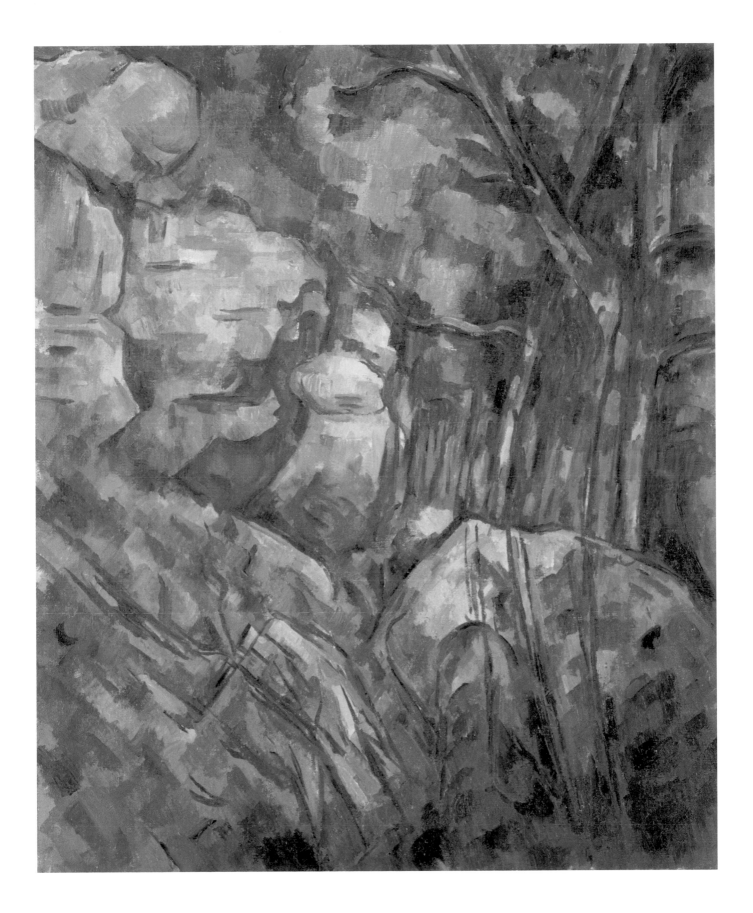

36 Paul Cézanne

France 1839–1906

Bathers (*Baigneurs*) c. 1890
oil on canvas, 60.0 x 82.0 cm

Musée d'Orsay, Paris, gift of the Baroness Eva Gebhard-Gourgaud
1965, RF 1965-3
© RMN (Musée d'Orsay) / Hervé Lewandowski

Given the prevalence of works by much younger artists in this exhibition, it is worth noting that Cézanne was more than fifty years old when he completed *Bathers*. The artist did hundreds of paintings of bathers over his career. The current work clearly relates to a preparatory work of the same name, *Bathers* 1890–92, and to another small study dated 1899–1900.[1] This was typical of Cézanne's working method. He produced study after study of the same subject, gradually refining his compositions until he achieved one which appeared to be the summation of them all.

In this work the arrangement of the bathers is brilliantly orchestrated—a complex grouping of foregrounded figures is contrapuntally arranged against another group occupying the middle ground. There is a strong classical echo to the triangular, pedimental architecture of these four foregrounded figures, anchoring the work compositionally. The effect is to create an architecturally interlocking circle of figures surrounding a group of bathers in the water or sitting on the banks. The corporeal presence of the foregrounded figures and the luminosity of their skin tones are echoed in the volumetric forms of the cumulus clouds that loom in the background. We see Cézanne's technical confidence in the way the terrain has been flattened and the treescape simplified. He uses trees here not for their anecdotal fidelity, but to anchor the composition at key points.

There is an undeniable sense of ritual in this work. Some commentators interpret the scene as baptismal— Cézanne became a devout catholic in 1890—with the figure at left pouring water over the head of a partially submerged bather to his right.[2] But it is also clear here that Cézanne mixes the sacred with the profane. There is a celebratory, Arcadian purity which finds its mirror in the compositional structure as a whole, whether it be the way in which light reflects off the facets of the bodies or in which it is refracted off the looming cloud masses. A paganistic, sensual exuberance informs the way in which the figures circle the bathers in the water, which Henri Matisse's famous *The dance* 1910[3] will later recall. (Matisse was a great admirer of Cézanne's work and owned a number of his paintings.) And it is probably no coincidence that the 'attendant' holds a luminous, vulva-shaped towel at the very centre of the composition. Grammatically, the title *Baigneurs* does not preclude the possibility that some of the participants may be female— the seated figure who is, significantly, adjacent to the towel, appears to be clearly female, for example. *Bathers*, then, is redolent with meaning. This is a powerfully multivalent work, and along with the later *The large bathers* paintings of 1894–1905 and 1900–05,[4] is considered to be one of Cézanne's great masterpieces.

Mark Henshaw

1 Held in the Saint Louis Art Museum and the Musée d'Orsay respectively.

2 See for example Mary Louise Krumrine, *Paul Cézanne: the bathers*, Basel: Öffentliche Kunstsammlung, 1989, p. 183.

3 The Hermitage, St Petersburg.

4 Held in the National Gallery, London, and the Barnes Foundation, Merion, Pennsylvania, respectively.

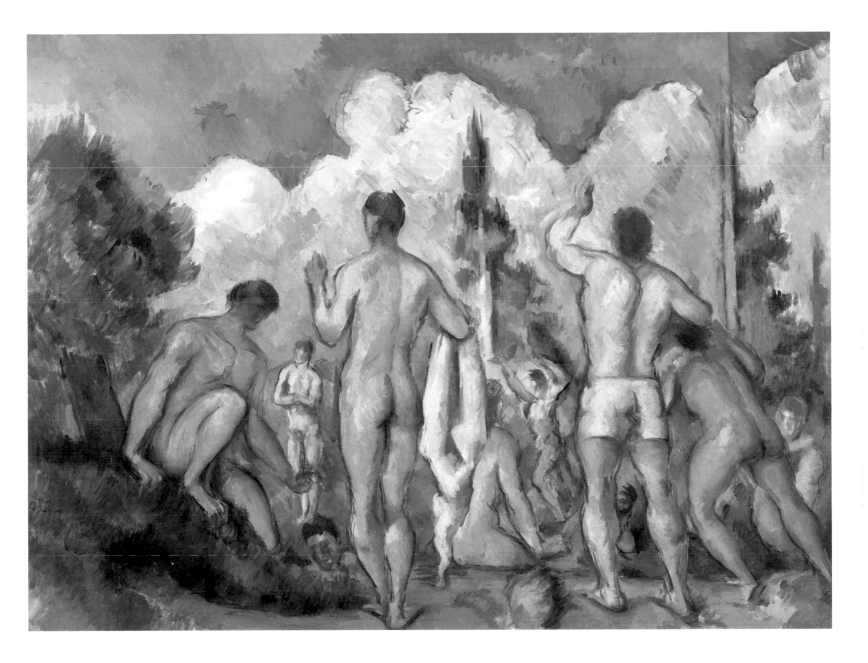

37 Paul Cézanne

France 1839–1906

Portrait of Madame Cézanne
(*Portrait de Madame Cézanne*)1885–90
oil on canvas, 47.0 x 39.0 cm
Musée d'Orsay, Paris, accepted in lieu of tax 1991, RF 1991-22
© RMN (Musée d'Orsay) / Hervé Lewandowski

Cézanne painted Hortense Ficquet many times during their long relationship. They met in Paris in 1869, when she was a nineteen-year-old model and he a thirty-year-old aspiring artist. He hid her existence from his disapproving father, despite the birth of their son in 1872. When his father discovered the family in 1876, he cut Cézanne's allowance. The pair married finally in 1886, with parental approval. This small portrait was made around this time, although it appears strangely impersonal, considering the couple's tumultuous personal circumstances. But then, the personality of his subjects concerned Cézanne very little, as he investigated the outer forms rather than the psychological experience of his sitter.

The subject looks into the middle distance, without meeting our gaze. She is presented very close to the viewer, but is restrained both in pose and expression. We see simple forms, an oval face on a cylindrical neck and triangular torso, with a very restricted colour palette. Almost everything is pale or hardly coloured: light pink skin, dark brown hair, light blue dress and background divided strictly between light blue-grey on the right, and a yellow-brown at the left. The sitter's face is slightly tilted. There is no signal of close personal ties, and little expression on her face; indeed hardly any indication of femininity at all. Her hair is parted severely in the centre, and appears almost to be painted on, like a wooden doll.

Cézanne builds up volume on the head and neck with subtle tones of darker hues. Black outlines the planes of the shirt, dividing flesh from fabric, and sitter from ground. The planes of the background are imaginary anyway, as no walls meet at the top, and then disappear further down. Instead we look at the artistic truth of the composition, the calmness and beauty of the reduced elements of the painting. *Portrait of Madame Cézanne* belonged to Henri Matisse, and was in his possession until his death in 1954. He admired the 'atmosphere of the serenity of life [which] radiates from the portrait … saying he wanted to endow his own work with a magnificent stillness'.[1] An anecdote related by Ambroise Vollard hints at another truth. While sitting for his portrait by Cézanne, Vollard moved, and Cézanne 'flew into a rage', saying: 'I told you to keep as still as an apple. Does an apple fidget?'[2] Madame Cézanne, it seems, in her perfection as a subject, did not.

Christine Dixon

1 'Portrait of Mrs Cézanne', website entry, 2006, Musée d'Orsay, Paris, viewed 22 September 2009, www.musee-orsay.fr/en/collections/works-in-focus/search/commentaire/commentaire_id/portrait-de-madame-cezanne-9881.html?no_cache=1.

2 *Museum of Modern Art: first loan exhibition, New York, November 1929: Cézanne, Gauguin, Seurat, van Gogh*, New York: Museum of Modern Art 1929, p. 20.

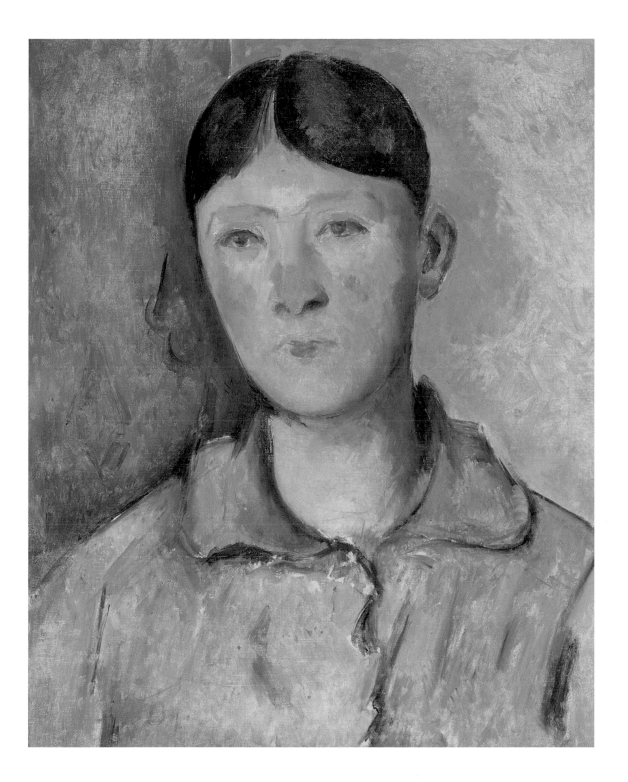

38 Paul Cézanne

France 1839–1906

Gustave Geffroy 1895–96
oil on canvas, 110.0 x 89.0 cm
Musée d'Orsay, Paris, gift of the Pellerin family 1969, RF 1969-29
© RMN (Musée d'Orsay) / Hervé Lewandowski

Cézanne's work faced the wrath of the French press during the 1870s. At the third Impressionist exhibition of 1877, his portrait of friend and patron Victor Chocquet was described as having a face that looked like it had been run through a mill, and so yellow it would give an unborn child yellow fever.[1] It was not until the critic Gustave Geffroy praised Cézanne in 1894 that the artist began to consider a re-entry into the Paris art world.[2] Monet believed that his old friend Cézanne had yet to receive the patronage that was his due, and explained to Geffroy how Cézanne had 'come to doubt himself far too much', while being 'touched' by Geffroy's comments.

A meeting was arranged by Monet, and Cézanne subsequently asked to paint Geffroy's portrait.[3] Geffroy is shown as a modern man of letters, seated in his library. Cézanne has tipped the desk towards the viewer to emphasise the sitter's engagement with writing. The desk is covered with open books, papers, and a cropped plaster figurine.[4] The writer gazes directly at the viewer. Perhaps Cézanne had in mind Degas' groundbreaking portrait of Edmond Duranty, shown in Paris in 1880 in the fifth Impressionist exhibition. The precedent of a portrait of a modern writer in a modern context had already been set by Edouard Manet, who had painted Cézanne's friend Emile Zola.[5]

Geffroy sat for Cézanne almost daily for three months from April 1895, and was painted, as the writer observed, 'with meticulous care and richness of tone, and with incomparable harmony'.[6] Yet something was amiss. Cézanne appeared incapable of completing Geffroy's face, only sketching his features. In mid June, Cézanne asked to be relieved of his commitment. At the writer's request the artist returned, however his heart was no longer in it.[7] Cézanne then left for Aix. In the following year, incapable of rendering the face of one of his great admirers, he wrote to Geffroy asking that his props be returned. The two men never met again.

Jane Kinsman

1 Cézanne was also advised to wear glasses. Charles S. Moffett (ed.), *The new painting: Impressionism 1874–1886*, 4th edn, Geneva: Richard Burton 1986, p. 215.

2 At a sale of Théodore Duret's collection, writing in *Le Journal*, 25 March 1894.

3 Gustave Geffroy, *Claude Monet: sa vie, son temps, son œuvre*, Paris: Crès 1922, quoted in Michael Doran (ed.) and Julie Lawrence Cochran (trans.), *Conversations with Cézanne*, Berkeley: University of California Press 2001, p. 4.

4 Identified by Geffroy as the work of Auguste Rodin. Geffroy, in Doran and Cochran, p. 197.

5 Musée d'Orsay, Paris.. Manet's painting had been selected for the Salon of 1868. Devoid of archaisms, Zola is shown at his desk with books, papers, ink pot and quill surrounded by favourite images such as a Japanese print by Kuniaki II and Manet's *Olympia* 1863.

6 Geffroy, in Doran and Cochran, p. 5.

7 Geffroy, in Doran and Cochran, p. 6.

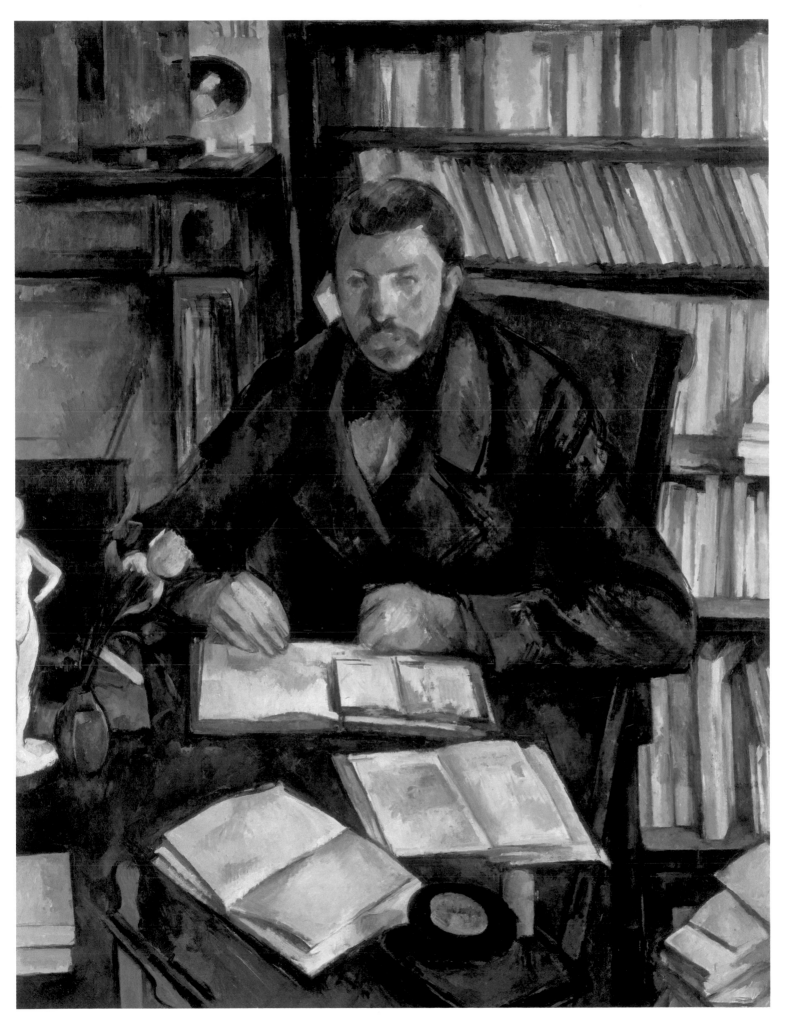

39 Maurice Denis

France 1870–1943

Homage to Cézanne
(*Hommage à Cézanne*) 1900
oil on canvas, 180.0 x 240.0 cm
Musée d'Orsay, Paris, gift of André Gide 1928, RF 1977-137
© RMN (Musée d'Orsay) / Hervé Lewandowski
© Maurice Denis. ADAGP/Licensed by Viscopy, 2009

Seven painters, a critic, a dealer and the artist's wife gather round a work by Cézanne, who is not present. His painting, *Fruit dish, glass and apples* 1879–80[1] previously belonged to another absent artist, Gauguin. Cézanne, presumably, is far from Paris, in his beloved Provence, while Gauguin is in the South Seas. Denis pays tribute not only to the modern master, but also to earlier formal portrait groupings by Henri Fantin-Latour, particularly his debt to Eugène Delacroix made manifest in *A studio at Les Batignolles* 1870.[2] By the respectful isolation of the older Symbolist Redon at left, Denis shows the younger generation's debt to earlier artists. Sérusier seems to be explaining to Redon why the Nabis admire the difficult art of Cézanne.

From left to right we see Redon, Vuillard, the writer and critic André Mellerio, the dealer Ambroise Vollard, the painters Denis, Sérusier, Paul Ranson, Roussel, Bonnard, and a sole woman, Marthe Denis. The scene takes place in Vollard's salerooms in the Rue Laffitte, with paintings by Gauguin and Pierre-Auguste Renoir on the walls.[3] What does this group portrait do that could not be portrayed more precisely by a photograph? There is its size, of course: the figures are almost life-size, and viewers encounter them as equals. Another element is the dynamism of positive and negative space, a rhythm unlike that of contemporary photographic compositions, in which people are static, lined up in rows, facing the front. Denis invigorates the canvas with strong verticals, especially the slightly angled trousered legs, Bonnard's cane, and the angled still-life by Cézanne. The painting nonetheless presents an extremely sombre, respectably-clad group of seemingly radical artists, dressed in the black suits worn by businessmen.

Homage to Cézanne was shown at the Salon de la Société Nationale des Beaux-Arts in Paris in 1901, and in Brussels the same year. According to the artist's diary, it was ridiculed: Denis referred to it as 'that painting, which still makes the public laugh'.[4] His friend, the writer André Gide, immediately offered to buy it. He kept it until 1928 when he donated it to the Musée du Luxembourg. The work therefore found its way into the national collection where it would eventually be seen in the context of Fantin-Latour's homages to earlier heroes of modern art and culture. Less than thirty years after its creation, both Cézanne and his admirers had moved from the margins to the centre of French culture. Old conventions remain undisturbed however: men are serious creative actors, while women hover at the margins, servitors to their male superiors.

Christine Dixon

1 Museum of Modern Art. New York.

2 Musée d'Orsay, Paris.

3 Jean-Paul Bouillon, 'Hommage a Cézanne', in *Maurice Denis* (1870–1943), Paris: Editions de la Réunion des musées nationaux 2006, p. 208.

4 Letter to André Gide in Maurice Denis, *Journal*, vol. 1, Pais: La Colombe 1957, p. 168.

40 Paul Cézanne
France 1839–1906

Still-life with onions
(*Nature morte aux oignons*) 1896–98
oil on canvas, 66.0 x 82.0 cm

Musée d'Orsay, Paris, bequest of Auguste Pellerin 1929, RF 2817
© RMN (Musée d'Orsay) / Hervé Lewandowski

By arranging a composition focusing on a wine bottle, a glass, an array of humble onions (a chief component of many Provençal peasant dishes), a knife to cut them with, and a simple white table cloth, Cézanne has created a celebration of simple country life in his beloved Aix-en-Provence. The table is from the artist's studio and is one which he frequently used for the base of his compositions. The furniture is cropped and set against a bare wall of daubed plaster, which also emphasises the scene's rustic air. Gone are the more elaborate earlier arrangements with ornamental drapes or statuettes previously favoured by Cézanne—*Still-life with onions* is a masterpiece of simplicity.

For Cézanne, the still-life genre was of paramount significance. He delighted in the depiction of objects as if they were living beings, and grappled with the pictorial problems of colour and space. In an account by Joachim Gasquet, Cézanne likened his still-lifes to portraits:

> We were talking about portraits. People think a sugar bowl has no physiognomy or soul. But that changes every day here. You have to take them, cajole them, those little fellows. These glasses, these dishes, they talk among themselves. They whisper interminable secrets. I gave up on flowers; they fade too soon. Fruits are more faithful. They love to have their portraits painted. They sit there and apologise for changing colour. Their essence breathes with their perfume. They come to you with all their aromas and tell you about the fields that they left, about the rain that nourished them, about the dawns they watched.[1]

The tradition of the still-life—so admired by a younger generation of artists, including the Impressionists—was set by the eighteenth-century French artist Jean Siméon Chardin. An 1860 retrospective of Chardin's work had revived interest in this genre, and inspired the young Cézanne. He was later to comment on Chardin's importance for the still-life genre and its history:

> [Objects] never cease to be alive … they spread themselves out imperceptibly among themselves by intimate reflections, as we do with our gazes and our words. Chardin was the first to see that, he painted the nuanced atmosphere of things.[2]

Cézanne contributed to the history of this genre in his own extraordinary, subtle way.

Jane Kinsman

1 As noted on p. 132, note 1, Gasquet took a fair amount of poetic licence in his reconstructions of his conversations with Cézanne. Quoted in Michael Doran (ed.) and Julia Lawrence Cochran (trans.), *Conversations with Cézanne*, Berkley: University of California Press 2001, p. 156.

2 Doran and Cochran, p. 157.

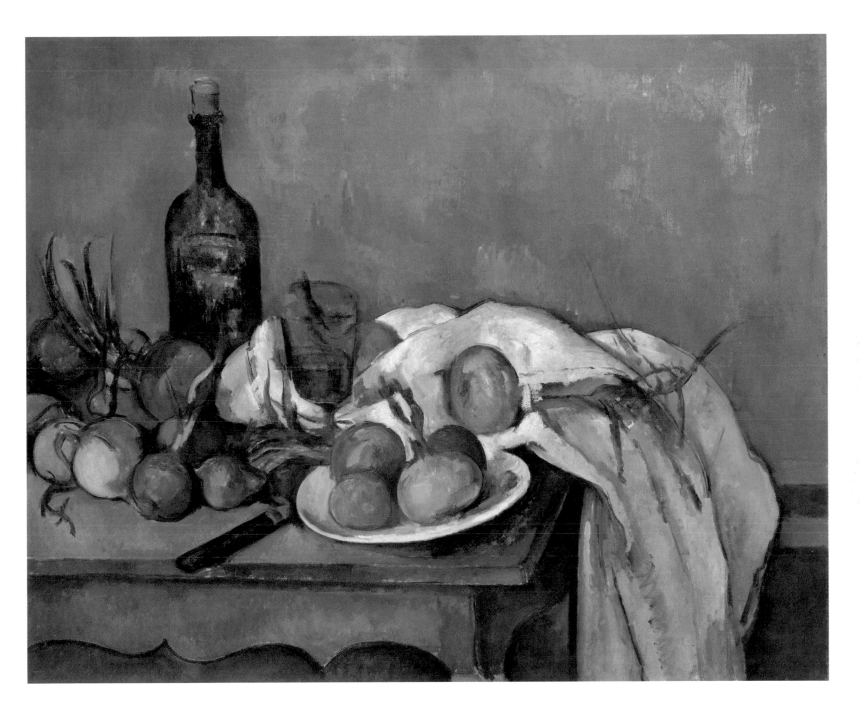

41 Paul Cézanne
France 1839–1906

Kitchen table (Still-life with basket)
(*La table de cuisine (Nature morte au panier)*) 1888–90
oil on canvas, 65.0 x 80.0 cm
Musée d'Orsay, Paris, bequest of Auguste Pellerin 1929, RF 2819
© RMN (Musée d'Orsay) / Hervé Lewandowski

Objects—pots, fruit, basket, cloths—are assembled on a table in a simply furnished kitchen. The artist nods to the historical tradition of still-life in previous centuries, from Italy and Spain, to the Netherlands and France. But really, as always, Cézanne's subject is painting itself. How can you render the real world using liquid pigments on a stretched flat canvas? Cézanne investigated forms, reducing them to simpler geometries, and reassembling them in complex combinations to represent painted truth.

The artist pushes the table and cloth close to the viewer, cropping them at the bottom. Individual pots sit uneasily on an impossibly tilted plane of table-top. The grey ginger-pot has no surface left to sit on, and neither has the large basket at the back. But they demand their space, painted from above, or front-on, as the composition requires. Similarly, the table, cupboard and chair line up diagonally on the left, none holding any probable perspective. A wooden member intrudes on the right, casting an unbelievable shadow, and belonging to what whole? It could be an errant stool, or ladder leg, perhaps. But compositionally, it continues the frame around the objects which begins in the lower-left corner with the table edge, and is then taken up by the line where the back wall meets the floor. The internal frames compress the composition even further, and force an overall lozenge shape.

And yet, each distorted element has its convincing volume, with a glorious harmony of red, green and yellow fruit. Warm hues of wood and cane contrast with the cooler white, grey and purple of cloth and ceramics. The loop of the ginger-pot is repeated larger in the basket handle, smaller and vertically in the handle of the coffee-pot, accentuating the rounded shapes of the fruit. All these circular forms cascade diagonally down the canvas, through the folds of the two white cloths which double and then unify the composition. *Kitchen table* is a very rich and variously populated still-life in Cézanne's oeuvre (see cat. 40) with details such as the floral decoration on the china coffee jug repeated on the round pot, then writ large in the flower painting on the wall.

In his lifetime, Cézanne was ridiculed for lack of conventional artistic skill, and excoriated for his aesthetic eccentricity. In other words, he did not paint like other people. But he stated 'I shall astonish Paris with an apple.'[1] Here he astonishes us with apples, pears and melons which jostle for their own space, and demand our attention like no static still-life or *nature morte* ('dead nature', as the French call it) ever could. Like most truly modern artists, Cézanne was wrestling with doubts, rather than representing certainties.

Christine Dixon

1 Quoted in Gustave Geffroy, *Claude Monet, sa vie, son temps, son œuvre*, Paris: Crès 1922, in Michael Doran (ed.) and Julia Lawrence Cochran (trans.), *Conversations with Cézanne*, Berkeley: University of California Press 2001, p. 16.

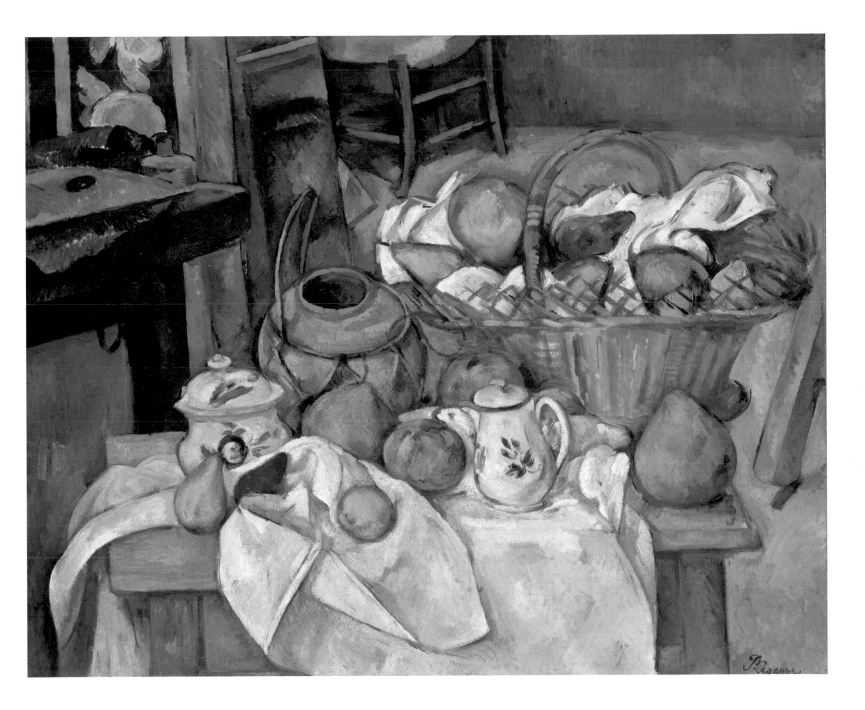

42 Paul Gauguin

France 1848 – Marquesas Islands 1903

Still-life with fan (Nature morte à l'éventail) c. 1889
oil on canvas, 50.0 x 61.0 cm

Musée d'Orsay, Paris, transferred in application of the Peace Treaty
with Japan 1959, RF 1959-7
© RMN (Musée d'Orsay) / Hervé Lewandowski

Gauguin produced around one hundred still-life paintings, forming one-sixth of his total oeuvre. He held firm views on depicting nature, of which his still-lifes are the exemplar. He railed against the prevailing Realist aesthetic. In an incident over lunch with several younger followers, Gauguin lost his temper when describing the transposition of an object to canvas. Gesturing towards a dish of apples, he shouted: 'For goodness' sake, that's not an apple, it's a circle!'[1]

Along with fruit, Gauguin often incorporated his own belongings into his still-lifes, especially favourite creations, which personalise the compositions and act as a second signature. The present work includes a Japanese-inspired fan and a ceramic pot, both of which also appear in his portrait, *Madame Alexandre Kohler* 1887–88.[2]

As one of the second wave of French artists who made fans in the Japanese manner,[3] Gauguin produced around twenty in pastel, gouache and watercolour, mistakenly hoping for their commercial success. They display similar themes to his paintings. In the fan depicted here, a distinctively clothed Breton woman bends in a field surrounded by russet-leafed trees.

The spatial arrangements in this work are unusual. Gauguin has placed the fruit on an undefined surface. The knife, designed to add a perception of depth, protrudes into an abyss of background. The fan encloses the back of the still-life without suggesting the edge of the table or a wall.

In *Still-life with fan* Gauguin also experiments with a combination of stylistic influences. He owned several still-life paintings by Cézanne, and borrowed and adapted the older artist's use of small repetitious diagonal brushstrokes for rendering his fruit. Degas was another artist with whom Gauguin exchanged ideas. In *Still-life with fan,* he adopts Degas' signature cropping device, with one group of fruit sliced in half by the edge of the canvas. Gauguin also gleaned ideas while working with the ceramicist Ernest Chaplet during the winter of 1886–87. Named *Rats with horns,*[4] the pot included in *Still-life with fan* was Gauguin's particular favourite. He rejected perfect glazed porcelain, believing it had 'killed ceramics'. He preferred the earthy hand-made style— 'God gave man a little bit of mud … and with it a little bit of genius.'[5]

Simeran Maxwell

1 Quoted in Claire Frèches-Thory and Antoine Terrasse, *The Nabis: Bonnard, Vuillard and their circle*, Paris: Flammarion 1990, p. 67.

2 National Gallery of Art, Washington D.C.

3 Fans became popular in France with the influx of Japanese paraphernalia from the eighteenth century. Impressionists, like Degas, tapped into this market and painted fans with their own designs.

4 Unknown date, and present whereabouts unknown.

5 Quoted in *A secret history of clay: from Gauguin to Gormley*, London: Tate Publishing 2004, p. 66.

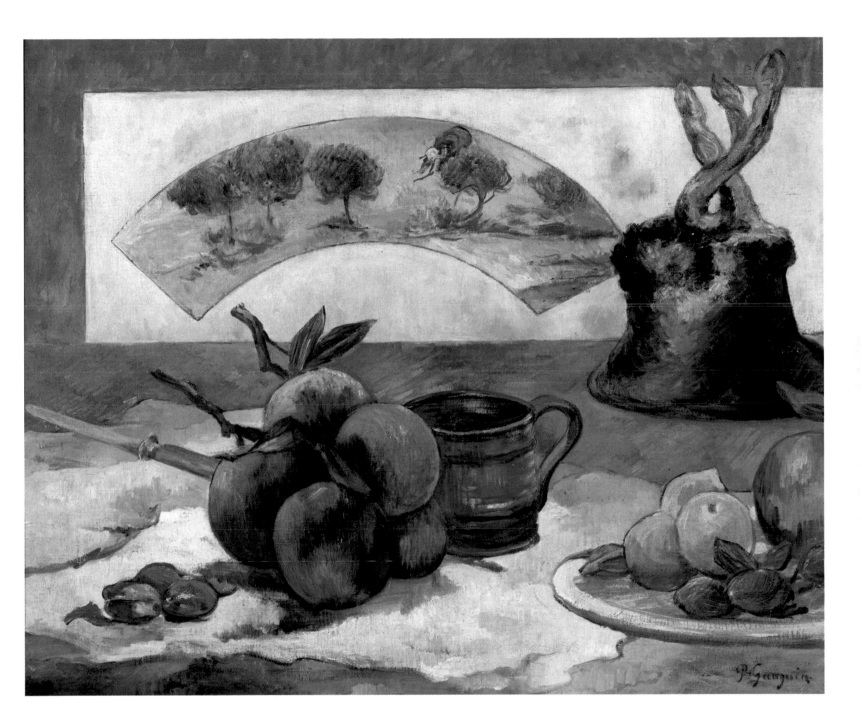

151

43 Paul Sérusier

France 1864–1927

Still-life: the artist's studio
(*Nature morte: l'atelier de l'artiste*) 1891
oil on canvas, 60.0 x 73.0 cm
Musée d'Orsay, Paris, bequest of Henriette Boutaric 1984,
RF 1984-11
© RMN (Musée d'Orsay) / Hervé Lewandowski

It was perhaps unfair of the critic Albert Aurier to malign Sérusier's early work as 'an almost slavish imitation of Gauguin'[1], yet when looking at *Still-life: the artist's studio* it seems this claim may be justified. The subject matter is almost identical to that of Gauguin, and the knife to the left of the composition rests in a strikingly similar position to Gauguin's in his *Still-life with fan* c.1889 (cat. 42).

But Sérusier's painting is not simply a copy. Both Gauguin and Sérusier were heavily influenced by the work of Cézanne (cats 40 and 41), in whose art Sérusier found a tangible expression of his desire to imbue subjects from the everyday with a sense of the spiritual. Of Cézanne's still-lifes with apples he said:

> He is … the pure painter … The purpose, even the concept of the object represented, disappears before the charm of his coloured forms … Of an apple by Cézanne one says: How beautiful! One would not peel it; one would like to copy it. It is in that that the spiritual power of Cézanne consists.[2]

While Cezanne's apples exemplified Sérusier's concerns, Gauguin's important colour lesson in the Bois d'Amour gave Sérusier a means to express them further (cat. 72).

In *Still-life: the artist's studio* Sérusier uses colour as an expression of emotion. The vibrant red of the table, a direct pictorial quotation from Gauguin's *Vision after the sermon (Jacob wrestling with the angel)* 1888[3], invigorates an otherwise neutral interior scene. Laid across this red plane the cobalt blue of the knife's blade leads the eye straight out the window and across the roofs of Paris, which gleam with bright oranges and flecks of yellow. The scene is further invigorated by Sérusier's odd juxtaposition of spatial planes: horizontals are created by

the table, the window sill and a distant building, and then cut through by the diagonals of roofs and the folds of the cloth. The whole composition is balanced by the strong, black verticals of the chair, echoed in the window frame and the distant chimney-stacks.

After experimental paintings such as this, Aurier's critical comment more fairly notes that Sérusier 'did not wait long to free his own personality and his later works show a poetic symbolism … a beauty and masterly synthesis of lines and colours'.[4]

Emilie Owens

1 Quoted in John Rewald, *Post Impressionism from van Gogh to Gauguin*, 2nd edn, New York: Museum of Modern Art 1962, p. 519.

2 Quoted in Maurice Denis, 'Cézanne', in Charles Harrison and Paul Wood (eds), *Art in theory 1900–2000: an anthology of changing ideas*, Oxford: Blackwell Publishing 2003, p. 42.

3 National Gallery of Scotland, Edinburgh.

4 Quoted in Rewald, p. 519.

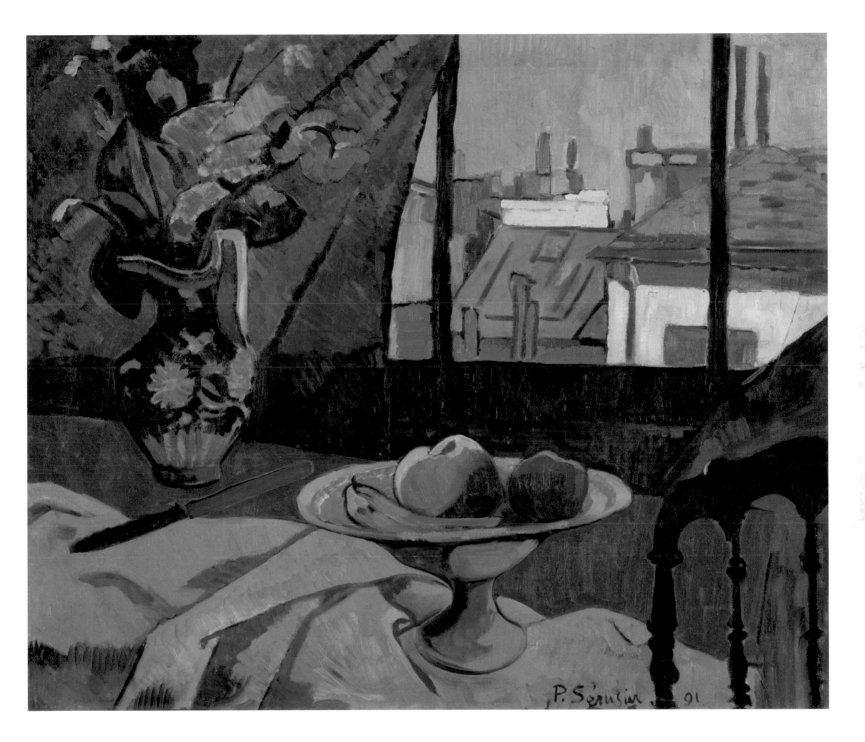

44 Pablo Picasso

Spain 1881 – France 1973

Large still-life (*Grande nature morte*) 1917
oil on canvas, 87.0 x 116.0 cm

Musée de l'Orangerie, Paris, Jean Walter and Paul Guillaume
collection, RF 1963-80
© RMN / Hervé Lewandowski
© Pablo Picasso. Succession Picasso/Licensed by Viscopy, 2009

Each generation of Cézanne devotees interprets his art in a different light. Picasso was one of many artists who claimed a direct artistic descendancy from Cézanne. (He was like 'our father', Picasso was later to recall.) Other followers had been Gauguin, the Nabis and, later, Henri Matisse and the Fauves, and George Braque and the Cubists. By 1906 Cézanne's influence was 'everywhere', according to Picasso, in one of his rare published comments on the master's influence: 'The art of composition, of the opposition of forms and of rhythms of colours was rapidly becoming commonplace.'[1]

A major retrospective of Cézanne's work held in October 1907 at the Salon d'Automne furthered the older artist's authority on a younger generation. Each artist had interpreted Cézanne in their own way and harnessed his lessons in their own artistic development. In Picasso's case, the effect was profound, his response dramatic. Beginning with reinterpretations of Cézanne's bathers, Picasso went on to explore that other great motif of the older artist—the still-life. Adopting Cézanne's spatial ploy of tilting the picture plane towards the viewer, Picasso was able to more fully understand the volume of his subject.

In his early Cubist phase and under the influence of Cézanne, Picasso (along with Braque) revealed the depth of a subject by depicting its different planes and adopting Cézanne's painting technique of laying down hatched brushstrokes of paint. In this way, the radical young Cubists broke down the tradition of three-dimensional space and replaced it with the depiction of a subject from multiple viewpoints.

In his later Cubist explorations, Picasso went on to dissect his own process. In *Large still-life* he has taken Cézanne's favoured still-life motifs—a wine bottle, a glass, a flask and a fruit bowl—extracted these individual elements, destroyed them, and then reconfigured them. Taking yet another favourite object from Cézanne's repertoire, the table, Picasso has cropped it just as Cézanne would, but let it hover in space within the canvas. The table and its contents are tilted towards the viewer in the manner of Cézanne—but it is as if Picasso has pulled them to pieces and then returned them to their tabletop in a new and radically distorted appearance.

Jane Kinsman

1 Quoted in John Elderfield, 'Picasso's extreme Cézanne', in *Cézanne and beyond*, Philadelphia: Philadelphia Art Museum 2009, p. 213. This essay provides both a masterful summary and interpretation of the influence of the older artist on Picasso.

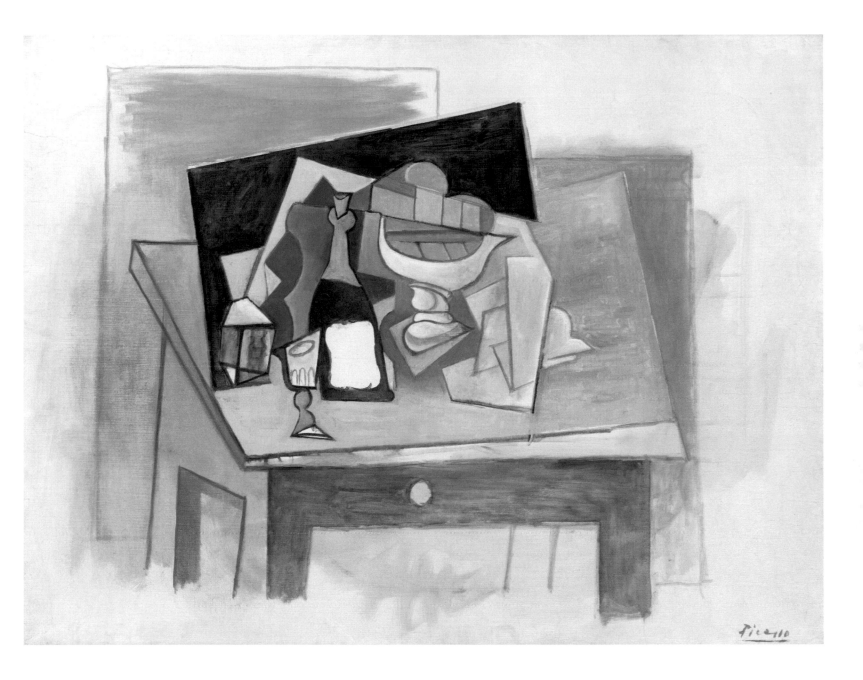

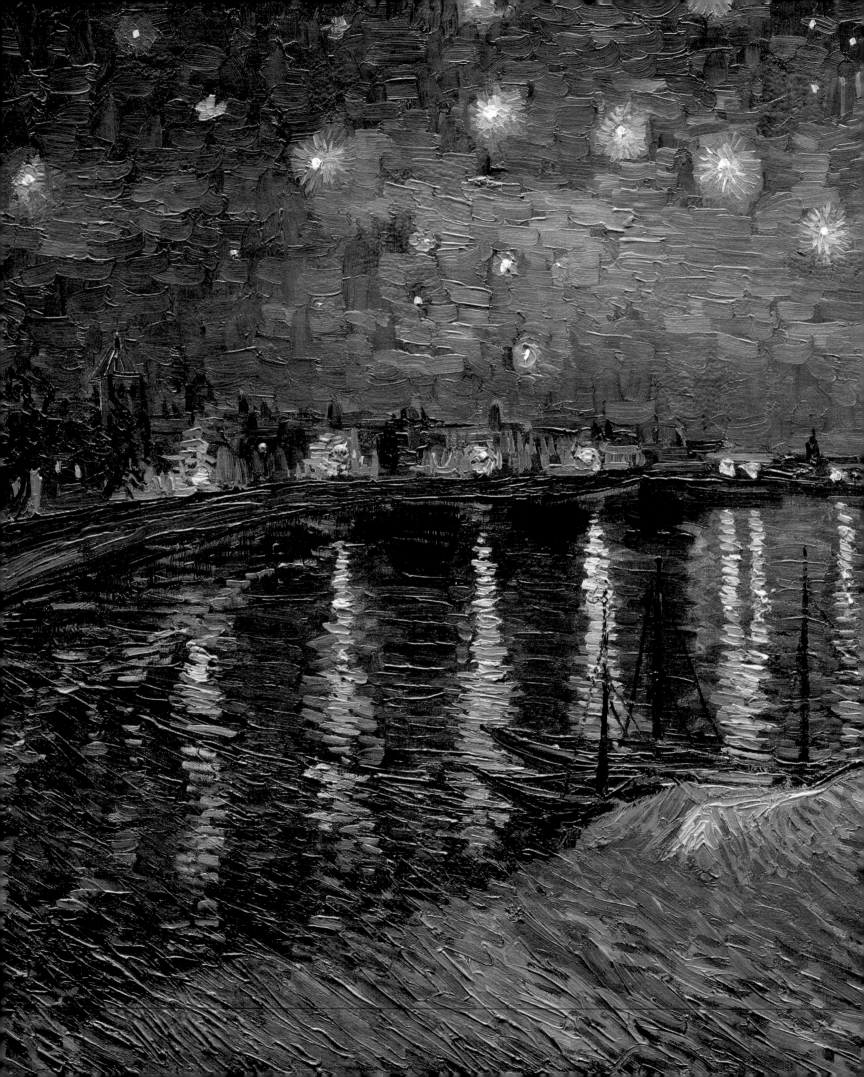

Van Gogh and Toulouse-Lautrec

Henri de Toulouse-Lautrec

Vincent van Gogh

45 Vincent van Gogh
The Netherlands 1853 – France 1890

Restaurant de la Sirène at Asnières
(*Le restaurant de la Sirène à Asnières*) 1887
oil on canvas, 54.5 x 65.5 cm

Musée d'Orsay, Paris, bequest of Joseph Reinhard 1921, RF 2325
© RMN (Musée d'Orsay) / Gérard Blot

We painted on the banks of the river and ate in a country café, and we returned on foot to Paris, through the streets of Saint-Ouen and Clichy. Van Gogh wore a blue zinc worker's smock and painted coloured smudges on the sleeves.—Paul Signac[1]

Van Gogh arrived in Paris on 27 February 1886, and left for Arles in February 1888. During this time he completed 230 paintings. His artistic metamorphoses— from rustic, Millet-like realist to radical colourist—is one of the more dramatic in nineteenth-century art. He arrived in Paris at a time when Monet, Auguste Renoir and Pissarro were rethinking their positions. Gauguin and Seurat were jostling for leadership of the avant-garde, and the younger trio of Bernard, Toulouse-Lautrec and Louis Anquetin were searching for signs and symbols in medieval glass, Japanese art and popular prints.[2] The young artists were eager to move beyond Impressionism. As they redefined their work both in terms of subject matter and stylistically, van Gogh began to refer to himself and his contemporaries as 'painters of the petit boulevard'.[3]

In 1887 van Gogh worked at Asnières—with Signac in late April and May, and, later, in the autumn, with Bernard. Asnières, on the banks of the Seine, was then one of the expanding suburbs of Paris, and its modernity attracted many artists: it was neither city nor country and, with a shifting population and volatile class structure, seemed in a constant state of flux. It was also at a walking distance from Montmartre, where Vincent lived with Theo. At Asnières Van Gogh painted riverside restaurants, public gardens, bridges and factories. As he later wrote to his sister Wilhelmina, Asnières allowed him to see 'more colour'.[4]

The Restaurant de la Sirène, at 7 Boulevard de la Seine (now Quai du Docteur-Derveux) near the Pont Asnières, was a substantial establishment. Van Gogh renders the buildings, sky and road in delicate greys, blues, yellows and tans, and then reanimates the whole scene with a rich brocade of climbing plants, flickering flags, and figures looking down from the second-floor balcony. In some sections, such as the shuttered facade of the tallest building at left, van Gogh applies his paint so thinly that the ground and drawing are visible. He uses the same thin brushstrokes to scratch the text on the hoardings. Touches of pure white are used to highlight elements of the facade and details such as the shirt of the figure on the street. The three men crouching over the cafe table are portrayed with minimal brushstrokes. The *Restaurant de la Sirène at Asnières* demonstrates van Gogh's absorption of both Impressionist and Pointillist techniques. Later paintings (cats 46–49) show him using the pure colours and intensely Expressionist marks for which he is best known.

Lucina Ward

1 As told to Gustave Coquiot, 1923. Quoted in Jan Hulsker, *The new complete van Gogh: paintings, drawings, sketches*, Amsterdam: J.M. Meulenhoff; Philadelphia: John Benjamins 1996, p. 282.

2 Ronald Pickvance, 'Van Gogh à Paris. Paris, Musée d'Orsay', *The Burlington Magazine*, vol. 130, no. 1021, April 1988, pp. 311–13; see also Bogomila Welsh-Ovcharov, *Van Gogh à Paris*, Paris: Ministère de la culture et de la communication: Editions de la Réunion des musées nationaux 1988, cat. 44, p. 126.

3 Cornelia Homburg, Elizabeth C. Childs, John House et al., *Vincent van Gogh and the painters of the Petit Boulevard*, Saint Louis: Saint Louis Art Museum in association with Rizzoli 2001, p. 21.

4 Paris, summer/autumn 1887, letter WO1, viewed 1 September 2009, www.vggallery.com/letter/557_V-W_W1.pdf.

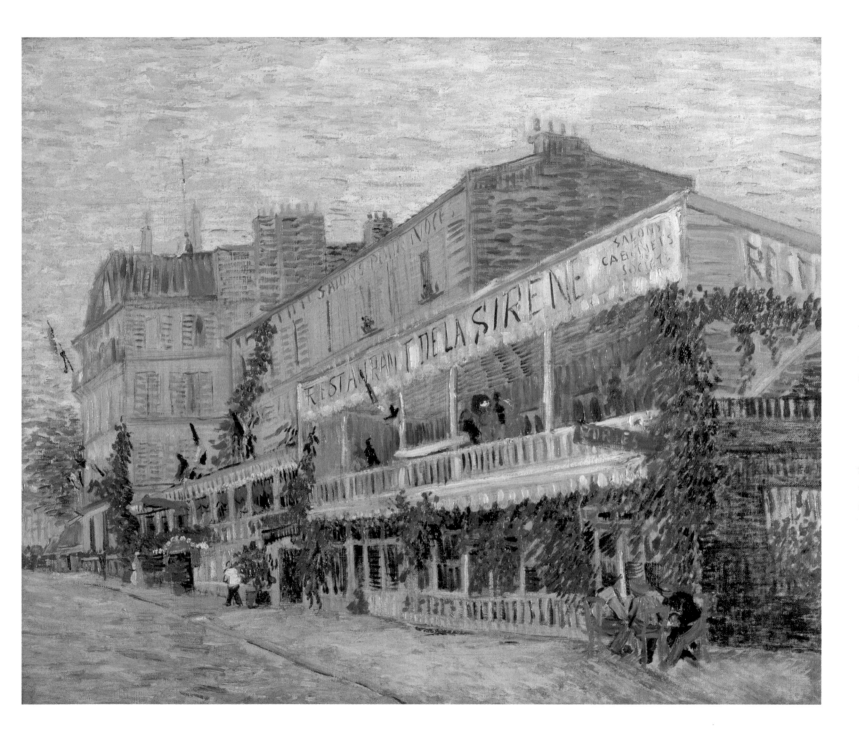

46 Vincent van Gogh

The Netherlands 1853 – France 1890

Imperial Crown fritillaries in a copper vase
(*Fritillaires couronne impériale dans un vase de cuivre*) 1887
oil on canvas, 73.0 x 60.5 cm

Musée d'Orsay, bequest of Count Isaac de Camondo 1911, RF 1989
© RMN (Musée d'Orsay) / Hervé Lewandowski

From March 1886 to February 1888 van Gogh lived with his brother Theo in Paris. Therefore almost none of their usually voluminous correspondence exists for this time. This period in Paris was Vincent's first encounter with Impressionism, and the resultant brightening of his palette can be seen, especially in the flower studies he painted. Theo wrote to their mother in July 1886:

> He is mainly painting flowers—with the object to put a more lively colour into his next set of pictures. He is also more cheerful than in the past and people here like him. To give you proof: hardly a day passes that he is not asked to go to the studios of well-known painters, or they come to see him. He also has acquaintances who give him a bunch of flowers every week which may serve him as models.[1]

Both Monet and Gustave Caillebotte painted flowers, and Theo's position as a dealer with Boussod, Valadon & Co. (successors to Goupil & Co.) may have allowed Vincent to see these works. It was, nonetheless, the Marseilles painter Adolphe Monticelli who influenced Vincent most, especially in his vigorous impasto and rich colours:

> In 1886 van Gogh discovered some of Monticelli's mature works in the Galerie Delarebeyrette, Paris. He began to imitate Monticelli's flower-pieces, for example in *Hollyhocks in a one-eared vase*[2] and later bought six paintings for his personal collection ... In 1890 van Gogh and his brother Theo funded the publication of the first book about Monticelli ... Most of Monticelli's experimental and stylistic innovations have been ascribed to van Gogh, although van Gogh readily acknowledged his indebtedness to the Marseilles painter.[3]

The spectacular blooms of the Imperial Crown or Kaiser's Crown fritillary can be seen in European gardens in late April and May. Here they seem to substitute for the sun's flames in front of a starry sky, the orange and gold petals whirling like a corona above the shining copper bowl. Striated green crowns are repeated in the abundant leaves and stems of the flowers, then dissolve into the neutral strokes of the brown table mat. Sparkling lights of tiny white spots glisten on the profoundly blue ground. Around September 1886 Vincent wrote in English to his acquaintance, the painter Horace M. Livens, explaining his strategy. He had no money to pay models, therefore:

> I have made a series of colour studies in painting, simply flowers, red poppies, blue corn flowers and myosotys, white and rose roses, yellow chrysanthemums—seeking oppositions of blue with orange, red and green, yellow and violet seeking *les tons rompus et neutres* [worn-out and neutral tones] to harmonize brutal extremes. Trying to render intense colour and not a grey harmony ... So as we said at the time: in colour seeking life the true drawing is modelling with colour.[4]

Christine Dixon

1 Viewed 28 August 2009, www.webexhibits.org/vangogh/letter/17/etc-fam-1886.htm?qp=health.dental.

2 1886, Kunsthaus Zürich, Zurich.

3 Aaron Sheon, 'Monticelli, Adolphe', in Jane Turner (ed.), *The dictionary of art*, vol. 22, London: Macmillan 1996, pp. 29–30.

4 Paris, around August–October 1886, letter 459a, viewed 28 August 2009, www.vggallery.com/letters/553_V-T_459a.pdf.

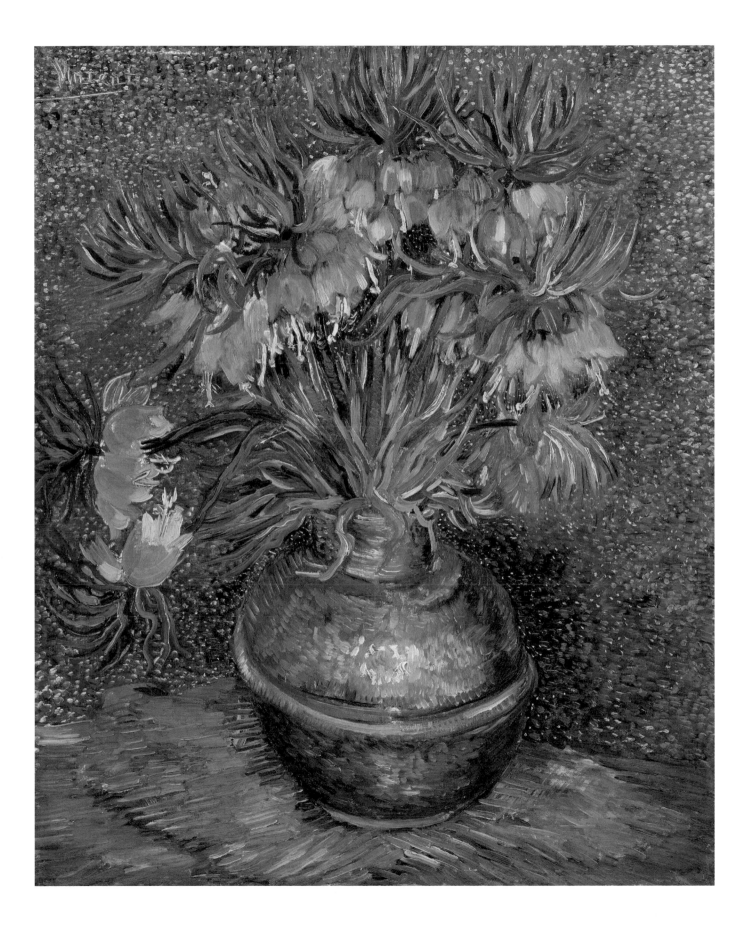

47 Vincent van Gogh

The Netherlands 1853 – France 1890

Portrait of the artist (*Portrait de l'artiste*) 1887
oil on canvas, 44.1 x 35.1 cm
Musée d'Orsay, Paris, gift of Jacques Laroche 1947, RF 1947-28
© RMN (Musée d'Orsay) / Gérard Blot

Vincent van Gogh arrived in Paris in late February 1886, landing suddenly on his brother Theo by means of a hand-delivered message asking to meet at the Musée du Louvre. He knew almost nothing of contemporary art, having spent his earlier months in Paris in 1875–76 working as an art dealer and looking at Old Master paintings. He was suspicious of the brightly coloured Impressionist manner of painting which had taken over Paris in the 1880s. He enrolled at Cormon's studio, where he encountered Toulouse-Lautrec and the Australian John Russell, who both painted his portrait (see pp. 45 and 46). Theo organised exhibitions of work by Monet and Pissarro, through which Vincent became familiar with the mature style of Impressionism. It was the explosion of Seurat's example, possibly the exhibition of his *A Sunday afternoon on the island of La Grande Jatte* 1886[1] (cats 13 and 14) at the Société des Artistes Indépendants that summer, which convinced Vincent of the expressive possibilities of colour in art.

The artist interrogates himself, and us, in a conventional head-and-shoulders view of his reflection. Painting oneself in a mirror had a lengthy art-historical tradition, from the Renaissance to Rembrandt, as well as contemporary examples. But it was not mere external appearances that van Gogh wished to convey; as he wrote to his sister around 22 June 1888, 'one seeks after a deeper resemblance than the photographer's'.[2] Although never a doctrinaire Neo-Impressionist, nor a follower of Seurat's theory of Luminism, van Gogh experimented with the idea that colour opposites—red/green, yellow/purple, blue/orange—produced brilliant effects when juxtaposed without the mediation of middle tones. He had earlier written to Theo: 'One finds the same thing in, say, portraits by Rembrandt. It is more than nature, something of a revelation.'[3]

Like a glowing sun in the dark blue heavens, van Gogh's golden head dominates the canvas. All life and energy emanates outwards from his face, stroked across his features and continuing into his leonine hair and darker orange beard. Blue circles for eyes and blue strokes through the flesh provide the necessary complementaries. A slashing band of white collar allows a separation from the planes of blue jacket and vest, modelled by contrasting bright and pale orange stripes and set off against a light blue cravat. The darker blue background is flatter, made by complex strokes of cross-hatching. Van Gogh painted and drew himself more than forty times in his short life as an artist. This self-portrait is one of the most considered views of the art student, painting himself as an example of the current aesthetic theory, yet adding that element of searching enquiry into self which he had absorbed from Rembrandt's example.

Christine Dixon

1 The Art Institute of Chicago, Chicago.

2 Letter W4, viewed 18 August 2009, http://www.vggallery.com/letters/610_V-W_W4.pdf.

3 Letter to Theo van Gogh, c.11 July 1883, letter 299, viewed 18 August 2009, http://www.vggallery.com/letters/355_V-T_299.pdf.

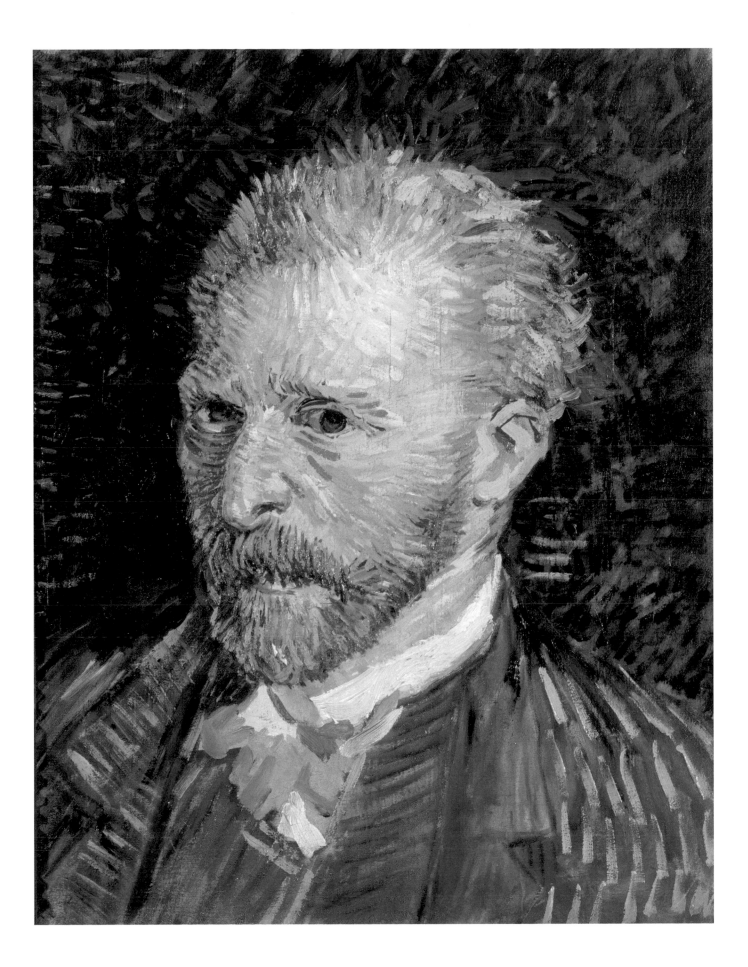

163

48　Vincent van Gogh

The Netherlands 1853 – France 1890

Eugène Boch or *The poet (Le poète)* 1888
oil on canvas, 60.0 x 45.0 cm

Musée d'Orsay, Paris, bequest of Eugène Boch, through the
Société des Amis du Louvre 1941, RF 1944-9
© RMN (Musée d'Orsay) / Hervé Lewandowski

Although van Gogh announced that he intended to acquaint the people of Arles with art through the medium of portraiture, he struggled to find suitable models in the south. Despite this fastidiousness, he was passionately committed to portraiture. In a letter to his brother Theo on 3 September 1888, van Gogh writes:

> And in a picture I want to say something comforting, as music is comforting. I want to paint men and women with that something of the eternal which the halo used to symbolise and which we seek to confer by actual radiance and vibration of our colourings … Ah! portraiture, portraiture with the thought, the soul of the model in it, that is what I think must come![1]

Rather than simply reproduce physical likenesses, van Gogh wanted to explore symbolism and mystery by using colour. He thought he might achieve this through a portrait of a fellow artist. In mid June 1888 van Gogh met Eugène Boch (1855–1941), a Belgian painter (and brother of Anna Boch, a founding member of Les XX), who was staying nearby in Fontvieille. Van Gogh spent considerable time in Boch's company, fruitlessly planning future artist colonies. This painting sprang from their friendship, and van Gogh imbued it with the admiration he held for his Belgian colleague.

Initially van Gogh recreated Boch's likeness as accurately as possible, before beginning to exaggerate the colours and tones. He also added supplementary elements: a thin halo encircles Boch's head with gold, and the background becomes an infinite starry night.

> Behind the head, instead of painting the ordinary wall of the mean room, I paint infinity, a plain background of the richest blue that I can contrive, and by this simple combination the bright head against the rich blue background gets a mysterious effect, like a star in the sky, in the depths of an azure sky.[2]

This work, which van Gogh originally titled *The poet*, was paired with an opposing portrait of Lieutenant Paul-Eugène Milliet, which he named *The lover* 1888.[3] The poet was designed to represent 'contemplation', while *The lover* would evoke a sense of 'activity'. Hung side by side in his bedroom at Arles, these works comprised part of a larger series, *Décoration*, which van Gogh created for his home. The two complementary works are visible on the wall in one of the versions of *Van Gogh's bedroom at Arles* 1888.[4] Van Gogh accentuated his application of colour theory by contrasting opposite colours not only within each individual work, but also between the pair of portraits when hung together.

Simeran Maxwell

1　Letter 531, viewed 1 September 2009, www.vggallery.com/letters/652_V-T_531.pdf.

2　Vincent to Theo, letter 520, 8 August 1888, viewed 1 September 2009, www.vggallery.com/letters/638_V-T_520.pdf.

3　Kröller-Müller Museum, Otterlo.

4　Van Gogh Museum, Amsterdam.

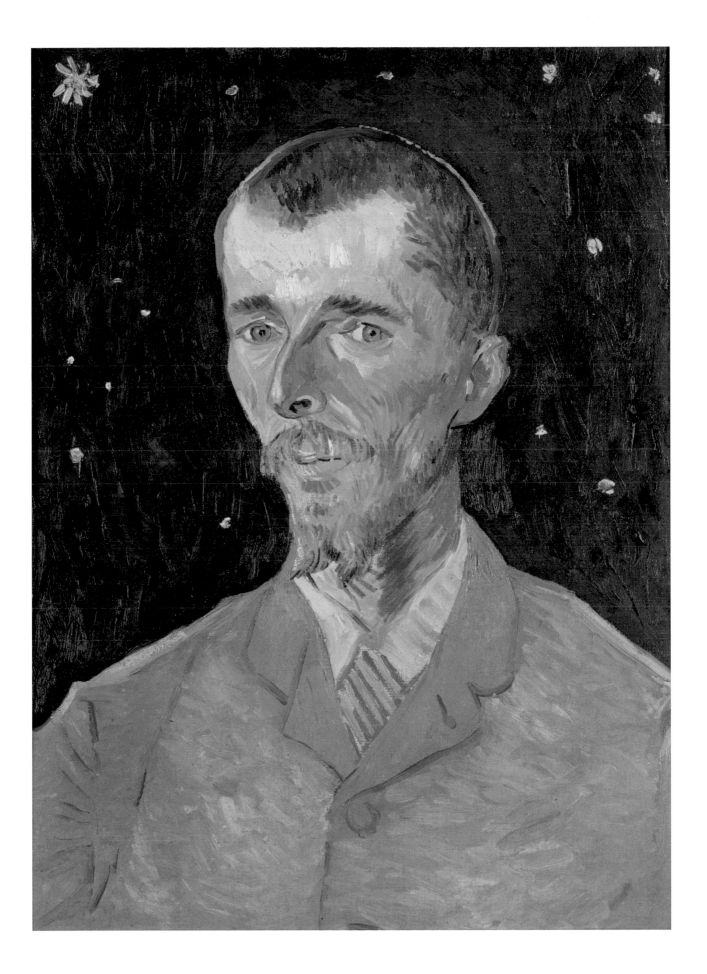

49 Vincent van Gogh

The Netherlands 1853 – France 1890

Starry night (*La nuit étoilée*) 1888
oil on canvas, 72.5 x 92.0 cm

Musée d'Orsay, Paris, gift of Mr and Mrs Robert Kahn-Sriber,
in memory of Mr and Mrs Fernand Moch 1975, RF 1975-19
© RMN (Musée d'Orsay) / Hervé Lewandowski

Van Gogh arrived in Arles in February 1888. In this small Provençal town and the surrounding countryside he was to spend an extraordinarily productive period painting, drawing and writing. He found the colours of the location—the skies, the river Rhône and the atmosphere—spellbinding, and reminiscent of the scenes found in Japanese *ukiyo-e* prints. The great expanse of the night sky was just as tantalising as that of the daytime, and the artist was keen to capture its majesty and its subtleties, writing to his sister in September 1888:

> At present I absolutely want to paint a starry sky. It often seems to me that night is still more richly coloured than the day, having hues of the most intense violets, blues and greens. If only you pay attention to it you will see that certain stars are citron-yellow, others have a pink glow, or a green blue and forget-me-not brilliance. And without my expatiating on this theme it will be clear that putting little white dots on a blue-black surface is not enough.[1]

He was determined to capture the richness of the night colours on the spot, just as the Impressionists painted in situ during daylight—although jokingly he confided to his sister that, 'Of course it's true that in the dark I may mistake a blue for a green, a blue-lilac for a pink-lilac, for you cannot rightly distinguish the quality of a hue. But it is the only way to get rid of the conventional night scenes with their poor sallow whitish light.'[2]

Van Gogh painted several canvases of the night skies as an accompaniment to a cafe scene or portrait (cat. 48), but with *Starry night* he possessed the confidence to have the massive night sky hanging over a gas-lit town with reflections in the water as his principal motif, with just the small inclusion of two locals on the foreshore. Van Gogh's true subject here is the drama and majesty of the night sky, 'the starry sky with the Great Bear'.[3] This work reveals all the wondrous colours of the sky, the reflections of the scene, and the striking contrast between the natural beauty of the stars and the artificial gas lights.

Painting the night sky was a serious preoccupation which engaged van Gogh throughout the summer months in Arles. His fears that he might not be able to meet the challenge were expressed to Bernard in a letter of June 1888:

> Alas, alas, it is just as our excellent fellow Cyprien says in J.K. Huysmans' 'En ménage': the most beautiful paintings are those which you dream about when you lie in bed smoking a pipe, but which you never paint.[4]

Despite his concerns, it is with *Starry night* that van Gogh came close to painting the 'unspeakable perfection' he so yearned to achieve—just two years before his life was cut short.

Jane Kinsman

1 Letter W 7, viewed 18 August 2009, http://www.vggallery.com/letters/656_V-W_W7.pdf.

2 Letter W 7, viewed 18 August 2009, http://www.vggallery.com/letters/656_V-W_W7.pdf.

3 A 'sparkling of pink and green on the cobalt blue field of the night sky, whereas the lights of the town and its ruthless reflections are red-gold and bronzed green', as he was to describe it to the poet Eugène Boch. 2 October 1888, letter 553b, viewed 18 August 2009http://www.vggallery.com/letters/670_V-E_553b.pdf.

4 Letter B7, viewed 18 August 2009, http://www.vggallery.com/letters/608_V-B_B7.pdf.

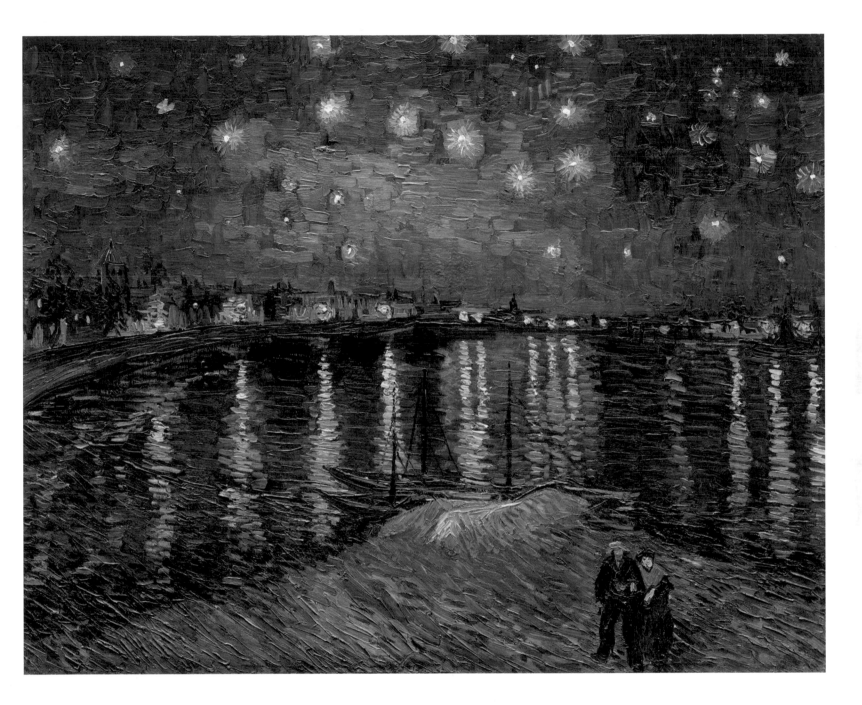

50 Vincent van Gogh

The Netherlands 1853 – France 1890

Caravans, gypsy camp near Arles
(*Les roulottes, campement de bohémiens aux environs d'Arles*) 1888
oil on canvas, 45.0 x 51.0 cm

Musée d'Orsay, Paris, bequest of Mr and Mrs Raymond Koechlin 1931, RF 3670
© RMN (Musée d'Orsay) / Hervé Lewandowski

This energetic painting shows the transition from van Gogh's more naturalistic Paris works to the extravagant colour of the south. Van Gogh moved to Arles in February 1888 and in the space of fifteen months completed 200 paintings—almost one every two days—as well as more than 100 drawings and watercolours. He often appealed to his brother Theo in Paris for money for materials; when funds were short, he concentrated on drawing in ink, with reed-pens he carved himself. Van Gogh's intense pace strained his mind and body: he described himself as being

> like an actor on the stage in a difficult part, with a hundred things to think of at once in a single half hour. After that, the only thing to bring ease and distraction, in my case and other people's too, is to stun oneself with a lot of drinking or heavy smoking.[1]

Early in his time at Arles, probably at the end of May 1888, van Gogh took a trip to Les Saintes-Maries-de-la-Mer, a coastal village in the Camargue. In the nineteenth century this area was still a sterile salty plain of lagoons and marshes, populated by flamingos, wild bulls and white horses. Saintes-Maries was also the site of annual pilgrimages for many Romany who came to worship the relics of the Marys. The outing proved inspiring and van Gogh returned with three canvases—the glorious *View of Saintes-Maries*, as well as two seascapes[2]—and a dozen drawings which he later worked up into paintings. *Caravans* probably dates from August 1888, after his return to Arles: in a letter of mid August van Gogh refers to 'a little study of a roadside inn, with red and green carts'.[3]

In *Caravans, gypsy camp near Arles*, van Gogh alternates between thick impasto in the foreground and areas of the sky, and the sparse mid-section where the canvas shows through. In this and other paintings from the period, he worked rapidly, executing a 'succession of studies with quick yet coherent brushstrokes'.[4] Here we sense the artist's intense feeling at a unique moment, and at a specific site: nothing breaks the horizon except a windmill, itself the merest suggestion of a distant structure. The frieze of figures, vehicles and horses, also rendered with minimal means, seems designed to emphasise the flatness of the landscape. Only the tree at right and the scrubby vegetation at left offer refuge from the sun. The empty foreground adds to the feeling of harsh desolation, a suggestion, perhaps, of the peripheral position of gypsy people. The intensity of the light suggests the glorious palette of works to come, such as *Van Gogh's bedroom at Arles* (cat. 51). As van Gogh wrote in June 1888:

> Now that I have seen the sea here, I am absolutely convinced of the importance of staying in the Midi, and of positively piling it on, exaggerated colour—Africa [is] not so far away.[5]

Lucina Ward

1 Letter to Theo, Arles, 29 June 1888, letter 507, viewed 1 September 2009, www.vggallery.com/letters/615_V-T_507.pdf.

2 Kröller-Müller Museum, Otterlo; the marines are: *The sea at Les Saintes-Maries-de-la-Mer* 1888, Van Gogh Museum, Amsterdam; *Fishing boats at sea* 1888, Pushkin Museum, Moscow.

3 Lettter to Theo, 13 August 1888, letter 522, viewed 1 September 2009, www.vggallery .com/letters/639_V-T_522.pdf.

4 Bogomila Welsh-Ovcharov, *Van Gogh in Provence and Auvers*, n.l.:Hugh Lauter Levin Associates 1999, p. 71.

5 Letter to Theo, Arles, 4 June 1888, letter 500, viewed 1 September 2009, www.vggallery .com/letters/604_V-T_500.pdf.

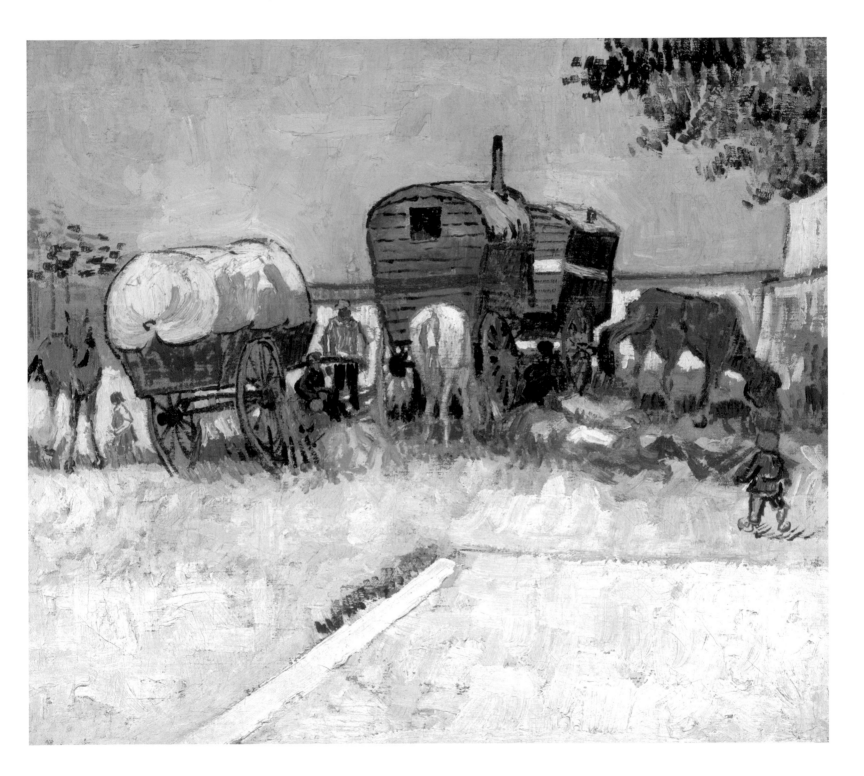

51 Vincent van Gogh

The Netherlands 1853 – France 1890

Van Gogh's bedroom at Arles
(*La chambre de van Gogh à Arles*) 1889
oil on canvas, 57.5 x 74.0 cm

Musée d'Orsay, Paris, transferred in application of the
Peace Treaty with Japan 1959, RF 1959-2
© RMN (Musée d'Orsay) / Hervé Lewandowski

After frantically completing five canvases in Arles in one week during 1888—depicting the gardens, roads, railway bridges and horse-drawn carriages in locations close to his house—van Gogh was exhausted. In a letter accompanied by a small sketch which has been dated to 16 October 1888, van Gogh wrote to his brother Theo about the next canvas he intended to paint:

> This time it's just simply my bedroom, only here colour is to do everything, and giving by its simplification a grander style to things, is to be suggestive here of *rest* or of sleep in general. In a word, looking at the picture ought to rest the brain, or rather the imagination.
>
> The walls are pale violet. The floor is of red tiles.
>
> The wood of the bed and chairs is the yellow of fresh butter, the sheets and pillows very light greenish-citron.
>
> The coverlet scarlet. The window green.
>
> The toilet table orange, the basin blue.
>
> The doors lilac.
>
> And that is all—there is nothing in this room with its closed shutters.
>
> The broad lines of the furniture again must express inviolable rest. Portraits on the walls, and a mirror and a towel and some clothes.
>
> The frame—as there is no white in the picture— will be white.[1]

In his state of fatigue, van Gogh had chosen to depict his bedroom in the Yellow House, where he rented four rooms for himself and for Gauguin—in anticipation of the artist's arrival, and his dream of establishing an artists' 'studio of the south'. The following day Vincent wrote to Gauguin, noting that 'I enormously enjoyed doing this interior of nothing at all. Of a simplicity à la Seurat'; and he explained his desire 'to express *absolute restfulness*'.[2]

The image of his own room remained a favourite for van Gogh. He later recorded: 'When I saw my canvases again after my illness the one that seemed the best to me was the "Bedroom".'[3] The artist made two further versions— including the canvas shown here.

The bedroom is an awkward shape (the outside wall with the open window is built at an angle) but van Gogh's style of painting it adds to the sense of unease—the room's details suggest something less than the 'restful' air that the artist would have us see.[4] The room's emptiness, the sweeping lines of the floor and the outline of the bed, the tilting chairs, tables and paintings on the wall, including his portrait, all evoke the artist's own personality—a 'self-portrait' capturing something of van Gogh's spirit without the presence of the sitter. Despite this, a certain haunting undercurrent, and sense of loneliness, seem to pervade the painting.

Jane Kinsman

1 Letter 554, viewed 28 August 2009, www.vggallery.com/ letters/683_V-T_554.pdf.

2 17 October 1888, letter B22, viewed 28 August 2009, www.vggallery. com/letters/684_V-B_B22.pdf.

3 Letter from van Gogh to Theo, Arles, 23 January 1889, letter 573, viewed 28 August 2009, www.vggallery.com/letters/731_V-T_573. pdf.

4 Roland Pickvance, in *Van Gogh in Arles*, New York: the Metropolitan Museum of Art 1984 p. 191, provides a plan of the bedroom with this external slanting wall and argues that this accounts for the dramatic distortion in the room.

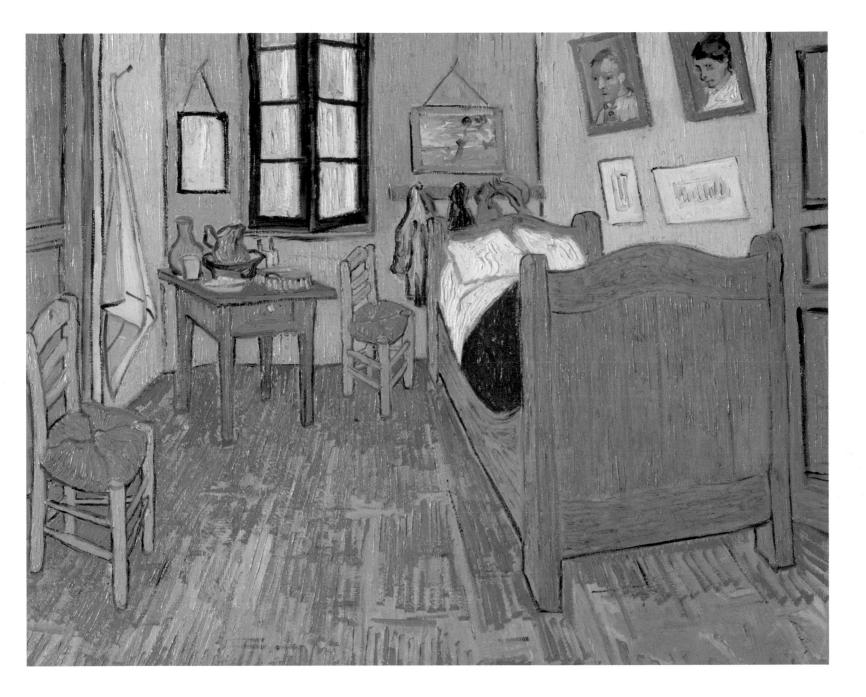

52 Henri de Toulouse-Lautrec

France 1864–1901

Redhead (Bathing) (*Rousse (La toilette)*) 1889
oil on card, 67.0 x 54.0 cm

Musée d'Orsay, Paris, bequest of Pierre Goujon 1914, RF 2242
© RMN (Musée d'Orsay) / Hervé Lewandowski

Redhead (Bathing) had long been thought to be another example of the artist's obsession with brothels at this time.[1] More recent research, however, has suggested an earlier date of 1889 for this work. From his home on the Rue Caulaincourt, Paris, Toulouse-Lautrec wrote to an art dealer in August 1890 about two paintings he had recently shown in Brussels with Les XX (The Twenty), a group of avant-garde Belgian artists. He described the work, listed as *Redhead* in the catalogue, as being: 'a red-haired woman seated on the floor, seen from the back, nude'.[2] The bright palette of blues, reds, greens and yellows, with highlighting in white, along with the loose brushwork, would support this date. At this time Toulouse-Lautrec often painted a finished work on cardboard. His technique of adding turpentine to thin the oil paint allowed him to develop the sketchy look seen in this painting.

What may have prompted Toulouse-Lautrec's interest in the subject at this time was the group of pastels that Degas displayed in the eighth and last Impressionist exhibition in Paris in 1886.[3] In 1889, Toulouse-Lautrec met Degas through their mutual friend the bassoonist Désiré Dihau. Toulouse-Lautrec was already a fan of Degas, and since the mid 1880s had adopted the subject-matter and style of the older artist.

Redhead reveals the artist's debt to Degas, but instead of the ungainly figures found in Degas' pastels, Toulouse-Lautrec has created a beautiful, slender figure with her back to the viewer and her rich red hair tied in a knot. The artist had a predilection for red-headed models and it has been proposed that a favourite model, Carmen Gaudin (1866?–1920), sat for this particular painting.[4]

As there are no known preliminary drawings for this work, it is likely the composition was painted directly from life. The wicker furniture and wooden floorboards suggest the likely location was Toulouse-Lautrec's studio, rather than a brothel. The selection of a favoured model, rather than a prostitute, would also indicate this. A photograph of the artist at work on *Training the new girls by Valentin 'the Boneless' (Moulin Rouge)*[5] in his studio at 7 Rue Tourlaque at this time shows a similar wicker chair and wooden floor to those seen on the left of *Redhead*.[6]

Certain props and clothing, however, imply that the woman was a courtesan—her state of undress, partially wrapped in a towel, while evidently wearing at least one dark stocking. The rest of her clothing is piled on a cane chair nearby, indicating she has recently disrobed. These details, loaded with innuendo, suggest she is in the business of doing sexual favours—another 'Nana' with a sponge.[7]

Jane Kinsman

1 M.G. Dortu, *Toulouse-Lautrec et son œuvre*, vol. 3, New York: Collectors Editions 1971, cat. P609, p. 374; *Toulouse-Lautrec*, Paris: Réunion des muées nationaux; London: South Bank Centre 1992, cat. 128, p. 412.

2 Letter 104, Lucien Goldschmidt and Herbert Schimmel (eds), *Unpublished correspondence of Henri de Toulouse-Lautrec*, London: Phaidon 1969, p. 117; *Toulouse-Lautrec*, London: South Bank Centre; Paris: Réunion des musées nationaux 1991, cat. 128, p. 412. Gale Barbara Murray, 'Henri de Toulouse-Lautrec: a checklist of revised dates, 1878–1891', *Gazette des Beaux-arts*, 6th series, vol. 95, 1980, pp. 77–90.

3 Shown washing and drying themselves, they shocked many in the art world because of their lack of idealisation. See Jane Kinsman, *Degas: the uncontested master*, Canberra: National Gallery of Australia 2008, pp. 30–31.

4 Julia Block Frey, 'Toulouse-Lautrec, Henri de', in Jane Turner (ed.), *The dictionary of art*, vol. 31, London: Macmillan 1996, p. 215. For the dating of some other images of Carmen Gaudin, see Murray, pp. 90–96.

5 *Dressage des nouvelles, par Valentin le Désossé (Moulin Rouge)*, 1889–1890, Philadelphia Museum of Art. Ill. in Gale B. Murray, *Toulouse-Lautrec: The formative years 1878–1891*, Oxford: Clarendon Press, 1991, ill. 80.

6 Photograph by Maurice Joyant.

7 Nana: the main character in Emile Zola's novel of that name (pub. 1880).

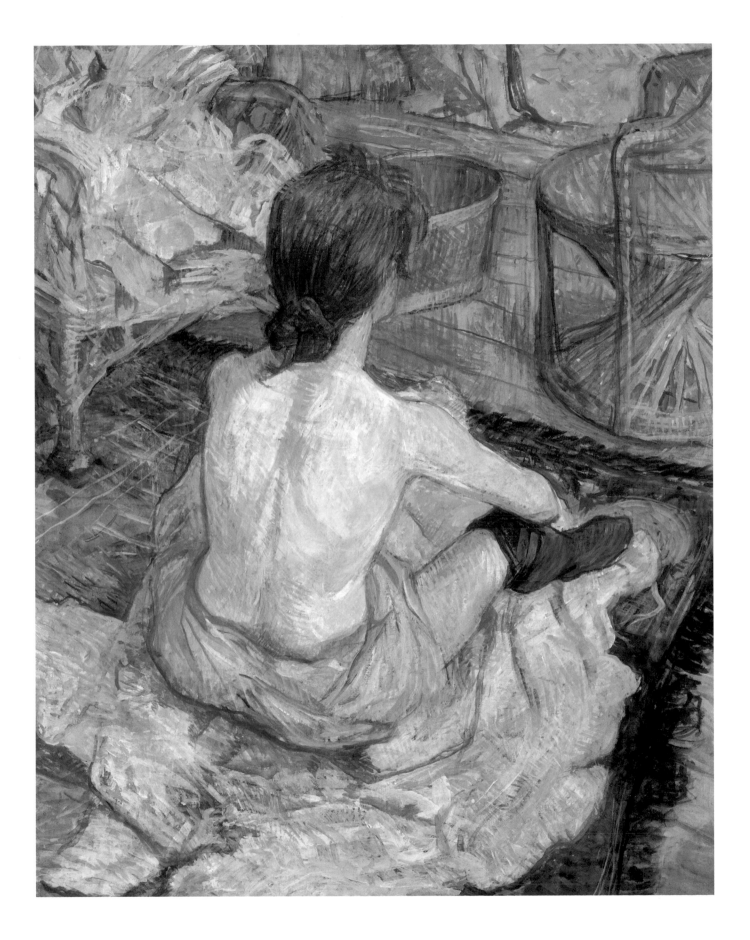

53 Henri de Toulouse-Lautrec

France 1864–1901

Woman with a black boa
(*Femme au boa noir*) 1892
oil on card, 53.0 x 41.0 cm

Musée d'Orsay, Paris, gift of Countess Alphonse de Toulouse-Lautrec, the artist's mother 1902, INV 20140
© RMN (Musée d'Orsay) / Hervé Lewandowski

Women who have exaggerated the fashion to the extent of perverting its charm and totally destroying its aims are ostentatiously sweeping the floor with their trains and the fringe of their shawls; they come and go, pass and repass, opening an astonished eye like animals, giving an impression of total blindness, but missing nothing … She is a perfect image of the savagery that lurks in the midst of civilization. She has her own sort of beauty which comes to her from Evil always devoid of spirituality, but sometimes tinged with a weariness which imitates true melancholy.—Charles Baudelaire[1]

Exhibited at the Goupil Gallery in London in 1898, this work was listed as *Portrait of a girl* (no. 35).[2] The pallid unnamed face which gazes out from the mass of feathers and tulle has a quizzical expression. Her face coated with rice-powder, her painted eyebrows arched, her hair arranged in a rough bun, the fabrics and ruches of her gown suggest the fabulous artifice of the Parisian demimonde.

In this portrait of remarkable economy, Toulouse-Lautrec describes only the essential features of his subject, with just enough detail to capture her personality. The painting is constructed of exceptionally flamboyant, virtuoso brushstrokes. By thinning his paint with turpentine and applying it as a wash, the fluid colours dried rapidly and ensured that Toulouse-Lautrec could work quickly, without having to wait for paint to dry. On a support of brown card, he has sketched the figure using blue oil paint. He has used a thicker brush, and wash-like black and green, to develop the structure of the figure. Streaks of emerald green, blue-grey and electric blue provide substance—around her neck they replicate the texture of the boa and gauzy fabrics. The mid-section of the painting is built up with rich peacock-like colours. The woman's hair is a delightfully unruly combination of olive and browns, highlighted with purple and maroon and touches of pale pink. Only around her face does the paint actually cover the card.

Toulouse-Lautrec's thin, spare colours and chalky, matt surfaces suited the darkened, interior scenes he painted. This composition is remarkably traditional: a three-quarter figure, facing front, with none of the cropping and other elements which suggest the fleeting encounters of the cabaret and dance halls, the brothels and cafes inhabited by the artist. The psychological acuity with which Toulouse-Lautrec captures facial expressions and body language—his ability to get behind the surface to expose the petty vanities, and reveal instead his models' vulnerabilities and vices—is what makes his works so powerful.[3] Toulouse-Lautrec's enigmatic woman, with her knowing smile, has the features of a true femme fatale.

Lucina Ward

1 Charles Baudelaire and Jonathan Mayne (trans. and ed.), *The painter of modern life and other essays*, London: Phaidon 1964, pp. 35–36. Baudelaire, XII: Women and prostitutes, *The painter of modern life* 1863.

2 *Toulouse-Lautrec*, London: South Bank Centre; Paris: Réunion des musées nationaux 1991, p. 540.

3 Julia Bloch Frey, 'Toulouse-Lautrec, Henri de', in Jane Turner (ed.), *The dictionary of art*, vol. 31, London: Macmillan, 1986, p. 213.

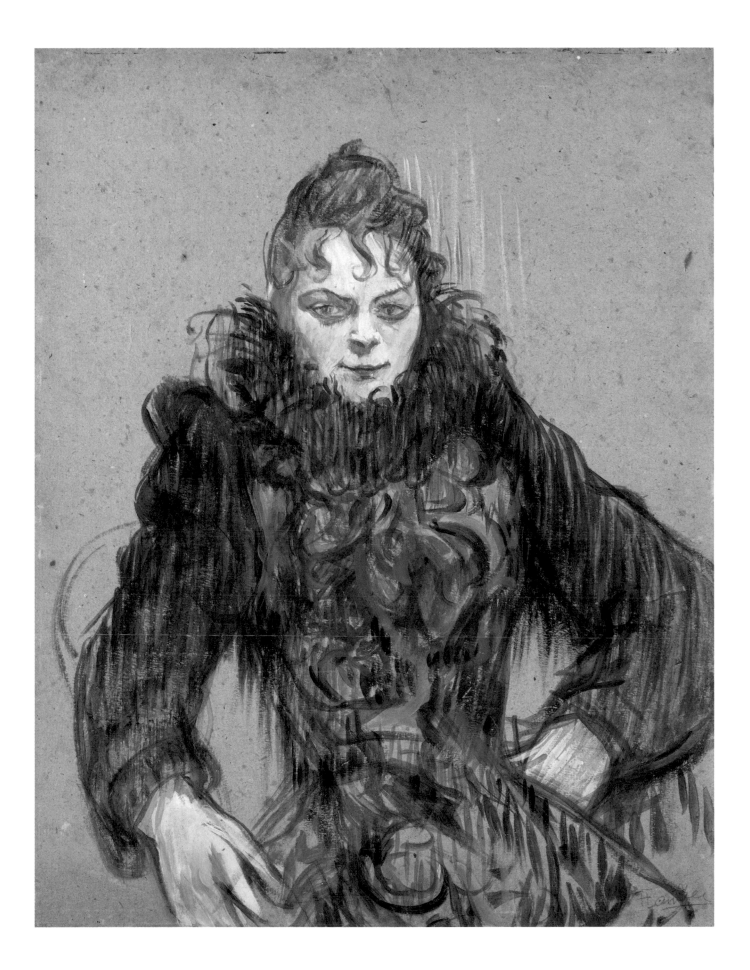

54 Henri de Toulouse-Lautrec

France 1864–1901

The clown Cha-U-Kao
(*La clownesse Cha-U-Kao*) 1895
oil on card, 64.0 x 49.0 cm

Musée d'Orsay, Paris, bequest of Count Isaac de Camondo
1911, RF 2027
© RMN (Musée d'Orsay) / Hervé Lewandowski

The dancer Cha-U-Kao was one of Toulouse-Lautrec's favourite models of the mid 1890s. She derived her nickname from the sensational *chahut chaos*—a high-kicking dance popular at Parisian dance halls of the time, including the newly established Moulin Rouge. Established in October 1889, this was the seediest of venues, and a place where Toulouse-Lautrec became a habitué.

Cha-U-Kao frequented the Moulin Rouge, as well as appearing at the Cirque Nouveau. She appeared in a series of Toulouse-Lautrec's paintings dated 1895[1] and in his 1896 brothel series, *Elles*, where the artist had taken his cue from the Japanese *ukiyo-e* tradition of depicting prostitutes in their daily lives (following such examples as Kitagawa Utamaro's *Twelve hours in the Yoshiwara* c.1794).

Described unceremoniously by the artist as the 'clown with tits',[2] the present painting is one of the more finished that Toulouse-Lautrec made. The composition is covered with visible brushstrokes—in a bright palette of various greens for the wall paper, a mixture of reds for the fabric of the couch, and blue over black for the *clownesse*'s costume. Most remarkable, and revealing Toulouse-Lautrec's dextrous brushwork, are the additions of luminous, almost translucent yellows for Cha-U-Kao's frills, and the pasty whites of her skin. The scene is an intimate one, where the *clownesse* is not under public gaze. The artist depicts her at an awkward moment, which is emphasised by the cropping of the voluminous folds of her gown to suggest they are billowing out further in the small space, and by the figure's concentration on the task of dressing. On the wall is a reflection of a man, perhaps a client, although Cha-U-Kao was well known in lesbian circles. This suggests another of Cha-U-Kao's roles.

In this world of the demimonde, Cha-U-Kao had once performed as a gymnast and had been extraordinarily subtle and slim, as evident in a photograph taken by Toulouse-Lautrec's close companion Maurice Guilbert, for whom she would pose. By 1895 however, the agile slender figure has metamorphosed into that of the ageing, overweight *clownesse*.

In some ways Cha-U-Kao's life—beginning with notoriety as a lithe-bodied performer, and ending with her sad demise and physical ruin—was a perfect example of Toulouse-Lautrec's interest in human physical destruction and decrepitude. This particular obsession of the artist was reinforced by his reading of Oscar Wilde's *The Picture of Dorian Gray*, first published in 1891 in English, and subsequently translated into French. Toulouse-Lautrec had become acquainted with Wilde, and painted Wilde's portrait in Paris the same year as this portrait of Cha-U-Kao.

Jane Kinsman

1 M.G. Dortu, *Toulouse-Lautrec et son oeuvre*, vol. 3, New York: Collectors Editions 1971, cats P580–P583, pp. 354–59.

2 Letter to Maurice Joyant, Paris, 16 November 1895, letter 439, Herbert D. Shimmel (ed.), *The letters of Henri de Toulouse-Lautrec*, Oxford: Oxford University Press 1991, p. 283.

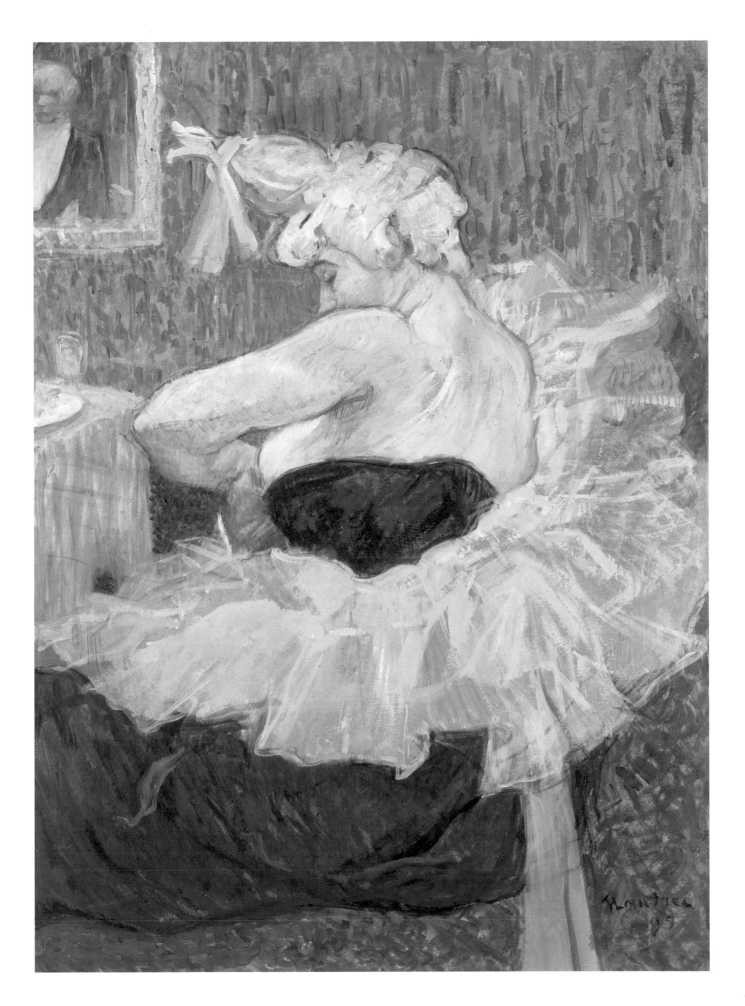

177

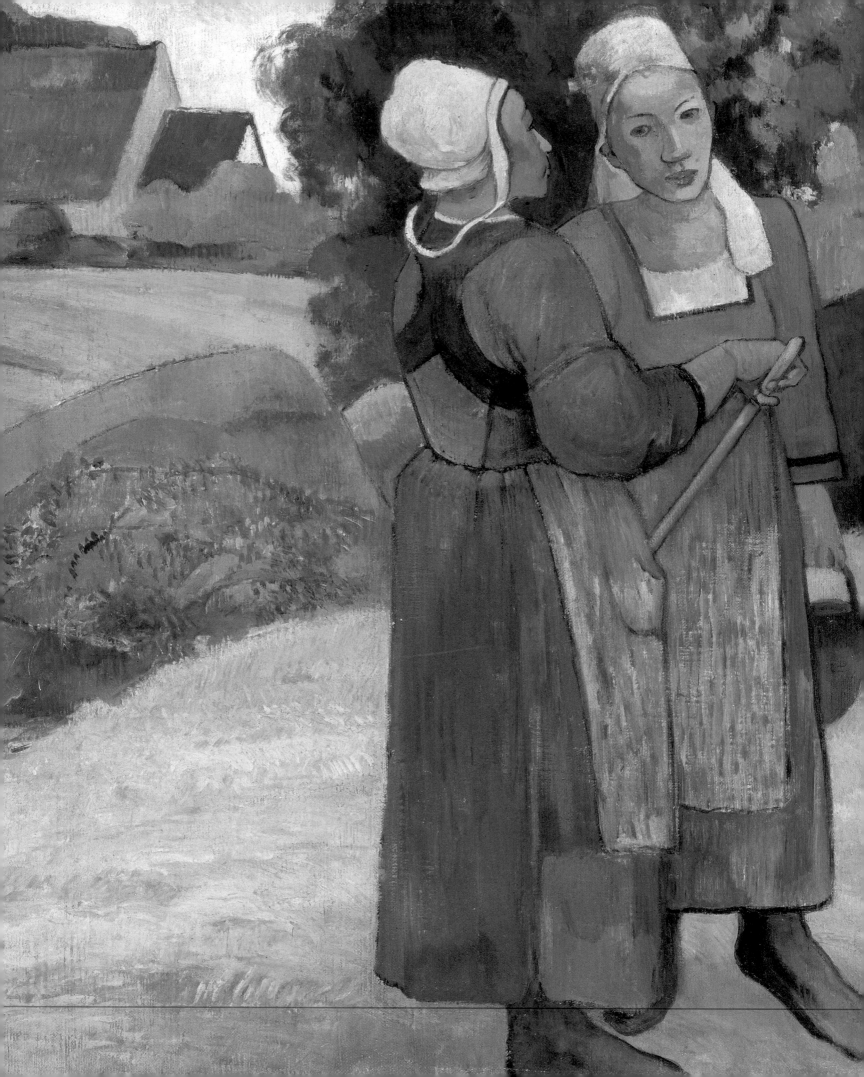

Pont–Aven

Emile Bernard

Maurice Denis

Paul Gauguin

George Lacombe

Charles Laval

Paul Sérusier

55 Emile Bernard

France 1868–1941

Bathers with red cow
(*Baigneuses à la vache rouge*) 1887
oil on canvas, 92.5 x 72.5 cm

Bernard, who came from a bourgeois family, was six when the first Impressionist exhibition was held in 1874 and eighteen when the last was held in 1886, the same year he was thrown out of the Atelier Cormon for unruly behaviour. On a walking tour of Brittany and Normandy he met Gauguin—first in 1886 and then again, in Pont-Aven, in 1888.

Bernard had already rejected the *plein-air* techniques of the Impressionists by the time he had left Cormon's studio. He would, however, along with his newfound friend Gauguin, appropriate the use of pure colour. But instead of molecularising colour in the way the Pointillists had, he chose to use it as a compositional device, using flat planes of largely uninflected colour in a lyrical manner, rather than attempting a realistic rendering of the subject. This approach had its antecedents in late medieval and early Renaissance frescoes, and the ecclesiastical use of stained glass: in 1888 the critic Edouard Dujardin would coin the term Cloisonnism to describe what both Gauguin and Bernard were doing.

While Bernard may have rejected his Impressionist precursors, we can see, however, in *Bathers with red cow* the influence of Cézanne. The latter artist has become famous for the number of works he devoted to bathers, and it is not difficult to see that the young Bernard's painting consists essentially of a series of floating figure studies whose rhythmical arrangement is given precedence over any felicity to perspective. Ironically, while he may have been thrown out of the Atelier Cormon, we can also see in this work the extension of the academic exercises he had found so tedious the year before.

For someone so young, this is already a bravura work. We can see the eighteen-year-old's emerging confidence in the way the red cow's head has literally been cut off—the painting was in fact sectioned down from a larger work. There is an element of subversive comedy in the way in which the groups of naked women are counterposed against this one solitary, partially depicted animal. Just how quickly Bernard's compositional sophistication was growing can be seen by comparing this work with the more radically clarified compositional skill of his painting *The harvest* (cat. 61) of the following year.

Bernard claimed it was he who introduced Gauguin to the Synthetist manner of painting, in which the aim of a work of art was not the realistic representation of a subject, but a combination of the subject matter and of the artist's emotional response to it. Form and colour were the means by which this synthesis took place. Two years after painting this work, Bernard would return to Paris where, with Gauguin and other Pont-Aven artists, he would participate in the first Groupe Impressionniste et Synthétiste exhibition at the Cafe Volpini.

Mark Henshaw

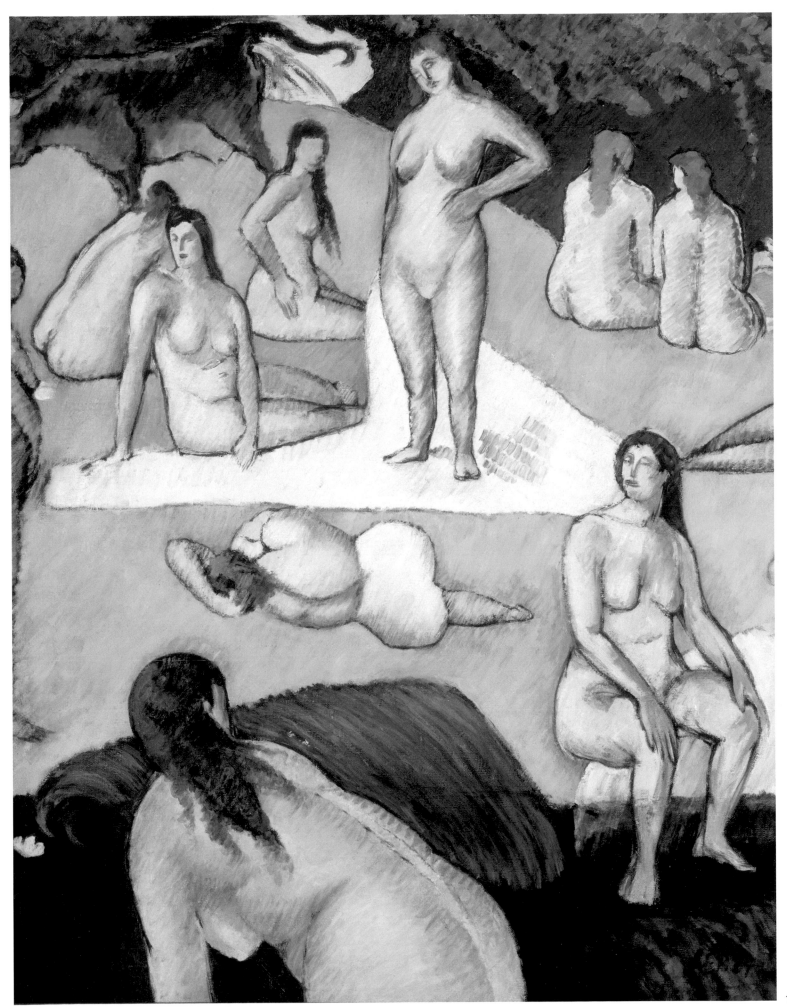

56 Paul Gauguin

France 1848 – Marquesas Islands 1903

Les Alyscamps 1888
oil on canvas, 91.5 x 72.5 cm

Musée d'Orsay, Paris, gift of Countess Vitali in memory of her
brother Viscount Guy de Cholet 1923, RF 1938-47
© RMN (Musée d'Orsay) / Hervé Lewandowski

Van Gogh, who migrated south from Paris in 1888,
envisaged a community of artists at Arles, and he
desperately wanted Gauguin to be involved. Finally
persuaded by Vincent (and by Theo's financial support)
Gauguin left Pont-Aven in Brittany, arriving in Arles in
October 1888. *Les Alyscamps* is one of the first paintings
he produced there. Van Gogh took Gauguin to his
favourite sites: the two artists painted together on
the plains of the Crau, and at the ancient cemetery,
Les Alyscamps.[1]

Gauguin later claimed to have been unimpressed by
the magnificent Roman remains at Arles and the flat
treeless landscape of the Camargue area. Les Alyscamps
was consecrated for the burial of Christians in the third
century by Arles' first bishop; very little of the Roman
necropolis remained in the nineteenth century other
than a few empty sarcophagi and an avenue lined with
poplars. The ancient site was partially compromised
by the proximity of the railway workshops just across
the Craponne Canal, but Gauguin only hints at this,
including a plume of smoke in the sky at left. Painting
from outside the tree-lined avenue, Gauguin concentrates
on the canal, the undulating ground and range of
vegetation, making the domed tower of the Romanesque
church and the three figures the focal point of his work.
He was more impressed by the local people themselves—
the Arlesiennes were famed for their spirit, dignity
and bearing, and reminded Gauguin, with their black
pleated shawls and elegant coiffure, of the women of
ancient Greece.[2] Les Alyscamps was also a popular place
for promenading, and a meeting place for lovers, and
Gauguin makes ironic reference to this with this work's
alternate title, *The three graces at the temple of Venus*. It was
under this title that he sent the work to Theo van Gogh
in December 1888.

Gauguin expends only the necessary paint on his canvas.
He composes the work according to traditional one-
point perspective but with few concessions to pictorial
realism. The recession of the canal at left, and the line
of trees at right, is undermined by the central figures
on what appears to be higher ground. The lower half of
the canvas—a patch-work of paths, stones and scraggly
bushes, grassy mounds with arbitrary patches of pale
orange and the flame-red bush—culminates in the
pyramid of trees crowned by the octagonal bell-tower
of Saint-Honorat. The canvas is divided: the 'cool' left
side, with sky and clouds reflected in the canal below,
contrasts with the extravagant, saturated hues of the
yellows and orange at right. The hatched brushstrokes
of the green foliage which punctuates the autumnal
trees is reminiscent of Cézanne. The massing of colour
and decorative quality would later be exploited to
extraordinary effect by the artist.

Lucina Ward

1 Douglas W. Druick et al., *Van Gogh and Gauguin: the Studio of the South*,
New York, London: Thames and Hudson 2001.

2 Belinda Thomson, *Gauguin*, London: Thames and Hudson 1987, p. 76.

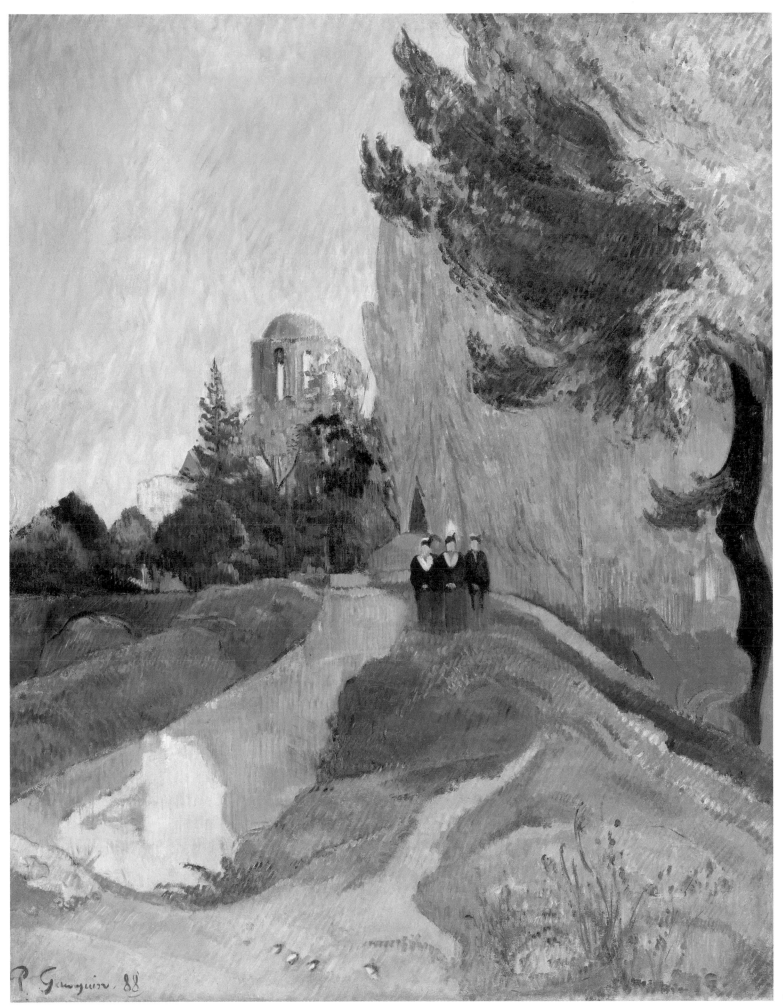

P. Gauguin. 88

183

57 Paul Gauguin

France 1848 – Marquesas Islands 1903

Washerwomen at Pont-Aven
(*Les lavandières à Pont-Aven*) 1886
oil on canvas, 71.0 x 90.0 cm
Musée d'Orsay, Paris, purchased 1965, RF 1965-17
© RMN (Musée d'Orsay) / Hervé Lewandowski

In 1885 Gauguin fled what he saw as the strictures of his life in Copenhagen with his Danish wife Mette and her family. Arriving back in Paris he hoped to be actively engaged as an artist, but very few financial prospects appeared. In August of that year he lamented:

> I have no money, no house, no furniture—only a promise of work from Bouillot if he has any. If he has, I shall rent a little studio from him and work and sleep there. I shall buy whatever food I can afford. If I sell some pictures, I shall go next summer to an out of the way spot in Brittany to paint pictures and live economically. Brittany is still the cheapest place for living. When I get over the worst, if business looks up, and my talents get suitably rewarded, I shall think of settling down somewhere.[1]

The following year, in the summer months of July to October, he settled in Brittany, seeking refuge from his penury and hoping to focus more completely on his art in a more exotic location. It was here that he painted the present work. In it we find that the artist is still under the pre-Pointillist stylistic influence of Camille Pissarro who, along with Edgar Degas, had invited Gauguin to join the fourth Impressionist exhibition in Paris in 1879; he continued to exhibit with the group until their demise with the eighth exhibition in 1886. For *Washerwomen at Pont-Aven*, Gauguin's brushstrokes are small and feathery and his outlines indistinct, with an emphasis instead on the immediate perception of motifs. The palette is lightened compared with his earlier Corot-inspired landscapes, and heightened with reds, oranges, blues and greens.

The location depicted is the old Saint-Guéolé Mill owned by the Simonou family of Pont-Aven. The focus, however, is not on the women themselves, but on their surrounds—the house, mill, barn and stable nestling amongst the trees, with a cloud-filled sky above. Gauguin has also included a sailing boat on the water. The figures of the washerwomen are derived from sketches the artist made in his notebooks of this period. The overall forms, composed with loose brushwork, suggest the wildness of the location, something Gauguin was later to recall in a letter to his friend the artist Emile Schuffenecker, when he wrote: 'I like Brittany, it is savage and primitive. The flat sound of my wooden clogs on the cobblestones, deep, hollow and powerful, is the note I seek in my painting.'[2]

Jane Kinsman

1 Letter to Mette, 19 August 1885, letter 24, Maurice Malingue (ed.), *Paul Gauguin: letters to his wife and friends*, London: Saturn Press 1946, pp. 48–49. His former landlord Jules Bouillot was a sculptor who taught Gauguin techniques.

2 February or early March 1888, letter 141, in Victor Merlhès (ed.), *Correspondance de Paul Gauguin*, Paris: Foundation Singer-Polignac 1984, quoted in Richard Brettel, Françoise Cachin, Claire Frèches-Thory et al., *The art of Paul Gauguin*, Washington D.C.: National Gallery of Art; Chicago: Art Institute of Chicago 1988, p. 55.

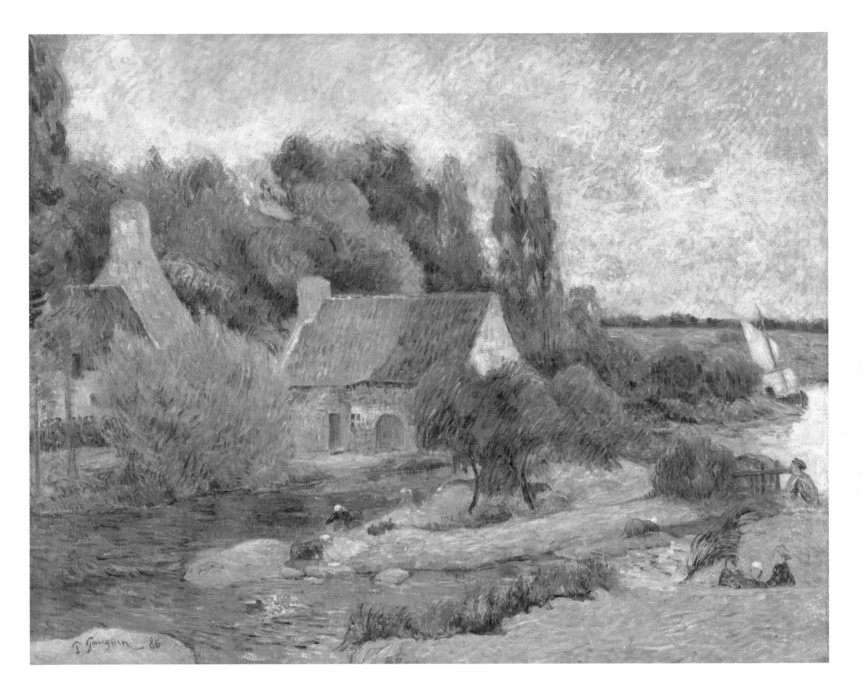

58 Paul Sérusier (above)

France 1864 – 1927

The flowery fence, Le Pouldu
(*La barrière fleurie, Le Pouldu*) 1889
oil on canvas, 73.0 x 60.0 cm
Musée d'Orsay, Paris, purchased 1980, RF 1980-52
© RMN (Musée d'Orsay) / Hervé Lewandowski

59 Paul Sérusier (below)

France 1864–1927

The fence (La barrière) 1890
oil on canvas, 50.7 x 62.3 cm
Musée d'Orsay, Paris, gift of Henriette Boutaric 1981, RF 1981-4
© RMN (Musée d'Orsay) / Hervé Lewandowski

In September or early October 1888 Sérusier went to stay at the Pension Gloanec, in Pont-Aven, Brittany, to paint scenes of peasant life. Among other artists there he met Emile Bernard, whose radical abandonment of three-dimensional space influenced Sérusier. Bernard also suggested that Sérusier approach Gauguin, who was living at the inn in Pont-Aven, to learn about the older artist's ideas. Gauguin was to have a significant impact on Sérusier, advising him to abandon his feathery strokes reminiscent of Pissarro, and to avoid shadowing and modelling. Instead, he was urged to adopt strong outlines in the manner of Japanese *ukiyo-e* prints, and to select a palette of simple bold colours with strong outlines of form.

Sérusier returned to Brittany the following summer, in 1889. By the autumn of that year Sérusier had followed Gauguin to the village of Le Pouldu, on the Breton sea coast, with its starker more barren landscape. This location and its people were described in the memoirs of the artist Archibald Standish Hartrick (who met Gauguin during his travels in France), as a place of:

> dramatic strangeness … peopled by a savage-looking race who seemed to do nothing but search for driftwood, or to collect seaweed with strange sledges drawn by shaggy ponies, and the women in black dress, who wore the great black 'coif'.[1]

Gauguin and Sérusier painted together here, and the latter produced these two landscapes of Le Pouldu village and its inhabitants.

Both Gauguin and Sérusier chose to depict a scene of village life viewed from the pasture's gate, with a rocky outcrop and a backdrop of farm housing.[2] *The flowery fence, Le Pouldu* shows the scene in blossom, depicting the trees in a decorative manner as a series of tree trunks

highlighted with foliage and placed at regular intervals, recalling the trees in Sérusier's most abstract composition, *The talisman* (cat. 72). Sérusier drew *The flowery fence* from Gauguin's painting *Hello, Mr. Gauguin* 1889,[3] where the artist depicts himself greeting a peasant woman at a village gate.

For *The fence*, painted a year later, Sérusier adopted a smoother downward brushwork. The landscape is unpopulated and the elements of the composition are shown in bold, almost geometric forms. The bright colours of the grassy fields and bushes contrast with the darker silhouetted forms of the trees which form the backdrop to this painting.

Sérusier went on to play a pivotal role in the development of a group of young artists, who were to call themselves the Nabis. He was the influential tutor for many of them at the Académie Julian—rejecting naturalism and proselytising the ideas and the style developed by Gauguin and other avant-garde artists at Pont-Aven.

Jane Kinsman

1 Archibald Standish Hartrick, *A painter's pilgrimage through 50 years*, Cambridge: Cambridge University Press 1939, p. 30, quoted in Caroline Boyle-Turner, *Paul Sérusier*, Ann Arbor: UMI Research Press 1983, p. 22.

2 The painting by Gauguin is *The gate (La barrière)* 1889, Kunsthaus Zürich, Zurich.

3 National Gallery, Prague. The composition was in turn inspired by Courbet's *Hello Mr Courbet (Bonjour Monsieur Courbet)* 1854, Musée Fabre, Montpellier.

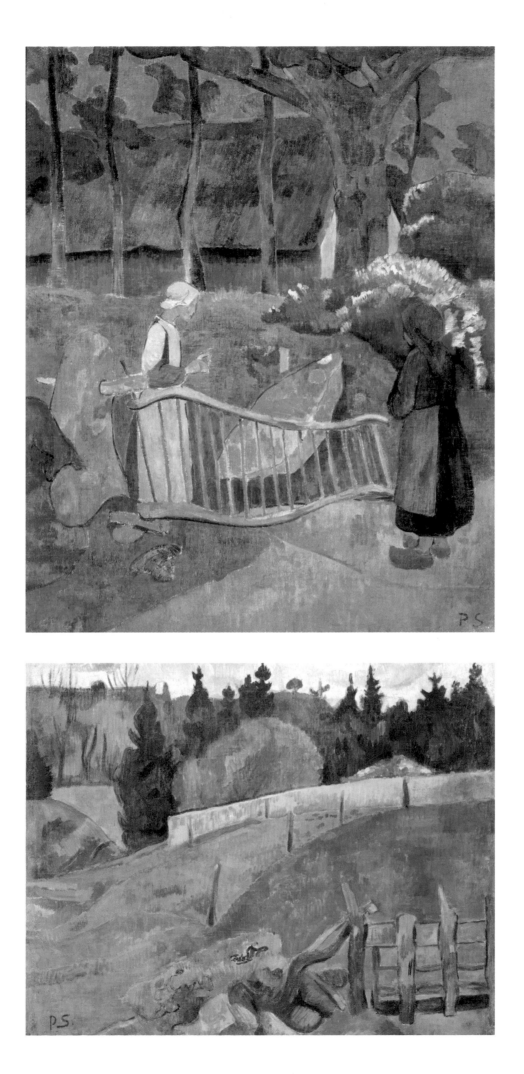

60 Emile Bernard

France 1868–1941

Madeleine in the Bois d'Amour or *Portrait of my sister* (*Madeleine au Bois d'Amour* ou *Portrait de ma soeur*) 1888

oil on canvas, 138.0 x 163.0 cm

In 1888 Sérusier painted the now famous but tiny painting *L'Aven au Bois d'Amour* (cat. 72)—literally *The Aven in the woods of love*. (The Aven is the river running through Pont-Aven in Brittany.) The work was later rechristened *The talisman* by the group of artists— former friends from the Académie Julian—who called themselves the Nabis and who gathered around the small Breton village. These painters, who included Sérusier, Bonnard, Ranson and Denis amongst others, sought to define and clarify the new art form being practised by Gauguin and Bernard, called Synthetism. Serusier's *The talisman, the Aven at the Bois d'Amour* became literally the talisman of the Nabis group.

Bernard's treatment of the same river and wood setting which Sérusier had depicted, seen here, is far less audacious than Sérusier's. It is also one of his least characteristic paintings from this period. It does not show the classic features of Cloisonnism (the partitioning of flat areas of heightened colour by the use of black lines) that characterises other works of his—the wonderful *The harvest*, from the same year, for example (cat. 61). Instead, its heritage seems to be some more Romantic Symbolist tradition. The overly elongated form of Bernard's seventeen-year-old sister Madeleine hovers awkwardly in the foreground, as if added to an already completed landscape. In Madeleine's prone figure there are also echoes of an earlier tradition which, although its aesthetic agenda was quite different, examined the often morbid psychopathology of female romantic longing—that of the English Pre-Raphaelites. There is, for example, the odd disjunction between Madeleine's very alive and clearly self-consciously posed reverie at one extreme of the painting, and the unnatural cadaver-like arrangement of her feet at the other; note also the awkward, funereal placement of her pale white hand at her waist.

The image is autobiographical. While in part homage to Madeleine, Bernard had met up with Gauguin again in Pont-Aven in the summer of 1888 and the latter had fallen in love with Madeleine. The reductive treatment of the landscape, in which vertical and horizontal elements are carefully orchestrated against an essentially flat plane, recalls the work of Puvis de Chavannes (cat. 85), while the reflections in the water prefigure elements of Art Nouveau. It is also useful to compare this strangely unsettling work with the heavily Symbolist-influenced *Landscape with green trees* by Denis (cat. 84).

Mark Henshaw

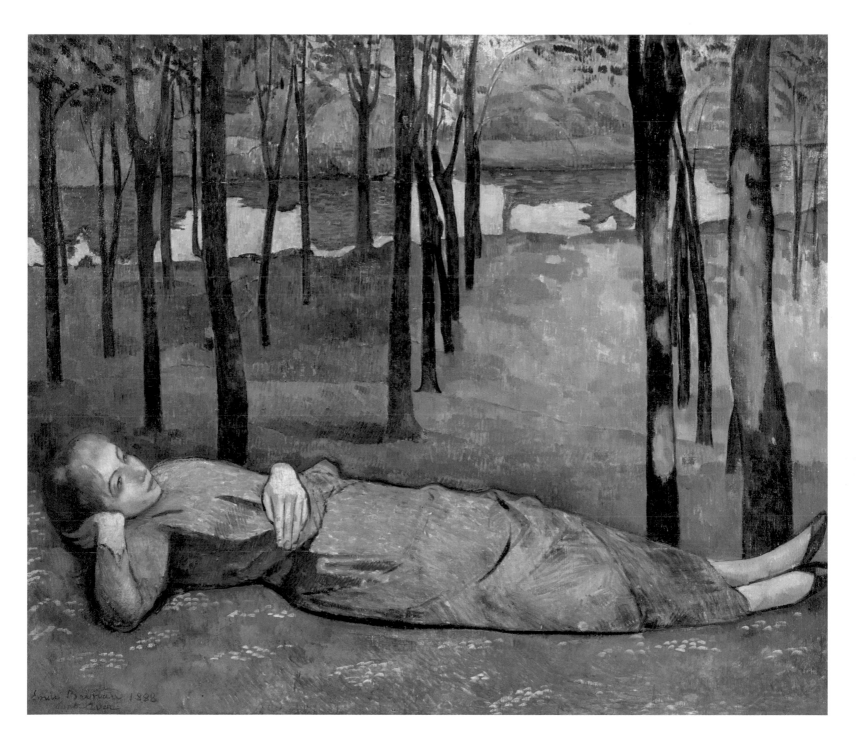

61　Emile Bernard

France 1868–1941

The harvest (Breton landscape)
(*La moisson (Paysage breton)*) 1888
oil on wood panel, 56.5 x 45.0 cm

Musée d'Orsay, Paris, purchased 1965, RF 1977-42
© RMN (Musée d'Orsay) / Jean-Gilles Berizzi
© Emile Bernard. ADAGP/Licensed by Viscopy, 2009

The Pension Gloanec, situated at the south-eastern end of the square on Rue du Pont at Pont-Aven, offered board and lodging and was popular with artists—English, Americans and Danes.[1] Many of them left a souvenir of their stay, or in lieu of payment. When Bernard's *The harvest* was hung on the dining room wall, guests threw bread balls at it. Begged to remove the painting, the landlady, Marie Jeanne Gloanec returned it to the artist, who exchanged it for a work with Gauguin.

Bernard's works are characterised by bold forms separated by dark contours, the sort of graphic innovation achieved by Toulouse-Lautrec and others, but using oils. In 1888 he painted at Pont-Aven for several months from mid August to early November, exploring aesthetic and theoretical innovations with Gauguin. This was his second trip: he had visited in August 1886, on a walking tour through Brittany, but had then found the older artist unreceptive. In 1888 Bernard carried an introduction to Gauguin from van Gogh, and his starkly drawn *Breton women in the meadow* 1888 fired Gauguin with new enthusiasm. This interest in Breton peasant life—Bernard also carved furniture and designed tapestries—continued after Pont-Aven, and *The harvest* is one of a group of canvases painted around the theme. Like Gauguin he also produced a portfolio of prints, *Bretonneries*, for the Volpini show at the time of the 1889 Universal Exhibition in Paris.

According to the artist's inscription on the back, *The harvest* caused 'great discord' among the boarders at Pension Gloanec because of its novelty, simplicity and rawness.[2] The absence of any spatial organisation is what makes Bernard's painting so astounding; this 'highly synthetic work is exemplary in its simplified

and separate fields of colour'.[3] The shapes used to define the harvesters and their surrounds are modulated only by the artist's brushstrokes, and the traces of extra colour incorporated from an uncleaned brush. Outlined with blue-black, the figures stand out against the creamy-yellow background, the radical simplicity of their flattened forms played off against the dramatic diagonal of the hill, and the darker green trees, green landscape and blue sky. The second pair of harvesters, ankle-deep in wheat and bent over their task, becomes simple arabesques. Only the standing figure has a hand. And given that the hand is green—and would be more at home in the work of twentieth-century masters such as Picasso or Henri Matisse—we may well understand the concerns of the pensionnaires Gloanec.

Lucina Ward

1　Judy and Charles-Guy Le Paul, *Gauguin and the Impressionists at Pont-Aven*, New York: Abbeville Press 1987, p. 50.

2　Jean-Jacques Luthi, *Emile Bernard: catalogue raisonné de l'oeuvre peint*, Paris: Éditions side 1982, cat. 121, p. 22.

3　Anne Roquebert, 'Emile Bernard: Breton landscape', in Rebecca A. Rabinow (ed.), *Cézanne to Picasso: Ambroise Vollard, patron of the avant-garde*, New York: Metropolitan Museum of Art; New Haven: Yale University Press 2006, p. 325.

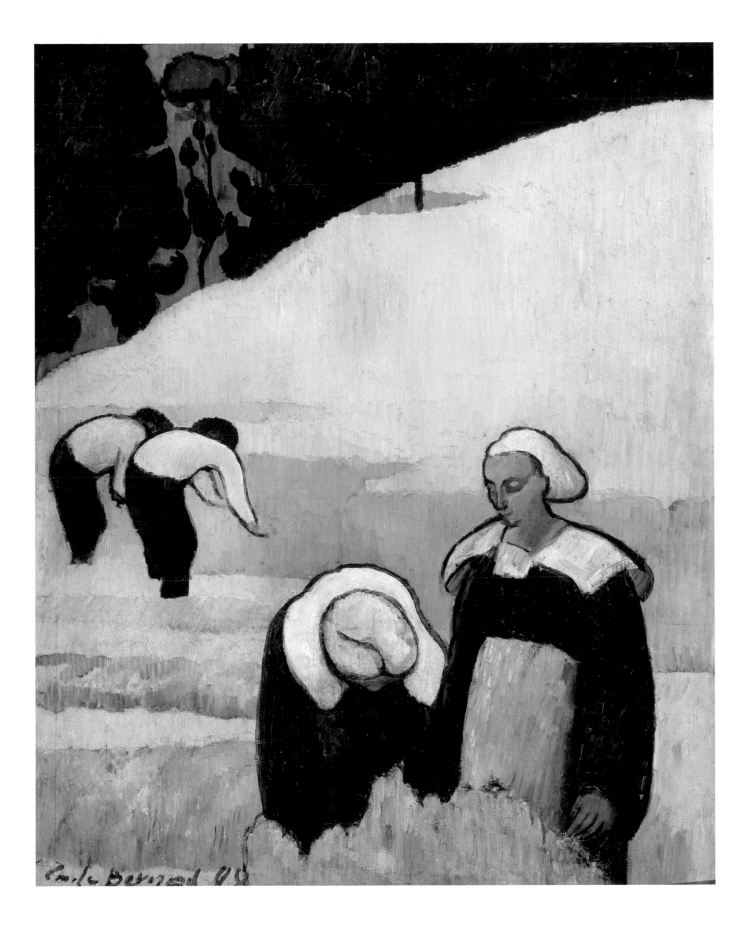

62 Paul Gauguin

France 1848 – Marquesas Islands 1903

Seascape with cow (At the edge of the cliff)
(Marine avec vache (Au bord du gouffre)) 1888
oil on canvas, 72.5 x 61.0 cm

Musée d'Orsay, Paris, gift of Countess Vitali in memory of
her brother Viscount Guy de Cholet 1923, RF 1938-48

When Gauguin returned to Brittany in February 1888,
it was for most of the year, until autumn, when he left
on an ill-fated trip to Arles to join van Gogh. In Brittany
he stayed at the Pension Gloanec in the small fishing
village of Pont-Aven. During late summer or early
autumn (August or September 1888) the artist made a
trip to the cliffs overlooking the little Porsac'h creek,
sited three kilometres west of Le Pouldu. In a letter to his
friend Emile Schuffenecker, written in September 1888,
Gauguin philosophised on aesthetic matters:

> In the absence of religious painting, what beautiful
> thoughts can be evoked with form and colour. How
> prosaic they are, those naturalist painters, with their
> trompe-l'oeil rendering of nature. We alone sail on our
> phantom vessels, with all our fanciful imperfection.[1]

Seascape with cow was made around the time that
Gauguin gave Sérusier his lesson in intensifying
pure colour, which resulted in Sérusier's *The talisman*
(cat. 72). Gauguin's dramatic composition is strengthened
by arbitrary colouring and his application of bright
complementary colours, orange and green. As we look
down the cliff, the creek rushes to meet the dark sea,
with white surf crashing against the rocks. We catch
a glimpse of a red-sailed Breton fishing boat. On land,
a black-and-white cow almost leaves the painting. The
animal stands near the brightest of haystacks, which are
opposed by similar shapes of brown rocks on the left,
echoed at the right. The central path of light green water
meets a viridian meadow across the front left.

Gauguin wrote to van Gogh on about 10 September
1888 that 'Forms and colours brought into harmony
produce poetry by themselves.'[2] He produces harmonies
here by four pairs of repetitions with variations: opposing
brown-purple rocks, two mounds of orange, bright green
field versus light green water, and below, a black-and-
white cow, while, above, the black sea breaks into white
waves. *Seascape with cow* is an extraordinarily abstract
painting for the late nineteenth century. Its artificial
planes sweep across the canvas like theatre curtains
drawing back one after another.

At the cliff edge was valued by Boussod et Valadon at
300 francs in an inventory of 1890. It was among the
thirty paintings Gauguin offered for sale at Drouot's
auction house on 23 February 1891 to finance his
trip to Tahiti. Now titled *Seascape with cow*, it sold for
230 francs at the auction.[3]

Christine Dixon

1 Quoted in Belinda Thomson (ed.), *Gauguin by himself*, Boston: Little, Brown 1993, p. 90.

2 Quoted in Thomson, p. 90.

3 Daniel Wildenstein, *Gauguin: a savage in the making, catalogue raisonné of the paintings (1873–1888),* vol. 2, Milan: Skira; Paris: Wildenstein Institute 2002, p. 488.

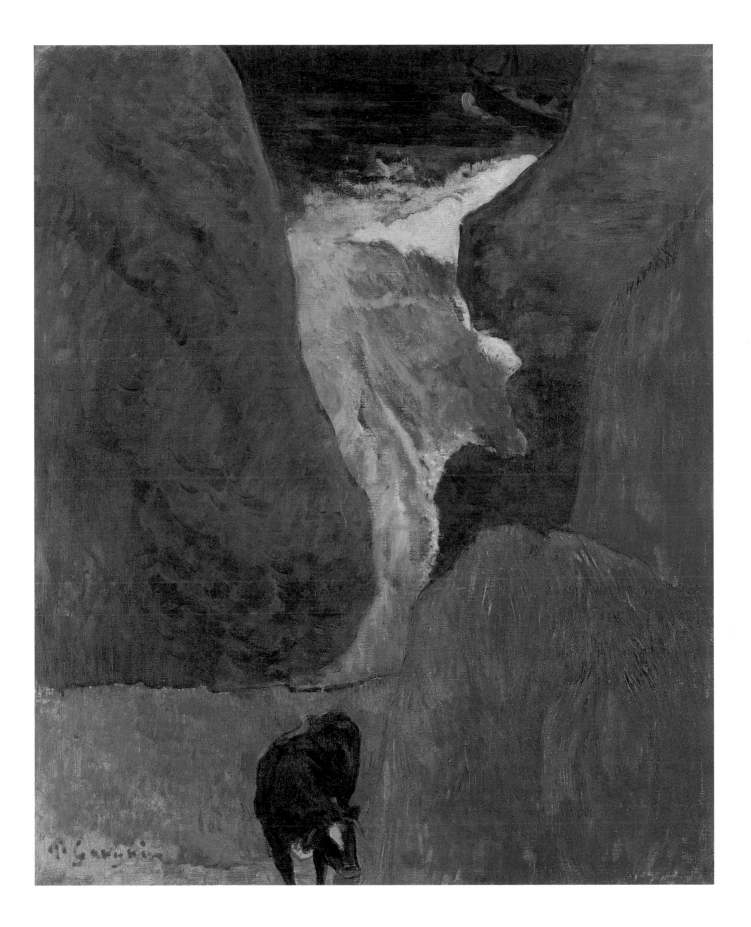

63 Paul Gauguin

France 1848 – Marquesas Islands 1903

Yellow haystacks (The golden harvest)
(*Les meules jaunes (La moisson blonde)*) 1889
oil on canvas, 73.5 x 92.5 cm

Musée d'Orsay, Paris, gift of Mrs Huc de Monfreid 1951, RF 1951-6
© RMN (Musée d'Orsay) / Hervé Lewandowski

This work was painted during Gauguin's third sojourn in Brittany, after the notorious episode with van Gogh at Arles. 1889 was a testing year for Gauguin: he was desperate for public recognition, to prove himself in the eyes of his estranged wife Mette. From Arles he had retreated to Paris, where feverish preparations for the 1889 Exposition Universelle were underway. In the first part of the year he alternated between Pont-Aven and the capital, making arrangements for an exhibition— Groupe Impressioniste et Synthétiste—which opened on 8 June at Volpini's Café des Arts. Like many artists, Gauguin saw the Universal Exhibition as an opportunity to draw attention to his work; he produced a portfolio of zincographs—images which repeat and expand on his work in Brittany, Arles and Martinique—printed on brilliant yellow paper.

Returning to Brittany for the summer, Gauguin found Pont-Aven so overtaken by artists that in July he sought quiet at the small fishing village of Le Pouldu, travelling between the two until February 1890. During his time in Le Pouldu, Gauguin lived cheaply, relishing the connections between people and land, and the 'archaic' way of life. He often returned to the theme of the haystack, or to views of the harvesting of seaweed. Like several earlier works—his landscape painted at Arles in 1888, which also featured a haystack, as well as the study of haymakers and another harvest scene[1]—*Yellow haystacks* features a palette dominated by flamboyant yellow, perhaps influenced by his time with van Gogh.

Gauguin sought to express harsh, primitive aspects of the Breton landscape through technique as well as subject. The dry, matt, even rustic technique—the texture of the haystack, whitewashed walls, grassy mound and ground strewn with straw—is applied to

advantage in this work. As Thomson points out, it is 'the strength of the underlying design rather than the colour or brushwork that establishes harmony: lines are smoothed and simplified and strong rhythms established through repeated shapes'.[2] The stones of the rock wall in the mid-ground are echoed in the curves of the haystacks and grassy mounds at left. The Cézanne-like brushstrokes of the tree are reprised in the foreground. The female figures in traditional Breton costume are dwarfed by the huge mass of the hay; indeed, standing on her step ladder, the woman at right seems about to be engulfed by the stack. The central figure is repeated in reverse in another work from the same period, *Haymaking in Brittany* 1889.[3] Simplified peasant figures are omnipresent in the work of the Pont-Aven artists, and Gauguin may have taken his inspiration from Bernard's painting, *The harvest* 1888 (cat. 61), which he briefly owned.

Lucina Ward

1 *Farm at Arles* 1888, also known as *Haystacks (Landscape at Arles)*, is in the Indianapolis Museum of Art, Indianapolis; *The haymakers* 1889 is in a private collection; *Haymaking in Brittany* 1889 is in the Courtauld Institute Gallery, London; Georges Wildenstein, *Gauguin*, Paris: Les Beaux-arts 1964, pp. 134–35.

2 Belinda Thomson, *Gauguin*, London: Thames and Hudson 1987, p. 102.

3 Courtauld Institute Gallery, London.

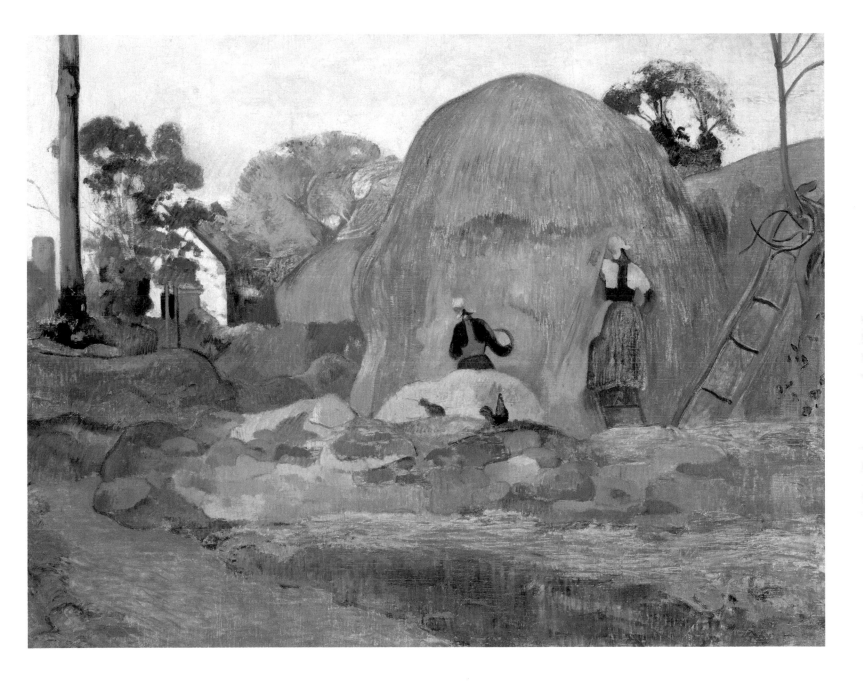

64 Charles Laval

France 1862–1894

Landscape (*Paysage*) 1889–90

oil on paper, laid on canvas, 55.0 x 46.0 cm

Musée d'Art moderne et contemporain, Strasbourg, on
long-term loan from the Musée d'Orsay, Paris, purchased 1938,
RF 1977-219
© RMN (Musée d'Orsay) / Christian Jean

Laval had exhibited at the Salon of 1880 at just eighteen years of age; he exhibited again in 1883. Born in Paris, he had pursued his artistic studies as a young man first at the studio of Léon Bonnat and then at the more liberal atelier of Fernand Cormon. In the summer of 1886, Laval followed the route of other artists to Pont-Aven in Brittany to compose images of the countryside and inhabitants. The Englishman Henry Blackburn had noted the town's importance as a location for artists just a few years earlier:

> Pont-Aven is a favourite spot for artists, and a *terra incognita* to the majority of travellers in Brittany. Here the art student, who has spent the winter in the Quartier Latin in Paris, comes when the leaves are green, and settles down for the summer to study undisturbed. How far he succeeds depends upon himself …[1]

Because of his modest output and relatively short life, Laval failed to reach his full artistic potential, but Pont-Aven was important for him because it was here the young artist met Gauguin and became one of his most devoted followers.

Tall and lanky in frame, Laval suffered poor health, partly due to his dissolute lifestyle. Keen to avoid the poverty of Paris and to continue to work with Gauguin in a warmer climate, in April 1887 Laval accompanied the latter to Panama. There they had hoped to live like savages.[2] This romantic notion was soon dispelled however, and reality required that Laval earn a living painting portraits of the locals. On their way to Panama, the pair had stopped in Martinique, in the Caribbean, and by June they returned to this more hospitable location. It was in Martinique that Laval adopted the more energetic and freely painted style which he and Gauguin jointly pursued, and which is evident in the later work, *Landscape*, seen here. In

December of 1887 Laval acknowledged his artistic debt to Gauguin, who had by then returned to France because of ill health: 'You rolled back my horizons and made space around me … the longer I live the more I admire your talent …'[3]

Landscape reveals the continued influence of Gauguin, and Laval's own stylistic development in 1889–90. The forms of the landscape, the grassy hillside, the untamed trees, the meandering stream and the grass-covered riverbanks in the foreground, have all been simplified and delineated with dark outlines. The brushwork is applied up to the contours in an almost decorative manner and there is a subtle mixture of colours. The palette adopted by Laval is one of bright hues. The grass covered hillsides have been painted in layers of reds, oranges and greens with touches of white, and the trees, in deeper greens with touches of red, appear as simplified shapes. A blustery sky completes what appears as an almost untamed landscape.

Jane Kinsman

1 Henry Blackburn, *Breton folk: an artistic tour in Brittany, with one hundred and seventy illustrations by R.. Caldecott*, London: Sampson Low, Marston, Searle, and Rivington 1880, pp. 128–30.

2 Quoted in Daniel Wildenstein, *Gauguin: a savage in the making: catalogue raisonné of the paintings (1873–1888)*, vol. 2, Milan: Skira; Paris: Wildenstein Institute 2002, p. 604.

3 Quoted in Wildenstein, p. 306.

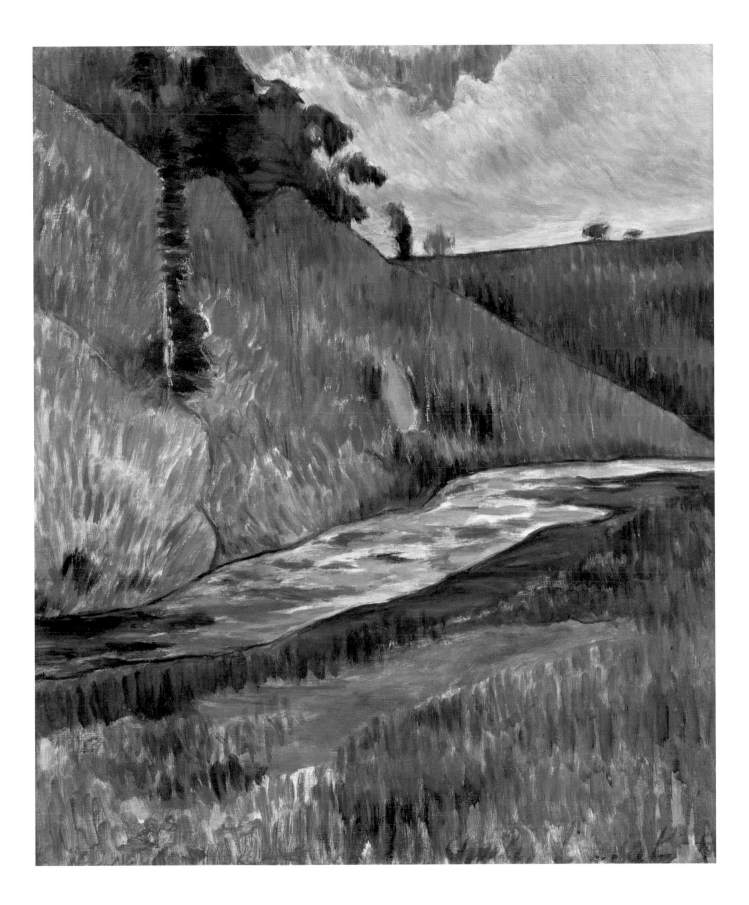

65 Paul Gauguin

France 1848 – Marquesas Islands 1903

Portrait of the artist with 'The yellow Christ'
(*Portrait de l'artiste au 'Christ jaune'*) 1890–91
oil on canvas, 38.0 x 46.0 cm

Musée d'Orsay, Paris, purchased with the assistance of Philippe
Meyer and patronage organised by the Nikkei newspaper 1994,
RF 1994-2
© RMN (Musée d'Orsay) / René-Gabriel Ojéda

In the history of European portraiture, since the days of
the Renaissance, the sitter was often painted with their
personal possessions, and particular care was taken with
gestures and facial expressions to denote the subject's
personality. In the tradition of self-portraiture, an artist
posed himself surrounded by his work.

As seen here, Gauguin has provided an innovative new
take on the art of self-portraiture. He has placed himself
in front of two works of great personal significance. One
of these is a glazed stoneware pot which is a self-portrait
from early 1889.[1] Gauguin considered the ceramic to
be 'one of my best things', and intended it as a gift to
Madeleine Bernard (Emile Bernard's sister, see cat. 60),
with whom he was infatuated. The distorted self-
portrait was in keeping with its medium of stoneware—
according to Gauguin, taking on the appearance of being
'scorched in the ovens of hell', as if 'glimpsed by Dante
on his tour of the Inferno'.[2]

The other reference work Gauguin includes in his self-
portrait is a cropped mirror image of his painting
The yellow Christ 1883[3], painted not long before. *The
yellow Christ* was one of Gauguin's most important
paintings of this period, interpreting a religious subject
in a radical style combining traditional Christian imagery
with a fantastic coloured palette. The motif of the Christ
was derived from a polychrome wooden sculpture of a
crucifixion from the eighteenth century, in the Chapel
of Trémalo near Pont-Aven. Gauguin's Christ, however,
is painted in brilliant yellows, oranges and browns, blues
and greens. The almost abstract forms, outlined in blue,
add further to his radical interpretation of the subject
and are a perfect summation of Gauguin's mature Pont-
Aven style.

The incorporation of these two important works in
his self-portrait reveals much about the artist's self-
perception—Gauguin considers himself both martyr
and savage. His letters in late 1889 make reference to
his keen sense of martyrdom in his fight against artistic
mediocrity, as he writes to Bernard advising that in
comparison to his own predicament, Bernard was too
young 'to carry the cross'.[4] When arranging the gift
of his ceramic self-portrait to Madeleine Bernard, he
described the work as 'the head of Gauguin, the savage'.[5]

For the self-portrait, Gauguin has set himself between
these two objects which express the duality of his
existence. His face seems burdened by the path he has
chosen. Yet he portrays himself as a determined character,
dressed simply, with a steely gaze; as a man who despite
the loss of his family and his failure to sell his art
continues to pursue his dream.

Jane Kinsman

1 Richard Brettel, Françoise Cachin, Claire Frèches-Thory et al.,
 The art of Paul Gauguin, Washington D.C.: National Gallery of Art,
 1988, cat. 65, pp. 128–29.

2 Letter to Emile Bernard, June 1890, letter 106, in Maurice Malingue
 (ed.) and Henry J. Stenning (trans.), *Paul Gauguin: letters to his wife and
 friends*, London: The Saturn Press, 1946, p. 148.

3 Albright-Knox Art Gallery, Buffalo.

4 November 1889, letter 92, in Malingue and Stenning, p. 130.

5 Letter to Madeleine Bernard, end of November 1889, letter 96,
 in Malingue and Stenning, p. 133.

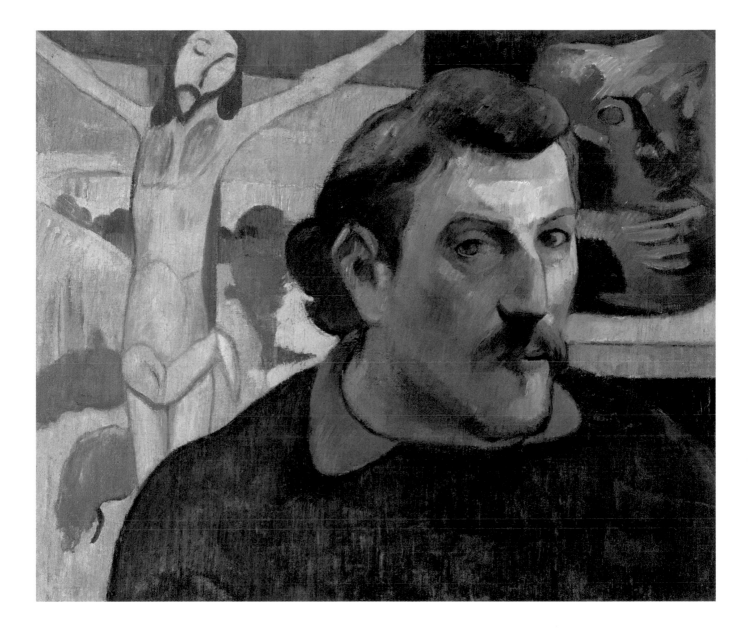

66 Paul Gauguin

France 1848 – Marquesas Islands 1903

Tahitian women (*Femmes de Tahiti*) 1891
oil on canvas, 69.0 x 91.5 cm
Musée d'Orsay, Paris, gift of Countess Vitali in memory of
her brother Viscount Guy de Cholet 1923, RF 2765
© RMN (Musée d'Orsay) / Hervé Lewandowski

Gauguin arrived in Tahiti in June 1891. The motives
for his flight from Europe seem to have been mixed—
artistic, domestic, political, aesthetic, and financial—and
well rehearsed. Always a traveller—from the days of his
childhood in Peru, his years in the merchant marines,
and a disastrous journey to Martinique in the West Indies
with Laval (cat. 64) in 1887—Gauguin was searching
for something that neither decadent Paris nor 'primitive'
Brittany could provide. As he wrote to Redon in
September 1890, from Le Pouldu:

> Even Madagascar is too near the civilized world; I shall
> go to Tahiti and I hope to end my days there. I judge that
> my art, which you like, is only a seedling thus far, and
> out there I hope to cultivate it for my own pleasure in its
> primitive and savage state.[1]

While Polynesia was not what he expected, neither was
Gauguin naïve: he understood there was to be no Utopia
of unspoiled 'nature'. As he wrote to his wife Mette in
late June 1891: 'Our missionaries had already introduced
a good deal of protestant hypocrisy, and wiped out
some of the poetry, not to mention the pox which has
attacked the whole race.'[2] The two Tahitian women that
he painted in his first months on the island display an
ambiguity of mood which seems to catch both artist
and subjects. The women do not engage us directly.
The woman on the left, dressed in a flowered *pareu* and
white blouse, is formed from arabesques of lowered
head, foreshortened body and leg, with a strong vertical
arm. The woman on the right is clothed in a coverall
pink missionary dress, a sequence of circles and ellipses
from head to torso and arm, and crossed legs under her
skirt. She is plaiting a basket, but looks out of the picture
beyond the artist, towards our right. Her occupation may
be traditional, but her clothing, like her friend's, is made
of cheap cotton imported from India or Europe.

The two figures are depicted close up, dominating the
space. Behind them lie horizontals of the black sea with
white wave-tips, the green lagoon and cream-coloured
sand. Rich and simplified colours fill in the planes, with
minimal distraction from impasto or painterly expression.
Instead, the introspective, even melancholy women sit
quietly on their beach. It was this introspective, symbolic
quality that Gauguin introduced so powerfully into art
after Impressionism. He rejected the artificial, mythical
narratives of Moreau or Puvis de Chavannes (cats 82
and 85) for deeper truths of the human condition.
These seemed pessimistic in the by-passed worlds of
Brittany or the South Seas, as touched by modernity
as the city of Paris.

Christine Dixon

1 Belinda Thomson (ed.), *Gauguin by himself*, Boston: Little, Brown 1993,
 p. 122.

2 Thomson, p. 167.

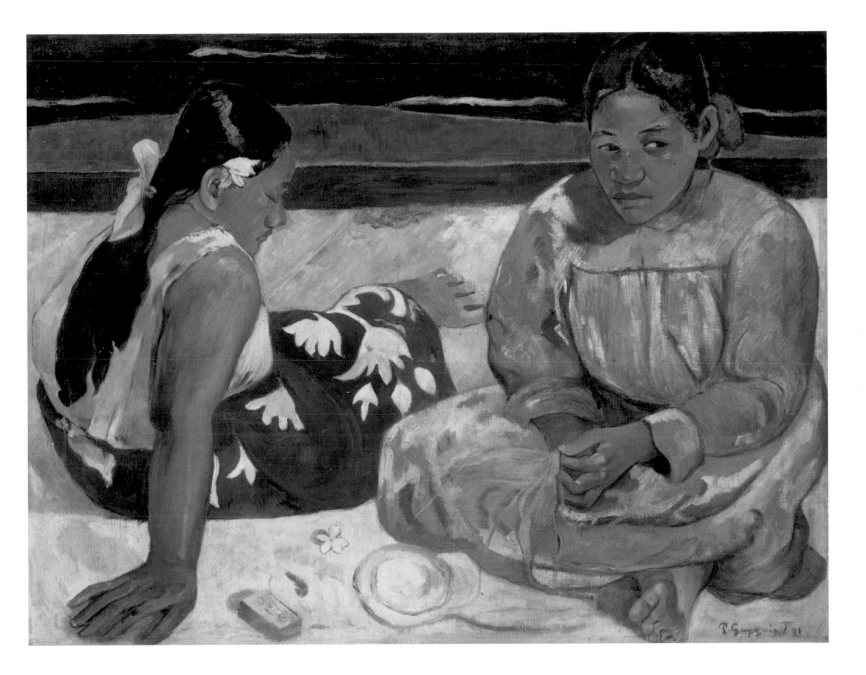

67 Paul Gauguin

France 1848 – Marquesas Islands 1903

Breton peasant women
(*Paysannes bretonnes*) 1894
oil on canvas, 66.0 x 92.5 cm

Musée d'Orsay, Paris, gift of Max and Rosy Kaganovitch 1973,
RF 1973-17
© RMN (Musée d'Orsay) / Hervé Lewandowski

Gauguin, born in 1848, was forty-six years old when he painted this work in 1894—twenty years older than the barely post-adolescent fellow-painter Emile Bernard, who had befriended him in Pont-Aven in 1886. It was this unlikely pair who would be the inspirational foundation for the group of artists who became known as the Nabis.

Gauguin and Bernard called their way of painting Synthetism. Its emphasis was on painting from memory, rather than from direct *plein-air* experience. Painting was not only a record of visual experience, but an expression of the artist's emotional response to it. The typically heightened colour palette and formalised use of flat areas of colour, often with strong black Cloisonnist outlines, indicated a synthesis between the subject matter and the artist's emotional response to it. Fundamental to Gauguin and Bernard's idea was the notion of artistic interpretation, as opposed to the concept of representation, which lay at the heart of Impressionism.

Paintings such as *Breton peasant women*, with its expression of idyllic tranquillity, stand in stark contrast to the actual tempestuousness of Gauguin's life and temperament. The work was painted during his second sojourn in or around Pont-Aven. In May 1894, after his two years in Tahiti, he had returned to the nearby town of Le Pouldu, in company with a very young woman called Annah la Javanaise, to whom he had been introduced by the Parisian entrepreneur and art aficionado Ambroise Vollard. His return to Le Pouldu was, however, emotionally, physically and financially fraught—Marie Meyer, the proprietor of the inn at which he had stayed prior to his departure for Tahiti, refused to return to him the paintings entrusted to her, claiming them as payment

for unpaid lodgings. Then, in June 1894, Gauguin was set upon by a group of sailors in nearby Concarneau; his leg was badly broken and would never properly heal. In August, Annah left him to return to Paris, where she sold all of his furniture and belongings from his Paris apartment. (Fortunately she left his paintings.)

During this period of personal upheaval, Gauguin somehow found time to paint *Breton peasant women*, one of his few paintings from 1894. The Synthesist-style composition is highly orchestrated. The figures have been strategically placed in the landscape, without regard to perspectival authenticity—the two tiny figures in the middle-ground, for example, imply that the cottages in the background are disproportionately large, although we do not read the overall composition in this way. *Breton peasant women* displays the synthesis of influences—the Polynesian architecture of the women's faces, the vividness of palette—that characterises Gauguin's French paintings of this period. It is also interesting to note the echo of the face of the right-hand woman with Picasso's famous 1906 portrait of Gertrude Stein.

Mark Henshaw

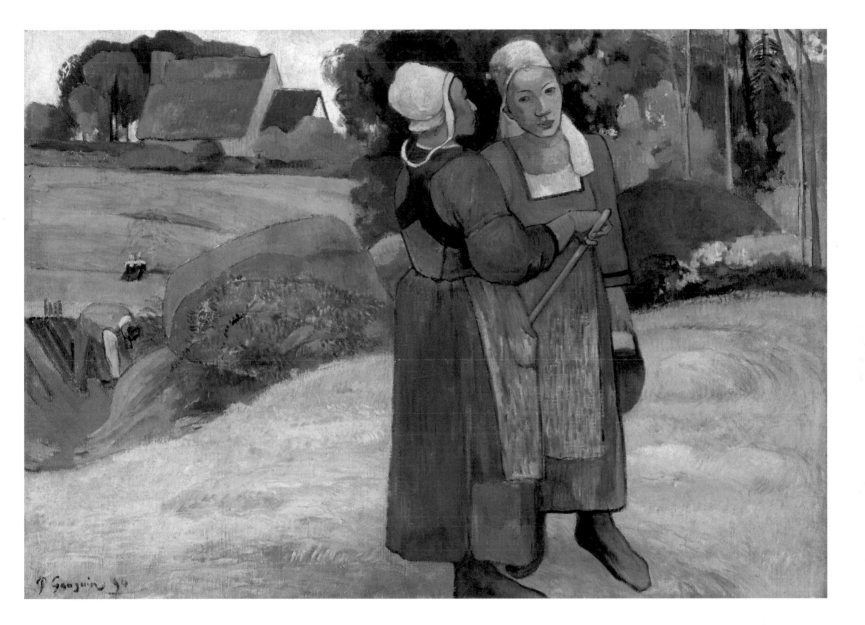

68 Maurice Denis

France 1870–1943

Regatta at Perros-Guirec
(*Régates à Perros-Guirec*) 1892
oil on canvas, 42.2 x 33.5 cm

The annual regatta at Perros-Guirec, on the Brittany coast, was held in late July. Many spectators gathered to bathe or to watch the boats at this popular event. Denis returned to the subject several times.[1] He captures the brilliance of the water, the vibrant colours of the fishing and pleasure craft, the animated details of the crowd and the decorative qualities of the surfaces.

As Guy Cogeval points out much of the originality *Regatta at Perros-Guirec* derives from the 'radical visual effects used by Denis: the extremely high line of the horizon and the exaggeratedly low viewpoint'.[2] This plunging composition is made flat by the white, lace-like pattern of arabesques on the surface of the water and the mast, to startlingly different effect.[3] Denis' palette is dominated by black and white, with apricot and olive-green used for the mid-tones. The work is structured around a series of triangles: the white sails of the boat are reprised by the mast with its radiating stays, and again by the pyramid of figures in the foreground. A further series of triangles, this time in a horizontal line, is found in the boat's sails, culminating in the tiny pale pink shapes at left. The highly simplified geometric forms of the boats, juxtaposed at impossible angles, are echoed by the flag flying atop the mast. At the end of the jetty, three female figures and a small child—distinguished only by their white headdresses and neck scarves—merge into a single mass. The composition of *Regatta at Perros-Guirec* has many similarities with another, earlier work, *Calvary* 1889 (cat. 83), with its mass of black figures, landscape constructed in bands and attention focused upwards. The mood, however, could not be more different.

Denis first visited Brittany as a child, and stayed at Perros-Guirec in 1892, returning there the following year to honeymoon with Marthe. In 1908 he bought a villa, 'Le Silencio', and Perros-Guirec became the site for the Denis family summer holidays. The place must have had many happy associations for the artist and *Regatta at Perros-Guirec* resonates with the pleasures of time and place.

Lucina Ward

1 Another version, *c.*1892, is at verso of a work in a private collection; see also *Regattas at Perros-Guirec view from the east jetty* 1897, Musée Départemental Maurice Denis 'Le Prieuré', Saint-Germain-en-Laye.

2 Guy Cogeval, 'Regattas at Perros-Guirec', in *Maurice Denis 1870–1943*, Ghent: Snoeck-Ducaju and Zoon 1994, p. 149.

3 As Nathalie Bondil observes, these arabesque patterns were a central part of Denis' formal vocabulary at the time and feature in many of his other works; in *Easter procession* (*under the trees*) 1892, private collection, for example, the arabesques become shadows. *Maurice Denis (1870–1943)*, Paris: Réunion des musées nationaux; Montréal: Musée des Beaux-arts de Montréal 2006, cat. 27, pp. 141–42.

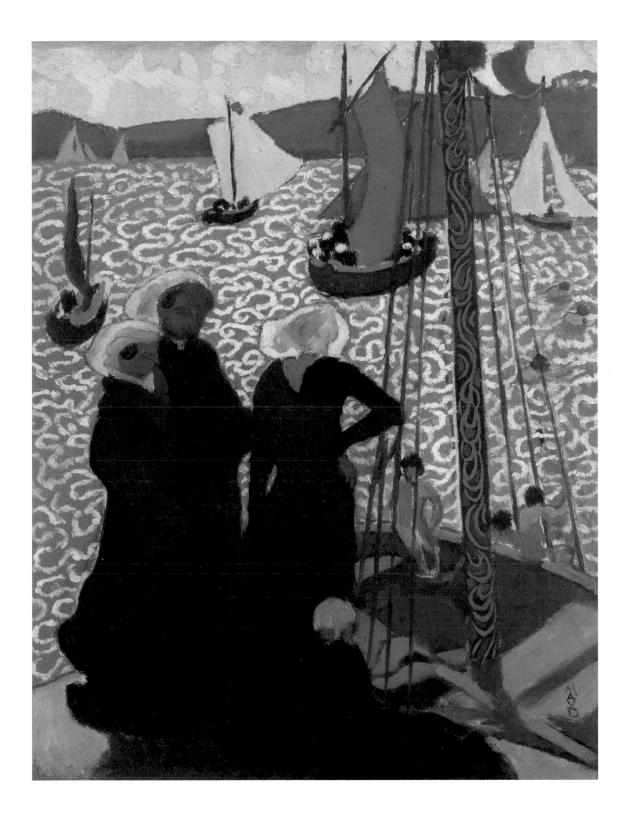

69 Emile Bernard

France 1868–1941

Breton women with umbrellas
(*Les bretonnes aux ombrelles*) 1892
oil on canvas, 81.0 x 105.0 cm
Musée d'Orsay, Paris, purchased 1955, RF 1977-41
© RMN (Musée d'Orsay) / Hervé Lewandowski

In 1886, at the age of eighteen, Bernard set off on a walking trip through Normandy and Brittany. There he met Paul Gauguin in Pont-Aven, at the recommendation of Emile Schuffenecker. Two years later, in a letter from Arles dated 20 June 1888, van Gogh proposed that Bernard meet again with the older artist: 'Gauguin too is bored at Pont-Aven and complains like you of his isolation. Why not go and see him?'[1] Bernard did so. He was just twenty years old and brimming with new theories and ideas about how to make art.

It was at Pont-Aven that Bernard painted a canvas, *Breton women in a meadow,* which, according to the artist, preceded Gauguin's radical painting *Vision of the sermon (Jacob wrestling with the angel).*[2] The two artists worked together, along with Louis Anquetin and Paul Sérusier, developing a style which came to be known as 'Cloisonismé', or Cloisonnism—a term coined by the critic Edouard Dujardin when reviewing the art of Anquetin in his essay for *La Revue indépendante*, 1 March 1888. Cloisonnism abandoned three-dimensional modelling for flatter two dimensional forms with heavy dark outlines. It was a style that shunned naturalism and adopted a more symbolic focus, assuming a brighter palette in order to express human emotion. It was, in part, inspired by Gothic art (particularly stained-glass and enamel work) and Japanese *ukiyo-e* woodblock prints, in vogue amongst many artists of the Pont-Aven school.

The close artistic collaboration between Bernard and Gauguin ended in 1891, when Gauguin was described as the founder of the evolving Pont-Aven movement.[3] Bernard considered this role rightfully his. Bernard's sister Madeleine (see cat. 60) accused Gauguin of reneging on his promise to exhibit together with Bernard before he left for Tahiti: 'you are a traitor, you

have broken your pledge and done the greatest harm to my brother, who is the real initiator of the art that you claim as being your own'.[4]

Breton women with umbrellas was made the year after this rift. It is one of a series of paintings created in bold outlines and colours which extend Bernard's monumental style of the late 1880s and signal his claim to be the originator of what he called 'pictorial symbolism'. The canvas reveals Bernard's continuing fascination with Gothic art and adds to the exotic perception of Breton women as timeless and immutable beings, living simple pious lives. The artist has depicted these figures in simplified forms and bold colours, and placed them within an almost two-dimensional village backdrop. Bernard came to admire these women, and frequently represented them as figures of devotion, as if they had stepped out of the art of the medieval ages.

Jane Kinsman

1 Quoted in Douglas Lord (ed. and trans.), *Letters to Emile Bernard*, New York: Museum of Modern Art 1938, p. 40.

2 National Gallery of Scotland, Edinburgh.

3 In an article by Albert Aurier, 'Le Symbolisme en peinture—Paul Gauguin', *Mercure de France*, March 1891, pp. 159–64.

4 Henri Dorra, Emile Bernard and Paul Gauguin, *Gazette des Beaux-Arts,* 6 series, vol. 45, April 1955, p. 244.

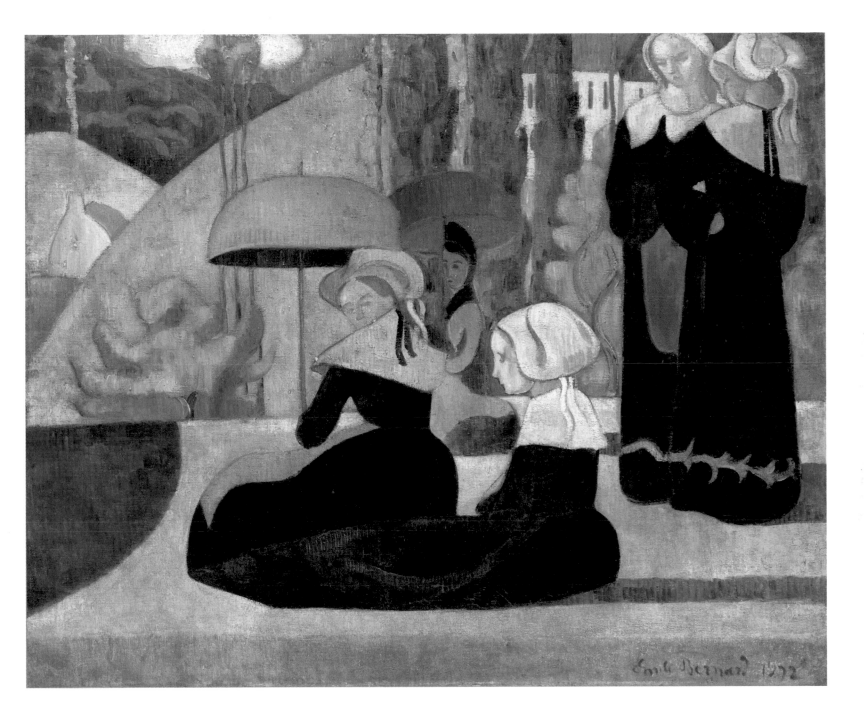

70 Paul Gauguin

France 1848 – Marquesas Islands 1903

Breton village in the snow
(*Village breton sous la neige*) c.1894
oil on canvas, 62.0 x 87.0 cm

Musée d'Orsay, Paris, purchased with funds from a Canadian
anonymous gift 1952, RF 1952-29
© RMN (Musée d'Orsay) / Hervé Lewandowski

Returning from Tahiti in August 1893, an almost penniless Gauguin arrived in Marseilles. His friend from his Pont-Aven days, the artist Sérusier, wired him 250 francs to make his way by train to Paris. There Gauguin held a sale of his art, mostly canvases from Tahiti, at the Gallery Durand-Ruel in November. This proved to be financially disastrous. Despite some monetary respite from an inheritance, in the northern spring of 1894 (probably at the end of April), Gauguin returned to Brittany in search of inspiration and a simpler, less costly life.

It was there he began painting *Breton village in the snow*, before leaving for Paris once again, on 14 November 1894. Whether *Breton village in the snow* was a scene drawn principally from Gauguin's imagination or was painted when the region experienced snowfalls during his stay, has been a matter of debate.[1] The painting was found on an easel in his studio at Papeete at the time of his death on 8 May 1903. It was unsigned and undated, and it appears that he had taken the painting on his second trip to Tahiti with the idea of continuing to work on the canvas there.

There has been a long tradition in European art of snow-scapes, from medieval times onwards. The Impressionist group of painters, notably Monet, Sisley and Pissarro all favoured the subject as they sought to capture the effects of winter's snow on the landscape under changing light and different weather conditions. Gauguin continued this interest, creating several canvases of snowfalls, but his interpretation of *Breton village in the snow* was less transitory in appearance. Japanese woodblock prints by Hiroshige, in particular, were also influential; their strong contours, simplified shapes and flattened two dimensional space also provided a visual cue in the depiction of a landscape buried in snow.[2]

Breton village in the snow is devoid of any narrative or human interest that might be found in the work of Gauguin's Impressionist contemporaries. Indeed, the artist's landscape of the Breton village scene set in the Lollichon field is without life—no villagers or farmer and no animals. X-radiography and infrared tests indicate that Gauguin actually edited out an animal in profile to the left of the foreground, and a human figure to the right.

In *Breton village in the snow* Gauguin has produced a bleak landscape of bold forms and strong outlines set in an ice-chilled light. The artist has created heavy contours for the snow-covered thatch roofed houses of the village, the central Gothic style church steeple and the stark appearance of the tree trunks in this barren landscape. The high horizon line, with the far-off view of smoking chimney stacks and wild clouds, all evoke a sense of drama and bitter cold in a barren winter. It is both austere and forsaken.

Jane Kinsman

1 For example, Eliza E. Rathbone in Charles S. Moffett, Eliza E. Rathbone, Katherine Rothkopf et al., *Impressionists in winter: effets de neige*, Washington: The Phillips Collection in collaboration with Philip Wilson Publishers 1998, p. 204; Charles F. Stuckey in Stephen F. Eisenman (ed.), *Paul Gauguin: artists of myth and dream*, Milan: Skira 2007, p. 380.

2 Utagawa Hiroshige, *Kambara: Snow in the evening*, quoted by Yann le Pichon and I. Mark Paris (trans.), *Gauguin: life, art, inspiration*, New York: Harry N. Abrams 1986, p. 193.

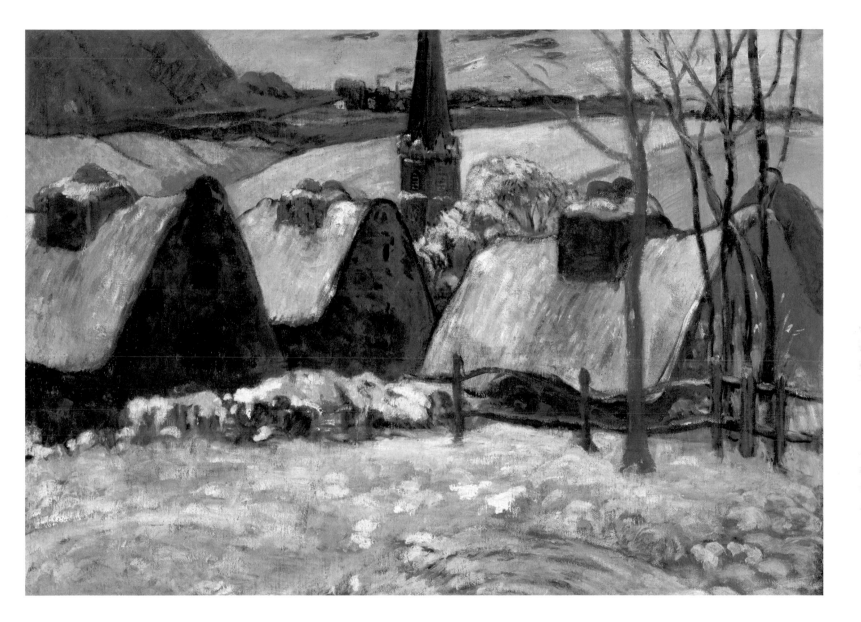

71 Georges Lacombe

France 1868–1916

The violet wave (La vague violette) 1895–96
oil on canvas, 73.0 x 92.0 cm
Musée d'Orsay, Paris, purchased 1988, RF 1988-18
© RMN (Musée d'Orsay) / Hervé Lewandowski

Lacombe visited the coastal village of Camaret-sur-mer in Brittany every summer from 1888 onwards. First taught to paint by family friends such as Gervex (cat. 4), Lacombe's career was galvanised by meeting Sérusier in 1892, then by seeing Gauguin's woodcarvings in Paris in 1893. Although primarily a sculptor and decorator in wood, he joined the Nabis—who dubbed him the 'Nabi sculptor'—and painted in an individualistic style in the 1890s.

Instead of painting the picturesque costumed Breton peasant women favoured by other artists, Lacombe often depicted unpeopled scenes: landscapes of brooding, druidic forests or rocky caves. He used the bright, restricted palette favoured by Sérusier and others: 'Three or four colours, carefully chosen, are enough, and quite expressive. Any more colours would only lessen the painting's impact,' Sérusier wrote in 1892.[1] In *The violet wave*, the artist employed purple-black for the rocks, white tinted violet for the raging surf, and orange to yellow hues for the cliffs and sky. Such an artificial colour scheme reinforces the 'scientific' colour theories current at the time, and particularly the idea of complementary opposites. Yellow, one of the primary colours, is intensified by violet, made by mixing red and blue, the other two primaries.

The violet wave shows a rocky cave under the cliffs of Toulinguet, a peninsula near Camaret in Brittany. But instead of portraying the cave from outside, Lacombe looked through the mouth of the cave out onto the sea and sky. Swirling, rhythmic strokes of paint mimic the arabesque lines and shapes used in Japanese woodblock prints, which came to haunt, even define, Art Nouveau. Interlocked dark purplish-black rocks dominate the central view. The stifling interior is accentuated by the power of a wave rushing in to fill the cave, replacing air with seawater. It is as though we, the viewers, are inside a whale, swallowed like Jonah in the Bible.[2]

The strange power of the image is reinforced by its decorative forms and anti-naturalistic style:

> Lacombe, by his refusal of realism, introduces us into a symbolic world: a kind of flux and surge of life, where the two contemplative forms, fusing with nature, stretch towards the sky, the only point of exit in the painting. The violet-mauve monochrome, precious and rare in this case, and the golden rose of the sky give this work an almost mystical meaning, and we can enter a world of musical correspondences.[3]

Christine Dixon

1 Letter to Jan Verkade, quoted in Joëlle Ansieau, *Georges Lacombe 1868–1916, catalogue raisonné*, Paris: Somogy 1998, p. 61.

2 Also suggested by Caroline Mathieu, 'George Lacombe', in *The Impressionists: masterpieces from the Musée d'Orsay*, Melbourne: National Gallery of Victoria 2004, p. 176.

3 Catherine Gendre, 'Catalogue no. 3', in *Georges Lacombe 1868–1916*, Versailles: Musée Lambinet 1984, p. 26 (trans. by author).

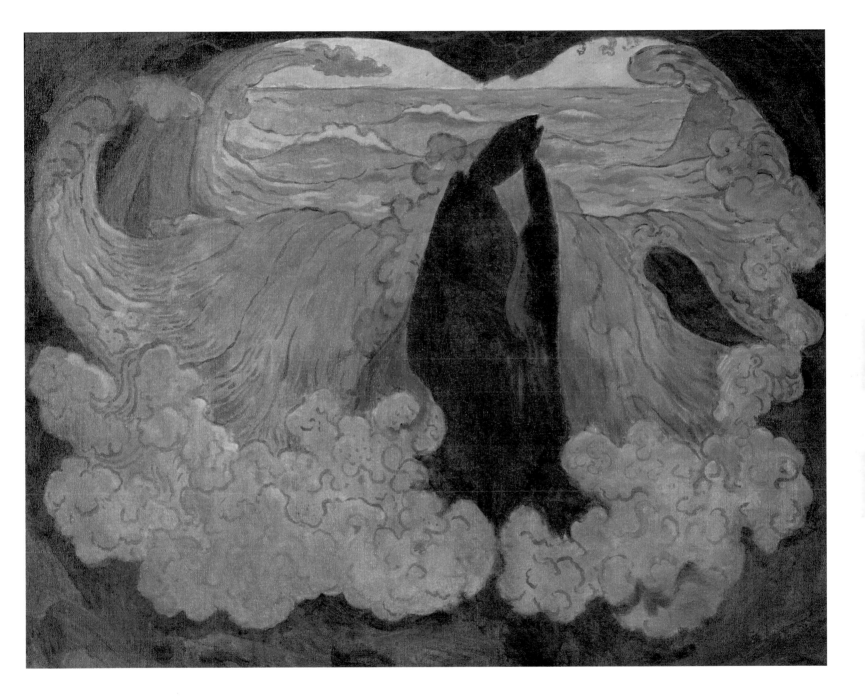

Symbolism and the Nabis

Emile Bernard

Pierre Bonnard

Henri-Edmond Cross

Maurice Denis

Vilhelm Hammershøi

Fernand Khnopff

Gustave Moreau

Pierre Puvis de Chavannes

Odilon Redon

Armand Séguin

Paul Sérusier

Félix Vallotton

Edouard Vuillard

72 Paul Sérusier

France 1864–1927

The talisman, the Aven at the Bois d'Amour
(*Le Talisman, l'Aven au Bois d'Amour*) 1888
oil on wood panel, 27.0 x 21.5 cm

Musée d'Orsay, Paris, purchased with assistance from P. M.
Through Fondation Lutèce 1985, RF 1985-13
© RMN (Musée d'Orsay) / Hervé Lewandowski

One day in October 1888, Gauguin gave Sérusier a brief
painting lesson in the Bois d'Amour on the bank of the
Aven River in Brittany:

> How do you see these trees? They are yellow. Well, then,
> put down yellow. And that shadow is rather blue. So render
> it with pure ultramarine. Those red leaves. Use vermilion.[1]

The resulting small painting was taken back to Paris, to
the Académie Julian, where Sérusier was a class monitor.
It was a revelation to the young painters there, especially
to Bonnard, Denis, Vuillard and Paul Ranson, who were
shortly to form the artists' group the Nabis, perhaps
owing to this painting. The work was nicknamed
'The talisman', that is, a secret and magical object.

Gauguin's instructions to Sérusier—to intensify
colour and simplify form—led to short, square vertical
brushstrokes, lengthened and continued as flat patches
of colour. There is no focus—even a denial of all
compositional arrangement—which is another reason
the work was so revolutionary. Denis' small painting
Sunlight on the terrace (cat. 73) also shows Gauguin's
influence, especially through his revelatory exhibition in
the Cafe Volpini in the summer of 1889. Crucial too was
the exhibition of Japanese woodblock prints at the Ecole
des Beaux-Arts in May 1890.

73　Maurice Denis

France 1870–1943

Sunlight on the terrace
(*Taches de soleil sur la terrasse*) 1890
oil on card, 24.0 x 20.5 cm

Unlike Sérusier's flat smooth brushstrokes however, Denis took the lesson of flatness and applied it in a strikingly different manner. Organic forms in bright red and orange contrast with light blue and darkest blue-green shapes outlined in dark yellow. The terrace is Le Notre's famed seventeenth-century terrace at the Chateau of Saint-Germain-en-Laye.[2] Apart from its title, *Sunlight on the terrace* seems pictorially comprehensible only through the figure of a child, and the trees on the right.

Although Sérusier's *The talisman* was recognised as important at the time, its radical nature meant it was never exhibited in the artist's lifetime, and neither was Denis' *Sunlight on the terrace*. They were both seen as experiments rather than finished works of art. In 1890 Denis wrote that a painting 'is essentially a flat surface covered in colour assembled in a certain order'.[3] The tendency of art towards abstraction can be seen here, in the late nineteenth century, but the consequences were not to be realised until Wassily Kandinsky's and others' explorations in the first decades of the next century.

Christine Dixon

1　Quoted in Edmund Capon, 'Director's foreword', in Roland Pickvance, *Gauguin and the Pont-Aven School*, Sydney: Art Gallery of New South Wales 1994, p. 7.

2　Denis grew up in the district of St Germain-en-Laye.

3　'Définition du néo-traditionnisme', *Art et critique*, no. 65, 23 August 1890, pp. 556–58.

74 Paul Sérusier

France 1864–1927

Portrait of Paul Ranson in Nabi costume
(*Portrait de Paul Ranson en tenue nabique*) 1890
oil on canvas, 61.0 x 46.5 cm

Musée d'Orsay, Paris, purchased 2004, RF 2004-8
© RMN (Musée d'Orsay) / Hervé Lewandowski

The group of Parisian artists who called themselves the Nabis was like other secret societies set up by idealistic young men. The P.R.B. or Pre-Raphaelite Brotherhood formed by painters and poets in England in the 1840s was another artistic cabal. As well as lofty talk about art and spirituality, the group dined and drank together, and had fun. 'Nabi' was a latinised version of the Hebrew and Arabic words for 'prophet', carrying the idea of 'the future'. It also bore the meaning of 'transformer', 'magician'—one who could change reality.

Sérusier founded the Nabis in 1888–89, and his friend Paul Ranson was a co-founder. He painted this portrait of Ranson dressed in Nabi costume in 1890. The earnest young artist is clothed in a blue gown with a flat gold collar and blue jewel. He wields a gilt sceptre, like a bishop's crozier. The gown is almost certainly fantasy, as neither Madame Sérusier nor any other witness recalls any exotic attire, but some remember the sceptre as a decorative rod used in meetings.[1] Symbols include the five-pointed star for truth, and the serpent for knowledge, evil or wisdom. Both men were interested in the occult, Theosophy and exotic religions, as well as aesthetic theories. Ranson was known as the 'Red-bearded Nabi', and is easily recognisable by his beard, his lorgnette, and chestnut hair. His right hand traces the unrecognisable text (probably Hebrew) of an illuminated volume with dark orange edges.

A lighter orange disc surrounds Ranson's head like a halo, implying sacred knowledge and enlightenment. Light blue cloth and text, and mid-blue background, are strong colour complementaries to the painting's orange and dark yellow hues. Widely read in the field of art, and an acquaintance of many contemporary modernist artists, Sérusier knew of the colour wheel and the argument

that placing a colour next to its complementary opposite (red–green, yellow–violet, blue–orange) intensified both. As well as Seurat and the Divisionists who adopted this practice as fundamental to their work, many other painters of the time, including Gauguin and van Gogh, experimented with it.

Sérusier's portrait of Ranson is unusual, both in subject and technique. He mainly painted landscapes with figures, particularly in Brittany in the early 1890s, where he looked to Gauguin (cats 57, 62, 63, 67 and 70) and used smaller, parallel brushstrokes and variegated colours. Here Sérusier draws dark blue outlines around the forms and fills them in with large flat planes of all but unmodulated colour. This Cloisonnist technique also owes something to Japanese woodblock prints, known to Sérusier through Gauguin and exhibitions in Paris. Sérusier also animates the composition by sharply angling the three-dimensional elements of figure, book and sceptre. Ranson and his book are set sixty degrees away from frontality, while the sceptre presents an abrupt line at an opposite thirty degrees from vertical. This disposition invites the viewer into the painting—perhaps to partake of the mysteries?

Christine Dixon

1 See Caroline Boyle-Turner, *Paul Sérusier*, Ann Arbor: U.M.I. Research Press 1983, pp. 37–38.

75 Edouard Vuillard

France 1868–1940

The reader (Portrait of K.X. Roussel)
(*Le liseur (Portrait de K.X. Roussel)*) c. 1890
oil on card, 35.0 x 19.0 cm

Musée d'Orsay, Paris, accepted in lieu of tax 1990, RF 1990-13
© RMN (Musée d'Orsay) / Hervé Lewandowski
© Edouard Vuillard. ADAGP/Licensed by Viscopy, 2009

Vuillard and the subject of this portrait—his future brother-in-law Roussel—met at the Lycée Condorcet and were lifelong friends. In 1889 both joined the Nabis group under the influence of Denis, a fellow student at the Académie Julian. By all accounts, the friendship that existed between Roussel and Vuillard was a case of opposites-attract. Vuillard, a reserved and exceedingly polite man, never married and lived with his mother until her death. He wore a perfectly manicured beard that made him appear old beyond his years, and his regimental appearance earned him the nickname 'the Nabi Zouave' (a reference to the North-Africa-based soldiers of the French Foreign Legion). Roussel, on the other hand, was a gregarious character. Attractive, intelligent and outspoken he read widely, and had a reputation as a ladies' man. He married Vuillard's sister Marie in 1893. The marriage, which produced two children, was evidently not a happy one.[1]

The reader is one of several portraits in which Vuillard depicts Roussel partaking in his most beloved activity. A look of rapt attention is captured on his face as he bends intently towards the page he is studying. His rather debonnaire green jacket contrasts strikingly with the red background of the work. Combined with the bright yellow upper third of the painting, these bold colours seem to suggest something of Roussel's audacious personality.

The portrait dates from the earliest period of Vuillard's painting career, when the influence of Synthetism is clear (cat. 76). The style, introduced to the Nabis group via Sérusier's aptly renamed work *The talisman* (cat. 72), is evident in Vuillard's application of bright colours in a flat, interlocking arrangement. Unlike Sérusier, however, Vuillard maintained a distance from the spiritual elements of Synthetism. Here he offers us a portrait of a man absorbed in the practical attainment of worldly knowledge.

As well as Synthetism the influence of Cloisonnism is obvious in *The reader*. The bold, simplified areas of pure colour are defined with a black outline, as in traditional cloisonné enamel work or even stained glass. Indeed, painted on a small card with rounded edges, and in brilliant colours, this work physically resembles the lid of a precious enamelled box.

Emilie Owens

1 For a more thorough examination of the relationship between Roussel and Vuillard, and Roussel's marriage to Vuillard's sister, see Guy Cogeval, *Vuillard*, Montreal, Montreal Museum of Fine Art; Washington D.C.: National Gallery of Art 2003, cats 8, 9 and 87, pp. 63 and 145.

76 Edouard Vuillard

France 1868–1940

Profile of a woman in a green hat
(*Femme de profil au chapeau vert*) c.1891
oil on card, 21.0 x 16.0 cm

Musée d'Orsay, Paris, accepted in lieu of tax 1989, RF 1990-14
© RMN (Musée d'Orsay) / Hervé Lewandowski
© Edouard Vuillard. ADAGP/Licensed by Viscopy, 2009

This work exemplifies the caricature-based drawing style which Vuillard embraced in the 1890s. His drawings and paintings from this period use simple figurative forms. A few assiduously placed details such as the hat and firm brow animate this cartoon-like figure from the static background. Vuillard paints the figure on a plane of single colour, a striking technique which creates a bold effect, with the image jumping from the canvas. He uses a somewhat similar technique in *The reader* (cat. 75).

Vuillard creates bold structures in these paintings, with heavy dark lines and flat areas of colour resembling cloisonné enamels. He emphasises the contours of objects, in this instance the woman's face, accentuating them against the background. In *Profile of a woman in a green hat*, it is interesting to observe that he creates his Cloisonnist lines negatively. Rather than painting the dark outlines in at the end, he applied a blue ground first, which he then covered up with blocks of colour, leaving only strips of the base colour around the face, hat and body.

Vuillard struggled with the extreme simplification demanded by Gauguin and his Synthetist aesthetic. His diary details how he made himself concentrate on the 'emotion' that the subject produced in him, forcing himself to ignore all nonessential details.[1] In *Profile of a woman in a green hat*, he achieves this aim. As Signac noted:

> …Vuillard as a painter has freed himself completely from that reality with which we others have to contend … The people in his pictures are not properly defined. As he's an admirable draughtsman it must be that he just doesn't want to give them mouths and hands and feet.[2]

Visiting the 1890 exhibition of Japanese art at the Ecole des Beaux-Arts in Paris inspired Vuillard to sketch Japanese-style women with similarly pinched faces, and assuming odd poses. In the present work, Vuillard creates an elusive face—just a clearly defined eyebrow and overly simplified eyeball, peering back over one shoulder. The face is an enigma. The conspicuous brow evokes a variety of responses in the viewer. Is the woman anxious, persecuted or suspicious? Is she shying away from our intrusive gaze, archly teasing us, questioning what we are looking at, or crossly glaring at us?

This work relies keenly on colour theory. Vuillard positions complementary colours against one another to create dramatic effect with minimal detail. Light and dark areas of yellow juxtapose sections of violet, while the green of the woman's hat is matched against her reddish-brown hair. This style of painting by Vuillard, with its deliberate colours and simplified forms, prefigured the bold manner of the Fauves.

Simeran Maxwell

1 Belinda Thomson, *Movements in modern art: Post-Impressionism*, London: Tate Gallery Publishing 1998, p. 49.

2 Quoted in John Russell, *Vuillard*, London: Thames and Hudson 1971, p. 95.

77 Pierre Bonnard

France 1867–1947

Intimacy (Portrait of Monsieur and Madame Claude Terrasse) (*Intimité (Portrait de Monsieur et Madame Claude Terrasse)*) 1891
oil on canvas, 38.0 x 36.0 cm

Musée d'Orsay, Paris, purchased with the assistance of Philippe Meyer through the Foundation for French museums 1992, RF 1992-406
© RMN (Musée d'Orsay) / Hervé Lewandowski
© Pierre Bonnard. ADAGP/Licensed by Viscopy, 2009

A work in which there are theories is like an object which still has its price tag on it.—Marcel Proust[1]

The term *Intimisme*, used from the 1890s to describe the genre scenes produced by Bonnard, Vuillard and others, might have been specifically invented to describe this work. The focus is close, the composition highly cropped, the colour muted, and the pattern intense. Moreover, the two figures are intimates of the artist: Bonnard's younger sister Andrée, an amateur musician, and her husband Claude Terrasse, a composer and music teacher. In April 1891 Bonnard visited his sister and brother-in-law at the Villa Bach, in Arcachon, and this work may have been conceived there. We may easily imagine him speaking in an aside with Andrée while he painted, with Claude seated nearby, lost in his own thoughts.

In 1891 Bonnard shared a studio with Denis and Vuillard, and exhibited five paintings at the Salon des Indépendants in March. His *France-Champagne* (designed 1889) was produced as a poster, and he began to devote himself to painting. Like the other Nabis, Bonnard's work shows the impact of three influences: nineteenth-century Japanese prints, Sérusier's painting lesson from Gauguin in the Bois d'Amour near Pont-Aven in October 1888 (cat. 72), and seeing Gauguin's work at the Cafe Volpini in Paris in the summer of 1889. Unlike his compatriots, Denis and Sérusier in particular, Bonnard was unaffected by theories of art, declaring that painting was 'the transcription of the adventures of the optic nerve'.[2] From the 1890s he also practised photography, producing small-format negatives using a Kodak camera.

Bonnard's fascination with patterning—and its possibilities for concealment—is evident in *Intimacy*. The work contains two figures, and the left hand of a third, holding a pipe; it may be the painter's, his other hand reserved for the brush. Equally, the hand could be one of our own, a device to lure us into the scene. In the yellow light, surrounded by wisps of smoke from the pipes, the puffs and trails of a cigarette, the figures are not immediately discernible. They and the smoke mingle and merge with the design of the wallpaper, like the rich patterns of an elaborate carpet. As Whitfield points out, the 'figures are fused in mutual closeness (perhaps listening to music)', this closeness conveyed in the way in which they are 'pressed up close to the painter's eyes, to our eyes, so close that it takes a while for our own vision to adjust, for us to be able to read these pressed-flat forms'.[3] This is a telescopic proximity, as if we are zooming in on the scene; the fact that Bonnard has enclosed our view in a painted frame is the painterly equivalent of composing a photograph within the lens.

Lucina Ward

1 Marcel Proust, 'VI–Time regained', *In search of lost time*, London: Vintage 1996, p. 236, quoted in Sarah Whitfield, 'Fragments of an identical world', *Bonnard*, London: Tate Gallery Publishing 1998, p. 9.

2 Bonnard's diary note, 1 February 1934, in Antoine Terrasse, 'Bonnard's notes', in Sasha M. Newman (ed.), *Bonnard*, New York: Thames and Hudson 1986, p. 69.

3 Whitfield, p. 10.

78 Pierre Bonnard

France 1867–1947

Portrait of Vuillard (*Portrait de Vuillard*) 1892
oil on wood panel, 14.5 x 21.8 cm

Musée d'Orsay, Paris, purchased with the assistance of Philippe
Meyer 1993, RF 1993-7
© RMN (Musée d'Orsay) / Hervé Lewandowski
© Pierre Bonnard. ADAGP/Licensed by Viscopy, 2009

Away with easel-pictures! … The work of the painter
begins where that of the architect is finished … There are
no paintings, but only decorations![1]

So Jan Verkade, a contemporary and friend of the Nabis,
recalled the group's aspirations some forty years after
its inception in 1889. This work, the odd shape of
which suggests it was intended as a decorative chimney
surround, provides a clear indication of the Nabis' desire
to break away from traditional modes of representation
and to merge art with daily life.

Known as the 'Japanese Nabis', Bonnard was heavily
influenced by Japanese prints, an exhibition of which he
had seen at the Ecole des Beaux-Arts in 1890. In *Portrait
of Vuillard* Bonnard employs typically Japanese pictorial
devices. Here we see Vuillard on the street, dressed in
the clothes of an upper-class gentleman. Behind him
walks a woman leading a child, whose face is visible at
his right elbow. The spontaneous image has the feeling
of a randomly snapped photograph. This invocation
of chance, and the unusual pictorial composition that
results, is typical of Japanese prints. The use of a large
frontal plane (in this case Vuillard's face) set against the
blurred image of the woman and child creates a false
sense of depth. The flat blocks of colour and minimal but
decorative background also suggest a Japanese influence.

Bonnard and Vuillard met at the Ecole des Beaux-Arts
in 1889. Both were founding members of the Nabis
and they remained close friends throughout their lives.[2]
It is of particular interest to note the similarities between
the shape of this 1892 work and that of the 1891 oil-on-
card sketch *Vuillard in profile*,[3] another of Bonnard's many
portraits of his friend. Though executed in different
styles, the two works appear to have been conceived as

companion pieces for either side of a single chimney.
Perhaps they were intended to decorate the studio
that Vuillard and Bonnard shared with Denis in
Montmartre's Rue Pigalle. Or had Bonnard simply
abandoned the idea, only to return to it with renewed
inspiration at a later date?

Emilie Owens

1 Quoted in Nicholas Watkins, 'The genesis of a decorative aesthetic', in
 Gloria Groom, *Beyond the easel: decorative painting by Bonnard, Vuillard,
 Denis and Roussel, 1890–1930*, Chicago: Art Institute of Chicago 2001,
 p. 1.

2 In his last letter to Bonnard, Vuillard wrote, 'If I wrote to you every
 time I think about you, our past, painting, etc. you would have enough
 letters to fill a library'. See Guy Cogeval, *Vuillard: Post-Impressionist
 master*, New York: Harry N. Abrahams 2002, p. 126.

3 Private collection. See Jean and Henry Dauberville, *Bonnard: catalogue
 raisonné de l'oeuvre peint*, vol. 1 (1888–1905), Paris: Editions J. et H.
 Bernheim-Jeune 1965, p. 102.

79 Pierre Bonnard

France 1867–1947

Checked shirt (Portrait of Madame Claude Terrasse at twenty) (Le corsage à carreaux (Portrait de Madame Claude Terrasse à vingt ans)) 1892
oil on canvas, 61.0 x 33.0 cm

Musée d'Orsay, Paris, purchased from Charles Terrasse, the sitter's son 1968, RF 1977-89
© RMN (Musée d'Orsay) / Hervé Lewandowski
© Pierre Bonnard. ADAGP/Licensed by Viscopy, 2009

In 1890 a retrospective of Japanese prints at the Ecole des Beaux-Arts took place. *Exposition de la gravure japonaise* contained work familiar to the informed French public. The effect of the exhibition on Bonnard, then aged in his early twenties, was profound. He later recounted the experience:

> I realized that colour could express everything as it did in this exhibition, with no need for relief for texture. I understood that it was possible to translate light, shapes and character by colour alone, without the need for values.[1]

Bonnard eagerly applied these lessons to his own art, and they are found thoroughly assimilated in the work reproduced here—the portrait of his sister Andrée, Madame Claude Terrasse, painted two years later in 1892. In the composition the principal figure is not depicted in three-dimensional space or point perspective, but rather the form of the figure is given substance by the flat pattern, sinuous line and curved shapes of the brightly coloured red-checked blouse. The influence of Japanese artists such as Utagawa and Toyokuni II Kunisada is evident, but most important is Kuniyoshi, whose print of a checked blouse was in the possession of Bonnard's friend Denis.[2] Despite the strong Japanese influence, the laid table, with its modelling and reflected light remains in the tradition of the still-life.

80 Pierre Bonnard

France 1867–1947

The white cat (*Le chat blanc*) 1894
oil on card, 51.0 x 33.0 cm

Musée d'Orsay, Paris, purchased 1982, RF 1982-74
© RMN (Musée d'Orsay) / Hervé Lewandowski
© Pierre Bonnard. ADAGP/Licensed by Viscopy, 2009

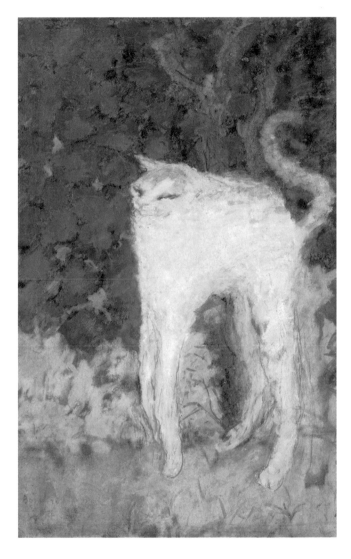

A cat features prominently in the work, and is the subject of his painting *The white cat* two years later. Edouard Manet, an avid Japoniste, had made many references to the cat in his art, including his celebrated painting *Olympia* 1863[3] (p. 18). This no doubt contributed to the inclusion of cats in late nineteenth-century French art. Aside from any literary or artistic tradition, the cat now had a new role to play—emblem of a growing intimate affection and a symbol of private life within the French family.[4]

Bonnard's sister, along with his brother-in-law Claude Terrasse and the couple's child, reappeared in Bonnard's colour lithograph *Family scene* 1892, in the portfolio *L'estampe originale*. The slim format and flat patterning of the composition, with its elegant lines suggesting form, also reveals the profound influence that *ukiyo-e* prints (in this instance one by Utamaro) had on Bonnard—who within the group of artists was dubbed the 'very Japanese Nabi'.

Jane Kinsman

1 Bonnard recount to Gaston Diehl, *Comoedia*, 10 July 1943, quoted in Claire Frèches-Thory and Antoine Terrasse, *The Nabis: Bonnard, Vuillard and their circle*, Paris: Flammarion 1990, pp. 86–87.

2 *Le Japonisme*, exhibition catalogue, Paris: Galleries nationales du Grand Palais 1988, cat. 266.

3 Musée d'Orsay, Paris.

4 Alain Corbain, 'Backstage', in Michelle Perrot (ed.) and Arthur Goldhammer (trans.), *A history of private life, vol. 4: from the fires of revolution to the Great War*, Cambridge, Ma.: The Belknap Press of Harvard University Press 1990, pp. 526–27.

81 Edouard Vuillard
France 1868–1940

Félix Vallotton c.1900
oil on card, laid on wood panel, 63.0 x 49.5 cm
Musée d'Orsay, Paris, bequest of Carle Dreyfus 1953, RF 1977-390
© RMN (Musée d'Orsay) / Hervé Lewandowski
© Edouard Vuillard. ADAGP/Licensed by Viscopy, 2009

Vuillard and Vallotton were both members of the Nabis, and were especially close friends. In this portrait, Vuillard reveals this familiarity through the informal way he portrays his fellow artist. Thirty-six-year-old Vallotton appears unceremoniously perched on a side-table, rather than sitting in a chair, in his studio at 6 Rue de Milan, Paris. He wears casual clothing—a blue house suit (equivalent to a modern tracksuit) and slippers.

Despite the comfortable nature of this portrait, Vallotton is presented as a reserved personality. Even amongst his intimates he was not gregarious, and many of his self-portraits reveal his introverted character (cat. 95). Here Vuillard has painted him with his arms folded firmly across his body and his legs entwined under him. Defensively withdrawn into a corner of his own room, the resigned expression on Vallotton's face suggests that the portrait was not his idea and that he is participating with reluctance. Interestingly, the physical attributes of the face are barely represented. The viewer's eyes are drawn instead to the brilliance of the red slippers and then the blue of the house suit. His face is the last place that the viewer looks, despite being immediately drawn to the figure.

A contemporary critic described Vuillard as: 'Above all … a painter of greys in which he produced the most unusual combinations'.[1] While this portrait is predominantly composed of muted greys and beiges, the figure of Vallotton is accentuated by his colourful clothes. The brightness of the red slippers, contrasting with the white skirting board, makes them leap off the canvas.

Like many Nabis, Vuillard often focused on domestic interiors, as well as portraits. Here he has combined both, creating a very personal portrait of his friend in his studio. The art displayed on the surrounding walls establishes a special intimacy. To the figure's left is a large Chinese silk painting depicting a wedding ceremony.[2] To the right is one of Vallotton's own woodcuts of famous authors, which included Fyodor Dostoyevsky and Edgar Allan Poe, although the rough nature of Vuillard's sketch makes it impossible to discern whose portrait it is.

Félix Vallotton was produced shortly after Vallotton's marriage to Gabrielle Rodrigues-Henriques, the widowed sister of the well-known Parisian art dealers Gaston and Josse Bernheim (see cat. 99). Despite the obvious benefits his friend might have expected to enjoy from the alliance, Vuillard, a confirmed bachelor, disapproved. The inclusion of the Chinese wedding scene could be read as a jibe at Vallotton's recent nuptials. Vallotton is also positioned in a comfortable middle-class setting because, in Vuillard's eyes, after his marriage to the bourgeois Gabrielle, his friend was no longer a 'starving artist', like many of their colleagues. The furniture and patterned carpet—neither expensive nor down-at-heel—convey a secure domestic atmosphere.

Simeran Maxwell

1 Adolphe Basler and Charles Kunstler (trans.), *The Post-Impressionists: from Monet to Bonnard*, London: The Medici Society 1931, p. 57.

2 Qing dynasty (1644–1912), China, *Wedding ceremony in front of ancient altar* c.1850, private collection.

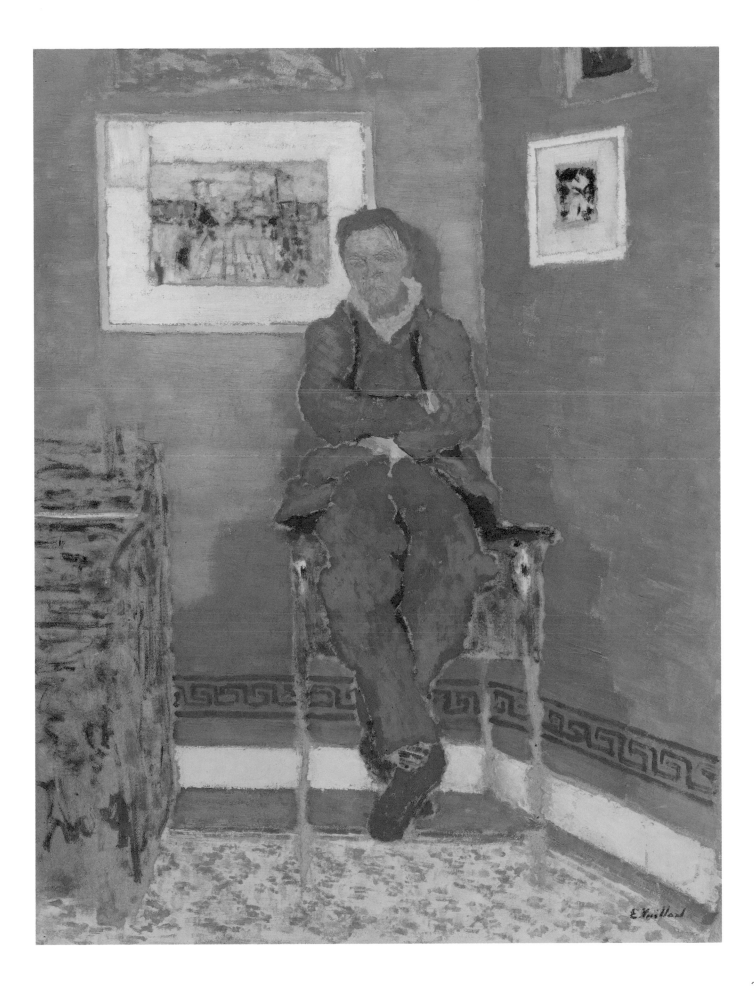

82 Gustave Moreau

France 1826–1898

Orpheus (*Orphée*) 1865
oil on wood panel, 154.0 x 99.5 cm
Musée d'Orsay, Paris, purchased from the artist 1866, RF 104
© RMN (Musée d'Orsay) / Hervé Lewandowski

An almost life-sized but curiously elongated female figure set against an elaborate Italianate backdrop is seen through a 'misty scrim of twilight tones'.[1] When shown at the 1866 Salon, this painting was published with the artist's own description: 'A girl reverently gathers up the head of Orpheus and his lyre borne on the waters of [the river] Hebros to the shores of Thrace.'[2] Moreau's unorthodox depiction made it necessary for him to identify the subject for his viewers. In Ovid's account, book XI of *Metamorphoses*, Orpheus—inconsolable after the death of Eurydice—is torn to pieces by incensed Maenads and thrown into the river, his head and lyre subsequently washing up on the island of Lesbos. There is, however, no mention of a Thracian maiden.

Moreau produced many studies for this painting. He posed his model holding a board in the shape of a lyre, using a cast of the face of Michelangelo's *Dying slave* 1513–16[3] for Orpheus' head. The features of the Greek poet and musician, and those of the maiden, are strangely similar: she contemplates the laurel-crowned head on its gorgeously decorated lyre as if examining her own reflection. Her elegant, orientalised costume contrasts with her large, sphinx-like feet. Subtle gradations of tone, achieved via glazing, are especially skilful on the dress. The delicate posy of flowers on her bodice is reprised by the lemons and leaves behind and at left of the figure.

Many of Moreau's landscape designs are based on Leonardo da Vinci's *Virgin of the rocks* c.1483–86 and *Bacchus* (*St John the Baptist*) c.1510–13.[4] In the present work, on the left, through the rock formation, we glimpse glaciers; at right a winding, silvery stream meanders through the distant landscape. The brooding sky lends a yellowish tinge to the fantastic scene. Moreau referred to the effect that he sought as *le rêve fixé* (the

fixed dream). Other bizarre details, such as the shepherds on the massive rock arch, and the almost 'grisaille' tortoises contribute to the dream-like effect. Moreau's approach has been compared to Wagnerian composition: the artist constructs his paintings as 'symphonic poems', loading them with significant accessories in echo of the principal theme, until the subject yields the last drop of symbolic sap.[5]

Moreau conveys the epic battle between the body's basest passions and the soul's loftiest aspirations via an amalgamation of Darwinist explanation and ancient myth.[6] The tale of Orpheus was popular in the 1850s and 60s, and a favoured theme of Symbolist artists. Critics such as Ernest Chesneau and Théophile Gautier have remarked on the connection between Moreau's rendition of Orpheus and his paintings of Salomé with the head of John the Baptist; the artist went on to create many images of this archetypal femme fatale in the 1870s.

Lucina Ward

1 Robert Rosenblum, *Paintings in the Musée d'Orsay*, New York: Stewart, Tabori and Chang 1989, p. 78.

2 Pierre-Louis Mathieu, *Gustave Moreau: complete edition of the finished paintings, water-colours and drawings*, Oxford: Phaidon 1977, cat. 71, p. 306.

3 Musée du Louvre, Paris.

4 Both Musée du Louvre, Paris.

5 Mario Praz, *The romantic agony*, 3rd edn, London: Oxford University Press 1970, p. 304.

6 Douglas W. Druick, 'Moreau's symbolist ideal', in Genevieve Lacambre, Larry J.Feinberg, Marie de Coutenson et al., *Gustave Moreau: between epic and dream*, Paris: Réunion des Musées nationaux, Chicago: The Art Institute of Chicago in association with Princeton University Press 1999, cat. 32, p. 96.

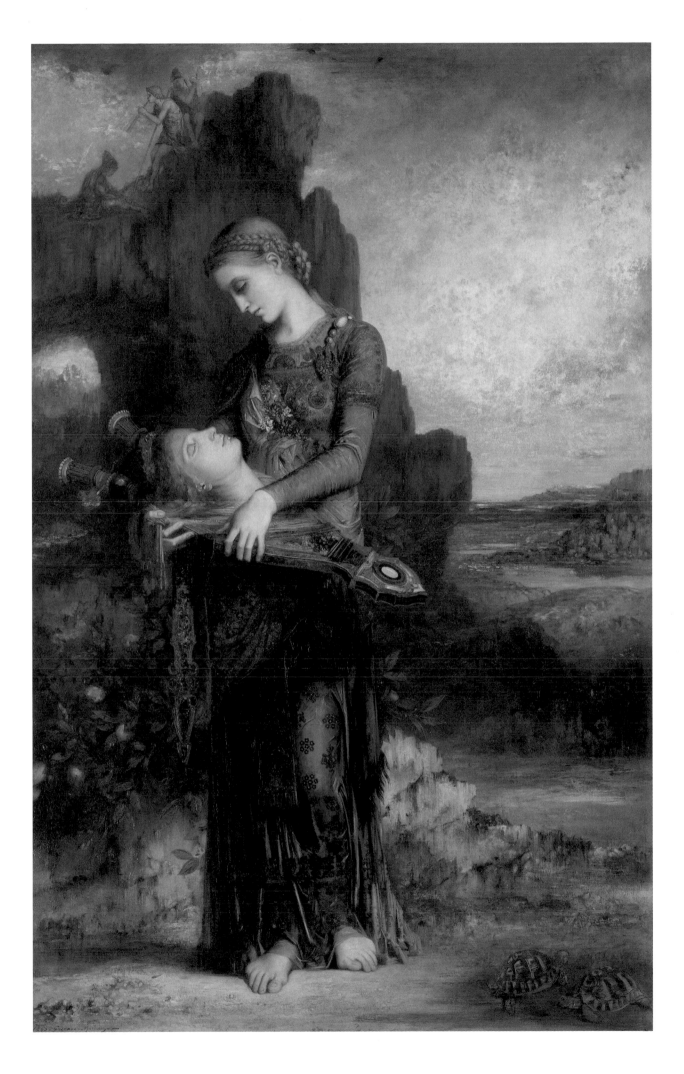

83 Maurice Denis

France 1870–1943

Calvary (Climbing to Calvary)
(Le Calvaire (La Montée au calvaire)) 1889
oil on canvas, 41.0 x 32.5 cm
Musée d'Orsay, Paris, gift of Dominique Maurice-Denis 1986,
RF 1986-68
© RMN (Musée d'Orsay) / Hervé Lewandowski
© Maurice Denis. ADAGP/Licensed by Viscopy, 2009

The graphic intensity of this painting is immense. *Calvary* is one of Denis' earliest works—a simple composition structured around the diagonal, dominated by dark tones and sombre in mood. The unmodulated mass of black, rising up like an arrow, accentuates the diagonal: only gradually do the female figures emerge as black-clad nuns, the simplicity of the cross at upper left parallels the extreme stylisation of their habits and clasped hands. These figures are cipher-like. But even if we have no knowledge of Christianity's most sacred story, we sense that the figure with the cross, who glows with the painting's only area of warmth, is its spiritual centre.

Denis, known as the 'Nabi with beautiful icons', was an ardent Catholic. As such we might expect a more immediately recognisable rendition of the moment when Mary, at the fourth station, embraces Jesus carrying his cross to Golgotha. The army of lance-bearing soldiers silhouetted against the sky suggests a specific time, but the artist takes liberties: it is emotion rather than the historical event that is of interest here.[1] Denis has absorbed the stylistic innovations of the Pont-Aven painters—Bernard in particular—surrendering the individuality of his figures and the specifics of place to the overall abstract and decorative qualities of his work. He had probably seen Gauguin's and Bernard's print portfolios, as well as another *Road to Calvary* 1889 by Bernard,[2] shown at the Cafe Volpini exhibition. The pyramid of figures and the tiered structure of the composition—the thin strip of pale sky, the misty band of pale aqua, and the third section which comprises the hill—directs the eye upwards.

The antique soul was coarse and shallow …
Christian suffering is immense,
Like the human heart,
It suffers, then thinks,
And calmly continues along the road.
—Paul Verlaine, *Sagesse (Wisdom)* 1881[3]

When Denis painted this work he was reading Verlaine's volume of poetry *Sagesse (Wisdom)*, concerning the poet's struggles with the Church and his religious beliefs. Denis made illustrations for *Sagesse* at this time, but although the author admired them the illustrated volume was not published until 1911, by Ambroise Vollard, and with wood engraving by Jacques Bellard. Denis' 1889 illustrations were produced in the style of ancient woodcuts, and he carried this generalised medieval style through to his painting. The tiny clusters of flowers in the present work suggests a tapestry, or the painted ceiling of a Gothic chapel. The dry, matt quality of Denis' painting was also cultivated by him to resemble frescos. There are close links between the poet's text and the painter's work in 'plastic form'. While the title identifies Denis' scene as particular to the Bible, the painting also encapsulates a more timeless, universalised expression of grief and suffering.

Lucina Ward

1 Isabelle Gaëtan, 'Le Calvaie (Montée au Calvaire)', in *Maurice Denis (1870–1943)*, Paris: Réunion des musées nationaux; Montréal: Musée des beaux-arts de Montréal 2006, p. 118.

2 Location unknown, ex collection Ambroise Vollard, see Jean-Jacques Luthi, *Emile Bernard: catalogue raisonné de l'oeuvre peint*, Paris: Side 1982, cat. 239, pp. 38–39.

3 XXIV. Quoted in Thérèse Barruel, 'Calvary', in *Maurice Denis 1870–1943*, Ghent: Snoeck-Ducaju and Zoom 1994, p. 123.

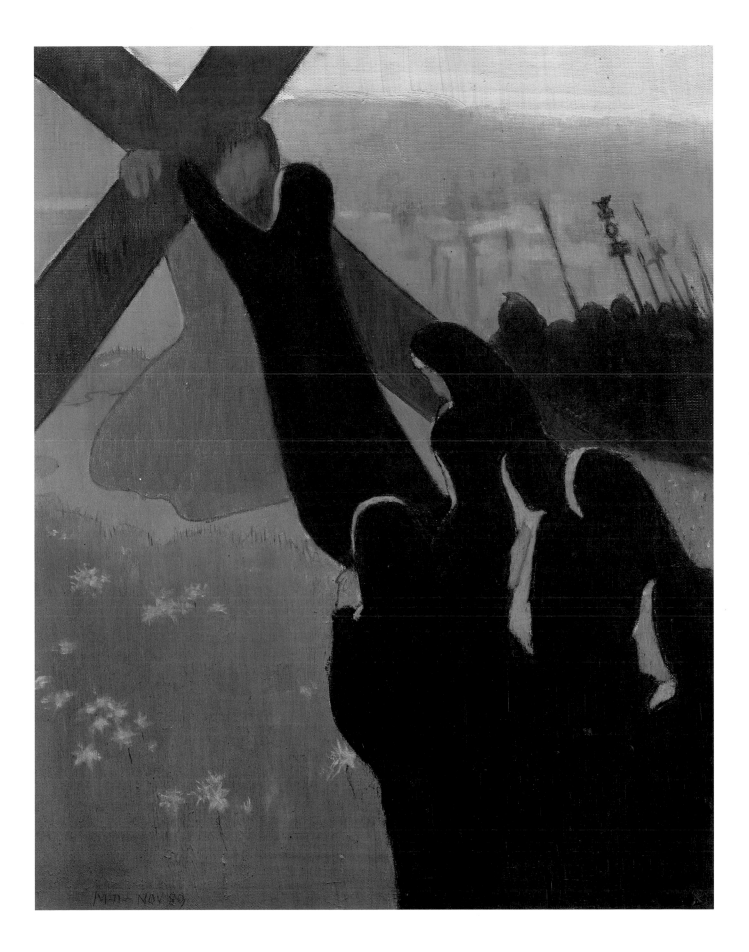

84 Maurice Denis

France 1870–1943

Landscape with green trees (Green trees) (Procession under the trees) (Paysage aux arbres verts (Les arbres verts) (La procession sous les arbres)) 1893

oil on canvas, 46.0 x 43.0 cm

Musée d'Orsay, Paris, accepted in lieu of tax 2001, RF 2001-8
© RMN (Musée d'Orsay) / Hervé Lewandowski
© Maurice Denis. ADAGP/Licensed by Viscopy, 2009

Denis first studied art at the Lycée Condorcet, along with Vuillard and Roussel. Then, in 1888 he attended the Académie Julian, along with Bonnard and Vuillard. That year he was also accepted at the Ecole des Beaux-Arts.

The tutor at the Julian was Sérusier, and he told his students of the exciting artistic developments being made by Gauguin and his circle at Pont-Aven. Instead of attempting to paint what they saw, they practised an art of the 'inner eye'.[1] Denis was later to recall this new style which so astonished the young artists: 'Instead of being windows onto the natural world, like the pictures of the Impressionists, these were large, strongly coloured decorative expanses with harsh contour lines …'[2]

In 1890 these young radicals formed a group calling themselves the Nabis. The term was proposed partially tongue-in-cheek by Sérusier, derived from the Hebrew word *nabi* meaning 'prophet', and coined by Sérusier's friend, the poet and student of Hebrew, Auguste Cazalis. Initially, it was a term they adopted to amuse themselves as much as anything else. Each member then acquired their own epithet, to highlight their particular interest or personality. Bonnard was dubbed 'the very Japanese Nabi'. The deeply religious Denis—inspired by the art of Puvis de Chavannes, and before him the Italian artists of the fourteenth and fifteenth centuries, especially Fra Angelico and Sandro Botticelli—came to be known as the 'Nabi of the beautiful icons'.

The present work is an extraordinary landscape far removed from the tenets of Impressionism. Denis' 'inner eye' sees a landscape that is a dream world, with elegant outlines of beech trees silhouetted against (*contre jour*) nebulous clouds floating in a blue sky. Gauguin had advised the young artists to pick the most beautiful colours, rather than the colours they might actually see in the external world. Here Denis has chosen the greenest greens and the bluest blues. A group of robed women glides silently through the forest; one has been called by an angel. Through his abstracted, decorative form and ambiguous narrative, Denis has created a landscape of great mystery.

This painting has also been known as *The beech trees in Kerduel*. In 1893 Denis married his great love, Marthe, and they spent their honeymoon in Perros Guirec in Brittany. Close by, the Forest of Kerduel was a location noted for its medieval history and stories of King Arthur. Denis had a strong affinity for Brittany, its landscape and sea, claiming: 'I should be a Breton, too. I'm just a Granvillois: still, it's on the same bay as Saint-Michel and Saint-Malo.'[3] This canvas, therefore, is a celebration of marriage and of a location Denis felt he strongly belonged to. It remained in his possession all his life.

Jane Kinsman

1 G.-Albert Aurier, 'Le Symbolisme en peinture; Paul Gauguin', *Mercure de France*, II, Paris, 1891, quoted in Herschel B. Chipp (trans.), *Theories of modern art: a source book by artists and critics*, Berkeley: University of California Press 1968, p. 89.

2 Denis, 'L'époque du symbolisme', *Gazette des Beaux-Arts*, March 1934, quoted in Claire Frèches-Thory and Antoine Terrasse, Mary Pardoe (trans.), *The Nabis: Bonnard, Vuillard and their circle*, Paris: Flammarion 1990, p. 19.

3 Granville was in neighbouring Normandy. Quote: Denis, *Journal*, vol. 1, Paris: La Colombe 1957, quoted in Frèches-Thory and Terrasse, p. 32.

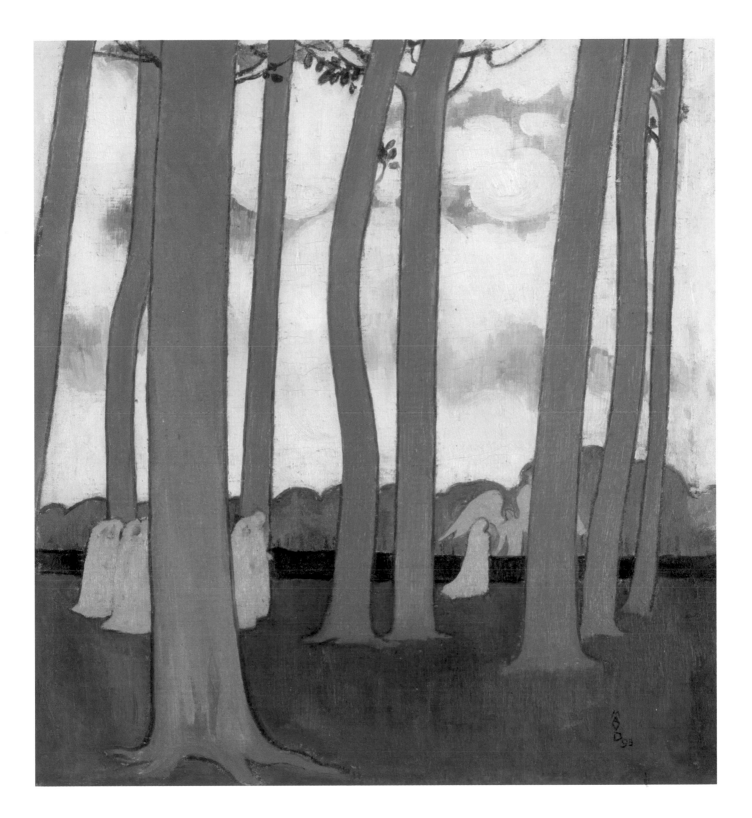

85 Pierre Puvis de Chavannes

France 1824–1898

The poor fisherman (*Le pauvre pêcheur*) 1881
oil on canvas, 155.5 x 192.5 cm

Musée d'Orsay, Paris, purchased from the artist 1887, RF 506
© RMN (Musée d'Orsay) / Hervé Lewandowski

Puvis de Chavannes (who had studied under, among other teachers, Eugène Delacroix)[1] was hailed by a younger generation of artists, including Seurat (see cat. 16), Gauguin and Denis, as a leader of the Symbolist movement. While Puvis ardently denied any links with Symbolism, many of his works—and this one in particular—are imbued with the mystical qualities so characteristic of that style.

This monumental work shows a widowed fisherman waiting despondently for a catch while his young daughter, left to care for her baby sibling, picks flowers on the shore.[2] He intended the painting as a social comment: concerned with the plight of the underprivileged, he stated that 'the true poor people, damn it, are invisible'.[3] By employing at the easel the scale and techniques he had learned as a celebrated muralist,[4] he attempted to reverse this situation by elevating a scene of abject poverty to the realm of myth and history painting.

There was a polarised response to this painting's appearance at the Salon of 1881: the young Parisian artists were excited by its departure from formalist tradition, but there was fierce criticism from some.[5] Auguste Balluffe described the painting as 'a short-hand note of a sketch'.[6] Balluffe distrusted the painting's impermanence, its simplified forms and rigid figures, its washed-out, unnatural colours and melancholic subject matter. These were precisely the elements that appealed to the artists of the avant-garde, and the broad expanses of flat colour that Puvis had borrowed from Italian fresco painting were quickly adopted by painters from Gauguin to the Nabis.

Perhaps Camille Mauclair illuminated *The poor fisherman* most clearly when, in 1928, he described it as:

> a fatalistic poem, as simple and touching as a popular song; it is the poem of a man of sorrows, him of the past or him of the present. Never has the power of this resolutely synthetic art idiom better appeared than in this unusual painting; it has pictural charm, surely, but standing before it one forgets the painting altogether.[7]

Emilie Owens

1 See Stéphane Guégan's essay (pp. 43–55) for details on Delacroix's influence on the Impressionists and Post-Impressionists.

2 Puvis de Chavannes himself describes the subject as such: see Aimée Brown Price, *Pierre Puvis de Chavannes*, New York: Rizzoli International Publications Inc. 1994, p. 47.

3 Brown Price, p. 47.

4 Notable mural projects include *The life of St Geneviève (La vie de Sainte Geneviève)* 1874–78 in the Panthéon, Paris, and the cycles of allegorical murals that decorate the staircases in the Musée des Beaux-Arts, Lyon, 1884–86, and the Boston Public Library, Boston, 1895–96.

5 Such a reaction was uncommon, Puvis de Chavannes' work was generally very well received.

6 Quoted in Edward Lucie-Smith, *Symbolist art*, London: Thames and Hudson 2001, p. 82.

7 Quoted by Jacques Foucart, 'The poor fisherman', in Louise d'Argencourt, Marie-Christine Boucher, Douglas Druick et al., *Puvis de Chavannes, 1824–1898*, Ottawa: The National Gallery of Canada 1977, p. 158.

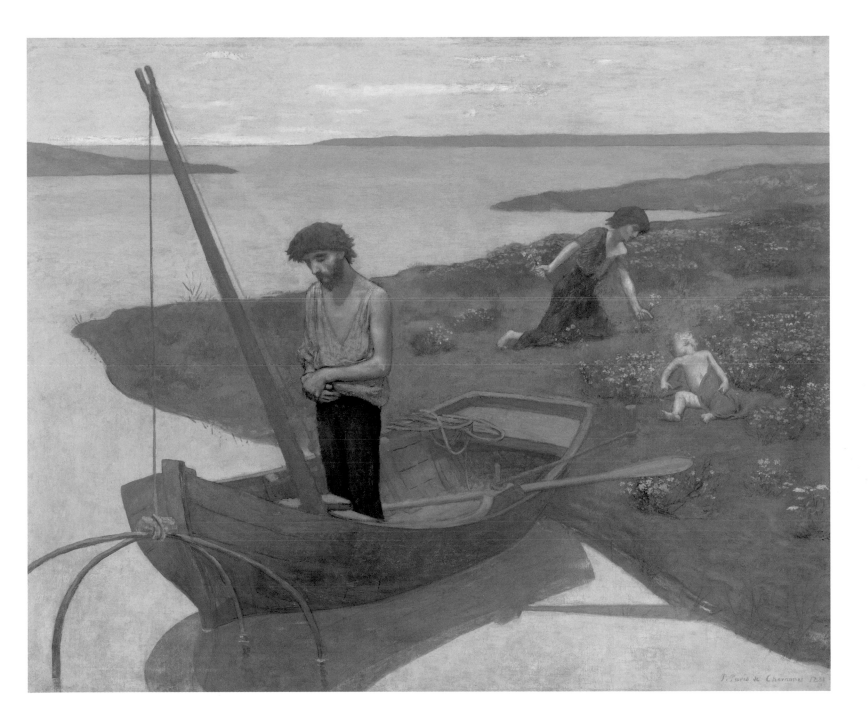

86 Odilon Redon
France 1840–1916

Eyes closed (*Les yeux clos*) 1890
oil on canvas, laid on card, 44.0 x 36.0 cm
Musée d'Orsay, Paris, purchased from the artist 1904, RF 2791
© RMN (Musée d'Orsay) / Hervé Lewandowski

A woman tilts her head, turning a naked shoulder and neck, while her body disappears into evanescent mists below. Her hair is long, but there is no feminine ornament or decoration. The subject is almost sexless, recalling images of Christ. Artistic exemplars include the perfect modelling of the Renaissance painters Piero della Francesca and Hans Holbein, as well as marble sculptures. The most striking parallel is Michelangelo's *Dying slave* 1513–16, held in the Musée du Louvre since 1794. That figure is similar in pose but more emotional, with arm flung up and head inclined further. Redon's subject is withdrawn rather than active, her face and flesh modulated by light falling from the right to define planes by contour rather than lines.

Redon creates a dream world, proposing an interior reality which is enigmatic and very difficult to penetrate. Instead of the colourful and tactile expressions of his contemporaries, the artist employed a very restrained method of painting. After a long apprenticeship in monochromatic drawing and printmaking, Redon began to explore colour through drawing in pastels, paler and less intense than oil paint. When he began using oils, this approach continued. *Eyes closed* has a pastel, chalky quality, not only in the pallid, restricted palette of blue and pink and brown, but in the paucity of paint applied. The canvas shows through, accentuating the minimal means used by the artist to convey the quiet, internal drama of the subject.

In *Eyes closed*, based on a drawing of his wife Camille, Redon investigates the ineffable state of sleep and dreams rather than the physical realm of bodily existence. He reveals the absence of personality in sleep, its similarity to death, and the ultimate mystery and unknowability of another person. Such elements were central to Symbolist artists and writers working in France in the second half of the nineteenth century. Emphasis on fantasy, the imagination, and spiritual rather than material striving, were tenets of the movement—and can also be seen in such other works as Moreau's *Orpheus* (cat. 82) and Puvis de Chavannes's *The poor fisherman* (cat. 85).

As demonstrated in Denis' *Homage to Cézanne* (cat. 39), in which Redon is represented at the work's far left as the focus of attention among the group, the artist was revered by the Nabis. His qualities of purity and simplicity inspired them in their search for the intimate, private and hidden life, rather than the overt or public and exposed experience. *Eyes closed*, an important work for the Nabis, became the first work by Redon to enter the French state collection, in 1904.

Christine Dixon

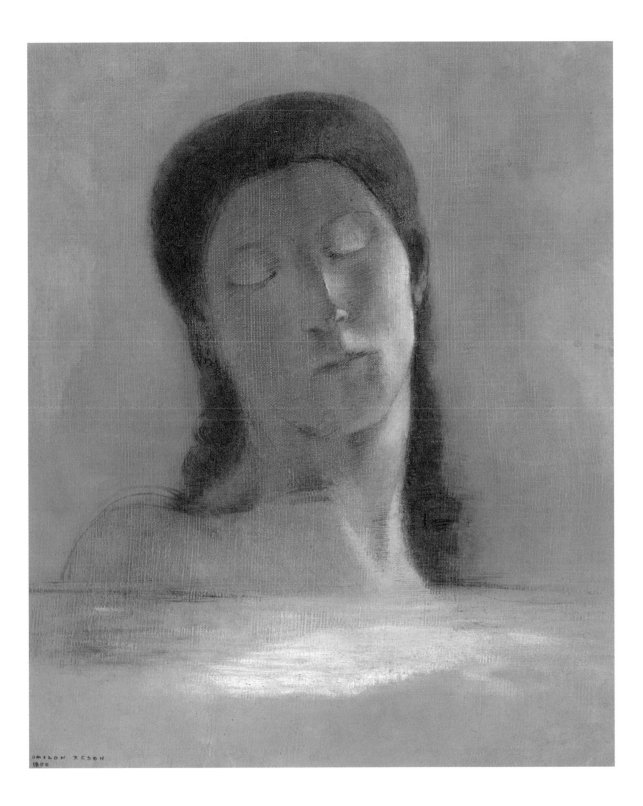

87 Odilon Redon
France 1840–1916

The sleep of Caliban (*Sommeil de Caliban*)
1895–1900
oil on wood, 48.3 x 38.5 cm

Musée d'Orsay, Paris, bequest of Mrs Arï Redon, according to the wishes of her husband, the artist's son 1982, RF 1984-48
© RMN (Musée d'Orsay) / Christian Jean

> Be not afeard; the isle is full of noises,
> Sounds and sweet airs, that give delight and hurt not.
> Sometimes a thousand twangling instruments
> Will hum about mine ears, and sometime voices
> That, if I then had waked after long sleep,
> Will make me sleep again: and then, in dreaming,
> The clouds methought would open and show riches
> Ready to drop upon me that, when I waked,
> I cried to dream again.
> —William Shakespeare, *The tempest*[1]

In *The tempest*, Caliban is a strange being who exists on the verge between human and animal. He and other creatures inspired Redon to produce many charcoal drawings in the 1870s. Known as 'noirs', these highly original works evoke mysterious beings in a world of subjective, often melancholic fantasy.[2] In graphic form Redon depicted Caliban as a sombre, pixie-like creature perched in the fork of a tree, looking pensively out at the viewer.[3] In the present work Redon returns to his earlier subject, using colour and a fantastical landscape to very different effect.

Redon admired Shakespeare, and the figure of Caliban (variously described as a wild or deformed man, or even as a combination of human and fish) is quite at home in the artist's complex repertoire of strange images. Literature, myths and his fascination with the natural world provided Redon's inspiration. He visited the Museum of Natural History in Paris, attended medical lectures, and studied scientific illustrations of the day; he was influenced by Darwinist notions of mutation and, via his friendship with the botanist Armand Clavaud, was introduced to a new world of nature as observed through the microscope. Many of the figures in Redon's compositions seem to have been inspired by amoebic forms.

The sense of heightened observation in Redon's work is combined with a dreamy otherworldliness. Decapitated, floating heads appear throughout his oeuvre—sometimes those of Orpheus or John the Baptist, at other times heads which are winged or borne aloft by balloon-like eyes. Even when attached to bodies (cat. 86), we have the sense that these heads might float free at any moment. Redon's fluttering, head-like creatures are often interpreted as a reference to Hypnos, the Greek god of sleep. In the present work, the heads may represent Ariel and the other spirits on the island. Rugged, gnarled trees are also consistent motifs in Redon's work. The large tree in the foreground here may be the one in which Ariel was imprisoned, and from which he was subsequently rescued by Prospero, an act which bound him in service to the magician. *The sleep of Caliban* is an impressive evocation of the sounds and 'sweet airs' of Shakespeare's world. Its gloriously encrusted paint surface and pastel-like colours are also a good example of Redon's impact on the Post-Impressionists generally, and on the Nabis in particular.

Lucina Ward

1 Act 3, scene 2, viewed on 1 September 2009, http://shakespeare.mit.edu/tempest/tempest.3.2.html.

2 Richard Hobbs, 'Odilon Redon', Jane Turner (ed.), *The dictionary of art*, vol. 26, London: Macmillan, 1996, p. 71.

3 *Caliban* 1881, charcoal on buff paper, 49.9 x 36.7 cm, Musée du Louvre / Musée d'Orsay, Paris.

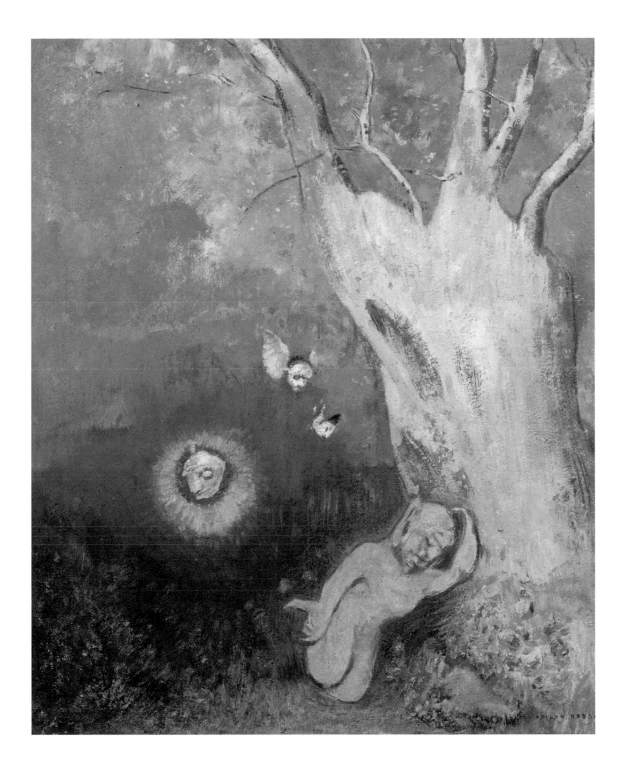

88 Fernand Khnopff

France 1858 – Belgium 1921

Marie Monnom or *Miss M. M...*
(*Mlle M. M...*) 1887
oil on canvas, 49.5 x 50.0 cm
Musée d'Orsay, Paris, purchased 1982, RF 1982-10
© RMN (Musée d'Orsay) / Hervé Lewandowski

Khnopff presents a tranquil interior for his portrait of Marie Monnom, painted in Brussels in the vital year 1887. She sits modestly in a simple hooped armchair, forced forward by a large cushion. Strong verticals divide the canvas, with a moonlike mirror at upper left. Two diagonals animate the composition: the skirt from waist to knee, and a counterposed corner where the right plane of the room meets the back wall.

In 1888 the painting was displayed at the exhibition staged by Les XX (The Twenty), the society of modern artists which Khnopff co-founded in 1883. The Twenty consisted of founder members who invited twenty Belgian and the same number of foreign artists to show together. James McNeill Whistler participated in the first two exhibitions, in 1884 and 1886, and his influence on Khnopff is clear. He exhibited four paintings at the first show: *Symphony in white, no. 3, Nocturne: blue and silver—Chelsea, Harmony in grey and green: Miss Cicely Alexander* and *Arrangement in brown and black: portrait of Miss Rosa Corder*. Whistler's titles express tonal harmonies and musical analogies which are more significant than the identity of the sitter.

In *Marie Monnom* Khnopff adopts a subdued Whistlerian palette of blue and grey, restricting the colour range otherwise to brown and black, white and grey and subtle pink skin hues. Silvery-grey gloves hide any other flesh. The subject is presented in profile, invoking the processional, almost frozen nature of ancient Egyptian and Greek prototypes, as well as Whistler's famous portrait of his mother. Also notable is the shallow space borrowed from Whistler. We have no sense of traditional orthogonal depth, which is cut off by dominant vertical planes and a flat blue curtain.

Who is this contained young woman? Marie Monnom (1866–1959) was the daughter of an avant-garde Belgian publisher, Veuve Monnom (the Widow Monnom). One of many little-known female modernists, Madame Monnom knew many artists and writers: she produced the journal *L'Art moderne*, where Emile Verhaeren heralded Khnopff, and printed the dramatic lithographs *Shadows* (*Les chimères*)1889 by Redon (cats 86 and 87). Marie, later Maria, would marry Khnopff's friend, the Belgian Divisionist painter van Rysselberghe (cats 23 and 26) in 1889.

This painting was shown in Paris in 1888, at the exhibition of painting and sculpture by thirty-three French and foreign artists. Khnopff's later career encompassed scandalous Symbolist works of the Rose + Croix period of the 1890s, a brilliant debut at the first exhibition of the Vienna Secession in 1898, and his extraordinary modernist house, the Villa Khnopff. But it is in these quiet paintings of his family and friends that the newly confident artist demonstrates his absorption of contemporary art.

Christine Dixon

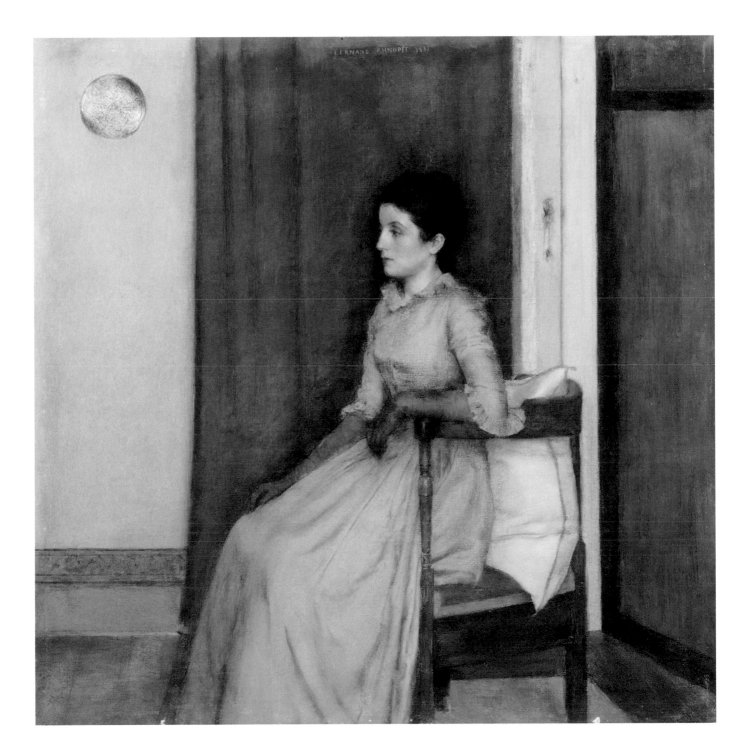

89 Vilhelm Hammershøi

Denmark 1864–1916

Rest (*Hvile*) 1905
oil on canvas, 49.5 x 46.5 cm
Musée d'Orsay, Paris, purchased with the assistance of
Philippe Meyer 1996, RF 1996-12
© RMN (Musée d'Orsay) / Michèle Bellot

A woman sits on a chair, close to us, alone in an almost empty room. Most unusually, we look at her from behind, with no indication of features nor facial expression. Light falls slowly into the room from a doorway or tall window at left, behind her, touching the wall softly. Hammershøi's composition presents strong verticals, the axis of seated figure, chair and shadow on the wall contrasting with the horizontals of tabletop, chair rungs and skirting board. Such stark geometry is challenged by the curves of the woman's neck, head and clothing, the scalloped dish and carved chairback. The palette is reduced to grey, white, black, brown, warmed by a dark red tablecloth and the palest flesh tones. But Hammershøi also plays with our perceptions of hard and soft, real and imagined. Hard porcelain materialises in white paint, while the painted white plaster or wooden skirting board is less defined, and immaterial light brightens a painted wall. The woman's black skirt disappears as light plays across the stuff of her grey blouse.

We assume the sitter is the artist's wife Ida, his favourite model. The two married in 1891. But who is she in essence? What is she doing or thinking? Is she resting from domestic toil, remembering, thinking of the future? There seems to be no class marker, as her blouse could be velvet or cotton, and she might be a wife or a servant. The only movement on the canvas is in the blouse, where creases in the sleeves and bodice and a slightly angled closure at the nape gently animate the surface. Overall there is an air of intimacy and mystery, even secrecy. Does the artist understand this woman, her thoughts and feelings? Can he communicate the unknowability of another person?

The great poet Rainer Maria Rilke admired Hammershøi's painting. The artist 'is not one of those of whom it is necessary to speak [of] *quickly*,' he wrote in 1905, the year *Rest* was made. 'His work is long and slow and at whatever moment one grasps it, it will always give ample opportunity to speak about what is important and essential in art.'[1] Ideas about modern art after Impressionism spread across Europe, to Belgium and the Nordic countries in particular. Hammershøi in Copenhagen, like Khnopff in Brussels (cat. 88), combined radical portraits with non-threatening intimist interiors.

The Danish painter reinvented the rear view, an unusual pose in the millennia-old tradition of the portrait. Sitters were almost always portrayed frontally, or at an angle, or in profile. In the seventeenth century the Dutch master Johannes Vermeer depicted women from behind in domestic interiors, while early in the nineteenth century Caspar David Friedrich showed a man from behind as a symbolic figure in the landscape. Hammershøi's rendering of a lone subject, usually his wife, mother or sister, is made unfamiliar and strange by the anonymity of an unseen face.

Christine Dixon

1 Letter to Alfred Bramsen, 10 November 1905, quoted in Anne-Birgitte Fonsmark and Mikael Wivel, *Vilhelm Hammershøi, 1864–1916: Danish painter of solitude and light*, New York: Solomon R. Guggenheim Foundation 1998, p. 191.

90 Maurice Denis
France 1870–1943

Princess Maleine's minuet (Marthe at the piano)
*(Le menuet de la princesse Maleine (Marthe au piano))*1891
oil on canvas, 95.0 x 60.0 cm

Musée d'Orsay, Paris, accepted in lieu of tax 1999, RF 1999-3
© RMN (Musée d'Orsay) / Hervé Lewandowski
© Maurice Denis. ADAGP/Licensed by Viscopy, 2009

Denis, a founding member of the Nabis group, believed that 'every work of art was a transposition, a caricature, the passionate equivalent of a sensation experienced'.[1] In this painting the particular 'sensation' Denis depicts is his love for his fiancée Marthe Meurier. She is shown here in a state of contemplation, turned slightly towards the viewer in three-quarter profile with her slender hands resting on the piano. This is one of the earliest of many portraits of Marthe painted by Denis, and she would remain a constant source of inspiration to the artist, even after her death.

Denis' Nabis roots are obvious in the highly decorative and whimsical nature of this canvas. The curls of Marthe's hair blend with the ornamental wallpaper, while the rhythmic lines created by her dress and elongated arms and fingers echo the arabesques on the frontispiece of the music behind her on the piano. Denis designed the frontispiece for this music, 'Princess Maleine's Minuet', himself.[2] The score was composed by Pierre Hermant and based on the play *The Princess Maleine* by Maurice Maeterlinck. The violence of the play provides a stark contrast to Marthe's serene attitude here: it is a tragic account of thwarted love, in which the protagonist Princess Maleine is murdered and, enraged by her death, her lover Prince Hjalmar kills himself and his new fiancée.

Here, however, the Princess Maleine tale operates as a symbol of the couple's love. A key figure in the Symbolist movement, Denis employs metaphors of personal significance to represent abstract ideas throughout his oeuvre. *The Princesse Maleine* was a favourite of both Denis and Marthe. The central themes of fate and the triumph of love over death were no doubt attractive to a pair of young lovers. Denis reports in his diary that Marthe 'is reading again *The Princess Maleine* until two in the morning'.[3] Music was significant to the couple,[4] and in accordance with the Nabis' desire to integrate all the arts, the score's presence unites literature, music and painting.

Emilie Owens

1 Denis, quoted in Wladyslawa Jaworska, *Gauguin and the Pont-Aven School*, London: Thames and Hudson 1972, p. 124.

2 Like many members of the Nabis group, Denis worked across a variety of media. He often designed stage sets and programs for theatre productions and musical concerts. The design for the frontispiece of the score featured in this painting has, unfortunately, been lost.

3 Maurice Denis, Journal, vol. 1, Paris: La Colombe 1957, quoted in *Maurice Denis (1870–1943)*, Paris: Réunion des musées nationaux; Montréal: Musée des beaux-arts de Montréal 2006, p. 132.

4 Marthe was an accomplished musician and often performed in concerts.

91 Maurice Denis

France 1870–1943

Young women at the lamp
(*Jeunes filles à la lampe*) 1891
oil on canvas, 36.0 x 65.0 cm

Musée des Beaux-Arts, Lyon, on long-term loan from the
Musée d'Orsay, Paris, accepted in lieu of tax, RF 2001-10
© RMN (Musée d'Orsay) / Hervé Lewandowski
© Maurice Denis. ADAGP/Licensed by Viscopy, 2009

The two young women shown here are Marthe and
Eva Meurier—sisters who were the subjects of many of
Denis' paintings. Denis and Marthe would be married
two years after this painting was made, in 1893, and
Young women at the lamp is imbued with the comfortable
familiarity that is to be expected between an affianced
couple. Marthe and Eva were both talented musicians
and are shown absorbed in their music, oblivious to
the presence of the painter who observes them. The
tenderness of the image is created through the use of
soft, undulating line. Indeed there are no straight lines in
the picture at all: the women's hair, faces, dresses, arms
and shoulders are all rendered with a gentle curve.

The intimacy of the work is emphasised by the use of
soft lamplight. Like many of his fellow Nabis, Denis
often portrayed scenes of domestic life in an Intimist
style. Characteristic of this style is the use of a single
light source—most commonly a lamp or candle—to
illuminate a scene (see Vallotton's *Dinner by lamplight*,
cat. 99). Here, Pointillist dots of warm yellow and peach-
pink show the glow of the lamp on the women's faces,
while tinges of blue and green create shadows where
the light does not fall. The use of decorative arabesques
on the lampshade is also typical of Intimist works[1] and
prefigures Denis' extensive use of this device in the
Regatta at Perros-Guirec (cat. 68), painted in 1892.

As in *Princess Maleine's minuet* (cat. 90), where Marthe is
shown seated at a piano, here both sisters are shown at
the instrument, Marthe bent towards it, listening intently
as Eva plays. The motif of music is important in Denis'
work—both as a symbol of his love for Marthe (with
whom he shared this passion), and also as a basis for his

colour theory.[2] In the final paragraph of his 1890 treatise,
Definition of Neo-Traditionalism, Denis wrote:

> And the lighting! The atmosphere! The blue arabesques in
> the background, with their insistent and caressing rhythm,
> form a prestigious accompaniment to the orange-hued
> motif, like the seduction of the violins in the Tannhäuser
> overture.[3]

Denis refers here to a synaesthetic interpretation of
Richard Wagner's opera, *Tannhäuser*, thus demonstrating
his belief that the visual arts can provoke an emotional
response through colour and form, in the same way that
music provokes emotion through the arrangement of
notes into harmonies.

In *Young women at the lamp*, we see Denis begin to
experiment with these ideas. Through the highly
simplified planes of Marthe's and Eva's faces, the stylised
arabesques, and the lamp's soft light, Denis imparts
his affections for the pair. This is not a naturalistic
representation of the Meurier sisters, but an idealised
expression of a young man's love.

Emilie Owens

1 See particularly Bonnard's aptly named *Intimacy* (cat. 77).

2 For a detailed discussion of Denis' musical preoccupations and their
 influence on his colour theory, see Gerard Vaughan, 'Maurice Denis
 and the sense of music', *Oxford art journal*, vol. 7, no. 1, 1984, pp. 38–48.

3 Denis, quoted in Vaughan, p. 38 (trans. Melissa McMahon).

92 Henri-Edmond Cross

France 1856–1910

Hair (*La chevelure*) c.1892
oil on canvas, 61.0 x 46.0 cm
Musée d'Orsay, Paris, purchased 1969, RF 1977-128
© RMN (Musée d'Orsay) / Hervé Lewandowski

The model for this work was Cross' future wife Irma, who also appears in the artist's first Pointillist work, *Madame Hector France* (cat. 31). However, unlike that earlier portrait, *Hair* shows none of the personality, social position or general stature of the woman. Instead, here Cross has concentrated solely on the pattern created by the cascading wall of hair, which blocks even a tiny glimpse of her face.

Cross was an important member of the second wave of Divisionism or Pointillism—the artists who followed Seurat's colour theories after his death. As a relative newcomer to the technique, Cross uses *Hair* to hone, improve and develop his application of Seurat's theories.

Following in Degas' footsteps, and subsequently in Seurat's, Cross attempted the subject of a woman at her toilette. Cross had seen Seurat's *Woman powdering herself* c.1890[1] when Signac staged a posthumous Seurat retrospective which included the late work. Seurat's painting is peppered with objects that assist in building an understanding of the woman through her surroundings. Cross dispenses with these, simplifying his work to focus on the woman's hair and through this emphasis on simplicity, strip away all elements of his model's surroundings. Unlike Seurat, Cross preserves the modesty of the woman from the viewer's gaze with the barrage of hair entirely blocking her face.

Cross also reveals a subtle Japonisme aesthetic in the way he describes the hair. Although thoroughly simple in its design, the artist also evokes seaweed and the idea of a wave in the rhythm of his composition.[2] He limits the number and intensity of colours, restricting himself to a muted palette of brown and mauve tones.

Cross remarked that art should reveal the 'moral and physical beauty of humanity' in the utopian future.[3] Yet, despite its physical beauty, *Hair* is not typical of Cross' pictorial ideals of this period. Like other Neo-Impressionists, he held firm anarchistic beliefs, which were inextricably intertwined with nihilist *fin de siècle* attitudes. As a consequence, the focus of many of his paintings from this period was on peasant women at work in lush landscapes. Nevertheless he remained concerned with the female figure. *Hair* can thus be viewed as an important link between the artist's development of his Pointillist style and his initial foray into the female form.

Simeran Maxwell

1 Courtauld Collection, London.

2 Françoise Cachin, 'Les Neo-Impressionnistes et le japonisme, 1885–1893', in The Society for the Study of Japonisme (ed.), *Japonisme in art: an international symposium*, Tokyo: Committee for the year 2001 1980, p. 235.

3 Letter to Luce, January 1896, quoted in Isabelle Compin, *H.E. Cross*, Paris: Quatre Chemis-Editart 1964, p. 53.

251

93 Armand Séguin

France 1869–1903

Gabrielle Vien 1893
oil on canvas, 88.0 x 115.0 cm
Musée d'Orsay, Paris, purchased 1929, RF 1977-313
© RMN (Musée d'Orsay) / Hervé Lewandowski

The sitter, Gabrielle Vien, was born in 1886 and was therefore in her eighth year when Séguin painted her portrait.[1] Her gaze encounters the viewer's directly, without coyness or false sentiment. She is a good child, posing dutifully, dressed in her best clothes. They are black—was she in mourning? Does she seem older than her years? This may be the result of the quizzical angle of her head, inclined slightly downwards, while the girl looks sideways at the artist, and at us.

Although Séguin was a friend of the Nabis painters, especially Sérusier and Denis, he never joined the group formally. Instead of the Nabis' small, informal studies of domesticity, *Gabrielle Vien* seems a much more ambitious and conventional portrait. Perhaps it was a commission, or an attempt by the artist for public recognition. Séguin presents his work as a modern version of a Renaissance portrait. A demure female subject sits in a dark interior, with patches of light emanating from her hair, face and hands, which clutch a white handkerchief. In the lower-left corner, a bright warm patch of colour—a bowl of flowers or fruit on a table—forms the left corner of the pyramidal composition. A window opens onto the outside world, showing a small village and tilled ground.

The painting was never completed, and some details are difficult to read. According to the model, the window and the landscape were painted by Gauguin.[2] He was a colleague, or rather a mentor, for Séguin, in Pont-Aven, and wrote an introduction for the younger artist's one-man show at the Galerie Le Barc de Boutteville in 1895. Gauguin called him a 'cerebral artist—he expresses not what he sees but what he thinks by means of an original harmony of lines, limited by arabesques'.[3] If the sitter is correct, it is rather Gauguin's curves and arabesques made by the curtains which complicate and ornament the simple arcs of the child's black dress. The small pleasures of texture and pattern are provided by an embroidered collar, floral decoration on the sofa, and lively waves of golden hair.

Christine Dixon

1 The sitter was brought up in Paris in intellectual circles, the daughter of Elizabeth de Saint-Maure. Gabrielle was widowed at twenty and became a singer under the name of Mary Christian. The partner of Marco de Gastyne, after their separation she became a writer, novelist, poet and journalist under the name of Marie Jade. Awarded the Prix Amie of the Academie francaise in 1970, she died in 1980.

2 'Gabrielle Vien', website catalogue entry, 2006, Musée d'Orsay, Paris, viewed 22 September 2009, www.musee-orsay.fr/en/collections/index-of-works/notice.html?no_cache=1&nnumid=007979&cHash=8e04573399.

3 Taube G. Greenspan, 'Armand Séguin', in Jane Turner (ed.), *The dictionary of art*, vol. 28, London: Macmillan 1996, p. 371.

94 Emile Bernard

France 1868–1941

Symbolist self-portrait (Vision)
(*Autoportrait symbolique (Vision)*) 1891
oil on canvas, 81.0 x 60.5 cm

In a highly populated self-portrait, Bernard depicts himself at the bottom of the canvas. He bends forward and glances sideways with a background of naked women and paired lovers. Centred at the top is a depiction of the Veil of Veronica, a medieval Catholic relic of the visage of Christ on his way to Calvary and crucifixion. The painter portrays himself in browns, blues and pale flesh, while the phantoms of his imagination are rendered in heated tones of orange and salmon pink. After his experimental essays into Pointillism, his invention of Cloisonnism with Louis Anquetin, and his development of Synthetism with Gauguin, Bernard now looked to a more overt Symbolism. In 1892 he was to join Khnopff, Ferdinand Hodler and Vallotton, among others, in the Salon de la Rose + Croix—an occult and fervently Roman Catholic group seeking to inject Christian religion as the basis of cultural and aesthetic life in modern France.

1891, however, marked Bernard's final break with Gauguin. In an important essay published that year, Bernard's friend Albert Aurier, the poet and art critic, championed Gauguin as the leader of the avant-garde in painting.[1] Already unhappy at the loss of his girlfriend Charlotte Buisse,[2] Bernard (only twenty-three years old) wished to assert his primacy in the artistic realm. Anxious about his reputation, and fearful of being overtaken by the older artist as the originator of modern Symbolism, he painted this vision as an overt claim to the style. Instead of the more characteristic self-representations as a painter in front of his canvases, Bernard portrays his creations as equal to reality.

After an argument with Gauguin at his Drouot sale in February 1891, the two men never communicated again. Bernard began to sign his letters 'Vostre fraire en J. Christus'[3], and increasingly painted religious subjects. *Symbolist self-portrait (Vision)* seems a more personal working out of the contradictions of the bourgeois artist and the Symbolist believer in the occult, as well as a realisation in paint of the tension between the pleasures of the body and the salvation of the spirit. The violence of the palette may refer to the non-naturalistic bright red field used by Gauguin in *Vision of the sermon (Jacob wrestling with the angel)* 1888,[4] never duly acknowledged, in Bernard's eyes, as being inspired by his own painting *Breton women in the meadow* 1888[5]. The anxious young painter seems haunted by his dreams, his God and his art.

Christine Dixon

1 'Gauguin: le symbolisme en peinture', *Mercure de France*, March 1891, quoted in Jane Turner (ed.), *The dictionary of art*, vol. 2, London: Macmillan 1996, p. 732.

2 Mary Anne Stevens, 'Chronology', in *Emile Bernard 1868–1941, a pioneer of modern art*, Zwolle: Waanders Verlag 1990, p. 99.

3 'Your brother in J. Christ', Stevens, p. 213.

4 Alexander Sturgis, Rupert Christiansen, Lois Oliver et al., *Rebels and martyrs: the image of the artist in the nineteenth century*, London: National Gallery Company 2006, p. 152. National Gallery of Scotland, Edinburgh.

5 *Le pardon de Pont-Aven*. Private collection.

95 Félix Vallotton

Switzerland 1865 – France 1925

Self-portrait or *My portrait*
(*Autoportrait* ou *Mon portrait*) 1897
oil on card, 59.2 x 48.0 cm

Musée d'Orsay, Paris, purchased 2007, RF 2007-6
© RMN (Musée d'Orsay) / Hervé Lewandowski

Born into a conservative middle-class family in Lausanne, Switzerland, Vallotton studied the classics before moving to France. During his early years in Paris he spent many hours at the Louvre, admiring the works of earlier artists such as Hans Holbein, Pieter de Hooch, Albrecht Dürer and Jean-Auguste-Dominique Ingres, who would act as exemplars throughout his career. In 1893 Vallotton noted, 'I have been thinking about … those exquisite masters, whose brilliant ideas, put down on canvas in perfect form, have an immediate impact even today, four centuries later.'[1] In fact, his own style gradually developed a flavour of Northern European realism which alienated him from many of his contemporaries.

While his earliest paintings were rooted in the academic tradition—he exhibited at the Paris Salon in 1886—during the 1890s Vallotton joined the avant-garde. However, his stiff, reserved personality prevented him from integrating easily into the Parisian art world.

Vallotton was always interested in faces, particularly his own. During his career he made no less that nine self-portraits, the earliest when he was seventeen. His shrewd perspicacity and often caustic aesthetic is evident in the portraits, especially the self-portraits, where his personal insights are accurately translated onto the canvas with finesse and precision. In this 1897 work, Vallotton makes no attempt at pictorial effects, leaving the background a sober taupe, and firmly focusing on his own face, where his reserved character is written so clearly.

Vallotton's paintings reveal a flatness of colour with hard edges and, increasingly, a sober, often biting realism, a development very much independent of his fellow Nabis. Many of his colleagues viewed his austere style as retrograde, too much reflecting the art and academic values of the past. In 1898 Signac commented that:

> Vallotton's paintings are anti-picturesque. He thinks that by employing a calculated and conservative technique he is imitating Holbein and Ingres, but he only succeeds in imitating Bouguereau's worst pupils. The result is ungainly and unintelligent.[2]

Contemporary critics were also disparaging, accusing Vallotton of 'paint[ing] like a policeman',[3] and describing his self-portraits as 'solid enough in construction, but … dead and lifeless'.[4] However, his precise techniques inspired a future generation of artists, such as the New Realists of the twentieth century.

Simeran Maxwell

1 Félix Vallotton, *Gazette de Lausanne,* 4 May 1893, quoted in Albert Kostenevitch, *Bonnard and the Nabis,* New York: Parkstone Press International 2005, p. 185.

2 Quoted in Kostenevitch, p. 185.

3 'Kleine chronik', *Neue Zürcher Zeitung,* 23 March 1910, quoted in Sasha M. Newman, *Felix Vallotton,* New Haven: Yale University Art Gallery; New York: Abbeville Press 1991, n. 55, p. 290.

4 'Independent Gallery. Paintings by Felix Vallotton', *The Burlington Magazine for Connoisseurs,* vol. 37, no. 212, November 1920, p. 264.

96 Edouard Vuillard (above)
France 1868–1940

In bed (*Au lit*) 1891
oil on canvas, 73.0 x 92.5 cm

97 Edouard Vuillard (below)
France 1868–1940

Sleep (*Le sommeil*) 1892
oil on canvas, 33.0 x 64.5 cm

Images of sleep, dreams, or loss of consciousness brought on by alternate states—of the body in its 'pure' form, and therefore closer to nature—were a favourite Symbolist theme. Both of these works by Vuillard show the combined influence of Synthetism, Symbolism, and Japanese woodblocks. Painted a year apart, in these paintings Vuillard portrays his sleeper in highly simplified form, using blocks of pale tones, and line to break up the areas of paint. The figures are daringly stylised, merging into the bed and surrounds: these are ambiguous images, full of a humour which verges on caricature. *In bed* is an unusually large, almost monochromatic canvas, broadly painted and evoking the muffled silence of deep sleep and dreams. *Sleep* is smaller, but possibly more radical, its subdued complementary tones capturing a sense of drowsiness. Both compositions are based on a network of lines, the horizontals and verticals enlivened by diagonals of the bedclothes and, in the case of *In bed*, the sleeper's raised knees.

The neutral colour scheme of *In bed* is broken only by the face and hair of the figure, and the hovering 'T' shape—perhaps a traditional Christian cross, partially obscured by the canopy of the bed, or even a 'thought-bubble', the symbol of the sleeper's dreams. The signature on high is as arbitrarily placed as a watermark. The stripe of pale green at top is echoed by the section of floor below. As Salomon and Cogeval point out, there is striking contradiction between the emphatic flatness of the sheets and blankets, and the shadows cast by them—creating an illusion of depth.[1] The luxuriously puffy pillows, and the proliferation of downy pale fabrics, serve to cushion and protect the sleeper from the world outside.

In *Sleep*, the overall effect is reminiscent of a woodblock. Rather than paint outlines, Vuillard allows sections of the maroon ground to show through, outlining the painted forms. Details, such as the cast-off slippers and the folded clothes on the chair, merge into the tones of brown, cream and olive-green—only the orange of the garment on the chair breaks the neutrality of the scene. In both works the fusion of the figures with their surrounds seems to prefigure Vuillard's large decorations such as *Public gardens* (cat. 108). In their solipsism and introversion, these works capture perfectly the uninterrupted sleep we all desire.

Lucina Ward

1 Antoine Salomon and Guy Gogeval, *Vuillard: the inexhaustible glance: critical catalogue of paintings and pastels*, vol. 2, Milano: Skira; Paris: Wildenstein Institute 2003, cat. 123, pp. 142–44; *Sleep* is cat. 124, pp. 144–45.

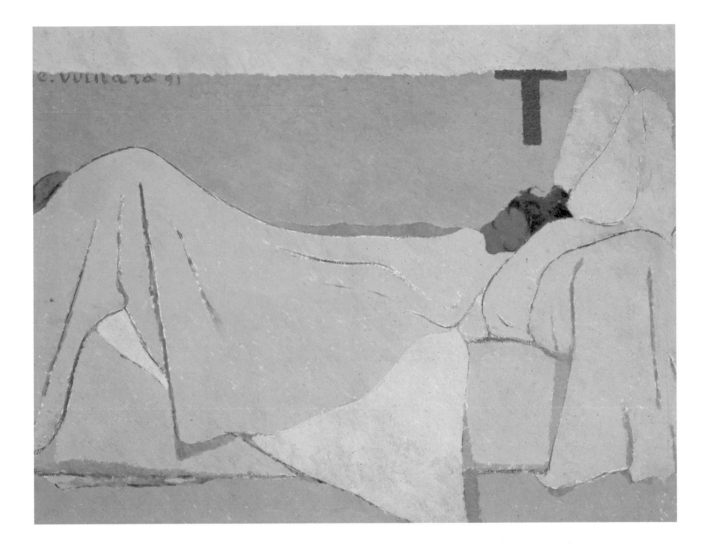

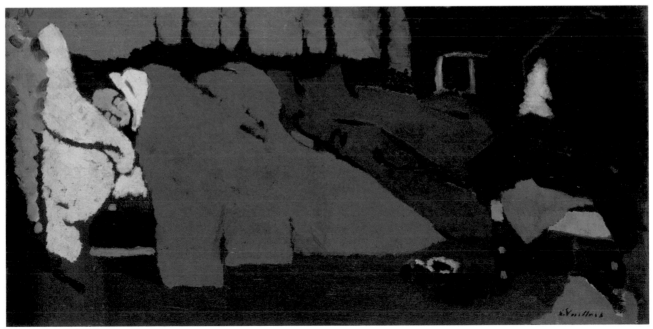

98 Félix Vallotton

Switzerland 1865 – France 1925

Misia at her dressing table
(*Misia à sa coiffeuse*) 1898
distemper on card, 36.0 x 29.0 cm

Musée d'Orsay, Paris, purchased with the assistance of
Nippon Television and Philippe Meyer 2004, RF 2004-1
© RMN (Musée d'Orsay) / Hervé Lewandowski

In the late 1880s and early 1890s Vallotton produced reproductive prints after Rembrandt and Jean-François Millet, worked as a conservator, and began to write art criticism. From 1891 he made woodcuts, lithographs, book illustrations and a design for stained glass. It is inevitable, then, that when the artist began to devote himself to painting in the late 1890s, his work should reflect aspects of these other disciplines. Vallotton's genre scenes, portraits and nudes are characterised by his use of flat areas of colour, hard edges and extreme simplification.

The unmodulated forms of the objects on the shelf behind the figure, the block-like shadows across her neck and torso, and the walls and floor of the room rendered as simple planes, are reminiscent of a woodblock print with colour applied. The 'carved' forms of the hanging towel, the fabric draped over the edge of the dressing table, and the strains of the figure's hair, reinforce this connection. Vallotton even includes one of his own prints, framed on the wall. However, despite its graphic nature, the painting is also remarkable for its sculptural qualities: the matt surface, as well as the solidity and presence of Misia, are reminiscent of polychrome wooden figures.

In 1898 the Polish-born pianist Misia Godebska (1872–1950) was married to the Parisian editor and publisher Thadée Natanson, co-founder of *La Revue blanche* (*The White Review*). Bonnard, Vallotton, Vuillard and others were frequent contributors to the magazine, and Thadée and Misia held a unique place in artistic circles in *fin-de-siècle* Paris, the centre of a galaxy of composers, writers and artists. Vallotton was a regular visitor to the Natanson's Parisian home, in Rue Saint-

Florentin, and to their country house, 'Le Relais', at Villeneuve-sur-Yonne in Burgundy, where *Misia at her dressing table* was probably painted.[1] A journal entry by Julie Manet, although written earlier, captures Misia as Vallotton painted her:

> Mme. Natanson, charming in a light blue dress with a high waist, a very pretty white low-cut square collar, and short sleeves. She wore a necklace on her lovely rounded white neck. She played Beethoven's C minor symphony in an extraordinary fashion, sad, noble, grave, suggesting all the instruments of the orchestra. She has a beautiful broad powerful way of playing, not at all French.[2]

Shown here in profile, in harsh light from an unseen source at left, Misia seems taut with concentration. We imagine, perhaps, the strength of her musical performance.

Lucina Ward

1 Two other portraits by Vallotton, both dated 1898, are *Misia Godebska* in Neue Pinakothek, Munich, and *The hand kiss (The lovers) (Thadée and Misia)* in a private collection; see Sasha M. Newman, *Félix Vallotton*, New Haven: Yale University Art Gallery; New York: Abbeville Press 1991, p. 107.

2 Julie Manet, journal entry dated 18 September 1896, quoted in Arthur Gold and Robert Fizdale, *Misia: the life of Misia Sert*, New York: Knopf 1980, pp. 61–62.

99 Félix Vallotton

Switzerland 1865 – France 1925

Dinner, by lamplight
(*Le diner, effet de lampe*) 1899
oil on card, laid on wood panel, 57.0 x 89.5 cm
Musée d'Orsay, Paris, purchased 1947, RF 1977-349
© RMN (Musée d'Orsay) / Hervé Lewandowski

Here the emphasis on light and dark echoes Vallotton's prints, which are dominated by bold black and white block motifs. Although the artist stopped producing prints in 1899 in order to concentrate on his painting, his work retained the same stark, often caustic, graphic style. Here the silhouetted figure of the artist dominates the centre of the canvas, flanked on his right by his new bride Gabrielle wearing a pink gown. On Vallotton's left sits his stepson Max Rodrigues, stifling a yawn. Above the artist's head is Madeleine, his stepdaughter, who stares out at her stepfather and, by extension, the viewer.

Dubbed Intimists, the Nabis drew their inspiration from Parisian life, including its domestic and private interiors. Vuillard asked, 'Why is it always in the familiar places that the mind and the sensibility find the greatest degree of genuine novelty?'[1] While, as a member of the diverse Nabis group, Vallotton embraced such subject matter, he held firm to his own precise visual style, rejecting his colleagues' predilection for pattern and texture. His interior works are often devoid of the warmth of familiar associations common to other Nabis interiors. In many of Vallotton's later portraits the interior becomes so significant that it is no longer a mere setting. Yet here, with the emphasis on the surroundings, it is easy to see how a group portrait could be mistaken for a genre scene.

Vallotton creates a mood of unspoken hostility through the use of silhouettes and striking shadows. The air of stillness enshrouds the typical Nabis subject—a family gathered round a table—with a sense of foreboding. Typically Vallotton's domestic scenes contain harsh light and sharply focused detail, which he borrowed from classical Northern European genre painting.

Vallotton's interiors have a motionless quality. Although the figure on the left is yawning, he seems frozen in the act. The rest of the family appears similarly lifeless. This melancholic stillness may express the artist's attitude towards his new family. Set in the dining room of Vallotton's house on Rue Beau-Séjour in Paris, it was painted just after his marriage to an art dealer's daughter. Vallotton hoped that the alliance would advance his career, but he found that married life did not suit him as well as he had supposed. A reserved person, he found the constant interaction with his wife and two stepchildren time-consuming and exhausting.

This is the first of two versions which Vallotton created of this scene.[2] Although this painting has slightly more muted tones, both versions have identical detail and a similar colour palette. They belong to a series of paintings conceived as modern renditions of the interiors of seventeenth-century Dutch master Pieter de Hooch.

Simeran Maxwell

1 Quoted in Belinda Thomson, *Movements in modern art: Post-Impressionism* London: Tate Gallery Publishing 1998, p. 51.

2 The second version, painted in 1900, is in the Kirov Regional Art Museum, Gorki.

100 Félix Vallotton

Switzerland 1865 – France 1925

The ball or *Corner of the park with child playing with a ball* (*Le ballon* ou *Coin de parc avec enfant jouant au ballon*) 1899
oil on card, laid on wood panel, 48.0 x 61.0 cm
Musée d'Orsay, Paris, bequest of Carle Dreyfus 1953, RF 1977-353
© RMN (Musée d'Orsay) / Hervé Lewandowski

A most ordinary scene of everyday life—a child playing with a ball in the park—is dramatised by the artist's high viewpoint, patterning and reduced range of colours. We look down on a little boy or girl (opinions differ) dressed in a white smock and straw hat, running after a red ball. Its circular shape is accentuated in the larger yellow hat, and repeated in another light brown ball lying in the trees' shadow to the left. The image is split vertically into shade on the left and sunlight on the right. It is divided again diagonally, into an ochre foreground and green and black upper ground. The light brown earth or grass is rounded like the curvature of the Earth itself, and we, the viewers, see it as a bird would, or as though from a tower.

The dynamic rendition of the floating smock is echoed in the child's shadow, which seems to move ahead of the trees' dappled shade reaching across the grass. Two women, one dressed in blue, the other in white, lead the eye on an opposite diagonal axis, from the child to the upper left. Like most of Vallotton's paintings, there is little colour or tonal modulation; rather he employs flat planes broken up into decorative shapes. The graphic quality comes from his other career: Vallotton made dynamic black-and-white wood engravings, with no half-tones, just positives and negatives.

Like most of the Nabis, Vallotton admired Japanese woodblock prints, and adapted many themes and stylistic conventions from them. *Ukiyo-e* depicted 'images of the floating world', the ephemeral, sensory pleasures of city life. Unlike Vuillard's and Bonnard's images of public gardens (cats 108 and 109) however, Vallotton did not decorate each view with ornamental patterns. He reduced rather than augmented the visual elements, and smoothed paint into a material parallel to reality.

Vallotton's is an outsider's view, and never one of unalloyed delight. He was born in Switzerland, and in Paris was named the 'foreign Nabis'. The child's playground is not rich green grass, but has been burnt dry and brown by the summer sun. He plays alone, supervised by the adults glimpsed in the background. The deserted ball hints at other children, now gone. It is a city pleasure for the offspring of the bourgeoisie, this solitary ballgame, and any pastime less rowdy or companionable can hardly be imagined.

Christine Dixon

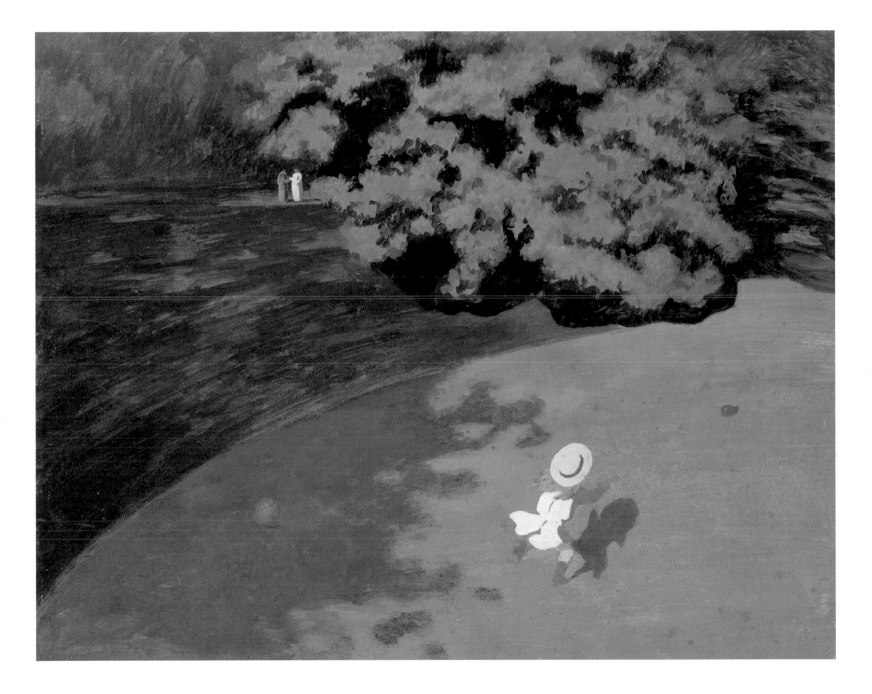

101 Pierre Bonnard

France 1867–1947

Woman dozing on a bed (Indolent woman)
(Femme assoupie sur un lit (L'indolente)) 1899
oil on canvas, 96.0 x 106.0 cm

While studying law—he was sworn in as a barrister in 1889—Bonnard had begun attending the Académie Julian, where he became friends with Sérusier, Denis and Paul Ranson. In 1888, Sérusier showed him his Gauguin-influenced *The Aven at the Bois d'Amour* (cat. 72)—later rechristened *The talisman*, in acknowledgement of the quasi-religious status this work held for the group of artists who became known as the Nabis. Bonnard himself would be inspired by seeing Gauguin's work at the famous Cafe Volpini exhibition in 1889.

With the commercial success of his 1891 poster for France-Champagne, Bonnard was able to turn his back on law to pursue art full-time. A key moment in his life and his art was his meeting the subject of the present work, the enigmatic twenty-four year old Maria (Marthe) Boursin. As Whitfield points out:

> By the time she met Bonnard on a Paris street in 1893 she had left home, moved to Paris, found a job and changed her name to Marthe de Meligny. She had so effectively erased her past that not even Bonnard learnt her real name until their marriage in 1925, nearly twenty years after they began living together.[1]

Despite her working-class background and difficult temperament, Marthe became Bonnard's muse, and the subject of many of his most enduring works. The present painting, showing Marthe lying provocatively on a bed, is one of a number of paintings devoted to the same subject. There is, for example, a small study dating from 1897–98 and another larger version from 1898 or 1899. Similarly there is a small crayon and graphite study for the illustration to page 100 of Paul Verlaine's poetry collection *Parallèlement* 1900, which Ambroise Vollard had commissioned Bonnard to illustrate. In the published edition, however, Marthe is posed a little more demurely—the tangled sheet obscures her sex, perhaps as a concession to the fact that *Parallèlement* was aimed at a broader audience.

There is no coyness in the present version of Bonnard's painting, at least in terms of pose. While the title *Woman dozing on a bed* might indicate a moment of erotic slumber, the pose itself—Marthe's hand cradles one breast, and her left leg, with its foot resting on her right thigh, is splayed so as to suggest it was raised moments before and has just now fallen open to display her sex—acts as a powerful erotic invitation. *Woman dozing on a bed* shows, then, a moment of mutual contemplation—Marthe presents to us, and to her lover Bonnard, her languorous, indolent sensuality, while Bonnard's contemplative presence is indicated by the skein of smoke wafting from his pipe towards her sex.

While Marthe features in many of Bonnard's early works, this is one of his first paintings in which he shows her completely nude and as such is one of the great Intimist masterpieces of the period.

Mark Henshaw

1 See Sarah Whitfield and John Elderfield, *Bonnard*, London: Tate Gallery Publishing 1998, p. 15. At the time of their meeting, Marthe also claimed to be only 16.

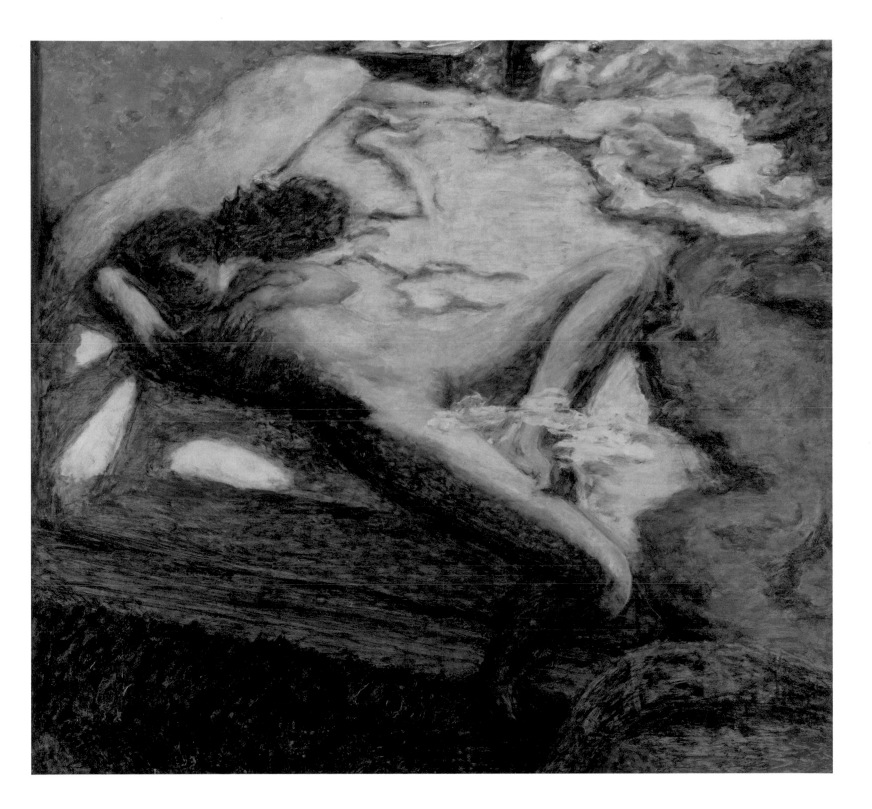

102 Pierre Bonnard

France 1867–1947

The man and the woman
(*L'homme et la femme*) 1900
oil on canvas, 115.0 x 72.5 cm

This Bonnard work is often seen as a companion piece to his *Woman dozing on a bed* (cat. 101). Indeed, the pose of the woman, again Bonnard's partner Marthe Boursin, is so similar that there seems a narrative continuity with *Woman dozing on a bed*, the latter being a preamble to the erotic interlude which is to follow in *The man and the woman*. Marthe now waits, distractedly playing with her cats, while Bonnard undresses.

By 1900, Marthe had featured in many of Bonnard's works. From time to time his work featured both himself and Marthe, although this is the only painting in which he shows a full-length portrait of himself naked with her. Usually his presence is only indicated by an intimate fragment—an arm or a leg—or alluded to by other means, such as the smoke from his pipe.

What strikes us immediately about the painting is its audacious structure—the screen which separates the two figures divides the work into a kind of diptych. Bonnard was particularly interested in and influenced by Japanese *ukiyo-e* prints. Indeed his nickname amongst the Nabis was 'Le Nabi très japonard' ('the very Japanese Nabi'). *Ukiyo-e* prints often employ a diptych or triptych format, echoing a two- or three-part narrative structure—in one part something is going on, while in another something else is going on. In Bonnard's image, each side of the canvas is treated quite differently. In the left 'panel' Marthe is proportionally quite small. Emphasis is given to the subtle articulation of her skin tones, while there is a deliberate contrapuntal balancing of the massed base of the bed upon which the cats play, and the image of the painting above Marthe's head. On the right we have the elongated form of Bonnard himself, almost a transposed echo from one of Cézanne's many bather paintings—by

1900 Cézanne's work had become much better known. In any other painter, Edvard Munch for example, the compositional device of dividing a world could have indicated some form of emotional abyss separating the lovers. Here however there is a quiet, intimate harmony; a kind of anticipatory stillness based on the unhurried familiarity which exists between the two lovers, and which serves as a prelude to the sexual union we assume is to follow.

Bonnard used painting not just to register what was there, but to see what was there. Painting, for him, was as much a process of contemplation, of discovery, as it was an act of depiction. The fact that this painting bears the simple, reductive title *The man and the woman* universalises the eternal nature of the moment Bonnard chose to depict. Again, this work shows Bonnard at his Intimist best.

Mark Henshaw

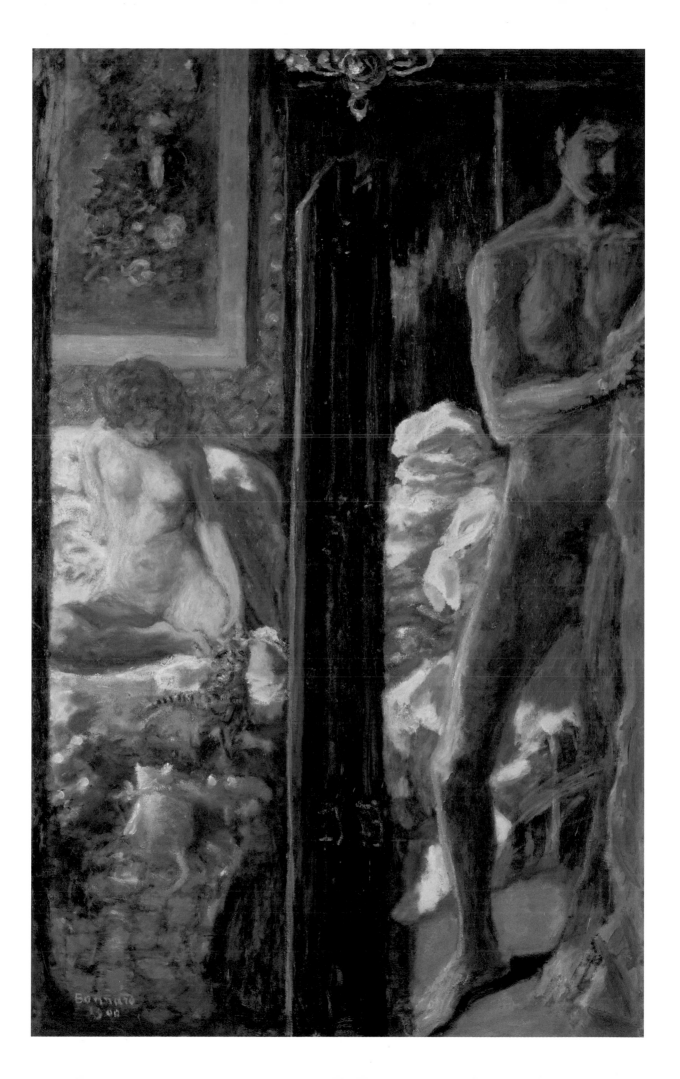

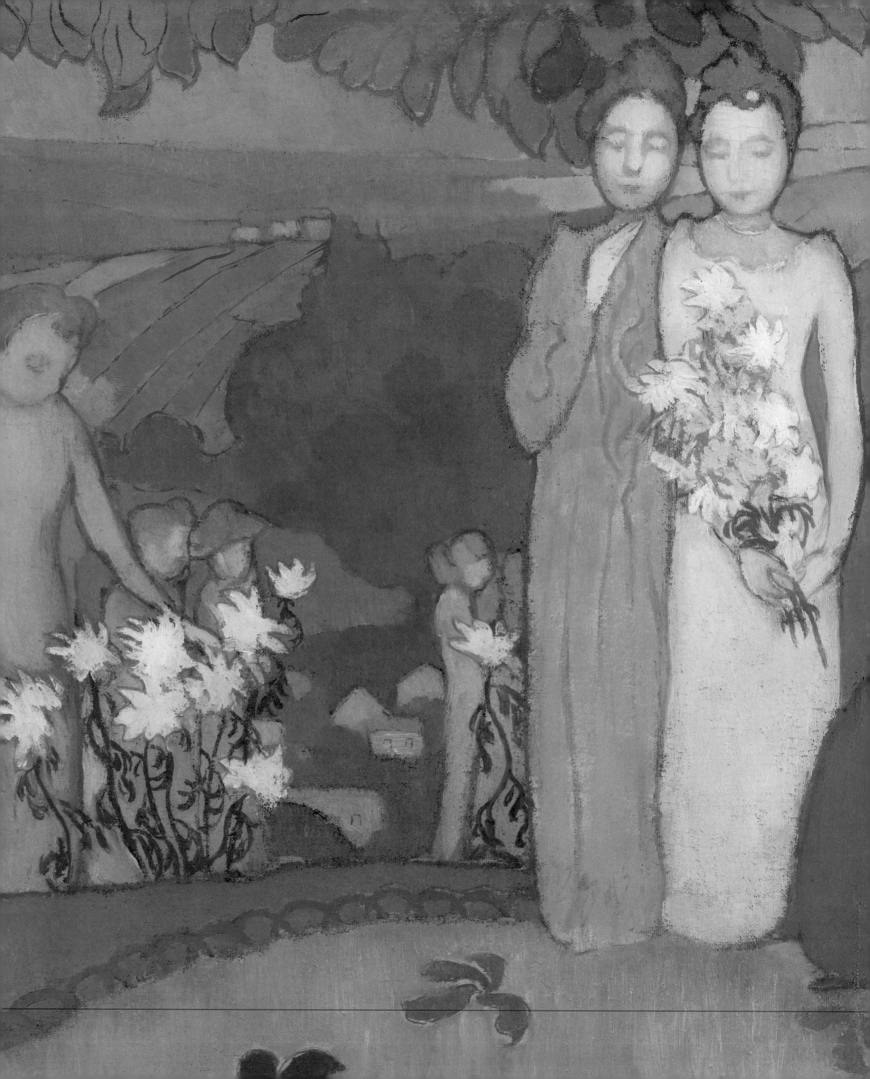

Decoration

Pierre Bonnard

Maurice Denis

Henri Rousseau

Ker-Xavier Roussel

Edouard Vuillard

103 Ker-Xavier Roussel

France 1867–1944

The terrace (La terrasse) c.1892
oil on canvas, 71.0 x 90.0 cm

This painting is one of Roussel's decorative works from 1890–95. Although plans for the project have been lost, this painting has been tentatively tied to two other canvases intended to decorate a mayoral office—*Conversation on the terrace* c.1892–93[1] and *Meeting of the women* c.1893.[2] Certain features appear in all three works—the autumnal leaves, the patterned dresses and the terrace itself. *The terrace*, however, has an aura of isolation, while the other two project an air of engagement and social interaction. Despite the women's close proximity, neither acknowledges the other.

The painting is set in the Tuileries Gardens, near Roussel's house at 346 Rue St Honoré. The architectural space is reminiscent of medieval walled gardens.[3] During the Middle Ages, the *hortus conclusus* (enclosed garden) developed as an allegory for the Immaculate Conception. This gave rise to images of the Virgin and Child in protected gardens. The spiritual symbolism of this would have appealed to Roussel's Nabis sympathies. Roussel also alludes to the European landscape feature of the 'clearing', a refuge in the wilderness, often seen in the work of Puvis de Chavannes whose theatrical mythical compositions, such as *The sacred grove, beloved of the arts and Muses* 1884,[4] had a considerable influence on *The terrace*.

The garden setting also signals the influence of Eastern, especially Japanese, art. The rendering of the tree has a Japanese quality, especially in the dotted sprays of leaves. Set slightly to the right, its many trunks have been cropped by the top of the canvas. The full extent of its glory is hidden, although the spread of its ochre-coloured leaves along the upper panel suggests its enormity. The canvas is broken into three horizontal sections: the upper above the terrace balustrade; the middle down to the base of the wall; and the lower where the woman lies prostrate. This tripartite division is a common device found in East Asian scroll paintings, where a poet or sage is often placed in the lower foreground of a landscape.

Roussel composes a quite theatrical stage for the two female figures. The middle section reduces the perspective, resulting in minimal depth, keeping the viewer's eye on the foreground. The main figure is isolated by the strong arch to the left and the tree to the right, which defines two distinct spaces. Sliced by the edge of the canvas, the unobtrusive figure of the second woman, an intruder in the tranquil garden, is not immediately apparent.

Simeran Maxwell

1 Collection Josefowitz, Lausanne.

2 Norton Simon Art Foundation, Pasadena.

3 Araxie Toutghalian, 'La terrasse', in Caroline Mathieu, Marc Bascon and Akiya Takahashi, *La modernité: collections du Musée d'Orsay*, Tokyo; Nihon Zeizai Shimbun 1999, cat. 166, p. 244.

4 Musée des Beaux-arts, Lyons.

104 Ker-Xavier Roussel

France 1867–1944

The seasons of life (*Les saisons de la vie*) 1892–95
oil on canvas, 58.0 x 123.0 cm

Musée d'Orsay, Paris, accepted in lieu of tax 1990, RF 1990-15
© RMN (Musée d'Orsay) / Hervé Lewandowski

Roussel painted according to the principles of Synthetism, using rhythmical flat planes of pure colour, with darker outlines. He also produced murals, lithographs and stained glass, but dated and exhibited few works, destroying many. The period and purpose of *The seasons of life*, found in the artist's studio at his death, is unclear. Four static, puppet-like figures are positioned against a theatre-like background. Using broad lines and patches of colour, the artist has articulated trees, rocks, hills and other landscape features. The autumnal palette, the careful interspersing of the female figures between the trees, the colour, draping and pattern of their robes, all contribute to the pleasing effect of this work. But somehow, something is missing.

Throughout literature and the visual arts the seasons are commonly portrayed as female figures at different stages of life. In Roussel's painting, the elderly female at left, with her hunched form and grey hair, may be winter but it is difficult to specify the other women as either autumn, spring or summer—unless the bare arms of the figure at right link her to warmer weather. The decorative quality and format of the work suggest a study for a mural, frieze, or panels for a domestic interior—like Vuillard's grand decoration, *Public gardens* 1894 (cat. 108). Another work by Roussel, sometimes referred to as a second version of *The seasons of life*, shows very similar figures but all young, in a dark green valley, with less topographical detail. These works are also linked with a further pair of paintings—*Meeting of the women* 1892–93[1] and *Conversation on the terrace* 1893[2]—in which the costumes are similar but the figures are placed in an architectural setting.

The figures are clothed in the long, loose, simple quasi-medieval gowns popular at this time—and also visible in Roussel's *The terrace* (cat. 103) and Denis' decorative panels (cats 105–107). The artist and his contemporaries were familiar with Italian predella panels in the Louvre, especially those by the Trecento and Quattrocento artists Fra Angelico, Pietro Perugino and Filippino Lippi. There may also be a connection to Edward Burne-Jones and the English Pre-Raphaelites, as Roussel and Vuillard visited London and the National Gallery in 1892. For all its simplicity, Roussel's *The seasons of life* is an attractive, intriguing work.

Lucina Ward

1 Norton Simon Museum, Pasadena.
2 Collection Josefowitz, Lausanne.

105 Maurice Denis (above)
France 1870–1943

Panel for a girl's bedroom: September evening (*Panneau pour une chambre de jeune fille: soir de septembre*) 1891
oil on canvas, 38.0 x 61.0 cm

106 Maurice Denis (below)
France 1870–1943

Panel for a girl's bedroom: October evening (*Panneau pour une chambre de jeune fille: soir d'octobre*) 1891
oil on canvas, 37.5 x 58.7 cm

For the Nabis there was no particular hierarchy in the arts. In the words of Denis' friend, Bonnard, 'Our generation always sought to link art with life'; what was 'envisaged' was 'a popular art that was of everyday application: prints, fans, furniture, screens'.[1] In this, Denis and other members of the brotherhood were influenced by the Arts and Crafts Movement in Britain, and the Applied Arts Movement in Belgium.

In 1891 Denis set out to create a suite of four paintings devoted to the seasons, which included those for September and October, seen here.[2] It is likely that the series was Denis' response to Bonnard's *Women in a garden* 1890–91,[3] exhibited in 1891.

Denis exhibited his horizontally formatted set of *Poetic subjects: four panels for the decoration of the bedroom of a young girl* at the eighth Salon de la Société des Artistes Indépendants in Paris in March–April 1892. A month previously he had shown *September evening* and *October evening* in Brussels, perhaps indicating that these works could be considered as individual paintings as much as a narrative series, though it has been suggested that together the series explores 'the four stages of a woman's life'.[4]

In *Panel for a girl's bedroom: September evening* Denis has painted the last glow of late summer, with the leaves still on the branches of the silhouetted trees. It is almost twilight and shadows sweep across a group of women on a terrace. Beyond, the sun sets, while the medieval knights on horseback complete the scene. Denis has depicted the trees, fabrics, garlands and fruit in an ornamental manner. The later companion panel, *Panel for*

a girl's bedroom: October evening, shows autumn. Leaves in browns, reds and golds provide a border for women in a garden. The results are paintings which are 'decorative, calm and simple' and 'very beautiful'; terms which Denis applied to the work of Puvis de Chavannes, whose work he much admired.[5]

The idea of painting *décoration* was promoted by Denis as a way forward in the development of composition, as well as a means of catering to the taste of the growing clientele of the Nabis. Such visions of peace and tranquillity served as foils against the chaotic aspects of modern life in Paris, as well as a way of creating a haven in the familial home.

Jane Kinsman

1 Bonnard's correspondence, 7 January 1923, quoted in Claude Roger-Marx, *Bonnard: lithogaphe*, Monte-Carlo: Editions du livre 1952, p. 11.

2 The other two were: *April evening*, Kröller-Müller Museum, Otterlo; and July evening, Fondation Rau pour le Tiers-Monde, Zurich.

3 Kunsthaus Zürich, Zurich.

4 Guy Cogeval, 'Symbolist echoes', in *Maurice Denis 1870–1943*, Ghent: Snoeck-Ducaju and Zoon 1994, p. 156. See also Gloria Groom, *Beyond the easel: decorative painting by Bonnard, Vuillard, Denis, and Roussel, 1890–1930*, Chicago: Art Institute of Chicago 2001, pp. 78–9, including notes, especially n. 6.

5 Maurice Denis, *Journal*, vol. 1, p. 67, quoted in Cogeval.

107 Maurice Denis

France 1870–1943

The Muses (*Les muses*) 1893
oil on canvas, 171.5 x 137.5 cm

Musée d'Orsay, Paris, purchased 1932, RF 1977-139
© RMN (Musée d'Orsay) / Hervé Lewandowski
© Maurice Denis. ADAGP/Licensed by Viscopy, 2009

On 12 June 1893 Denis married his great love, Marthe Meurier. The reception was held on the terrace in front of the Pavilion of Henri IV in the forest of St-Germain-en-Laye, Paris, which had been the setting for Denis' major painting *The Muses*, completed earlier that year. This large decorative composition was both a significant representation of the artist's style at the time, as well as a remarkable prefiguring of Art Nouveau, which emerged in the mid 1890s.

For Denis—like one of his heroes, Cézanne—it was not enough to just copy nature.[1] For this canvas, he has taken the subject of the Muses of Greek literature, in which nine goddesses were associated with nine arts and identified by nine symbols. Denis has chosen to paint his new wife as the three principal figures in the foreground. She is shown as the representation of 'Art' (with a sketch book on her lap), as 'Love' (seen from behind, dressed in a ball-gown with the luminous skin of her shoulders and back revealed), and as 'Religion' (with her hair veiled and her religious text open).[2] Further female figures pose quietly among the trees, adding to the ethereal nature of the composition.[3]

Another great influence on Denis' work was Puvis de Chavannes. Denis had become particularly enamoured with Puvis' art when he'd visited an exhibition in 1887, noting in his journal: 'I found the decorative, calm and simple appearance of his paintings very beautiful.'[4] By 1893 Denis had matured as an artist and was confident enough to have adopted a far richer palette of reds, golds and greens for his composition. The sinuous lines and decorative patterning of the trees—their trunks, their leaves, and the leaf-strewn ground which appears like a Persian carpet—creates a sense of other-worldliness, mystery and stillness.

This painting was commissioned by Arthur Fontaine, a senior bureaucrat in the French government and one of the wealthy patrons for whom the Nabis provided their painting and applied arts. An interior view of Fontaine's house at 6 Rue Greffuhle in Paris, dated 1904, was painted by Edouard Vuillard. That painting includes a depiction of Denis' *The Muses* hanging on the wall. This painting of a painting, and an interior with figures, captures a sense of the private space and private subject matter that Denis and many of his fellow Nabis sought to create in their art, and which the new clientele of the *haute bourgeoisie* eagerly acquired.

Jane Kinsman

1 Maurice Denis, 'Cézanne–II', *The Burlington Magazine for Connoisseurs*, vol. 16, no. 83, February 1910, p. 275.

2 Jean Paul Bouillon quoted in Gloria Groom, *Beyond the easel: decorative painting by Bonnard, Vuillard, Denis, and Roussel, 1890–1930*, Chicago: Art Institute of Chicago 2001, p. 83.

3 A variant version of this composition, *Women in a park* (*Femmes en parc*) 1893, Musée Leon Dierx, St Denis de la Reunion, adds specificity and character to the women, thus detracting from their other-worldliness. See Groom, p. 85, fig. 1.

4 Referring to events of 18 December 1887, Denis, Journal, vol. 1, p. 67, quoted in Guy Cogeval, 'The heavens cannot wait: Maurice Denis and the Symbolist culture', in *Maurice Denis 1870–1943*, Ghent: Snoeck-Ducaju and Zoon 1994, p. 21 (Art to Art trans.).

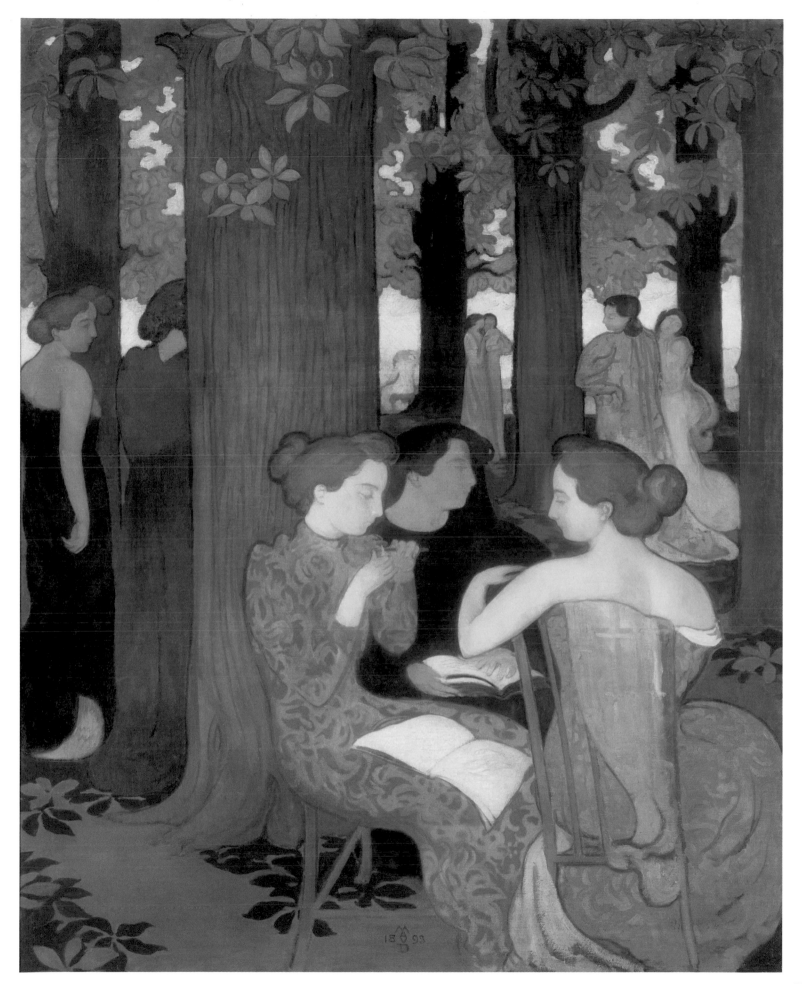

108 Edouard Vuillard

France 1868–1940

(left)

Public gardens: girls playing
(*Jardins public: fillettes jouant*) 1894

distemper on canvas, 214.5 x 88.0 cm

(second from left)

Public gardens: the question
(*Jardins public: l'interrogatoire*) 1894

distemper on canvas

214.5 x 92.0 cm

(three right-hand images)

*Public gardens: conversation, nurses,
the red parasol*
(*Jardins public: la conversation,
les nourrices, l'ombrelle rouge*) 1894

distemper on canvas

213.5 x 73.0; 213.0 x 154.0;
214.0 x 81.0 cm

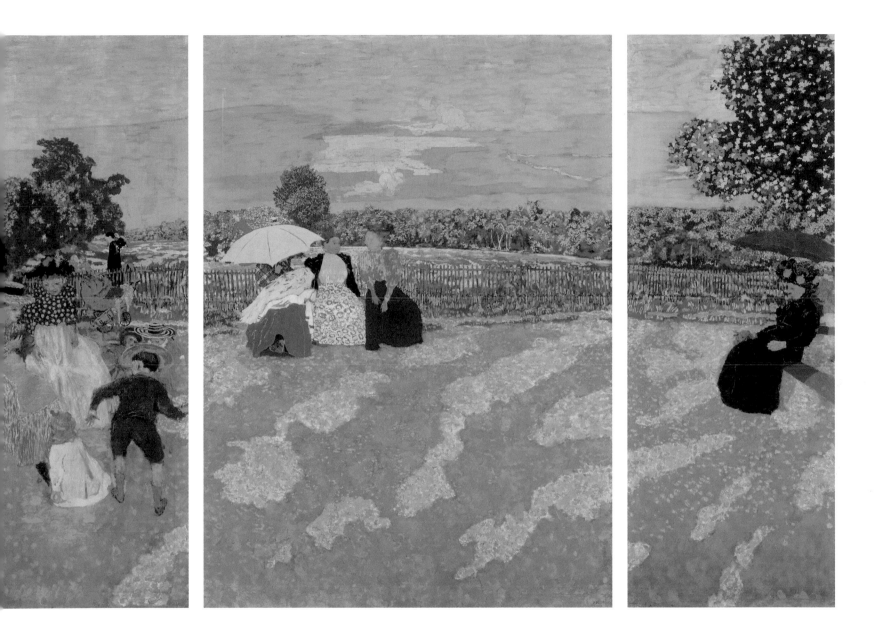

These are five of the nine-panel ensemble commissioned by Alexandre Natanson in January 1894. They were designed for the ground-floor salon of a residence on the Avenue du Bois (now Avenue Foch) in Paris. The central triptych hung along the long wall of a rectangular space that functioned as both living- and dining-room. The other two panels were hung together to the left of the triptych. Two further pairs hung at the right, and opposite, with two over doors completing the room.[1] From a point in the centre of the room, the illusion of a circular panorama must have been extraordinary. *Public gardens* was installed at the end of 1894, and remained there until 1908.

Public gardens is variously reminiscent of tapestries, frescoes and Japanese screens. Distemper, Vuillard's favoured medium, involved mixing dry pigments with a sizing (usually rabbit glue), then heating the mixture to a liquid state. It required the artist to work rapidly to achieve a distinctive, smooth, matt paint surface. The ensemble holds together via the sky and backdrop of vegetation linking the scenes, and by the gloriously patterned shadows across the foreground, and yet each panel is remarkably discrete. Vuillard's radical tilting of the picture plane, the cropping and asymmetry of his composition, emphasise the decorative qualities of trees, grasses and flowering shrubs, as well as the fabrics of the figures' clothing. These flat, decorative forms are partially a result of the medium but also reflect Vuillard's admiration of tapestries, and his knowledge of Japanese art.

Children were one of Vuillard's favourite motifs. In this work they play the leading role, darting around the enclosed space, watched over by their fashionably dressed nannies or by ladies who converse on park benches. Initially the artist may have planned to incorporate a number of city parks into the scheme, but in the end he limited the suite to the Tuileries Garden and the Bois de Boulogne, both of which were better suited to the panoramic program of the project.[2] The public life of the Tuileries was both narrow and definite; since the bourgeoisie conformed to the upper-class standards and unofficial dress code of the once-royal garden, the Tuileries were the destination of a more exclusive and outwardly uniform group of social types.[3] Vuillard, who had made his first decorative panels in 1892, completed eight different projects consisting of more than thirty pieces until 1899, most of which were commissioned by members of the Natanson family and their associates.

Lucina Ward

1 The panels which hung to the right of the triptych, *The promenade* and *First steps*, are now in the Museum of Fine Arts, Houston and the Tom Jones Company / Oxford Clothes; those opposite, *The two schoolboys* and *Under the trees* are in the Musées Royaux des Beaux-Arts de Belgique, Brussels, and at the Cleveland Museum of Art, Cleveland; the over doors may be those in the Françoise Marquet Collection, Paris, but other candidates such as those in the Musée des Beaux-Arts, Rouen, have also been proposed. For annotated sketches of the layout of the ensemble, see Guy Cogeval, *Edouard Vuillard*, Washington D.C.: National Gallery of Art 2003, cats 120–22, p. 181.

2 Kimberley Jones, 'The public gardens', in Guy Cogeval (ed.), *Edouard Vuillard*, Washington D.C.: National Gallery of Art 2003, cats 116–24, p. 176.

3 *The promenade* and *First steps* panels, on the other hand, contain a broader mix of social classes; see Gloria Groom, *Beyond the easel: decorative painting by Bonnard, Vuillard, Denis, and Roussel, 1890–1930*, Chicago: Art Institute of Chicago; New Haven: Yale University Press 2001, cats 32–33, p. 120.

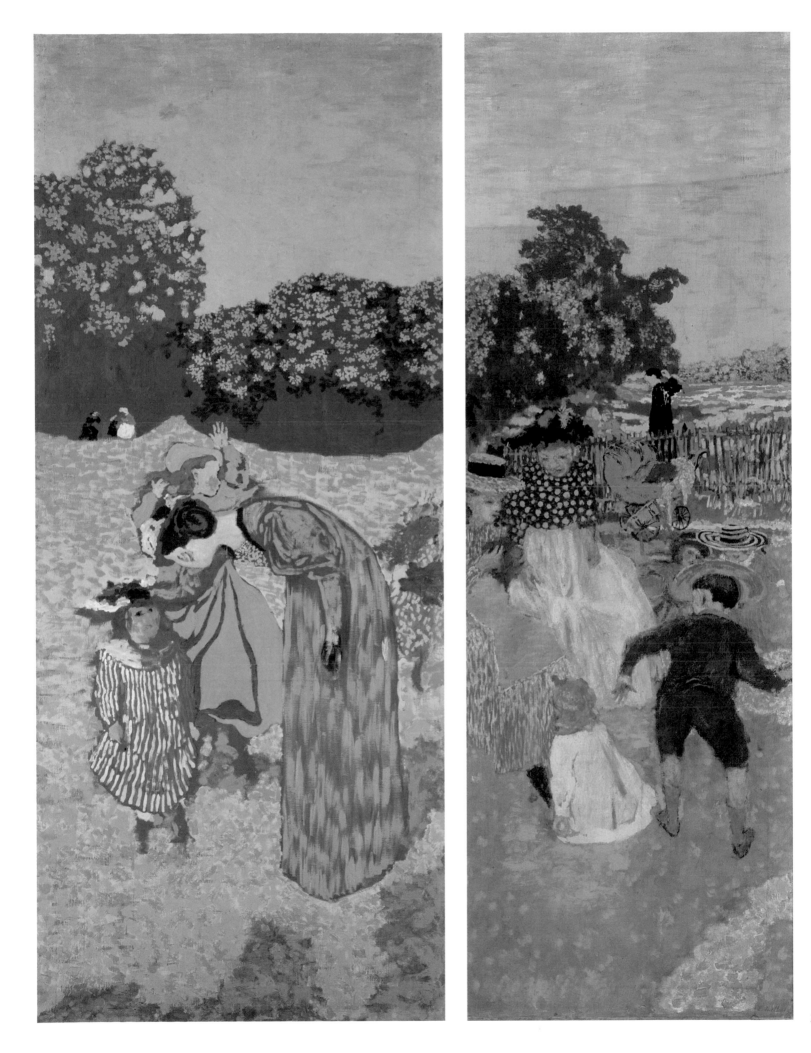

109 Pierre Bonnard (above)

France 1867–1947

Decorative panel: water games (The voyage)
(Panneau décoratif: jeux d'eaux (Le voyage))
1906–10
oil on canvas, 248.5 x 298.5 cm

Musée d'Orsay, Paris, purchased with the assistance of the Fonds
du Patrimoine 1996, RF 1996-18
© RMN (Musée d'Orsay) / Hervé Lewandowski
© Pierre Bonnard. ADAGP/Licensed by Viscopy, 2009

110 Pierre Bonnard (below)

France 1867–1947

Decorative panel: pleasure
(Panneau décoratif: le plaisir) 1906–10
oil on canvas, 230.0 x 300.0 cm

Musée d'Orsay, Paris, accepted in lieu of tax 2007, RF 2007-22
© Musée d'Orsay, Dist RMN / Patrice Schmidt
© Pierre Bonnard. ADAGP/Licensed by Viscopy, 2009

In July 1906 Bonnard accompanied Misia, his friend, muse and patron, and her new husband, the millionaire press baron Alfred Edwards, on a pleasure trip on their yacht.[1] Misia met Bonnard when she was married to Thadée Natanson, owner and editor of *La Revue blanche* (*The White Review*). Through Natanson, she encountered the modern artists, writers and musicians of Paris, including the Nabis—Bonnard, Denis, Roussel, Vuillard and Vallotton—the poets Paul Verlaine and Stéphane Mallarmé, and the composers Claude Debussy and Maurice Ravel. In 1905 Misia became the fourth of Alfred Edwards' wives (he eventually had six). In August Bonnard began a commission for four large panels[2] to decorate the Edwards' dining room at 21 Quai Voltaire in Paris. The marriage was short however, as by December 1906 Edwards had fallen for a young actress, Geneviève Lantelme.[3] So the commission, begun in harmony for husband and wife, ended in discord.

Bonnard's large decorative internal borders, Rococo or Chinese in inspiration, feature magpies with strings of pearls, and cavorting monkeys. Magpies are gossips and thieves of shiny objects, while monkeys are lewd and ugly. The reference to the new lover and the old husband seems overt, especially since Misia told of a confrontation with her rival in which Lantelme asked for pearls, money—and Misia.[4] The bright orange borders surround classical scenes of pleasure and sensory delights, where men, women and children in tunics swim and play in gardens or on the seashore. Like the lovers in Jean-Antoine Watteau's *Return from the island of Cythera* 1717,[5] this is a fantasy world of imagined immediate experience, existing in a limbo of memory and desire.

The four panels were finished for display at the Salon d'Automne in 1910, where they were reviewed favourably in *L'Art décoratif* by that severe critic of modern art, Louis Vauxcelles:

> M. Bonnard is fantasy, instinct, ingenuous spontaneity, French charm, both tender and mischievous. He delights the eye with attenuated colour harmonies suggesting the tones of faded tapestries, and iridescent, pearly skin in semi-darkness.[6]

Vuillard attended the 'evening party for Bonnard's panels'[7] held at Misia's home on Christmas Day 1910, where her friends celebrated the fruits of Misia's patronage.

Christine Dixon

1 I am indebted to Gloria Groom's extensive research and commentary on these works, published in her exhibition catalogue *Beyond the easel: decorative painting by Bonnard, Vuillard, Denis, and Roussel, 1890–1930*, Chicago: Art Institute of Chicago 2001, pp. 173–77, and in her essay 'Bonnard's decorative style: shifting boundaries', in *Pierre Bonnard: observing nature*, Canberra: National Gallery of Australia 2003, pp. 78–116.

2 The other two panels are *Landscape animated with bathers* 1906–10, 251.5 x 470.0 cm, J. Paul Getty Museum, Los Angeles, and *After the flood* 1906–10, 250.0 x 450.0 cm, Ikeda Museum of Twentieth Century Art, Tokyo.

3 Misia divorced Edwards in 1909, and married the Spanish painter José Sert, who worked with Serge Diaghilev on Ballets Russes commissions. She is often referred to as Misia Sert.

4 Groom, 2003, p. 100.

5 Musée du Louvre, Paris.

6 Quoted in Groom, 2001, pp. 173 and 268, n. 2.

7 Quoted in Groom, 2003, p. 115, n. 51.

111 Pierre Bonnard

France 1867–1947

View of Le Cannet (*Vue du Cannet*) 1927
oil on canvas, 233.6 x 233.6 cm
Musée d'Orsay, Paris, gift of the Fondation Meyer 2008,
RF 2008-52
© Musée d'Orsay, Dist RMN / Patrice Schmidt
© Pierre Bonnard. ADAGP/Licensed by Viscopy, 2009

In 1926 Bonnard bought a house, the Villa Rose, on the French Riviera, high in the village of Le Cannet.[1] He renamed it 'Le Bosquet' (meaning wooded or bosky). *View of Le Cannet*, like the decorative panels of *Water games* and *Pleasure* (cats 109 and 110), is among the largest canvases Bonnard ever painted. Shaped like an architectural feature, perhaps a window or archway, the vista is contained within a valley seen from the hilltop.

Instead of using conventional greens, Bonnard depicted the palm trees and woods, which frame the composition, in silvery-blues and lime-yellow. The village houses are presented as white walls and red or orange tiled roofs, all but drowning in the bright gold of the mimosa trees. They serve as a yellow fog, half masking the town—like a Renaissance village in an Old Master painting, timeless and perfect. But the scene is also modern, as we can see in the apartment buildings impinging on its edges. At first sight the town seems uninhabited, then we notice people gathering at its arched entrance, perhaps going to market or other daily activities.

Bonnard's search for beauty and harmony is revealed in the contrasting elements of the painting. The cubes and prisms of buildings appear artificial and geometrically precise, allowing a firm structure for the central valley. Natural elements, especially the sweeping arcs of palm foliage and the silvery-grey bushes, are less formal, and highly decorative.

Characteristics such as beauty and decoration became deeply unfashionable as Modernist artists sought more abstract and extreme solutions to pictorial and aesthetic questions in the twentieth century. But for Bonnard, decorative qualities do not detract from the work of art, they are essential. As Henri Matisse stated:

> The character of modern art is to participate in life. A painting in an interior spreads joy around it through its colours, which calm us. The colours obviously are not composed haphazardly, but expressively. A painting on a wall should be like a bouquet of flowers in an interior.[2]

The wealthy industrialist Bernard Reichenbach bought this painting for his new house in Paris, where it probably hung in an alcove in the bedroom.[3] For the owner of the painting on a grey Parisian day, surely Bonnard's *View of Le Cannet* brought a breath of southern spring.

Christine Dixon

1 Le Cannet, then a separate village on the French Riviera, is now part of the large urban area of Cannes.

2 Quoted in Gloria Groom, *Beyond the easel: decorative painting by Bonnard, Vuillard, Denis and Roussel, 1890–1930*, Chicago: Art Institute of Chicago 2001, p. 146, notes 16 and 165.

3 Acquisitions, October 2008, Musée d'Orsay online, viewed 13 August 2009, http://www.musee-orsay.fr/en/collections/acquisitions/recent-acquisition.html#c29264.

112 Henri Rousseau

France 1844–1910

War (*La guerre*) c. 1894
oil on canvas, 114.0 x 195.0 cm
Musée d'Orsay, Paris, purchased 1946, RF 1946-1

War, personified as a wild woman in white, riding a black horse, gallops through a desolate landscape strewn with butchered bodies. Colour and life are drained out of everything, leaving only death and destruction. A clear blue sky heightens the impact of her passing: behind her a tree is burnt black, while the grey tree in front awaits fire and obliteration. She carries a flaming torch and a bare sword—but this is no classical Bellona, Roman goddess of war.[1] Rather, she is an elemental force, humanity's worst side made as irresistible as a force of nature.

Rousseau permits no hope in this vision—his most violent subject. Dead and dying humans are cut off like tree limbs, their pale flesh coloured orange like the smoky clouds behind. Jagged black elements recur, from the elongated horse's mane to War's own hair, almost an animal's pelt. The pattern is repeated in some victims' hair, and in the crows pecking at their bodies. Rousseau was very much affected by the Franco–Prussian War of 1870–71 and the Siege of Paris in 1871; the effects were still visible in the streets in the 1890s, with many amputees to be seen.

The catalogue of the Salon des Indépendants, where the painting was first exhibited in 1894, listed it as: 'War; she passes terrifyingly, leaving despair, tears, ruin all around.'[2] Rousseau depicts the horse as one of the four ridden by the Four Horsemen of the Apocalypse (from the Book of Revelation), while appropriating the form of Théodore Géricault's flat-out racer in *Epsom Derby* 1821.[3] By this time, Eadweard Muybridge's photographs had proven that all four hooves never left the ground together in this way, but the frightening image of War floating over her victims was more visually compelling than mere empirical reality.

Rousseau's sources for his compositions included popular engravings and illustrations, as well as works by the Old Masters. An anonymous lithograph portraying the Tsar as a caped Cossack with sword was published in the socialist journal *L'Egalité* on 6 October 1889, and republished as an advertisement in *Le Courrier francais* on 27 October 1889.[4] Another inspiration was *Night* (*Die Nacht*) 1889–90, by the Swiss painter Ferdinand Hodler, shown in Paris at the Salon des Artistes Français in 1891.[5] Hodler portrayed strongly foreshortened prone figures surrounding a hooded black figure of Death.

Like all Rousseau's works, *War* was received controversially. Both critics and public ridiculed the artist's naivety, or scolded his lack of skill and strange subjects. Others, like the young writer Alfred Jarry and some of the modern painters, celebrated Rousseau's difference. The young painter Louis Roy wrote that War 'may have seemed strange only because it does not recall anything seen up to now. Is this not a supreme quality? ... [Rousseau] strives towards a new art.'[6]

Christine Dixon

1 The painting is also known as *The ride of Discord*, invoking the Roman Goddess Discordia.

2 '*La guerre; elle passe effrayante laissant partout le désespoir, les pleurs, la ruine.*'

3 Musée du Louvre, Paris. The source was pointed out by Michel Hoog in *Henri Rousseau*, New York: The Museum of Modern Art 1985, p. 120.

4 Yann Le Pichon and Joachim Neugroschel (trans.), *The world of Henri Rousseau*, New York: Viking Press 1982, p. 222.

5 Kunstmuseum, Bern. See Hoog, p. 121, fig. 2.

6 Review in *Le Mercure de France*, March 1895, quoted in Dora Vallier, *Henri Rousseau*, Naefels: Bonfini Press 1979, p. 60.

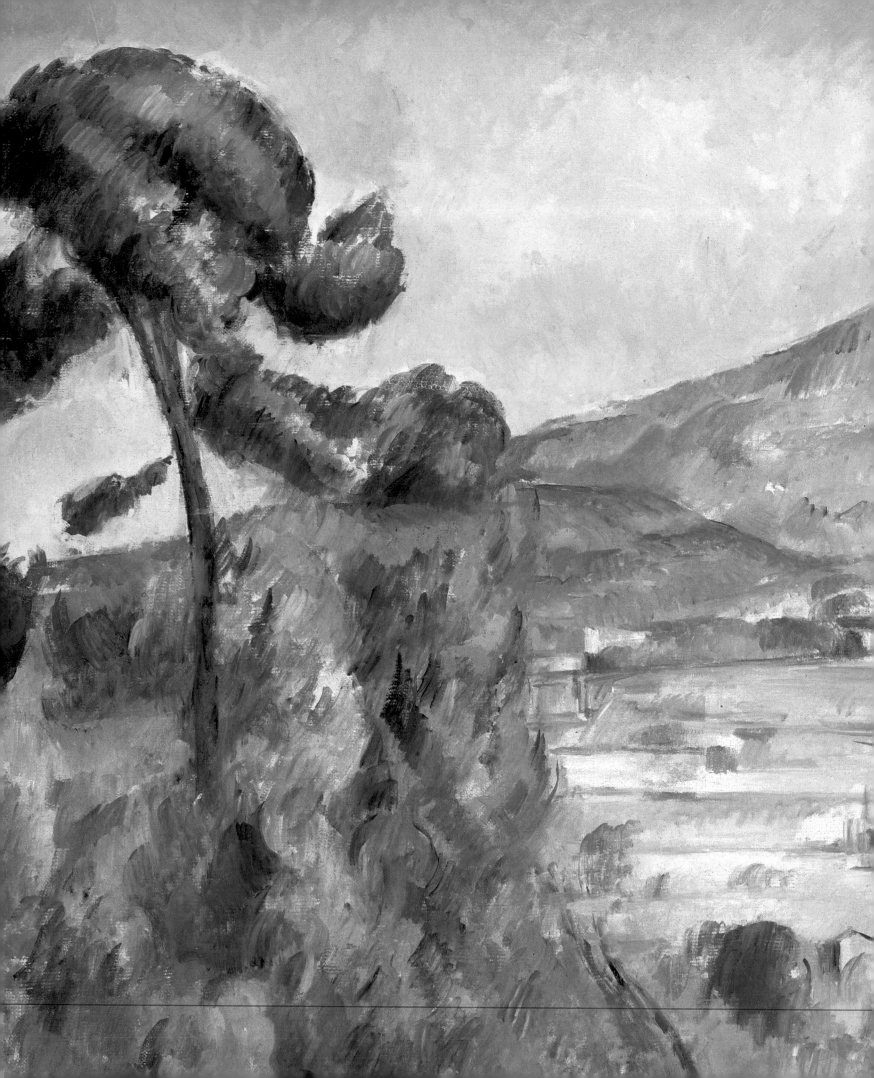

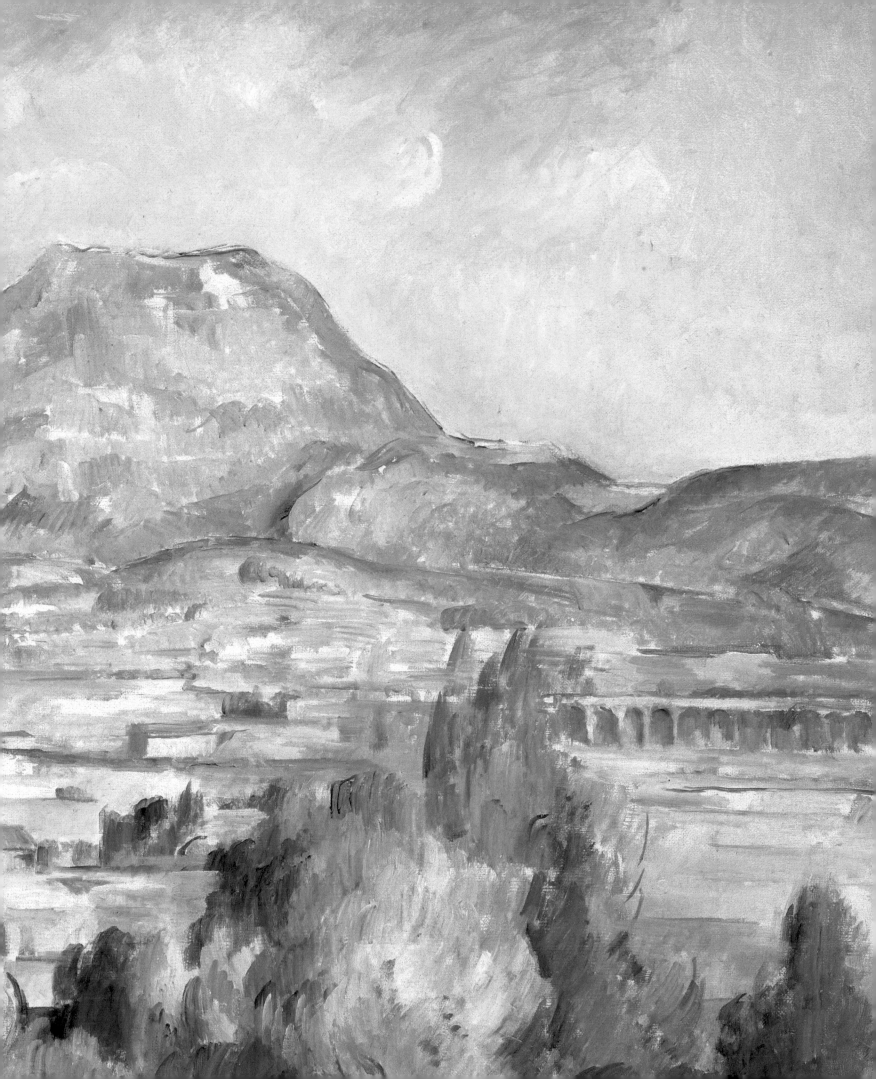

Acknowledgments

An exhibition of this scale and quality cannot be realised without the assistance, support and cooperation of governments, institutions, organisations and many individuals.

The National Gallery of Australia acknowledges the support of the Minister for the Environment, Heritage and the Arts, the Hon. Peter Garrett, AM, MP; and the support of the Department of the Environment, Heritage and the Arts.

We are extremely grateful to the Australian Government's indemnification scheme, Art Indemnity Australia, through which the loans from the Musée d'Orsay have been indemnified. Without this generous assistance, the exhibition could not have been realised.

The Gallery acknowledges the generous support of our exhibition partners. We would like to thank our Presenting Partners—Musée d'Orsay, Australian Capital Tourism and Art Indemnity Australia; our Principal Partners—National Australia Bank, Channel Nine and JCDecaux; our Major Sponsors—Qantas, Yulgilbar Foundation, NGA Council Exhibition Fund and The Canberra Times; and our Supporters—ABC Radio, WIN TV, Novotel, Champagne Pol Roger and Yalumba Wines.

Praise and thanks are due to Guy Cogeval, President of the Musée d'Orsay, whose vision and selection of works have made this a great exhibition. Many people from both the National Gallery of Australia and the Musée d'Orsay have contributed to achieving this significant exhibition and accompanying publication.

From the Musée d'Orsay

We acknowledge the curators Stéphane Guégan and Sylvie Patry. And other staff who have made major contributions—Elsa Badie-Modiri, Stéphane Bayard, Martine Bozon, Myriam Bru, Evelyne Chatelus, Christine Cuny, Annie Dufour, Hélène Flon, Françoise Fur, Thierry Gausseron, Amélie Hardivillier, Caroline Mathieu, Nathalie Mengelle, Anne Meny-Horn, Odile Michel, Jean Naudin, Olivier Simmat, Denis Thibaud and Araxie Toutghalian.

From the National Gallery of Australia

We acknowledge the coordinating curators Christine Dixon and Lucina Ward, and assistant Simeran Maxwell; and the other contributors to the publication—Mark Henshaw, Jane Kinsman and Emilie Owens.

Other staff—Hester Gascoigne and Rebecca Scott (Executive); Jacqui Ockwell, Sophie Ross and intern Krysia Kitch (International Art); Debbie Ward, David Wise and team (Conservation); Natalie Beattie, Mark Bradley, Deb Hill, Sara Kelly and art handlers (Registration); Mark Bayly, Emma Doy, Patrice Riboust, Tui Tahi and the Installations crew (Exhibitions); Mark Mandy and Jodie Tunks (Facility Management); Paul Cliff, Julie Donaldson, Kirsty Morrison, Nick Nicholson and Kristin Thomas (Publishing); Andrew Powrie and team (Online); Gillian Currie, Helen Hyland, Melissa Cadden and Joy Volker (Research Library); Irene Delofski, Joanne Tuck-Lee and Maryanne Voyazis (Membership); Kirsten Downie, Eleanor Kirkham, Svetlana Mironov and Sandra Sweeney (Marketing and Communications); Frances Corkhill, Belinda Cotton and Liz Wilson (Sponsorship and Development); Elizabeth Malone and the Gallery Shop team (Commercial); Adriane Boag, Michelle Fracaro, Kirsten Jeffcoat, Margie Kevin, Denise Officer, Peter Naumann, Katie Russell, Frances Wild and Edith Young (Education and Public Programs); David Pang and photographers (Imaging Services); Craig O'Sullivan and Security staff; and the Gallery's voluntary guides.

Finally, I acknowledge the support of the Gallery's Council, Foundation and its executive—Alan Froud, Simon Elliott, Shanthini Naidoo and Adam Worrall.

**Ron Radford AM, Director,
National Gallery of Australia**

Authors and contributors

Guy Cogeval has been Chair and President of the Musée d'Orsay since March 2008. A former resident-fellow of the Académie de France in Rome, he was director of the Musée National des Monuments Français (1992–96) and the Montreal Museum of Fine Arts (1998–2007). A specialist in the Symbolist movement, in particular the Nabis, he has curated a number of significant exhibitions in this area: *Maurice Denis* (1994), *Le Symbolisme en Europe* (1995), *Le temps des Nabis* (1998) and *Vuillard* (2003). He also has an interest in the relationship between art and cinema and was one of the curators of *Hitchcock et l'art* (2000–11) and *Il était une fois Walt Disney* (2007). His *Catalogue raisonné des peintures et pastels de Vuillard* was published in 2004.

Christine Dixon is Senior Curator, International Painting and Sculpture, at the National Gallery of Australia. She has curated numerous exhibitions on subjects including Chinese woodcuts, the Russian Ballet, William Morris and 1968. Most recently she was co-curator and writer for the catalogue of the major exhibition *Turner to Monet: the triumph of landscape painting in the nineteenth century* (2008). She is the editor of a major project producing extensive catalogue entries of the Gallery's collection of American and European paintings and sculpture. Her particular interest is European modernism 1890–1940; she is currently working on the Surrealist artist Max Ernst.

Stéphane Guégan is a curator at the Musée d'Orsay in Paris. He is a specialist in nineteenth-century art and has studied French painting and art criticism for the past twenty-five years, focusing on Romanticism and its legacy. He has published *Théophile Gautier: La critique en liberté* (1997), *Delacroix: L'Enfer et l'atelier* (1998), *Gauguin: Le sauvage imaginaire* (2003), *Ingres érotique* (2006) and edited *Salons of Stendhal* (2002). He has curated or co-curated several exhibitions including *Chassériau: Un autre romantisme* (2002–03), *De Delacroix à Renoir: l'Algérie des peintres* (2003) and *Ingres* (2006).

Sylvie Patry has been a curator at the Musée des Beaux-Arts de Lille, the Galeries Nationales du Grand Palais and, since 2005, the Musée d'Orsay. She has curated a number of international exhibitions dedicated to major painters of the second half of the nineteenth century including *Berthe Morisot* (2000), *Maurice Denis* (2006), *Ferdinand Hodler* (2007) and the touring exhibition *Renoir* (2009-10), for which she co-edited the catalogue. She is currently working on the Claude Monet retrospective which will open in 2010 at the Galeries Nationales du Grand Palais in Paris.

National Gallery of Australia contributors

Mark Henshaw is Curator, International Prints, Drawings and Illustrated Books. His most recent exhibitions and publications include *Degas' world: rage for change* (2009) and *Birth of the Modern poster* (2008).

Jane Kinsman is Senior Curator of International Prints, Drawings and Illustrated Books. She has curated numerous exhibitions and written for the associated catalogues including *Degas: master of French art* (2008–09), *Paris in the late 19th century* (1996) and *The prints of R.B. Kitaj* (1994).

Simeran Maxwell is the Exhibition Assistant for *Masterpieces from Paris: Van Gogh, Cézanne, Gauguin and beyond*. She also assisted on the exhibition *Degas: master of French art* (2008–09) and wrote for the catalogue.

Emilie Owens has been an assistant in the International Art department at the National Gallery of Australia since 2006 and has contributed to catalogues including *Soft sculpture* and *Turner to Monet: the triumph of landscape painting* (2008).

Lucina Ward is Curator, International Painting and Sculpture. Her recent projects include *Soft sculpture* (2009) and she was co-curator of *Turner to Monet: the triumph of landscape painting* (2008).

Index of artists

Index of works

Other works mentioned in text
Italics indicate image

© National Gallery of Australia, 2009

All rights reserved. No part of this publication may be reproduced or transmitted in any form or by any means, electronic or mechanical (including photocopying, recording or any information storage and retrieval system), without permission from the publisher.

The National Gallery of Australia is an Australian Government Agency

nga.gov.au

Produced by NGA Publishing
National Gallery of Australia, Canberra

Editing: Paul Cliff*

Design and production: Kristin Thomas*

Rights & permissions: Nick Nicholson*

Publishing manager: Julie Donaldson*

Indexer: Sherrey Quinn

Pre-press and printing: Blue Star, Melbourne

*National Gallery of Australia

National Library of Australia Cataloguing-in-Publication entry
Masterpieces from Paris: Van Gogh, Gauguin, Cézanne and beyond:
Post-Impressionism from the Musée d'Orsay/Guy Cogeval ... [et al.]
1st ed
ISBN 9780642334046 (pbk)
Includes index
Subjects: Musée d'Orsay—Exhibitions.
National Gallery of Australia—Exhibitions.
Impressionism (Art)—France—Exhibitions.
Other Authors/Contributors: Cogeval, Guy.
National Gallery of Australia
Dewey Number: 759.4074947

Published in conjunction with the exhibition
Masterpieces from Paris: Van Gogh, Gauguin, Cézanne & beyond
Post-Impressionism from the Musée d'Orsay
at the National Gallery of Australia, Canberra
4 December 2009 – 5 April 2010

Reprinted January 2010